FEROCIOUS REALITY

VISIBLE EVIDENCE
Michael Renov, Faye Ginsburg, and Jane Gaines, Series Editors

(continued on page 337)

FEROCIOUS REALITY

Documentary according to Werner Herzog

ERIC AMES

Visible Evidence 27

University of Minnesota Press
Minneapolis · London

The University of Minnesota Press gratefully acknowledges financial assistance provided for the publication of this book from the Department of Germanics, University of Washington.

A portion of chapter 2 was previously published as "Herzog, Landscape, and Documentary," *Cinema Journal* 48, no. 2 (2009): 49–69; copyright 2009 by the University of Texas Press; all rights reserved. Part of chapter 5 was previously published as "The Case of Herzog: Re-opened," in *A Companion to Werner Herzog,* ed. Brad Prager, 393–415 (Oxford: Wiley-Blackwell, 2012).

The Minnesota Declaration copyright by Werner Herzog.

Published by the University of Minnesota Press
111 Third Avenue South, Suite 290
Minneapolis, MN 55401-2520
http://www.upress.umn.edu

Library of Congress Cataloging-in-Publication Data

Ames, Eric.
 Ferocious reality : documentary according to Werner Herzog / Eric Ames.
 (Visible evidence ; 27)
 Includes bibliographical references and index.
 ISBN 978-0-8166-7763-4 (hc : alk. paper) — ISBN 978-0-8166-7764-1 (pb : alk. paper)
 1. Herzog, Werner, 1942—Criticism and interpretation. 2. Documentary films—History and criticism. I. Title.
 PN1998.3.H477A63 2012
 070.1'8—dc23

 2012030014

Printed in the United States of America on acid-free paper

The University of Minnesota is an equal-opportunity educator and employer.

20 19 18 17 16 15 14 13 12 10 9 8 7 6 5 4 3 2 1

CONTENTS

ACKNOWLEDGMENTS

I have a number of people to thank for the help they gave me in writing this book. Several people read portions of the manuscript, and it benefited enormously as a result. They include Maya Barzilai, Jane Brown, Dan Gilfillan, Deniz Göktürk, Marianne Hirsch, Anton Kaes, Monika Kaup, Sudhir Mahadevan, Brigitte Prutti, Mark Sandberg, and Diana Taylor. Special thanks go to Brad Prager for his detailed and constructive feedback on the entire manuscript. At the University of Washington, I am grateful to my students for exploring the films with me, to Stephanie Welch for helping me prepare the illustrations, and to the Department of Germanics for providing a book subvention. Both the German department at Columbia University and a Herzog retrospective at Arizona State University gave me opportunities to hone key ideas and their presentation in writing. At the University of Minnesota Press, I am particularly grateful to Jason Weidemann and to his assistant, Danielle Kasprzak, for their editorial guidance. Finally, I want to thank my family—Veronika, Isaac, and Max—for their constant love and support in all my endeavors. This book is dedicated to them.

THE MINNESOTA DECLARATION

Truth and fact in documentary cinema
"Lessons of Darkness"

1. By dint of declaration the so-called Cinema Verité is devoid of verité. It reaches a merely superficial truth, the truth of accountants.

2. One well-known representative of Cinema Verité declared publicly that truth can be easily found by taking a camera and trying to be honest. He resembles the night watchman at the Supreme Court who resents the amount of written law and legal procedures. "For me," he says, "there should be only one single law: the bad guys should go to jail." Unfortunately, he is part right, for most of the many, much of the time.

3. Cinema Verité confounds fact and truth, and thus plows only stones. And yet, facts sometimes have a strange and bizarre power that makes their inherent truth seem unbelievable.

4. Fact creates norms, and truth illumination.

5. There are deeper strata of truth in cinema, and there is such a thing as poetic, ecstatic truth. It is mysterious and elusive, and can be reached only through fabrication and imagination and stylization.

6. Filmmakers of Cinema Verité resemble tourists who take pictures amid ancient ruins of facts.

7. Tourism is sin, and travel on foot virtue.

8. Each year at springtime scores of people on snowmobiles crash through the melting ice on the lakes of Minnesota and drown. Pressure is mounting on the new governor to pass a protective law. He, the former wrestler and bodyguard, has the only sage answer to this: "You can't legislate stupidity."

9. The gauntlet is hereby thrown down.

10. The moon is dull. Mother Nature doesn't call, doesn't speak to you, although a glacier eventually farts. And don't you listen to the Song of Life.

11. We ought to be grateful that the Universe out there knows no smile.

12. Life in the oceans must be sheer hell. A vast, merciless hell of permanent and immediate danger. So much of a hell that during evolution some species—including man—crawled, fled onto some small continents of solid land, where the Lessons of Darkness continue.

Werner Herzog
April 30, 1999

INTRODUCTION: WERNER HERZOG, DOCUMENTARY OUTSIDER

On April 30, 1999, Werner Herzog visited the Walker Art Center in Minneapolis, Minnesota, for a public dialogue with film critic Roger Ebert. After they had both been introduced, Herzog walked alone to center stage of the museum's theater and addressed the audience of more than three hundred people. "Ladies and gentlemen," he said with a German accent,

> before we start this dialogue, I would like to make a statement. It is something that I have reflected upon for many years in the frustration of seeing so many documentary films. When you look at television, you probably have experienced a similar frustration. There's something ultimately and deeply wrong about the concept of what constitutes fact and what constitutes truth in documentaries in particular. And very recently, traveling around a lot, I was jetlagged, woke up a couple of times during the night, tried to switch on television, and it was all bad. Between 3:00 and 3:15 in the morning in Sicily, I wrote down quickly a manifesto, which I would like to read to you. I would like to call it the Minnesota Declaration.

The audience responded with laughter and applause, effectively setting the tone for Herzog, who went on to declaim the twelve-point manifesto, subtitled "Lessons of Darkness."[1] The performance, which the filmmaker later called a "rant," was more than just another occasion to rehearse his well-known diatribe against cinema verité.[2] It was also a way of promoting his own contribution to documentary in terms that he uses to describe all his films. Here is the key point (number 5) of the manifesto: "There are deeper strata of truth in cinema, and there is such a thing as

poetic, ecstatic truth. It is mysterious and elusive, and can be reached only through fabrication and imagination and stylization."[3] Whereas Herzog introduced the manifesto with a mix of narrative (one sleepless night in Sicily), exposition (generalizations about documentary), and humor (emphatic seriousness), he concluded by dramatically claiming a minority position for himself, involving the audience in his performance and soliciting their assent. "Ladies and gentlemen, I've never had a majority on my side throughout my life. I wish you to adopt this as the Minnesota Declaration by acclamation." Cheers followed applause when, on Herzog's cue, theater ushers handed out signed copies of the manifesto "as a souvenir of this evening," which had only just begun.

Since then, the Minnesota Declaration has had an extraordinary afterlife, one that tells us something unique about Herzog's approach to documentary filmmaking. Like other notable manifestos, it has been printed, circulated, and anthologized. In an interesting twist, however, part of this declaration, which is based on Herzog's previous work, would later be converted back into a film. In *Encounters at the End of the World* (2007), his feature-length documentary filmed in Antarctica, an aging scientist named Sam Bowser contemplates the thought of making his final plunge into the subarctic sea before "passing the ball off to the next generation," a moment that also reflects Herzog's situation as a grizzled veteran filmmaker. The biologist proceeds to describe an undersea world of "horribly violent" conditions. Speaking with Herzog, whose voice can be heard off camera, Bowser rehearses almost verbatim the final point of the Minnesota Declaration, which reads, "Life in the oceans must be sheer hell. A vast, merciless hell of permanent and immediate danger. So much of a hell that during evolution some species— including man—crawled, fled onto some small continents of solid land, where the Lessons of Darkness continue." Herzog thus takes a point of the manifesto, encapsulating his characteristically grim vision of the natural world, reframes it as a point of biological fact, and puts it in the mouth of an expert witness. More than just a humorous scene parodying the conventional use of scientific authority, it rehearses and restages a part of Herzog's manifesto, now in the form of a documentary film.

The turn of the twenty-first century marked a period when the German-born director, long known for his "visionary masterpieces"

such as *Aguirre, the Wrath of God* (*Aguirre, der Zorn Gottes,* 1972) and *The Enigma of Kaspar Hauser* (*Jeder für sich und Gott gegen alle,* 1974), had been working intensively in the documentary mode. This surge of activity, resulting in such films as *Little Dieter Needs to Fly* (*Flucht aus Laos,* 1998), *My Best Fiend* (*Mein liebster Feind,* 1999), and *Grizzly Man* (2005), may have coincided with documentary's return to mainstream theaters and critical consciousness in the United States and elsewhere but was for Herzog nothing new. Neither was his comment on documentary epistemology, the Minnesota Declaration. Over the course of his career, from 1962 to the present, Herzog has directed almost sixty films, roughly half of which are indexed as documentaries.

This book explores Herzog's ambivalent and innovative relationship to documentary cinema. It proceeds from the counterintuitive idea that Herzog dismisses documentary as a mode of filmmaking to creatively intervene and participate in it. The book's title, *Ferocious Reality,* comes from an essay by Amos Vogel (an early advocate of Herzog's work) on the visual taboo against showing actual death on film.[4] While Herzog in fact deals with this taboo (most recently in *Grizzly Man*), the title of this book also evokes the filmmaker's testy and contested relationship with his environment. In a memorable scene from *Burden of Dreams* (1982), Les Blank's documentary on the making of *Fitzcarraldo* (1982), the German filmmaker looks into the camera and describes his emphatically antiromantic vision of nature as "the harmony of overwhelming and collective murder." *Ferocious Reality* takes seriously Herzog's aim to hold an unflinching gaze on the world, his much-cited claim that "the camera knows no mercy."[5] On another level, the title refers to what he calls "the assault of virtual reality" on everyday life, meaning the proliferation not only of digital imaging technologies but also of video games, the Internet, and reality television—a phenomenon that has only increased his stake in the documentary image and in its associated claims to truth and reality.[6] Finally, the book's title bears a further reference to the filmmaker's hostile attitude toward "the documentary tradition" in the narrowest sense of the phrase.

Herzog's position as a documentary outsider has not only been self-imposed but also reinforced by others. Until recently, his irreverent attitude and avowed penchant for staging and fabrication had all but

disqualified him from serious consideration by scholars of documentary. Hence his conspicuous absence from the literature; Herzog may be the most influential filmmaker whose contribution to documentary is nowhere discussed in the major studies and standard histories of the form. This situation might not last, however, and there are already signs of change. The new *Encyclopedia of the Documentary Film,* for example, includes a substantial entry for Herzog.[7] In 2007, he appeared alongside Nick Broomfield, David Maysles, Errol Morris, and others in *Capturing Reality: The Art of Documentary,* an educational program produced by the National Film Board of Canada. The following year, he received the International Documentary Association's career achievement award, recognizing both the extent of his output and its decisive impact on documentary's evolution, and *Encounters at the End of the World* was nominated for an Academy Award (another first for Herzog) in the category of best documentary feature.

If Herzog and his films are now being absorbed by the field of their own resistance, there are reasons for this development. One of them has to do with disciplinary history. Herzog and his films could hardly serve (except as a negative example) in establishing documentary as a legitimate object of study, in separating it from fiction, or in maintaining a history of documentary before and after Grierson—all motivating concerns behind much of the previous scholarship.[8] Another reason for the changing situation comes from Herzog's films. For even as he refuses to align himself with the documentary tradition (or with any tradition, for that matter), and although his work has been either overlooked or neglected by scholars of documentary, Herzog has in many ways added to the vitality and visibility of documentary cinema internationally for more than four decades.

Critique and Continuity

Herzog is not an easy example through which to explore the vicissitudes of documentary cinema. The director himself declares the line between fiction and nonfiction to be blurred throughout his work. Most commentators follow suit, noting how his documentaries are staged and how his fiction films involve documentary elements, without, however,

engaging (much less exploring) specific issues or questions of documentary, in effect bracketing off an entire area of inquiry. Herzog obviously resists having his work pigeonholed or otherwise subjected to analytical categories, which is easy enough to understand (even if we know that categories are neither fixed nor static but rather fluid and subject to change). He also exploits documentary's indeterminate generic and epistemological status at every turn. And yet the difference between his documentary output and that of other filmmakers is less extreme than scholars have yet to acknowledge. Herzog may blur the distinction between fiction and nonfiction, but he also trades on the cultural capital and authority that have historically accrued to documentary, always to his own advantage. Indeed, all the films discussed in this book have been indexed (i.e., designated for distribution and marketing) as documentaries by various distributors as well as by Herzog's own production company—a practice that not only reinforces the same distinction that he dismisses in public but also shapes the conditions of their reception, as the filmmaker is well aware. All claims to the contrary notwithstanding, the context of documentary circumscribes much of his work, providing the very forms, conventions, rituals, and taboos that he both refuses and engages in his films. Even as Herzog bemoans the category, he employs it in meaningful ways. "The term 'documentary' should be handled with care," he says, "for it is only an attempt to categorize. We just haven't developed a more appropriate concept." Nevertheless, he continues, "I prefer using the word 'documentary' with caution, because we have in our daily language a very precise definition of it, which we carry around with us constantly."[9] This book, too, uses the term *documentary,* without, however, setting it in quotation marks or apologizing for lack of a better term. The task is to investigate how the concept of documentary has informed Herzog's practice and how the filmmaker in turn has responded and contributed to the history of documentary film and television.[10]

Although it is tempting to claim that Herzog intervenes provocatively (even perversely), it is important to remember that intervention occurs more or less in all documentaries. A similar provision needs to be made for *stylization,* a term that encompasses the aesthetic effects of filmmaking, the translation of a director's perspective on the world, and his involvement with the film's subject as well. After all, Herzog's

documentaries only become staged, stylized, and discussable as such through the prevailing discourse of documentary. On another level, we need to recognize that there can never be any representation without style, indeed, to recognize and accept that techniques of stylization are integral to documentary filmmaking and not necessarily opposed to it, as some commentators would seem to assume. This particularly holds for Herzog's reenactment films such as *Little Dieter Needs to Fly*. Even in this case, however, the received idea that the film is "scripted"—both literally, as following a written dialogue, and figuratively, as being invented by the filmmaker—would seem to be overstated. A 1998 interview with the film's subject, Dieter Dengler, makes this point clear. It also reads like a comedy sketch. Asked about his experience of working with Herzog, and specifically about the process of "scripting" the film, Dengler explains,

> There's no script. He would stand behind the camera and do like this [Dengler hooks his finger into his mouth and bugs his eyes out crazily]. He'd make all these hand signals, and I'm trying to figure out what I'm supposed to say, and I said, "Werner, I have no clue what you're trying to tell me! Why don't you just put up a sign that tells me what you want me to say?" And Werner said, "I don't work like that. I want you to just say what comes to your mind."[11]

However odd and humorous this exchange may sound, it reminds us that Herzog's documentaries are collaborative endeavors that typically negotiate multiple voices and perspectives. They are scripted, staged, arranged, and fabricated, as is well known, but they are also unscripted, improvised, contingent, and exploratory. The question is how to analyze this mix of elements in specific situations.

Herzog's engagement with documentary cinema can be traced back to the context of independent filmmaking in West Germany during the 1960s and 1970s, where documentary played an important role—one that has since been almost forgotten. "It is not often appreciated," Thomas Elsaesser writes in his history of the New German Cinema, "that virtually every feature filmmaker" associated with the movement "started in documentary films." Indeed, he claims, feature filmmaking in West Germany "renewed itself primarily by its rediscovery of documentary."[12]

Here, as elsewhere, commissioned work from industry, government, and nonprofit organizations provided a key source of filmmaking experience for young and aspiring directors across the board.[13] Herzog, for one, took his first commission, *The Flying Doctors of East Africa* (*Die fliegenden Ärzte von Ostafrika,* 1969), at a pivotal time in his development as a filmmaker. Hired by the German chapter of the African Medical and Research Foundation (AMREF), the documentary, subtitled "On the Difficulties of Medical Development Aid: A Report by Werner Herzog," showcases the work of an air ambulance unit serving remote areas of Kenya, Uganda, and Tanzania.[14] Its relation to the development of Herzog's style is easy to overlook, given the film's status as a commission (as opposed to an authored work, although the subtitle would already seem to blur this distinction).[15] In terms of documentary, however, the fact of its sponsorship makes the film even more interesting, for it clearly exhibits many of the formal elements (pans, aerials, long takes) and thematic concerns (foreign peoples, strange behaviors, vulnerable bodies, alluring landscapes) that commentators would later use to distinguish Herzog's authorial signature, only now they are mobilized to serve the needs of a specific organization. At the same time, the travel, the funding, and the experience of this commission directly informed and materially supported the productions of *Even Dwarfs Started Small* (*Auch Zwerge haben klein angefangen,* 1970) and *Fata Morgana* (1971). It also helped establish a larger pattern of making both documentary and fiction films, while exploring the space between them. In this regard, Herzog is not alone; many filmmakers associated with the New German Cinema—Alexander Kluge, Wim Wenders, and Volker Schlöndorff, among others—worked and continue to work in both modes and have proved to be especially innovative in producing "hybrid forms."[16]

Resituated in its formative context, Herzog's work refers us to a conception of documentary that is also a form of counterdocumentary and thrives on this supposed contradiction—a view that may seem either foreign or familiar, depending on one's perspective. Documentary film in West Germany encompassed a broad spectrum of meanings and approaches: from the observational techniques of Klaus Wildenhahn, who protects documentary against any incursions of fiction, to the montage techniques of Kluge, for whom fiction and documentary are interrelated

and not antithetical. Of particular interest is Kluge's theory of cinematic realism, which treats stylization as tantamount to revelation as well as to social commentary.[17] In an influential text from 1975, he outlines a model of documentary cinema based on subjective terms such as *desire, emotion, experience,* and *sense perception,* and always engaged in a productive tension with fiction. On this model, documentary appeals not to an anterior truth but rather to the desire and to the sensory experience of the film spectator. In his words, "desire is the form in which facts are perceived."[18] On another level, that of production, Kluge regards documentary filmmaking as "an experimental process" that works to reveal hidden aspects of reality and does so necessarily by means of artifice and stylization.[19] Hence the role of opera that runs throughout his work; transported to this context, the "total stylization of opera" becomes a cinematic signifier that refers to and thereby comments on the notion of "documentary authenticity."[20] Other privileged forms of artifice in his films include voice-over narration (spoken by Kluge himself), fabricated interviews, and found images.[21] Although this description may seem to fit Herzog's films, there are, of course, substantial differences between them.[22] A comparison with Kluge is not my point. What interests me, rather, is the expanded view of documentary, its dual ethos of resistance and innovation, its playful mix of encounter and artifice, which Kluge so effectively articulates. By 1975, Herzog had already been pursuing similar ideas in his own work and broadcasting them wherever he went. Since then, he has extended his engagement with documentary beyond the New German Cinema and into the present situation, which is increasingly discussed in terms of transnational cinema, media convergence, and the proliferation of hybrid forms.

Today, most scholars of documentary emphasize its status as a "blurred genre," meaning that its boundaries are in many ways shifting and unstable. Issues of stylization, once deemed extrinsic to documentary, are now considered to be intrinsic. Bill Nichols made the following observation in 1994:

Traditionally, the word *documentary* has suggested fullness and completion, knowledge and fact, explanations of the social world and its motivating mechanisms. More recently, though, documentary has come

to suggest incompleteness and uncertainty, recollection and impression, images of personal worlds and their subjective constructions. . . . Documentary and fiction, social actor and social other, knowledge and doubt, concept and experience share boundaries that inescapably blur.[23]

It is in this context of a larger, ongoing shift in documentary theory and practice that Herzog's work has obtained new relevance. Tellingly, the very issues of stylization that once separated Herzog from documentary cinema now suggest his connection to it. This is especially true regarding aesthetics, performance, embodiment, and subjectivity—issues that are now widely discussed in the literature on documentary and have long been central to Herzog's work as well.

This study shows how Herzog works simultaneously within and against the context of documentary cinema. Even his savaging of cinema verité represents not just a point of difference but also one of continuity. By cinema verité, he means not the French movement of the 1950s associated with Jean Rouch (whose work Herzog admires) but rather the American brand of observational cinema espoused by Robert Drew, Richard Leacock, D. A. Pennebaker, and Fred Wiseman, or what Albert and David Maysles called "direct cinema." In the Minnesota Declaration, Herzog mocks this brand of observational cinema and its patent claim to truth. Here is the first point of the manifesto: "By dint of declaration the so-called Cinema Verité is devoid of verité. It reaches a merely superficial truth, the truth of accountants." What counts for knowledge in direct cinema Herzog would expose as naive; to what direct cinema posits as the objective and the authentic, he counters with the subjective and the staged. Rather than imagine observational cinema as a documentary ideal, he dismissively emphasizes its servile, stenographic function as mere recording. The accent, bravado, and hyperbole may distinguish him, but in this argument, Herzog is not alone; Lindsay Anderson, Emile de Antonio, Joris Ivens, David MacDougall, Errol Morris, Jean Rouch, Dai Vaughn, and other documentary notables, each with a distinct set of concerns and emphases, have made similar criticisms of observational privilege and purism going back to the early 1960s. For this reason, too, one might find it odd that Herzog should continue to rant against cinema

verité as he does. His tenacity, however, reflects the continued influence of documentary's observational ideal. According to Stella Bruzzi, "the role of American *cinéma vérité* has proved the crucial historical factor in limiting documentary's potential and frame of reference."[24] Indeed, she continues, "virtually the entire post-*vérité* history of non-fiction film can be seen as a reaction against its ethos of transparency and unbiased observation."[25] Herzog offers a case in point. Although Bruzzi does not discuss his work, it provides further evidence of what she calls the "paradox" of post-vérité documentaries, which not only react against observational cinema as a culturally sanctioned ideal but "also flaunt their lack of concern with conforming to the style of objectivity dictated by documentary history and theory."[26]

However, documentary cinema appeals to Herzog for much the same reason why he finds it so objectionable, that is, for its privileged relationship to knowledge. The Minnesota Declaration makes this point explicit. In articulating his own position on this issue, Herzog trades on certain statutory oppositions—fact versus truth, observation versus stylization, science versus art—oppositions that are not just familiar from other contexts but also oversimplified and strategically employed for their appeal to common sense. On one hand, he dismisses the cultural associations of fact and science already attached to documentary. On the other hand, Herzog needs these associations to maintain his own alternative truth claims. His is an "ecstatic truth," based on stylization as opposed to mere observation, but no less problematic, especially where it seems to connote an essence of truth. Herzog employs this term as subsuming all others that might be applied to his method; he is anxious to be treated as a poet, not a documentarian. And yet it remains a form of intervention. If documentary film could once be understood as a "discourse of sobriety" (to borrow a well-worn phrase from Nichols), then Herzog co-opts this discourse in the context of ecstasy.[27] There is nothing inherently wrong with this move. On the contrary, as Michael Renov has suggested, "a view of documentary which assumes too great a sobriety for nonfiction discourse will fail to comprehend the sources of nonfiction's deep-seated appeal."[28] Herzog, too, makes the case for an ecstatic view of documentary, as this book aims to show. At stake in this study, however, is not just the filmmaker's singular vision but the larger, more encompassing domain of documentary cinema.

The Performance of Documentary

This book takes performance as an organizing concept for the study of documentary, and of Herzog's documentaries in particular. To emphasize performance is hardly novel but is still worth doing because it confronts head-on some of the most vexing issues of documentary theory, without pretending to resolve them once and for all. When other scholars of documentary emphasize performance, they tend to do so by treating it either as a special type of film or as an effect produced by the interaction of filmmakers, subjects, and spectators. Bill Nichols, for example, identifies "the performative documentary" as a particular mode of representation that has governed the organization of documentary material since the 1980s. Part of a larger taxonomic system of documentary production that Nichols has developed throughout his work, the performative mode emerges in contrast to other, preexisting modes such as the expository, the observational, and the reflexive.[29] To put it in positive terms, as he also does, the performative mode shifts the focus of interest away from the referential world of history, the baseline of documentary representation for Nichols, and toward the affective world of the film spectator. This shift further blurs the distinction between fiction and nonfiction, while at the same time promoting subjective and embodied forms of knowledge. On the other end of the spectrum, parallel to the emphasis in literary studies on speech acts as derived from J. L. Austin's theory of language and from Judith Butler's work in philosophy and gender studies, Stella Bruzzi suggests that all "documentaries are performative acts whose truth comes into being only at the moment of filming," as opposed to the received idea that documentaries are defined by their appeal to an anterior truth.[30] She also uses the term in a narrower sense to identify certain films that are performative "in themselves," meaning that they foreground the necessarily partial, authored, and constructed status of documentary representation and knowledge, resulting as they do from the involvement of filmmakers with their subjects.[31] A wholly appropriate emphasis on these matters, which can also be traced throughout Herzog's films, cannot, however, account for the importance of performance to documentary.

This study takes a broader, more inclusive view of performance. It is based on Richard Schechner's concept of "restored behavior," or what he also calls "twice-behaved behavior." Both formulations refer to physical,

verbal, or virtual action that is in some way learned, prepared, and rehearsed. To illustrate the point, Schechner offers the analogy of film editing and the use of found footage:

> Restored behavior is living behavior treated as a film director treats a strip of film. These strips of behavior can be arranged or reconstructed; they are independent of the causal systems (social, psychological, technological) that brought them into existence. They have a life of their own. The original "truth" or "source" of the behavior may be lost, ignored, or contradicted—even while this truth or source is apparently being honored and observed.[32]

The key move is Schechner's theoretical distinction between the performing self and the behavior performed because it allows for both the transmission and the transformation of performance across time and space. It also helps account for the many different and sometimes contradictory uses of the word *performance,* its diverging connotations (from the authentic to the constructed), and their intrinsic connectedness. Restored behavior acknowledges that performance extends across a vast spectrum of personal and social activities, including (but not restricted to) art, play, ritual, politics, business, medicine, entertainment, and everyday life.

While connections can be made and generalized on a theoretical level, performances are specific and different in terms of form, context, and function. The concept of restored behavior needs to be translated to study documentary film "as" performance. In terms of restored behavior, the differences include and become manifest through the tradition and conventions of documentary, the personal choices of filmmakers and social actors, various cultural patterns, historical circumstances, and particularities of film viewers. From this perspective, one can ask performance questions of Herzog's documentaries: how do they not only accomplish but also mark and show their difference from (or subversion of) specific documentary forms and conventions? How does the filmmaker display and conceal himself in the process of making a documentary? What roles do social actors play, and how exactly are they framed, staged, or employed? How can we account for Herzog's emphatically "physical" approach to filmmaking and its implications for spectatorship? Assuming

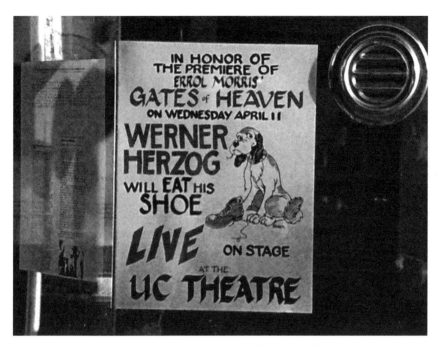

Announcing the event, *Werner Herzog Eats His Shoe* (1980; dir. Les Blank).

that expectations of a Herzog documentary vary among audiences—some expect "no lies and no tricks," others expect "a Herzog film" complete with staged scenes and scripted lines—and assuming that expectations also change over time, to what extent does Herzog fold these expectations into each successive film? A performance lens offers an especially powerful means for analyzing complex, hybrid forms such as those that define the current documentary cinema, moving as they do across various media and in an increasingly globalized and intercultural context. Rather than imagine performance either as a special type of documentary film or as an expansion of linguistics into documentary cinema, this book treats documentary as contingently produced and constantly reinvented in performance, which includes the act of filmmaking.

The idea of restored behavior as it relates to both Herzog and documentary cinema can be briefly illustrated by *Werner Herzog Eats His Shoe* (1980), Les Blank's documentary about the German director doing exactly what the title says. The twenty-minute film mixes interviews with Herzog on various subjects, images of him cooking a pair of old leather

boots (adding garlic, rosemary, duck fat, and other ingredients, under the supervision of celebrity chef Alice Waters), and footage of Herzog making a spectacle of himself. Standing in a Berkeley movie theater, he displays the cooked shoes (after hours of simmering in fat, they only shrank and tightened), cuts them into bite-sized pieces, and proceeds to eat them before an audience, which in this case is a double audience: that of the event and that of the film.

Ostensibly, the film shows Herzog making good on a promise to eat his shoe if and when Errol Morris, then a graduate student at Berkeley, completed his first film, *Gates of Heaven,* which he did in 1979. Herzog now fulfills his part of the bargain, and he does so dramatically, in public and on camera. The resulting film represents more than just an early "stunt documentary" (eat your heart out, Morgan Spurlock). It also provides one of many occasions for Herzog to act out his own directorial persona in a documentary made by another filmmaker. In this regard, *Werner Herzog Eats His Shoe* demonstrates his claim to take everything literally, without irony.[33] It further recalls his "physical" approach to filmmaking.[34] Speaking to the audience, in an awkwardly self-deprecating gesture, Herzog compares his role as a filmmaker to that of a "clown." Here and elsewhere in the film, Blank intercuts footage of Charlie Chaplin as the Tramp eating his shoe, from a memorable scene in *The Gold Rush* (1925). This is an interesting move on Blank's part because it highlights the status of Herzog's self-display, which is already marked and framed as performance—indeed, doubly so, once by the theater setting and again by the documentary camera. Put another way, the use of recycled footage here literalizes Schechner's "filmstrip" analogy for restored behavior. His may be an "aesthetic of the singular," as another filmmaker describes Herzog's work, but its apparent singularity breaks down on closer inspection.[35] In this case, *Werner Herzog Eats His Shoe* recombines the various elements of his famous leap into a cactus, fulfilling a promise he once made to the actors of *Even Dwarfs Started Small,* a story he also recounts in Blank's film. Now, as then, Herzog rehearses certain phrases, gestures, anecdotes, and strategies—indeed, an entire repertoire—which he has developed, employed, and revised throughout his career. The appearance of singularity is a function of context, of reception, and of the countless ways in which his existing repertoire can be organized, reworked, and displayed.

The following chapters develop a performance model of documentary cinema while exploring and accounting for Herzog's intervention. To that end, the chapters revolve around the specific forms, issues, and questions of documentary that Herzog has engaged in his films. Chapter 1 addresses questions of corporeality, focusing on *Land of Silence and Darkness* (*Land des Schweigens und der Dunkelheit,* 1971) and *Wodaabe: Herdsmen of the Sun* (*Wodaabe: Hirten der Sonne,* 1989). Although these examples are topically different—the one concerns disability, the other ethnography—discussing them together elicits their shared emphasis on embodiment, while indicating the range of Herzog's engagement with documentary film and television. Chapter 2 explores issues of space and place through Herzog's treatment of landscape in films such as *Fata Morgana, La Soufrière* (1977), *Lessons of Darkness* (*Lektionen in Finsternis,* 1992), and *Wheel of Time* (2003). The discussion here foregrounds the different functions of landscape in Herzog's work and their shared allegorical movement from the visible world toward the invisible. Following on this discussion, Chapter 3 takes up Herzog's fascination with pilgrimage as a long-distance physical journey and relates it to his documentaries, especially *Huie's Sermon* (*Huie's Predigt,* 1980)*, Bells from the Deep* (*Glocken aus der Tiefe,* 1993)*,* and *Pilgrimage* (2001). Of particular interest here are the corporeal treatment of spiritual themes and the association of physical and cinematic motion. Chapter 4 locates Herzog's documentaries vis-à-vis the transatlantic revival of the baroque in twentieth-century culture. The baroque, which is characterized in aesthetic terms by hyperstylization, offers both an interpretive key to Herzog's vision of documentary cinema and an important context for his contribution to it. From *The Great Ecstasy of Woodcarver Steiner* (*Die grosse Ekstase des Bildschnitzers Steiner,* 1974) to *Death for Five Voices* (*Gesualdo: Tod für fünf Stimmen,* 1995) to *God and the Burdened* (*Gott und die Beladenen,* 2000), Herzog's documentaries involve various manifestations of the baroque, past and present, sacred and secular, in Europe as well as in Latin America. Chapter 5 addresses the political aspect of Herzog's documentaries since his fall from grace in the early 1980s, especially around the making of *Fitzcarraldo* (1982) and the charges of environmental and human rights abuse that came with it. Close analysis of such films as *Ballad of the Little Soldier* (*Ballade vom kleinen Soldaten,*

1984), *Ten Thousand Years Older* (2002), and *The White Diamond* (2004) shows how Herzog appropriates certain documentary conventions and forms of truth telling and puts them in the service of revising his own cinematic past. Chapter 6 investigates Herzog's approach to historical reenactment as a documentary technique, which is fully developed and articulated in *Little Dieter Needs to Fly* and *Wings of Hope* (2000). At issue here is the role of staging and dramatization, as one might expect; it's also the filmmaker's effort to ground his personal vision in the bodies and the testimonies of other people and their lived experiences. In closing, this chapter looks briefly at *Rescue Dawn* (2007) as both a restaging of and a variation on *Little Dieter Needs to Fly,* only now in the mode of fiction. Chapter 7 focuses on questions of subjectivity, identification, and self-reflection. It emphasizes both the persistence of autobiography in Herzog's body of work and the diversification of first-person forms in documentary film and video more generally, as evidenced by *I Am My Films* (*Was ich bin sind meine Filme: Ein Portrait von Werner Herzog,* 1978; dir. Christian Weisenborn and Erwin Keusch), *Portrait Werner Herzog* (*Werner Herzog: Filmemacher,* 1986), *My Best Fiend,* and *Grizzly Man.* The conclusion gathers up the book's main strands, reflects on their implications for our understanding of Herzog and of documentary, and points to some areas of future inquiry.

Ever since Herzog delivered the Minnesota Declaration, his relevance to contemporary understandings of documentary has only increased, indeed dramatically so, both despite and because of his aversion to that tradition. What emerges, then, is a larger project. "There is something that we should work on," he stated in the ensuing dialogue with Roger Ebert, rallying his audience around the idea of documentary as a form of imaginative knowledge. "And that's why the gauntlet is thrown down," he explained, referring to point 9 of the declaration. "That's why I go into such wild rambling statements like, [point 11] 'We ought to be grateful that the Universe out there knows no smile.' It has nothing to do with truth and fact in cinema, and yet it *is* connected, because there is a poetic truth." Here, as in his documentaries, Herzog's performance as a filmmaker hinges on the act of making truth claims. Although such claims have historically served to distinguish documentary as a film genre, his are emphatically unorthodox truths. This book sets out to explore them.

1 SENSATIONAL BODIES

Picture the scenario that precipitated the Minnesota Declaration: a restless night of watching bad television in a foreign hotel room. Surfing the available channels, as Herzog recalls in interviews, he came across "a very stupid, uninspiring documentary, something excruciatingly boring about animals somewhere out there in the Serengeti." Later, flipping through channels again, he landed on a "hard-core porno," which struck him as "real" by comparison. "For me," he says, "the porno had real naked truth." With that, the filmmaker (who is also a television viewer in this anecdote) wrote down his manifesto on "truth and fact in documentary cinema."[1]

The anecdote itself suggests a way of thinking about Herzog's approach to documentary filmmaking. In addition to its brash assertions of truth and reality, the channel-changing scenario readily evokes a miscellany of genres (nature and porno films); a focus on bodies and behaviors (animal and human); a sense of otherness and adventure (foreign and sexual) mixed with wildness and violence; and a range of implicit strategies (from observation to staging), motivations (from knowledge to pleasure), reactions (from boredom to excitement), and implications (from domination to decadence). The writhing prurience associated with "hard-core porno" gives the entire scenario an edge of humor—especially the favorable comparison to documentary. But Herzog makes this comparison only somewhat tongue in cheek. After all, however staged or artificial it may be, pornography, too, relies on what Bill Nichols calls "the documentary impulse, a guarantee that we will behold 'the thing itself.'"[2] On further reflection, Herzog's provocation becomes less brash and more "organic" to the context of discussion. Pornography, of course, revels in physical movement and exuberance, and that makes sense for a

director who advocates a "physical" approach to filmmaking and claims to find truth in forms of "ecstasy." Many film genres focus on the sensuous body engaged in different types of movement. For Herzog, in fact, this epitomizes the cinema, capturing its quintessence as a medium: "Porno films are movie movies. Karate films are movie movies. Fred Astaire films are movie movies."[3] In this sense, Herzog's documentaries aspire to be "movie movies" as well.

The hard-core comparison also makes explicit some of the reasons why his work has been excluded by scholars of documentary proper. There is something illicit, excessive, promiscuous, and stigmatized about Herzog's documentaries, a sense of transgression he clearly enjoys and deliberately cultivates. Critics of Herzog and scholars of documentary alike tend to regard his techniques of stylization in particular as gratuitous excesses violating the supposed norms of documentary cinema. We should not, however, belabor the comparison. The impropriety on Herzog's part only goes so far. His very first documentary short, *Game in the Sand* (*Spiel im Sand,* 1964), offers a case in point. To this day, it has never been released or even publicly exhibited. Shot at a Croatian settlement in southern Austria, the film reportedly shows a group of children playing with a rooster and contains a scene in which they bury the animal up to its neck in sand and proceed to kill it on camera. "The film apparently 'became a terrifying document of violence,' as the children's latent sadism was unleashed during the filming."[4] Did Herzog in some way arrange this event for the camera or contribute to its unfolding? If the event got out of control, as he suggests, did he intervene and try to stop it? What did he learn from this incident, as far as the ethics, dangers, or limits of documentary filmmaking? We don't know. Since then, he has said almost nothing about *Game in the Sand,* except to acknowledge its existence and reaffirm his intention to keep it from circulating. On one hand, it seems that his initial foray into documentary swiftly and unexpectedly resulted in a type of snuff film. On the other hand, the fact that he has not released it "indicates at least that he is well aware of an ethical boundary and a taboo."[5] The knowledge informing this example is entirely anecdotal. Both for its explicit display of actual violence (assuming the verbal report is accurate) and for being withheld from circulation (assuming the film exists), *Game in the Sand*

remains an exception within Herzog's body of work.[6] What makes this film relevant, though, is its focus on bodies and behaviors in relations of power, including the unseen body of the filmmaker, and the corporeal reactions this material elicits even by way of anecdote.

This chapter asks how Herzog's documentaries involve sensational bodies, including the bodies of spectators. In her important work on such film genres as horror, melodrama, and hard-core pornography, Linda Williams uses the term *body genres* to capture their shared focus of visual interest: the spectacular body caught in the grips of intense emotion or sensation, what Williams describes as the body in "ecstasy." Analyzing them as "systems of excess," the questions she asks of these popular genres—how they deviate from the realist norms of narrative cinema, how the forms and functions of bodily excess vary generically and historically, how they seem to grab us emotionally as well as physically—can also be asked of documentary film and especially of Herzog's take on it.[7] At issue is not just the body on screen but also the body of the film spectator and the nature of their relationship. So it is important to emphasize the corresponding model of spectatorship Williams develops, which is one of "embodied presence."[8] Rather than imagine a model of absolute detachment from the moving image, she allows for a range of bodily responses, both mimetic and nonmimetic. The implications of this move are considerable, perhaps especially in the context of documentary, where representation is understood to have a privileged relationship to lived experience.

The term *ecstasy* as it is being used in each context requires brief explanation. As Williams points out, it originates in the Greek word for madness or bewilderment, conditions of being "beside oneself," though she uses the word primarily for its contemporary meanings of "sexual excitement and rapture."[9] And yet *ecstasy* remains a layered term with more than one set of meanings. In the twentieth century, it obtains "a spiritual register, of harmony and tranquility, which involves stepping outside of the self and experiencing the eternal cosmos; but it also has a commonly perceived sexual register, which can be positive (a sign of *eros* or life force) or can be imagined as a state of excess, frenzy, and potential violence."[10] This double valence can also be traced throughout Herzog's films. In much of the literature on Herzog, a one-sided emphasis

on the metaphysical meanings of ecstasy reveals a certain bias against materialist perspectives. In more complex readings, ecstasy is recognized as coterminous with the body; it's never just one or the other. On the contrary, as Brad Prager suggests in his comprehensive study of Herzog's work, "the ecstasies that attend his films—the deliberate abandonments of the body—are induced by way of our bodies."[11] Ecstasy, consequently, becomes not just a way of abandoning the body but also a way of embracing it.

This chapter necessarily brings various films to bear, but it focuses on two examples in particular, namely, *Land of Silence and Darkness,* Herzog's personal portrait of a deaf and blind woman, and *Wodaabe,* his quasi-ethnographic film about a group of African nomads. The context of disability hardly coincides with that of ethnography. And yet both these films prioritize forms of embodied knowledge and experiment with the physical aspects of viewing as well as image making. In different ways, as we shall see, they each represent the sensational body as a crossing point, a site of encounter between self and other.

Touching Images

Land of Silence and Darkness is Herzog's personal portrait of a deaf and blind woman named Fini Straubinger. At the age of five, Straubinger suffered a traumatic fall, resulting in her eventual loss of hearing and vision. Nevertheless, her memories of sight, sound, and language remain strong. Unlike many other people who appear in this film, she is able to speak clearly to a hearing audience. She also knows how to pose before a camera. Such communicative competence provides a key to her success as a social activist. For four years, she has traveled around Germany ministering to other members of the deaf–blind community and lobbying for their benefit. She participates in Herzog's film as a way of promoting her cause to a wider public. Organized as a series of interviews and tender visits, *Land of Silence and Darkness* maps a half-hidden and mostly forgotten area on the margins of postwar German society. The stations of her journey—schools, asylums, and other institutions—are sequenced within the film to create a sense of movement toward ever-greater social isolation. They also chart an emotional itinerary, from

pictured scenes of joyful exploration to haunting images of disquieting abjection. Throughout her travels, Straubinger maintains an unswerving belief in her personal ability to reach even the most isolated members of the community. What matters in this film is not only Straubinger's speech performance but also—more pressing—her relation to others by means of touch. Touch is for her a point of connection, and the film explores this idea of communication through the skin.

Critics and scholars who discuss this material generally put emphasis on issues of optical visuality, on metaphors of blindness, and on the related notion of Herzog as a "visionary" filmmaker.[12] They also highlight problems of stylization, and with good reason.[13] *Land of Silence and Darkness* is an excellent example of Herzog's approach to documentary cinema. Stylization here usually denotes the use of certain techniques—scripted lines, staged scenes, handheld camera work, and nondiegetic music— whose cumulative effect is understood as excessive and tantamount to fictionalization. My sense of this film is different. In *Land of Silence and Darkness*, I suggest, Herzog engages the materiality of the cinema itself, with particular emphasis on the tactile properties of the film medium and on the spectator's sense of touch. When the film premiered at the Mannheim Film Festival in 1971, Herzog referred to it as "a monograph on the hands of a deaf–blind woman."[14] Following such hand signals and concentrating on issues of tactility provides a key to understanding the function of the very scenes that have been stylized and so accorded "fictional" status by other commentators. As we shall see, however, stylization provides the necessary means by which Herzog engages the corporeal aspects of documentary filmmaking and spectatorship.

What emerges is an entirely different strategy, one that needs to be explored in terms of performance, because it relies for its effect on the spectator's embodied presence. Most film viewers, presumably, have a different relationship to tactile perception than people who are deaf and blind might have, but touch remains a shared sense and a potential means of communicating.[15] For this very reason, I suggest, *Land of Silence and Darkness* becomes a site of encounter, indeed, a site of contact, between disabled and nondisabled bodies. The strategy is to foreground acts of physical contact, while appealing to the viewer's own sense of touch by means of stylization.

The context of disability is one that Herzog first explored in *Handicapped Future* (*Behinderte Zukunft,* 1971), a documentary which by any standard is remarkably direct and conventional. "The reason this film is in no way stylized," he explains, "is because . . . it was proposed by someone else."[16] Herzog had been commissioned to make a film about victims of thalidomide (or Contergan, as the drug is known in German). And in the course of developing this project, he widened its scope to include physical disability more generally. The early 1970s marked the beginning of the disability rights movement in West Germany. *Handicapped Future* was made for various organizations supporting people with disabilities, to assist these organizations in "raising public awareness of their cause."[17] Unlike most of his subsequent documentaries, then, Herzog's film makes explicit both its social engagement and its political stance. Much of the footage is shot in the United States, where social attitudes and policies are favorably compared and promoted as an alternative to conditions in West Germany. *Handicapped Future* also breaks what was then a cultural taboo by suggesting that the Nazi view of the physically impaired as "lives unworthy of life" continues to prevail in the Federal Republic. We watch and listen as a boy, surrounded by his friends, reads aloud from a letter, signed by a self-named "friend of humanity," advocating "euthanasia" for those affected by thalidomide as a merciful way of "redeeming them from this torture that is no longer a life." Using the film camera as a way of answering back to such a letter, the boy and his friends speak at length of their different experiences, feelings, and dreams.

In many ways, *Handicapped Future* responds to the German legacy of eugenic policies and practices. Although she doesn't mention Herzog's work, historian Carol Poore has shown that visual images—films, posters, exhibits, photographs—and various forms of spectatorship were absolutely crucial to the shaping and reshaping of disability in twentieth-century Germany.[18] This is also the context in which *Land of Silence and Darkness* was first received and needs to be resituated.[19] Indeed, Herzog first met Straubinger while filming *Handicapped Future,* when they both attended a speech by the West German president Gustav Heinemann. Footage of this event appears in both films. They also have the same narrator, Rolf Illig.[20] The point of resituating *Land of*

Silence and Darkness in this historical context is not just to remind us that the disabled body was stigmatized in postwar Germany; rather, it also helps explain why the film's emphasis on touch—the very idea of creating a physical connection, real or imagined, between the viewer and the viewed—could seem so provocative and unsettling.[21] According to one report, both films were received in West Germany with a mix of "prejudice and defensiveness."[22]

The shared context of reception makes the stylistic differences between these two films all the more striking. Whereas *Handicapped Future* emphasizes verbal commentary and develops an argumentative logic, with visuals serving more or less as illustrations of the argument, *Land of Silence and Darkness* creates and explores a "sensuous geography."[23] The inquiry is open ended, the terrain unknown, the results uncertain. Although the two films are contemporaneous, only *Land of Silence and Darkness* reaches beyond its context of origin. Its staying power as a film, however, is at least partly due to the unresolved social issues of disability and their continued relevance for a wide diversity of audiences. Herzog's authored films cannot be simply reconciled with the Griersonian model of documentary as a social education project. In interviews, he often casts doubt on intellectual efforts to elevate the film medium by asserting its "social value," which is obviously not his project. And yet *Land of Silence and Darkness* clearly owes a certain debt to documentary as a form of humanist advocacy—a point that is only strengthened by the film's genealogical relationship to its sponsored counterpart.

If *Handicapped Future* takes as its subject the social and historical contexts of disability (state and federal legislation, popular mentalities and prejudices, social services and institutions), then *Land of Silence and Darkness* changes the subject to focus more closely on bodies and physical sensations. What distinguishes this film, more than anything else, is its provocative treatment of touch. *Land of Silence and Darkness* encourages the spectator to adopt a type of bodily relationship to the image that can best be described as "haptic," by which I mean the integral role of touch and tactile properties in cinematic representation as well as in spectatorship. Laura Marks defines haptic perception as "the combination of tactile, kinesthetic, and proprioceptive functions, the way we experience touch both on the surface of and inside of our

bodies. In haptic *visuality,* the eyes themselves function like organs of touch."[24] Haptic *images,* then, encourage a corporeal response from the viewer, which is different from the more familiar structure of character identification (though not necessarily at odds with it). Rather than identify with a character, the viewer inhabits the intensity of a tactile feeling, an effect of simulation and spectatorship. Writing of the senses and their particular role in films that traverse cultural boundaries, Marks contends that "an understanding of the embodied experience of cinema is especially important for representing cultural experiences that are unavailable to vision."[25] To stress the tactile, she argues, is "a strategy that can be called upon when our optical resources fail to see."[26] What makes this notion of touch so intriguing is its potential for creating an ethical relationship between the viewer and the viewed. To "feel" an image as Marks suggests is to acknowledge its presence and to respect its otherness at the same time. This dual attitude has to do with the specific properties of tactile sensation. As Walter Ong has written of touch, "When I feel this objective something 'out there,' beyond the bounds of my body, I also at the same instant experience my own self. I feel other and self simultaneously."[27] The sense of touch as defining at once contiguity and separation, identity and difference, is equally central to Herzog's body of work.

Like so many Herzog films, *Land of Silence and Darkness* begins with landscape. This film alone, however, begins ekphrastically—that is, with a verbal representation of a landscape view. We hear a woman speak the following words over music by Vivaldi and a series of black frames: "I see before me a path that leads across a plowed-up field, and clouds are hastily flying overhead."[28] The initial ekphrasis is then reversed. A picture flashes on screen, the appearance of which is visually analogous to the verbal representation. A grainy black-and-white image, it flickers unsteadily, alternating between under- and overexposure, shifting in and out of focus. Throughout her analysis, Marks puts emphasis on such microlevel techniques as extreme close-ups, optical printing, and scratching the emulsion—techniques that emphasize the materiality of the image by creating an impression of surface texture. The opening shot of Herzog's film produces a similar effect. The resulting landscape refers not to a place but rather to a way of feeling (in every sense of the word).

The alternation of voice and image is repeated in the next sequence, only this time, the voice is identified as that of "the deaf–blind woman Fini Straubinger," and the cut-in footage is coded as a memory of vision. "Once, when I was a child, when I could still see and hear," she says, "I was a spectator at a ski-jumping competition. And this image keeps coming back to me, the way these men hovered in the air. I looked very closely at their faces. I wish you could see that once, as well." Cut to a ski jumper filmed in extreme slow motion. Finally, the emphasis on touch is made explicit by an intertitle, which reads, "I jump when someone touches me. Years go by in waiting." Here, *in nuce,* is a textual evocation of the film's governing movement, vacillating as it does between near and far, fear and desire, curiosity and shame, pleasure and pain. The entire film works to elicit bodily responses to the image that implicate the viewer so that the boundary between the film and the viewer begins to collapse. The intertitle suggests the felt anxiety of unexpected touch, on one hand, and the longing for social and physical contact, on the other hand. The use of the subjective "I" allows for multiple readings, while positioning the film spectator in a felt relation to the haptic world that begins to unfold on screen.

That Herzog invented this "memory" of vision has been treated by other scholars as evidence of falsification. What interests me, by contrast, is how it introduces Straubinger as a privileged spectator in her own right and the implications of this move for the film audience. Here is another strategy for encouraging a practice of connective seeing. It is repeatedly employed, throughout the film, at major institutions of modern visual culture: Straubinger and her friends visit the zoo, the natural history museum, and the botanical garden. At each location, they handle a variety of display objects that are more typically exhibited at a remove from visitors. The analogy to the cinema is crucial: here, as in the museum, spectators are usually taught to hold back, to look and not touch. Depicted in this film, however, is a group of spectators who are permitted and encouraged to literally feel the displays with their hands. As a representation of touch, it is direct and seemingly obvious, which may explain why other scholars have yet to address it. Writing in another context, Marks boldly dismisses images that depict the act of looking at hands, arguing that they promote character identification

as opposed to haptic visuality.[29] While I share her preference for a more subtle relationship to the body than that which character psychology would seem to allow, I see no reason to dismiss or even demote such imagery, whose effect really depends on the context of viewing. In *Land of Silence and Darkness,* looking at images of hands and seeing others in the act of touching raises a thorny question: is identification even possible in a film that depicts the deaf and blind? If identification requires a certain distance from the image, can this distance be closed to an extent under such extreme circumstances?

The question of identification raises a larger, more interesting point about spectatorship and the assumptions that other commentators make about it with this particular film. *Land of Silence and Darkness* is usually discussed in terms of sensory deprivation. Just as the deaf–blind are deprived of "our" sensory world, the logic runs, so "we" are deprived of theirs.[30] The deficit model of physical, cognitive, and sensory impairment has, of course, been challenged in the field of disability studies, and this has certain implications for our understanding of Herzog's film. In this context, to privilege either vision or its loss is to miss the key point; that is, touching functions as a mode of spectatorship in its own right. And the act of showing touching doubles as a strategy for encouraging the film spectator to see differently, to feel with her eyes.

The most blatant example of showing touching can be found in a passage that takes place at the botanical garden. There we observe Straubinger as she feels her way through the exhibits, cautiously running her fingers over the soft and prickly spines of cacti, grasping bamboo stalks, all of which creates a strong impression of texture. Suddenly, the camera breaks free of her and begins roving around the garden, in a movement that mimics the exploratory act of touching. Fern branches and palm leaves brush up against the lens and drag across its surface. For Gertrud Koch, this is the point where "the viewer is carried off to an unreal realm, in which he hears and sees what the individuals on the screen cannot hear and see."[31] What most interests me, however, is the shift in visual emphasis from the gaze of the roving camera to the graze across the surface of its lens. This is just one of many different shots that assert the camera's presence and complicity (instead of pretending it isn't there), thus directing our attention to the materiality of the

The graze across the lens, *Land of Silence and Darkness* (1971).

cinematic image in terms of its perceived tactility.[32] In one of the film's first American reviews, critic Jim Hoberman makes a similar point: "Seldom has tactility been so forcefully portrayed. As Fini and her compatriots fondle cactus thorns with delight, you become aware of the pressure of air, the sensation of the theater seat."[33] Instead of dismissing the camera work by assigning it to the "unreal," as Koch would have us do, I suggest we can understand it as part of a larger process of translation among the various senses within the body and translation between self and other.[34]

Acts of translation are absolutely central to the film. Translator figures, both men and women, appear in almost every scene, quietly at work. The work they do is called *tactile translation*. In one passage, Straubinger herself dons a single white glove, a teaching aid for sighted people, and demonstrates the "touch alphabet," which is used throughout the film.[35] The physical presence of a translator is always required to communicate with people who are not versed in tactile sign. This is one reason why Straubinger's translator appears in almost every scene. At the same time, her on-screen presence is a constant reminder of the

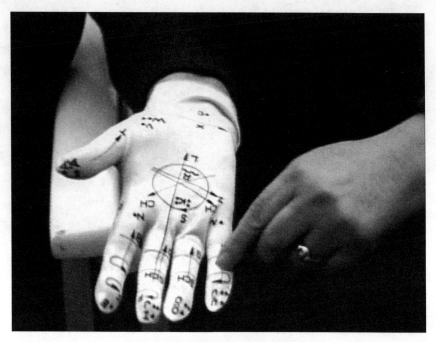

Tactile translation, *Land of Silence and Darkness* (1971).

work of translation that the film itself is doing. In regarding touch as a mode of spectatorship, *Land of Silence and Darkness* stages an interchange of the senses, while reminding the film audience that hearing and vision are only two parts of a larger cooperative perceptual system. Take the camera work, for example. As one commentator put it, "Jörg Schmidt-Reitwein's camera becomes the guide, the translator for us, by moving in with close-ups on the hands. Seeing the hands, hearing the voices, it's as though we are watching a doubly-subtitled film."[36] In interviews, Herzog even styles himself as a figure of tactile translation, one whose presence in the film is "felt," although it remains unseen and unheard. He compares "the very physical relationship" he has with his cinematographer during a shoot to the relationship of Straubinger and her translator, silently and subtly communicating with each other by means of touch.[37]

Translation, of course, goes only so far. As Noël Carroll has emphasized in his discussion of the film, "language remains serviceable between us and the deaf–blind, but when it comes to thoughts and

feelings, or better, the associations attending such discourse, we sense a radical problem of translation."[38] This is undoubtedly the case, but Carroll frames the issue in terms of *conceptual* knowledge, whereas the film revolves around the rather different idea of *perceptual* knowledge. Herzog pushes as hard as he does on touch in this context because it is a sensory experience shared by the film spectator and linked to her other senses as well. The film's project is not one of "translating" deaf–blind experience into a set of propositional statements that either explain or generalize, as Carroll would seem to assume, nor is it a poetic project of representing deaf–blindness as a "land of silence and darkness," a point Straubinger herself makes explicit; rather, translation here means enacting specific experiences for audiences to see, hear, and feel in their own bodies.

Consider the scene filmed at the Hannover School for the Deaf and Blind, part of a longer section devoted to children who, unlike Straubinger, were born deaf–blind and therefore have no sense memories of the visible and acoustic world. A student named Harald is learning how to swim. The camera shows the boy with his teacher and caregiver as they shower and prepare to enter the water. Then it pans to show Straubinger and her translator, seated at the edge of an indoor pool, appearing once again as spectators. The scene runs nearly five minutes. Harald is repeatedly asked to dunk his head underwater, and each time he goes a little deeper without totally submerging. Music from Bach commences as Harald begins to move through the pool on his own. Once this movement is established, the camera pans back and forth between Harald and Fini. This is followed by a return to the shower, without either music or commentary. In a long take, the camera tilts up and down between the shower head and Harald, who is raising his hands and giggling in the spray. Thus the entire scene evokes a visceral sense of wetness, immersion, and the associated feelings of fear and loss of control. Throughout, Straubinger remains in silent contact with her translator; she doesn't offer any commentary to the camera. And yet, by enacting the role of spectators, she and her translator implicate the film viewer in a scene that recommends another way of looking, indeed, a connective vision.

As the pool scene makes clear, Herzog's film remains subject to criticism for its representation of people with disability, even as it rejects

Touching the spray, *Land of Silence and Darkness* (1971).

old prejudices and advocates a more nuanced and literally sensitive approach. Corporeally, the disabled here serve to "enflesh" a theme or idea that is particular to the filmmaker.[39] Acoustically, the sentimental use of string music is a musical stereotype of disability with a history in film and television. Visually, Herzog's use of extremely long takes in effect stylizes the cultural practice of staring at disabled bodies. Rose-marie Garland Thomson explores a similar issue in photography, with particular emphasis on the absent body of the disabled. In that context, she argues, the "inherent distancing within the photographic relation-ship replicates the social untouchability of disabled people."[40] But this is where Herzog's film becomes interesting, even provocative. For although it tends to "stylize staring," as Thomson writes of photography, this par-ticular film also engages touch as a mode of spectatorship that depends on contiguity as well as distance. Let me be clear: I do not mean to sug-gest that the audience is either physically or metaphorically "immersed" in the deaf–blind world; what I contend, rather, is that Herzog's film insistently refers to a shared world of touch, while encouraging a form

of connective seeing that holds potential for overcoming the perceived limitations of one's own body. In so doing, the film not only depicts an enormous challenge faced by others but also implies an enormous self-challenge faced by the spectator.

Ultimately, *Land of Silence and Darkness* is more than a site of encounter between disabled and nondisabled bodies. It is also a site of public fantasy, a safe space of alterity, where audiences can work through some of the more troubling social implications of that encounter. Notably, the 1971 report characterizing public reactions to Herzog's film in terms of "prejudice and defensiveness" goes on to describe a different, presumably subjective experience, framed in terms of "empathy" *(Einfühlung)*. Not only the filmmaker's approach but also the spectator's activity is described as "empathetic" *(einfühlsam)*. "In the editing of these images, in the carefully thought-out pans and tracking shots, a world becomes perceptible [*spürbar*], a world that is incongruent with that of our own, but one that by means of its very existence points to the delicate state of our self-image, beginning with our shared possibilities of communication."[41] In making this world apprehensible to film viewers, *Land of Silence and Darkness* also takes certain liberties with its subjects, which is part of the film's provocation.[42]

This brings us to the ethics of touch. Under such extreme conditions, the stakes of representation are high enough that the practice of stylization, indeed, the very idea of documentary filmmaking, raises a number of ethical issues, above all, the lack of reciprocity between the viewer and the viewed. As deaf–blind participants are not easily involved in a process of negotiating and verifying the final image, a filmmaker who represents them presumably carries an extra burden of responsibility. Power relations between the viewer and the viewed are so unequal that the decision to show the body at all becomes problematic.

Interviews from the period indicate that Herzog was aware of this issue, especially while shooting the film's last scene.[43] In it, Straubinger visits a fifty-one-year-old man named Heinrich Fleischmann, whose family so neglected him, we are told, that he lost all means of communication and somehow spent five years in a stall among cows. Now he is living with his mother in a nursing home. He endures Straubinger's visit but evidently wants nothing to do with her. When she signs good-bye, he

pulls his hand out of hers and shuffles away. After a brief hesitation, the cameraman trails him, initially from a distance and then more closely, to show Fleischmann as he literally embraces a tree. (When Herzog, in interviews, discusses his "physical relationship" to the cameraman, turning or otherwise directing him by means of touch, this is his prime example.) The film then cuts to another angle with even tighter framing, which has the effect of underscoring the camera's intrusive presence. At one point, Fleischmann abruptly rears back, as if he senses the presence of another or perhaps even bumps into the cameraman, who seems to be that close to him. The proximity of the camera, the relentlessness of its gaze, the felt impact of the filmmaker on the documentary subject—in so many ways, the scene provokes discomfort.

The camera work epitomizes the "merciless gaze" that, with this film, became a hallmark of Herzog's style. This aspect of the film has, of course, been criticized, but perhaps a bit too hastily. After all, in the field of disability studies, the reverse idea of the camera and the spectator casting a "merciful gaze" on the disabled is itself highly problematic. In this context, moreover, the sense of touch and the contiguity it produces are openly advocated in opposition to the distancing effects of visual representation. Even as these developments give us pause, Herzog's use of touch raises further questions: is it possible to activate connections between the viewer and the viewed without impinging on the lives of others? Do documentary images such as these necessarily imply an act of violence, however tender it may seem to be? And if so, as I suspect they do, then is such a transgression ever morally or politically justified?[44]

Questions of power, encounter, and corporeality extend throughout Herzog's documentaries. Their persistence and the added concern with different cultural styles of embodiment can both be demonstrated by Herzog's engagement with ethnographic film. Touch and tactility remain operative in that context, but the emphasis shifts to vocal acts of translation and narration. Following *Land of Silence and Darkness,* Herzog began voicing the commentary for all his documentaries, and he has done so ever since. As he explains it, "I had the feeling that the films were more credible if I spoke my own commentary, if *my presence was physically there in a way.*"[45] Today, the idea of Herzog making a new documentary

without adding commentary and without voicing it himself is almost inconceivable; his voice and his documentaries have fused over time.

One result of this development is a heightened awareness of vocal presence as a means of performing documentary. By vocal presence, I mean the palpable effect of bodily presence that is produced by the recorded voice and how we hear it as maintaining a relatively strong connection to the speaking body (even if the latter remains unseen). Vocal presence should not be confused with voice-over narration, though they are, of course, related (narration being a particular instantiation of vocal presence). It is closer to what Roland Barthes calls "the *grain* of the voice," meaning its materiality, including breath, accent, timbre, and other inflections. Barthes in fact defines his term by analogy with the sound of recorded speech in the cinema—a sound the ear, he says, encounters as a body.[46] At the present writing, I can say without exaggeration that Herzog's vocal presence is among the most widely recognizable in all of cinema. The task now is to attend more closely to the uses and effects of vocal presence in a specific situation.

Vocal Presence

"The Wodaabe are among the last true nomads on earth," says the narrator. They follow their herds of cattle across the Sahel, a vast West African steppe. The film shows images of everyday life for a representative family of nomads. Members of the family speak on camera, explaining their different tasks and interests and occasionally answering the questions of an anthropologist (her voice is heard but she remains off camera). The narrator, for his part, describes the central role of taboo in Wodaabe society, the ordeals of migration, and the mounting pressures to settle once and for all. The dramatic high point of this fifty-two-minute program is its portrayal of the *geerewol* (or *jeerewol*), which is the name of both a dance and a festival. Two different lineages of the tribe come together for a weeklong celebration held toward the end of the rainy season. It culminates in an extraordinary beauty contest where the handsomest young men compete and a group of young women serve as judges. During the 1970s and 1980s, a series of droughts ravaged the Sahel, and the annual celebration was generally suspended. When it rained again

with any consistency, in 1988, the *geerewol* resumed and a small group of filmmakers, having traveled from Europe to Africa for the occasion, was also there to record it.

The film I am describing is not one of Herzog's but a well-known documentary called *The Wodaabe* (1988). Directed by Leslie Woodhead, it first aired in the United Kingdom as part of *Disappearing World,* a major series of anthropological films made for Granada television. Later that year, it was broadcast in West Germany and elsewhere. As its title suggests, the series claimed "to record other peoples' way of life before it was too late," while simultaneously appealing to a popular audience of prime-time television viewers.[47] Each program involves the collaboration of a filmmaker and an anthropologist in the field, supporting the show's claim to scientific value and authority. The series takes as its motto a line from Bronislaw Malinowski: "The final goal of which an anthropologist should never lose sight is to grasp the native's point of view, his relationship to life, and to realize his vision of the world."[48]

The context of anthropology on film and television is also the context for Herzog's *Wodaabe.* The film was commissioned by television networks in France and West Germany, where it was also first broadcast in 1989. An English-language version appeared later on BBC as part of its own anthropology series called *Under the Sun,* presumably as a way of competing with Granada, tapping into the enthusiasm for *The Wodaabe,* in particular. Although they share this context of production and circulation, it would be difficult to find two more dissonant films with parallel subjects made on location during the same period of time. And yet this dissonance makes Herzog's project even more interesting, for he, too, travels with a small crew to a remote location in the Republic of Niger, and they, too, live for a time with a group of herdsmen for the sole purpose of making a film. With the *Disappearing World* filmmakers, Herzog shares a genuine interest in the Wodaabe as "the last true nomads." In interviews, he celebrates "the nomadic way of life," aligning it with what he calls "the essential," as opposed to what consumer society has to offer.[49] For Herzog, too, nomads embody a way of life that is "disappearing." Rather than organize the film around a single person, as he does elsewhere, Herzog represents the Wodaabe as a collective body of non-Western others. There is precedent in ethnographic film "for a wide

range of treating and ignoring individuals."[50] The *Disappearing World* series seeks middle ground, giving names to certain individuals, while at the same time treating them as representatives of a larger whole. In Herzog's film, by contrast, individuals are shown and even interviewed on camera, but they remain anonymous. Unlike the *Disappearing World* filmmakers, Herzog makes no attempt to portray an entire way of life from "the native's point of view," nor does he claim to "preserve" their traces in archival fashion. He is obviously not trying to have his work accepted as anthropology or authenticated by experts. Instead, he explains, "What I'm trying to do in a different culture, in a different environment, very often I give it a voice, like in *Wodaabe: Herdsmen of the Sun*. These tribal people have a voice all of a sudden that they have never had before."[51]

What does it mean to give other people a voice, and one that they admittedly never had before? Whose voice is it? What constitutes "voice" in this sense of the word? Is Herzog speaking for others, about them, through them, or with them? For all the romantic sentiment conceivably supporting his notion of nomadic life, *Wodaabe* raises a number of questions about the effects of voice and vocal presence in Herzog's documentaries as well as in the context of ethnographic film and television.[52]

While there is no point in querying the scientific basis of *Wodaabe,* I do want to suggest that Herzog engages the practice of ethnographic film and that he does so from a distance, in passing, without any pretense to scientific authority. By ethnographic film, I understand a special form of documentary in which the human body features prominently and problematically. "The most important difference" from other documentary forms, according to David MacDougall, "is that ethnographic film always has a *transcultural* component. It marks the encounter of two societies or communities, or the filmmaker and his subject, and reflects their cultural differences."[53] In this context, issues of voice are absolutely central and frequently contested. *Wodaabe* not only marks an encounter of two societies; it also stages Herzog's confrontation with the tradition of ethnographic film. Whereas Herzog is known for dismissing the observational style associated with direct cinema, ethnographic film has generally embraced this style, with some scholars even regarding it "as being mimetic of anthropological practice."[54] If documentary and anthropology are "discourses of sobriety" (Nichols), it is no wonder that

Herzog should resist such terms for discussing his own work. And yet ethnographic film is also a site where forms of ecstatic experience have actually been embraced and explored (in the cinema of Jean Rouch, for example), as Herzog is well aware.[55]

The opening scene of *Wodaabe* provides an emblem for the entire film: its underlying principal of cultural juxtaposition, its visual focus on bodies and faces in motion, and its particular use of voice. The scene begins with a piece of recorded music. It is audibly worn, culturally inappropriate, and blatantly asynchronous. Accompanied by piano, what seems to be a falsetto voice sings Gounod's "Ave Maria" in a peculiarly affecting historical style, applied to Bach's First Piano Prelude. As the music plays, a drama unfolds on-screen between the film camera and the subjects, between the observer and the observed. We see one group of people dancing in extravagant costumes and another group watching them dance, with the camera circulating among and interacting with them all. Indeed, it is the camera's proximity and mobility that results in a dramaturgy of looks. The dancers stand side by side in one line, facing the camera and facing their audience. As the camera moves down the line, we see a series of faces, elaborately painted and textured, making strange and dreamy movements. Every few seconds, the dancers widen and roll their eyes, while turning their heads from side to side and showing off their teeth in broad, exaggerated smiles. We also encounter a range of returned looks: whereas the dancers appear to be mugging for the camera, the spectators either glare back at it or avert their eyes altogether. Though the dancers move their mouths as if speaking or making sounds, only the voice of the soloist can (as yet) be heard.

This is an evocative scene. What are we as film viewers to make of it? In a way, it aims to strike us dumb. Implied by this ritualized choreography of facial expressions are those of our own: mouths gaping, eyes agog. As the number and range of returned looks would seem to suggest, the film takes place in relations of power that are complex and not straightforward. Like the bodies on-screen, the camera solicits attention, excites wonder, and promotes ambiguity, all at the same time. *Wodaabe* is another film that favors sensory response and emotional involvement over understanding. As viewers, we are encouraged to make certain

Mugging for the camera, *Wodaabe* (1989).

assumptions about the bodies on-screen and about the body of the film itself, only to have those assumptions either scuttled or suspended. Discursively, for example, *Wodaabe* presents itself as an ethnographic film. Its title and subject are conventional enough. In the opening scene, the camera mimics the act of observing, focusing on the bodies of others while asserting its presence on location. Although the movement of the camera suggests its participation in the scene, the incongruous use of music disrupts such a fantasy before it can take hold, while adding to the film yet another (acoustic) layer of texture and sensuality. Deploying asynchronous sound foregrounds "the material heterogeneity of the cinema," as opposed to masking or naturalizing it by means of ambient sound.[56] Instead of ethnographic authenticity, the music denotes artifice, and it does so in grand style.

The artifice of music deserves brief comment. In his best-known essay on ethnographic film, "The Camera and Man," Rouch summarily dismisses musical accompaniment in favor of synchronous sound. Even "in the commercial cinema," he adds, "the use of music follows nothing

but an outdated theatrical convention."[57] Indeed, this is precisely the effect that Herzog would achieve. In his words,

> I purposefully pull away from anything that could be considered anthropological. In the opening scene of the film the tribesmen are rolling their eyeballs, extolling the whiteness of their teeth, making these ecstatic faces, and on the soundtrack over these images you hear Gounod's "Ave Maria." . . . Using the aria means that the film is not a "documentary" about a specific African tribe, [but] rather a story about beauty and desire. . . . Without the music, the images of this amazing and bizarre male beauty contest just would not touch us as deeply.[58]

Herzog may be wrong about the impact of silent images, but the use of extremely inappropriate music and the governing interest in emotional contact seem clear. What allows this scene to become filled with such emotion, and what makes it emblematic for the film as a whole, is both the separation and the connection of the "ecstatic faces" and moving lips, shown in close-up, and the incompatible singing, amplified by the sound track.

The opening scene thus raises the question of *voice*. By that I mean not just the role of recorded voices in *Wodaabe* (which is important enough, as we shall see) but also (following Nichols) that which articulates a documentary's various elements to create a particular story, affect, argument, or perspective, as the case may be.[59] Voice in this sense has become a widely used term in documentary theory for describing a film's articulation of its material. The voice of *Wodaabe*, for example, would seem to be that of Herzog's own, which is (literally and figuratively) imposed on the cultural performance of others. If this is "a story about beauty and desire," as Herzog would have it, then it is manifestly *his* story and not that of the Wodaabe. The prerecorded voice of the soloist, played over the muted image, perfectly captures this interpretation and its corresponding power dynamic. At the same time, however, we also need to account for the cultural encounter that defines this material and complicates it. Not only Herzog's perspective but also his interaction with others is inscribed within the film. By attending to certain aspects of *Wodaabe*, beyond the filmmaker's authorial imprint, we can

begin to make out other voices, even within the film's opening scene.

Consider the dancers mugging for the camera. What are we to make of such overt exhibitionism? For several decades, as Mette Bovin (the anthropologist for *Disappearing World*'s *The Wodaabe*) has shown, the Wodaabe have sought to shape and broadcast their public image by means of film, television, and live performance. The key to their effort is the *geerewol* because it already involves a wide diversity of spectators. The audience "is often multi-ethnic in nature, and includes spectators from different ethnic groups of the region as well as Europeans and North Americans, eager to watch Wodaabe perform. To this audience, the Wodaabe are 'exotic.' The performers know this and they play on it" by exaggerating the strangeness of their appearance, by asserting their identity as nomads, and by foregrounding their difference from sedentary cultures. The strategy involves not hitching their wagons to the tourist economy but rather pushing back against certain pressures to abandon the nomadic way of life. Rather than make images of themselves, the Wodaabe have chosen to participate in ethnographic films made by others, shaping their public image and perception indirectly to the extent this structure allows. If Bovin is correct about the politics of dance, and the Wodaabe deliberately perform their own exoticism for the camera, then Herzog's film has a role to play in their story, too, whether or not he is even aware of it.[60] The question of voice cannot be answered by that of the filmmaker alone, as though the Wodaabe were somehow mute or silenced, which is simply not the case.

Indeed, following this scene and throughout the rest of the film, Wodaabe voices are not only heard but also subtitled in English. Acts of translation run throughout Herzog's documentaries, but they are especially noteworthy in the context of ethnography. Subtitled translations of spoken dialogue first appeared in the 1970s, beginning with the influential films of David MacDougall (e.g., *To Live with Herds,* 1971) and continuing in the realm of popular culture with the television series *Disappearing World,* where subtitles later became a policy. "Before that," writes MacDougall, "almost all ethnographic films had been constructed around a voiceover commentary which spoke about the people concerned but rarely allowed them to speak themselves."[61] As ethnographic films adopted subtitles, they attended as never before to the emotional and

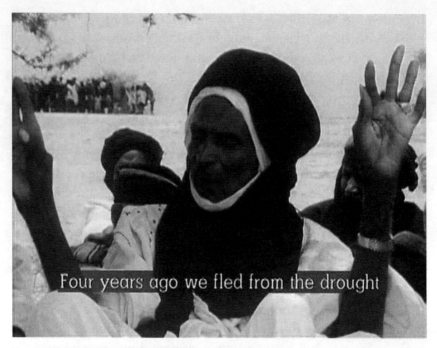

Four years ago we fled from the drought

A subtitled translation from *Wodaabe* (1989).

intellectual lives of their subjects. "Audiences no longer listened to spoken information about people in these films but began to watch and listen to them more directly."[62] So, while it may seem unremarkable in the context of Herzog's work—I have already discussed translation in *Land of Silence and Darkness,* for example—the use of subtitles in *Wodaabe* is complex, variable, and not self-evident.

While the camera revolves around faces and bodies, *Wodaabe* devotes attention to various forms of speech, from ritualized language to informal conversation. The passages of spoken dialogue show people addressing one another, addressing the filmmaker directly, and perhaps even addressing other audiences indirectly, through the film. The corresponding subtitles have various functions: from providing context for the images to highlighting particular themes. And yet, even as *Wodaabe* incorporates native voices, to borrow a point that Nichols has made elsewhere, "a gap remains between the voice of a social actor recruited to the film and the voice of the film" as a whole.[63] One example from *Wodaabe* is the scene that takes place in Arlit, an industrial town and site of the

largest uranium mine in Niger. "We went there," Herzog explains on the voice-over, "because many Wodaabe had taken refuge there during the drought, hoping to find a survival job. These were people who had lost all their cattle and whose children now forage for food in the garbage." Herzog interviews two men, both of whom describe sedentary life as "a prison." Off camera, a translator can be heard asking questions, which are also subtitled for the film viewer: "Where would you like to be?" "What is your dream?" At these moments, we can almost hear an echo of Rouch's *Chronicle of a Summer* (1960) and the questions asked of Parisians in that film: "How do you live?" "Are you happy?" Such questions invite reflection from the person being interviewed, with the film camera serving as catalyst for self-expression. Clearly Herzog is "interested" in the critique of sedentary life that informs this scene. To hear the questions asked, and to see them translated on-screen, makes vivid how interviews shape the terms of discussion, while allowing for improvised responses. "Sometimes, at night," says one man, "I lie on my back in the sand, staring up at the starry sky, and then I feel delirious with bliss."

Not only spoken dialogue but also voice-over narration connects the various dance sequences that run throughout the film. Whenever Herzog voices the commentary, he also embodies "the archetypal solid male narrator" and uses this stereotype in conventional and unconventional ways.[64] In *Wodaabe,* his commentary is relatively freed from scientific obligations and allowed a more creative (but no less problematic) role in relation to the image. He still employs a discourse of ethnographic authenticity, to be sure—especially when providing context about tribal matters, however inadequate this context may be in comparison to films made for and within the discipline of anthropology. He does so, moreover, from an assumed position of knowledge and authority. This position becomes available to Herzog largely owing to his status as a traveling director. Writing of ethnographic film, Nichols observes that travel "underwrites authority by means of bodily presence," even when the body of the filmmaker "disappears" behind the camera.[65] The signs of travel, however, need to be constructed, deployed, and arranged within a film for them to be understood as such. In *Wodaabe,* this process becomes clear through the commentary. When voicing the commentary, which is obviously done later (in postproduction), Herzog speaks in hushed tones,

as if he were still on the scene, observing an important ritual and trying to remain as unobtrusive as possible. The effect is literally dramatic.

Herzog's focus on ritual, here and throughout his documentaries, needs to be put in perspective, and the context of ethnographic film suggests a way of doing so. Historically, that is, a great many ethnographic films revolve around particular events or customs. It is one of the most common ways in which the film medium has been used to make cultural generalizations out of specific images.[66] Regarding the prevalence of ritualized behaviors, Rouch offers another, more revealing explanation: "If young ethnographers are well advised to favor rituals and techniques as subjects for filming, it is because rituals and techniques incorporate their own *mise en scène*."[67] The target of this comment is the widespread aversion in anthropology to film becoming "art"—an aversion Herzog shares, albeit for different reasons. Rather than disavow the aesthetic elements of filmmaking, Rouch points out that rituals, customs, and processual forms actually provide such elements for a film and seem to do so "naturally," of their own. In other words, filmed rituals seem to corroborate the camera's stenographic function as a recording instrument, producing spectacles that are visually potent yet permitted owing to their origin (so the logic runs). Although this comment was made in another context, the example of Rouch helps shed light on Herzog's own preference for ritual events (contests, festivals, ceremonies, processions, reenactments), which is most especially pronounced in his documentaries.[68] In this context, such events seem to provide their own scenic components because they are preexisting forms of performance, only to be further stylized and cinematically transformed according to a particular logic or vision, beholden to Herzog. Because of its relation to ethnographic film, however fraught that relation may be, *Wodaabe* provides the key example. More, its focus on ritual makes the film doubly pertinent to a study of documentary through the aspect of performance.

A traditional ritual of bodily exhibition based in the social life of the community, the *geerewol* festival would have happened in this way and at this time whether or not Herzog and his crew had been there to film it. And yet, precisely because the film crew is there, the depicted ritual is also performed self-consciously for the camera, as the opening scene makes clear. Speaking the voice-over, Herzog acknowledges the

complexity of the *geerewol*, the fact that it has distinct phases and regulations, but the details are withheld; they don't concern him. In other words, *Wodaabe* makes no effort to represent "whole bodies and whole peoples in whole acts," a key statement of ethnographic film from the period.[69] Herzog has different priorities. This, too, is clear from the opening scene, with its close-up shots and asynchronous sound, and it is reinforced throughout the film by the editing, keyed as it is not to the shape and rhythm of the festivities but rather to the film and its audience.

The *geerewol* and its surrounding events provide the scenic elements for a story which is literally narrated by Herzog and embodied by tribal people. The story adopts the particular format of a beauty contest and takes place within its arrangement of front-stage and back-stage settings. The format, however, differs in significant ways from that of beauty contests, which work to produce "idealized versions of femininity" in corporeal form.[70] Inverting this formula, the Wodaabe contestants are young men, who compete against each other in beauty and charm, performing masculinity in terms of certain dress codes, body decorations, and dance moves. They take great care in preparing themselves. "Preparations take hours," we are told. "Some men need a whole day to make up." By setting the images of primping to opera music, Herzog momentarily transforms a back-stage scene into a front-stage scene for the film viewer. When the dance begins, the sound track shifts to the ambient sounds of clapping and singing. Now the men literally put themselves on display, and the women serve as judges. Herzog continues, "Most of them are married girls who disappear for a few nights into the bush with a man of their choice, and return him afterwards." The results are mixed. One woman smirks and says of her pick the night before, "He was nothing special. I'll choose a better one tonight." Another woman adds reservedly, "I am in love with one, I admit it, but I won't say any more."

For his part, which is equally remarkable, Herzog adopts the role of presenter at a beauty pageant. The *geerewol*, of course, has its own mediators, such as the women who serve as judges. On the final day of the festivities, they act as the representatives of the tribe in selecting the most beautiful man, who is then marked by a tribal elder for all to see and admire. Herzog, by contrast, acts as the representative of the film viewer, directing his attention and providing the commentary that

situates the contestants as well as the judges in relation to the film audience. "This girl has been chosen to select the most beautiful man. He will then belong to her. She walks along the row of dancers. The one she points to last is the winner. It was hard for us to make him out, at first. This one is the most beautiful. . . . The slender one in the middle, that's him." The repeated use of deictic gestures (e.g., "this girl," "that's him") is significant for it locates the filmmaker and his cameraman in the physical presence of the contestants.[71] At the same time, it underscores the demonstrative function that Herzog assigns to the voice-over here and throughout the many films in which he speaks the commentary.

Herzog's vocal presence signals more than just a documentary convention; it becomes a way of moving and thereby mediating between the observer and the observed. Writing of beauty pageants and other forms of bodily exhibition, such as the circus and the fairground, Rosemarie Garland Thomson observes that "the mediator is always of the audience rather than of those exhibited. No dialogue transpires between spectator and spectacle; instead, the mediator, who possesses voice, agency, and power, conducts the drama both for the viewers and before the viewers by explicating the intensely visible, mostly silenced spectacle."[72] Herzog, too, mediates between the spectacle and the film spectator, and he does so most conspicuously by means of his vocal presence. The resulting dynamic, however, is different from that which Thomson describes in another context. By inserting himself as a vocal presence within the film, Herzog not only adopts the role of presenter but also models the role of the embodied observer, looking through the camera as a way of engaging (and not engaging) others.

Despite being external to the world of the Wodaabe, and without claiming to be part of it, Herzog uses the film to open up a space of encounter and translation, which is also a space of narration. Rather than silence native voices, he involves them in a story of his own design. The voice of the film as a whole at once amplifies other voices, which are internal to the film, and translates them accordingly. *Wodaabe,* like *Land of Silence and Darkness,* can thus be seen as an arch-humanistic project. The director himself would seem to support this idea, when he says, "I actually stylize . . . these people in a way that they become dear to us. . . . They become part of a universal understanding of us as a human race."[73]

It is always important to distinguish between Herzog's pronouncements and the many possible ways of interpreting his films. In this case, it is worth observing a point the filmmaker either neglects or overlooks, that is, the limits of such a singular universal humanism, a perspective he clearly adopts here, which may also betray a philosophical limitation of his own worldview.[74] Moreover, Herzog remains unapologetic about making such a pronouncement (however problematic it may be), and the same can be said of the film itself. *Wodaabe* neither endorses the protocols of ethnographic film nor concedes the failures of representation. What remains, instead, is a story of embodiment and an embodied approach to storytelling, an approach that puts the encounter of other peoples and remote locations in the service of incorporating the various parts of the filmmaker's narrative and conveying it to a public audience. For all the rhetoric of universal humanism, Herzog also stages his own cultural difference—and does so primarily by means of asynchronous music and his use of vocal presence—as if it were the only way he could acknowledge difference as internal to the project of representing others.

The point can be amplified by comparison with an earlier film by Robert Gardner, another traveling director of international standing and a major figure of ethnographic film in the United States. For some commentators, he remains the ethnographic filmmaker par excellence; for others, particularly those committed "to observational filming with social science goals, Gardner was the Recording Angel who fell, a man of extraordinary creative ability who simply would not make his films the way the scholarly community needed them."[75] The critical polarity through which his work has been viewed is strikingly similar to that which defines the Herzog scholarship. On one side, Gardner has been criticized for "aestheticism," for "neo-colonialism," for privileging visual style over anthropological knowledge, for imposing his personal vision on images of others, and—last but not least—for bracketing off historical context in favor of universal archetypes. On the other side of the spectrum, he has also been celebrated for some of these same qualities, especially his creative vision, affective style, and poetic sensibility. As other scholars have noted, using terms that might equally apply to Herzog, Gardner is "more interested in the agonistic and the ecstatic—in extremes of emotion and sentiment—than he is in the normal or the typical."[76]

All criticisms of the filmmaker notwithstanding, Gardner's *Deep Hearts* (1979) was by far the most widely known film about the Wodaabe at the time Herzog began his project, and it remains so to this day.[77] In it, Gardner refers to the people as "Bororo," an ethnic term not used by the Wodaabe themselves, which roughly means "herdsmen in tatters." This film, too, is structured around a performance of the *geerewol,* but Gardner's primary interest lies in the realm of moral philosophy. Several months before Herzog's *Wodaabe* was first broadcast on West German television, the Munich Film Museum held a retrospective of Gardner's films, including *Deep Hearts.*[78] For all these reasons, the film provides a useful reference point.

What most interests me about *Deep Hearts* is how it gradually but insistently transforms the ceremony into "a moral tale of envy and vanity."[79] The Bororo are introduced by Gardner's voice-over as a group largely preoccupied with their own personal charm and beauty, and the *geerewol* serves to celebrate this preoccupation of theirs. Only midway through the film does he introduce the concept of "deep hearts," which then complicates matters. A concept of native origin, it is defined as an internal means of hiding and controlling intense emotions, particularly those of extreme pride, envy, and disappointment. According to Gardner, the Bororo sense of their own specialness results in both excessive self-regard and excessive fear of losing what they have: "Their greatest fear is to be devoured by another person's eyes or mouth by the way they might look or speak." As other scholars point out, however, Gardner's images not only fail to support this narration, they contradict it. "From the images alone viewers get a sense of the rapport that men exhibit in assisting each other to beautify themselves. . . . In short, they look as if they are enjoying themselves *together.*"[80] Nor are any native voices offered, which might have either supported the narration or suggested an alternative way of thinking about the *geerewol.* The film viewer is left with the gloominess of the narration, on one hand, and the vitality of the imagery, on the other hand. As the film closes, we are informed that the outcome of the beauty contest is fixed: the tribal elders, all men, decide in advance who the winner will be, and their decision is merely carried out by the jury of young women.[81] At the bottom of "deep hearts," says Gardner, lies a profound uncertainty as to whether the Bororo

and human beings more generally in fact have any choice of their own.

In a way, Herzog's film offers an answer back to that of Gardner. Rather than invent "a moral tale of envy and vanity," Herzog tells "a story about beauty and desire." The concept of "deep hearts" is nowhere mentioned in *Wodaabe*. Instead, the film provides a final interview with the winner of the beauty contest and the woman who selected him. "Were you told to do this," the man asks, "or was it your personal choice?" To this she replies, "I have chosen you with my heart." This is how the story ends. Choice is coded in terms of love and compassion, or what Herzog has elsewhere called "a concordance of hearts."[82] As such, the final dialogue might well be scripted, not merely as a reply to Gardner, but also—more importantly—to address and hold a public audience on the level of emotional contact that governs the entire film.

Wodaabe tacitly reaffirms the cinema's social function as a key site of encounter between bodies that are otherwise remote. Under such conditions, vocal presence—that of the filmmaker and that of the film's subject—goes a long way toward making such connections between the bodies on screen and those in the audience. After all, however mobile and accommodating it may be as a ceremony, the *geerewol* remains a situation in which few of the film's viewers will ever find themselves. Instead, and partly for this very reason, it is mediated by more familiar, thoroughly ritualized forms of spectacle—including opera, festival, dance, and beauty pageant—all of which become repurposed as forms of cultural translation.[83] To these I would add the film itself. Knowledge of the other in Herzog's work is directed toward ritual rather than ethnographic ends, and the ritual at stake is that of film spectatorship. Curiosity is harnessed not so much for interpreting a strange culture as for overcoming the supposed limitations of one's own body as a film viewer. The transgendered, transcultural bodies that the film constructs by means of artifice create points of connection as well as difference.[84]

In some ways, this chapter's key examples would seem to resist comparison. Topically, the one involves disability, the other ethnography. Theoretically, the idea of sensory translation is not the same thing as cultural translation. And yet, as we have seen, these films turn out to be closely related in other, less obvious ways. What links and supersedes them is not just the sensational display of other people or a common

fascination with the strange and the "exotic." It is, much rather, a corporeal approach to documentary filmmaking that works primarily to affect the bodies of spectators. Clearly Herzog is fascinated with overcoming extreme physical forces (think of *Fitzcarraldo*). What the documentaries add, then, is a process of overcoming the perceived and culturally prescribed limitations of one's own body. It is a process of translation that involves the spectator in various ways, depending on the material at hand. Ultimately, and contrary to what an auteur study might suggest, this process of translation, this privileging of the body, not only distinguishes Herzog's films but also connects them to various genres of documentary film and television, indeed, to the nature of "movies."

2 MOVING LANDSCAPES

For a traveling filmmaker who has worked on every continent, Herzog approaches the physical environment with striking uniformity of vision. Combining a passion for landscape views with an insistently inward movement, his ephemeral vistas open up a space of imagined interiority that is also a representation of the physical world we inhabit. Herzog's films engage us, and we remember them, by their remarkable use of landscape. Of course, landscape can neither be found nor discovered, as if it simply existed in the natural world. Like documentary, it is a product of human interest, perception, and representation. Despite their distinct histories, both terms are plural, ambiguous, and sometimes contradictory. When Herzog speaks of landscape, he uses it to designate a place, an object, a representational practice, or a way of seeing, depending on the situation.[1] Yet this intrinsic ambiguity and historical multivalence make landscape productive as an analytical category. More specifically, Herzog's landscapes can be seen as layered images, prepared by cultural modes of perception, conditioned by historical precedents, surrounded by discourse, and governed by relations of power.[2] Some of his landscapes are inspired by traditional framed images. As cinematic views, all of them are technologically mediated, transformed in terms of temporality, and supplemented by sound and movement.

Landscape is central to Herzog's notion of documentary because he explicitly stylizes it. In interviews, he even characterizes himself as "a director of landscape."[3] However pretentious it may sound, the phrase accurately suggests that Herzog takes landscape out of the category of scenery and makes it a subject of his work. Although overlooked or neglected, the point is crucial: despite the indexical relationship between reality and the photographic image, Herzog does not imagine the film

camera to be an objective or nonarbitrary means of inscription. Because it is already (at least once) transformed by virtue of technological recording, the documentary image offers not unmediated reality but a means of further transformation. If all documentaries combine aleatory and preconceived material, Herzog's represent a highly self-conscious version of this dynamic. In terms of landscape, then, stylization refers not only to the composition of images by means of recording, cinematography, editing, and laboratory work but also to the informing role of prior landscapes. Herzog uses many of the same techniques of stylization in all his films, but landscape is an area where one would not expect it to show up in different ways. For scholars of documentary who accept the role of style, Herzog's landscapes are constitutive. For those who reject it, his claim to stylize becomes an act of provocation.

Herzog's landscapes claim to visualize the inner world of the emotions, the psyche, and the soul—vast areas of human experience that are not directly observable and therefore tend to be ignored by scholars of documentary.[4] Elsewhere, I have discussed the nexus of landscape and documentary in terms of "emotional cartography," or the mapping of feelings onto images of the world.[5] Because this chapter builds on that discussion, I need to at least sketch the central point, focusing on an exemplary scene from *The Dark Glow of the Mountains* (*Gasherbrum: Der leuchtende Berg,* 1985). A portrait of the elite mountain climber Reinhold Messner, Herzog's film bears witness to an unprecedented (and, since then, unparalleled) event, namely, the attempt by Messner and his partner to climb two of the world's tallest peaks in succession, without returning to base camp in the interval. More important, the film addresses the emotional and physical intensities that not only distinguish such climbers but also connect them to film viewers. As Herzog puts it on the voice-over, "We weren't so much interested in making a film about mountain climbing per se, or about climbing techniques. What we wanted to find out was what goes on inside mountain climbers who undertake such extreme endeavors. What is the fascination that drives them up to the peaks like addicts? Aren't these mountains and peaks like something deep within us all?" As Herzog speaks, the camera scans the horizon of the Himalayas from a distance through a powerful telephoto lens, panning and tilting to trace the jagged outline of the peaks. The

lens and camera movement flatten out the physical environment into a graphic pattern, transforming the mountains and ravines into the highs and lows of an inner world, which the camera seems to register like the moving stylus of an automatic instrument. This visual strategy relies for its effect on the spectator's powers of visualization and projection so that the cinematic landscape also becomes a site for eliciting emotions from the audience. At the same time, the telephoto lens maintains the necessary distance of the audience from the documentary subject. Only at such a remove could a landscape of this magnitude be made to serve double duty as a screen for projecting the inner world of the spectator. Thus the image becomes a double vision of inner and outer landscapes.

The practice of aestheticizing the interior by means of landscape may be unusual in documentary cinema, but it has an extensive and much-vaunted history in art and literature. Herzog is well aware of this history and stakes a certain claim to it. "For me," he says,

> a true landscape is not just a representation of a desert or a forest. It shows an inner state of mind, literally inner landscapes, and it is the human soul that is visible through the landscapes presented in my films, be it the jungle in *Aguirre,* the desert in *Fata Morgana,* or the burning oil fields of Kuwait in *Lessons of Darkness.* This is my real connection to Caspar David Friedrich, a man who never wanted to paint landscapes *per se,* but wanted to explore and show inner landscapes.[6]

The nod to Friedrich recalls Herzog's connection to the German aesthetic tradition and to the legacy of romanticism in particular. With further study, however, we find that Herzog also builds on the work of older artists, some of them more obscure than others, including Albrecht Altdörfer, Hieronymus Bosch, Pieter Bruegel, Francisco Goya, John Martin, John Milton, Leonardo da Vinci, and Rogier van der Weyden. As even this partial list of names suggests, the visual sources for Herzog's landscapes are not restricted to either Germany or romanticism, nor do they always work to visualize the interior. Most commentators would seem to agree that Herzog uses landscape as a nascent theater for the emotions. I do, too, when I speak of emotional cartography. But we need to look closer. Although it serves an expressive

function in Herzog's documentaries, landscape does much more than that.

This chapter explores the different functions of landscape in Herzog's documentaries. The names of these functions—trance, parody, testimony, and allegory—serve as the categories that frame my analysis of individual films. They also identify how landscape connects different material, that of Herzog and that of others. Though under certain circumstances, it is helpful to think of landscape as a static element of Herzog's work, it is also necessary to see how it varies historically and generically. Most of all, we need to recognize the function of landscape in Herzog's documentaries, indeed, to recognize that it has many functions (not just one), to understand how his contribution to documentary is as rich as it is paradoxical.

Trance

Herzog divorces landscape from place. "The starting point for many of my films is a landscape," he states, "whether it be a real place or an imaginary or hallucinatory one from a dream, and when I write a script I often describe landscapes that I have never seen. I know that somewhere they do exist and I have *never* failed to find them."[7] In making such claims, he assumes the role of a visionary artist whose landscapes arise less from an external source than they do from an inner process or imagination.[8] Throughout his career, Herzog has advocated the related ideas of staging landscapes and visionary landscapes—not only in his own work, and not only in the context of film. Referring to Hercules Segers, a seventeenth-century Dutch artist much admired (and collected) by Rembrandt but since then almost forgotten, Herzog writes, "Here is someone who painted images of landscapes in rapture, in trance, who understood landscapes as *stageable (inszenierbar)*. That has become possible again with film, and I myself have always tried to discover in the desert and in the jungle entire planets which only become visible by means of staging" or creative treatment in the broadest sense.[9] The primacy of landscape in Herzog's films has almost naturalized his self-stylization as a visionary director, as if it could be confirmed by the authority of reality itself.

How interesting, then, that Herzog makes travelogues, the bulk of

his documentary output. Although travelogues are "nonfiction films that take place as their primary subject," as Jennifer Peterson defines them, Herzog steers them away from locale and toward an inner world.[10] Landscape should convey a sense of the site where individual and collective identities are formed, where memories are shaped over time.[11] It is a thorny problem, then, to realize that Herzog travels to far-flung locations in search of particular landscapes, but the resulting images tell us little, if anything, about their contexts of origin. Instead, they confront us with a space of representation that oscillates between presence and absence, history and fantasy, place and no place.

An early and particularly important example is *Fata Morgana*, a film that Herzog describes as having "crystallized" his audience at a crucial stage of his career.[12] It began as a mere side project, shot between November 1968 and December 1969, parallel to *The Flying Doctors of East Africa,* while Herzog was scouting locations in the Canary Islands and across the southern Sahara for *Even Dwarfs Started Small*. Though *Fata Morgana* was originally conceived as a science fiction film, the idea was soon abandoned. In his words, "the mirages that had taken hold of me and the visionary aspects of the desert landscape were so much more powerful than any single idea for the film I had previously had, so I junked the story, opened my eyes and ears, and just filmed the mirages of the desert."[13] Thus, rather than tell a story or explore a specific locale, *Fata Morgana*, as its title implies, represents a landscape of suggestion. However found and fleeting, it is emphatically composed. Hence the film's opening passage, a succession of airplanes landing in the desert heat. Filmed over an extended period of time, from a fixed position at a slight angle to the landing strip, the planes appear to float down along a vertical axis. The static camera and telephoto lens call attention to the sun's heat, which becomes increasingly visible in the form of waves. As the opening passage would seem to suggest, *Fata Morgana* explores the movement, temporality, and ambiguity of the cinematic landscape, where nature and technology unavoidably blur, where the rhythmic succession of images and the increasingly hazy field of vision induce a trance that is the film itself.

The notion of "trance" comes from the avant-garde. In 1964, Herzog saw a program of work by American independent filmmakers organized

by Jonas Mekas and presented by P. Adams Sitney in Munich.[14] Herzog's review of the exhibition focused on the films' "visionary traits." Significantly, he writes, "The visions happen of their own *(ereignen sich)*; they are not forced from literature or from a script." What is more, "visionary seeing demands a new relation to reality" and thus a "new style of representation." Both involve "the documentary character of every film recording, which is consciously manipulated through camera movement, editing, or laboratory work, in order to overcome an anachronistic naturalism."[15] Like the surrealist experiments on which it builds, American avant-garde film (even Sitney's influential presentation of it) prepares the ground for Herzog's visionary landscapes. Specifically, *Fata Morgana* exploits some of the forms that Sitney attempts to isolate as "pure" states of origin and development in his later study of the American avant-garde. They are, most notably, "the trance film," the key example being Maya Deren's work from the 1940s, and "the mythopoeic film," which emerged in the 1960s. For Sitney, each form corresponds to a different way of dealing with visionary experience.[16] *Fata Morgana* draws on elements of both forms, revising them at will. In Herzog's version of a trance film, for example, the interior quest of the protagonist becomes that of the observational camera; instead of a somnambulist, we see moving landscapes throughout the entire film. *Fata Morgana* suggests a dream experience not just by rehearsing surrealistic imagery but also by juxtaposing landscape views shot in various places to produce a creative geography.

Although it is filmed in Africa, *Fata Morgana* refers to a space that is fleeting and ambiguous. In one passage, for example, the camera performs a 180 degree pan, as if it were slowly moving along a cinematic continuum, from the seemingly solid ground of a rock formation to the shimmering mirage of a desert lake. Another passage, shot from a fixed camera position, creates a similar continuum by compressing it into a single frame, with the interval here extending from the foreground to the horizon by means of deep focus. The paradox is clear: by "holding" on the physical world that appears before it, the camera renders a shifting landscape, which appears to lose its referentiality in the course of its depiction. In visionary landscapes such as these, the vanishing point of perspective becomes temporal as well as spatial, and the moment of

Desert landscape, *Fata Morgana* (1971).

vanishing becomes a cinematic spectacle, a sight to behold for as long
as it lasts. An ephemeral vista unattached to place yet originating in
the material world, the mirage becomes for Herzog the quintessential
cinematic landscape.

Landscape in this film serves to enthrall. Rather than hypnotize the
audience, however, it calls our attention to the act of looking itself. The
mirage involves a fascination with seeing what isn't literally there. So
does the notion of trance. What's interesting about trance, moreover, is
its association with dreamlike kinesthetic experience. It should come as
no surprise, then, that *Fata Morgana* goes beyond the mirage to show a
range of landscapes, all in motion. Herzog takes the observational camera
and drives with it, at once creating and traversing space by means of
pans, tilts, aerial views, and traveling shots—many of them taken from
the roof of a VW van or through the window of a small airplane. The
effects of this driving movement are immediate, visceral, and unresolved.
What should be travel images have been radically decontextualized. The
moving camera often lingers on traces of industrial detritus (abandoned

factories, oil drums, plane wrecks, and car parts) strewn about the land. Where did these things come from, and why are they "here" in a desert? The image track begs the question, but the sound track answers back with escalating uncertainty. Instead of clarifying the flow of images, the music and the narrative only muddle it. But that is precisely the point. Visionary seeing for Herzog means overcoming a form of naturalism that no longer holds.

This is also the reason why *Fata Morgana* has a mythological framework that proves to be so unstable. Structurally, the film is divided into three parts: "Creation," "Paradise," and "The Golden Age."[17] Each part features a different voice-over narrator and a different mythical source, ranging from the sacred (excerpts from the Mayan sacred text known as the Popol Vuh, read by Lotte Eisner) to the didactic (part of a story from the popular German children's book *Struwwelpeter*) to the absurd (original texts written by Herzog himself). Rather than promote understanding by creating a sense of narrative cohesion, the framework generates semantic chaos. Herzog's version of mythopoeia is as parodic as it is extravagant. Multiple narrators and nonsensical discourse (a male voice states matter-of-factly, "While you are sleeping, acids gnaw and leeches suck at the tuna fish") combine to parody the authority of voice-of-God narration in documentary cinema. If the mythical framework promotes an ironic interpretation of the images, it does so without providing the necessary discursive backup for a coherent specific interpretation. Thus "Creation" can be understood as a litany of colonial violence, "Paradise" as a postapocalyptic landscape of ruination, "The Golden Age" as an era of inescapable destitution. Yet this is only one possibility, and there is no secure referential structure to support any one reading as opposed to another. The film thus appears to be organized by its mythical structures, but none of them come to bear. "In paradise," the narrator repeats, "there is landscape even without deeper meaning." The refusal of other meaning also holds for the larger film, which is equally porous and resistant to specific interpretation. The jarring discontinuity of musical selections (from Handel to Leonard Cohen) both underscores and amplifies this effect. If the juxtaposition of music captures the varying moods and rhythms of the landscape, the individual selections refer to a spectrum of metaphorical spaces ranging from the sacred to the subjective. On every

level, then, *Fata Morgana* creates a jumble of associations. Herzog and others discuss it in terms of inner landscapes. But even a stable internal landscape breaks down in this film.

The ambiguity and multivalence of Herzog's landscapes vividly summon the historical nexus of documentary and the avant-garde. As Bill Nichols reminds us, avant-garde filmmakers of the 1920s and 1930s asked questions of perception and consciousness, of ethics and aesthetics, of behavior and desire. In so doing, the avant-garde "contributed something quite vital to the appearance of documentary film; it imaginatively reconstructed the look of the world with images, or shots, taken of this world."[18] Herzog not only recalls this connection but reactivates it in a new context. Historical commentators took notice. Amos Vogel, a key proponent of the American avant-garde and a mentor for Herzog during this time, marveled at the landscapes of *Fata Morgana* for being made "solely with the materials of reality."[19] To realize that Herzog's landscapes correspond to an artistic tradition—in this case, the American avant-garde—does not in any way lessen their magic. On the contrary, it opens up Herzog's imaginative transformation of inherited forms and visions.

Parody

Nowhere is this dynamic more intense and constitutive than in *La Soufrière*. With its spectacular footage of an explosive volcano on the French Caribbean island of Guadeloupe, the film is usually discussed in terms of the Sublime, a philosophical concept that has also become a privileged category of the Herzog scholarship. For Brigitte Peucker, "the cloudlike billows of smoke, emerging from the crater and misting over the abyss, stand as perhaps the central Herzog image of sublimity enshrouded."[20] The film itself, however, abruptly terminates after less than thirty minutes, when the volcano fails to explode, resulting in the filmmaker's admittedly "pathetic" show of embarrassment. Landscape in this film provides more than just an iconography of the Sublime or a theater for its associated ideas, forces, and emotions. It becomes a way of staging—and upstaging—what was then the dominant practice of documentary filmmaking, namely, cinema verité.

Herzog sometimes uses cinema verité as a cover term for documentary very generally, but in this film, he specifically targets the work of Robert Drew and Drew Associates, a group of journalists and filmmakers including, most notably, Richard Leacock, Albert Maysles, and D. A. Pennebaker. With support from Time Inc., they developed a model of observational filmmaking closely associated with photojournalism.[21] The Drew films defined American-style cinema verité in an early and crucial phase of its development. They also transformed documentary itself, creating a new set of norms, practices, and expectations as well as new points of resistance.

Although the Drew films engage various subjects, they characteristically move toward a dramatic moment of crisis. "The basic organizing principle behind a Drew film," according to Stephen Mamber, "can usually be stated in the form of a success-or-failure question. Will John Kennedy win the election, or will Hubert Humphrey? . . . Will Paul Crump be saved from the electric chair? Will the Kennedys' integration strategy work?"[22] It is a question that underlies all dramatic and narrative structure and is not particular to documentary. But that is precisely Mamber's point: that the Drew films, like other forms of drama and storytelling, revolve around conflict and work to resolve it. As Drew himself described the project, "it would be a theater without actors; it would be plays without playwrights; it would be reporting without summary and opinion; it would be the ability to look in on people's lives at crucial times from which you could deduce certain things, and see a kind of truth, that can only be gotten from personal experience."[23] To see how people react in real-life situations of intense physical pressure—that's the distinguishing promise of the Drew films. At issue here is the origin of the crisis moment, whether it is imposed or simply captured by the filmmakers. In practice, then, to avoid the impression of staging or influencing the events filmed, "situations are selected where a crisis is inevitable, even if the precise outcome cannot be foreseen."[24]

Herzog made a similar choice when he set out for Guadeloupe. What better place to test this structure than on the crater of an explosive volcano? *La Soufrière* starts with the portentous sound of rumbling and the image of smoke rising from the open fissures of a mountain. The title is superimposed onto the fuming landscape, and then the subtitle,

"Waiting for an Inevitable Catastrophe."[25] Thus the volcano is framed and represented as a crisis event par excellence. Yet another subtitle, "A Report by Werner Herzog," suggests the context of eyewitness journalism and indicates that this is an authored film. Herzog speaks his own commentary. He begins by sketching a scene of overwhelming instability: "In parts of the world, the earth began to shake everywhere—in northern Italy, in the Philippines, worst of all in China and in Central America." Against this backdrop, he explains, La Soufrière, too, showed signs of unrest in summer 1976:

> Things began to take a dramatic turn towards the end of August. What was expected was no ordinary eruption but an explosion of the whole volcano, with a force of at least five or six atomic bombs. Thus seventy-five thousand inhabitants were evacuated from the surrounding volcano, the whole southern part of the island. I was immediately fascinated when I read in the newspaper that one single poor peasant living on the very slopes of the volcano had refused to be evacuated. The very same day I set out, together with my two cameramen, Jörg Schmidt-Reitwein and Ed Lachman.

The sheer audacity of this endeavor gives *La Soufrière* its unique status within the Herzog material. It sealed the myth of the filmmaker as risk taker. But the decisive point here comes from close analysis: spoken in a tense and hushed voice, the commentary immediately establishes the success-or-failure question and thus provides the film's governing logic of organization. In this case, many questions arise. Will the volcano explode or not? Why did this person refuse to leave? Will he live or die as a result? What will the filmmakers find, and how will they respond? Some of these questions are more urgent than others. Because the film was first broadcast almost one year later on West German television, some viewers—those who, like Herzog, had followed the news story— knew that the volcano would not in fact explode.[26] For them, perhaps, the sense of crisis would be all the more conspicuous as both a dramatic structure and a narrative strategy.

Working against the obvious, then, Herzog's voice-over develops and intensifies the anticipated crisis by dramatizing space, adding discursive

"Waiting for an Inevitable Catastrophe," *La Soufrière* (1977).

pressure to a situation that is already visibly and audibly unstable. The commentary is pressing for another reason too: because Herzog simultaneously uses it to separate his work from that of cinema verité. Along with movie music, formal interviews, and other signs of overt staginess, the American proponents of cinema verité rejected voice-over commentary in favor of direct sound, the acoustic corollary to mere observation. Herzog's voice-over thus involves a double gesture, which is both opposed to verité and complicit with it. "Then," he says, pausing for effect, "the situation became very tense during the night. There was a seismic crisis marked by fourteen-hundred tremors and shock waves within ten hours. The mountain seemed about to explode, and the last of the scientists fled in a boat. It was said that the catastrophe was inevitable within the next few hours." As this passage makes clear, the narration not only develops the crisis structure but also multiplies the moment of crisis to create many successive events. The effect is plural and sometimes contradictory. Take the next passage, for example: "The sea was full of dead snakes. They had crawled down during the night

by the thousands from the mountain jungles and into the sea, where they promptly drowned." The commentary describes one landscape, but the image shows us another: the empty waters of the harbor at Basse-Terre, sans snakes. Rather than simply comment on the unreliability of visible evidence, the discrepancy of voice and image calls attention to the dramatic effects of the crisis structure, how it creates expectations which may or may not be fulfilled but on which the entire film relies for its success—or failure.

The dramatic effects of voice and image are particularly interesting in the absence of people to observe. Consider the film's treatment of Basse-Terre, a town of forty-five thousand inhabitants located at the base of the volcano. With the entire population having been evacuated, the empty spaces provide a physical setting for evoking the emotional experience of those who fled in haste. Visual and acoustic signs of former presence—a blinking traffic light, shutters banging in the wind, the footsteps of the filmmakers echoing through "eerie" silence—capture and convey a sense of fear, dread, even panic around the moment of mass departure. The found objects function as traces of former presence. And yet the search for traces produces both a space and a movement all its own. Here, as in *Fata Morgana,* the camera goes exploring, and it does so in all directions, tracking, tilting, panning, and moving straight ahead. In one passage, the camera is mounted on the front of an unseen car, driving unimpeded through deserted city streets. This is Herzog's version of the "phantom ride," what Tom Gunning has elsewhere described as "early cinema's most powerful landscape form."[27] Aerials further develop this form, extending it up into the sky. "We flew over Basse-Terre by helicopter," says Herzog. "During the flight, we got the impression that these were the last hours of this town and the last pictures ever taken of it." The phantom rides and aerials create a ghostly place of presence and absence, of life and death. But it is Herzog's spoken commentary that gives the landscape its theatrical character as the scene of an anticipated crisis.

Editing, too, plays a role. At one point, the film cuts to another time and place—to the island of Martinique, where Mont Pelée erupted in 1902, in what is generally considered the worst volcanic disaster of the twentieth century. The residents of Saint-Pierre mostly ignored the warnings of catastrophe: more than thirty thousand people died. Cutting

from one volcano to another becomes a strategy of editing for conflict. It contributes to the expectation of disaster in several ways: by referring to historical precedent, by providing views of incinerated landscapes, and by drawing parallels to La Soufrière. Filming in a local history museum, the camera shows a selection of archival images and artifacts. Recoded as cinematic signifiers, they not only bear witness to past catastrophe but also become subjunctive images of anticipation, of what could possibly happen on Guadeloupe. As the camera lingers on one particularly surreal landscape, Herzog remarks, "It is an actual photo, not a painting." The comment obviously puts emphasis on the indexical relationship of image and reality, which the film, too, presupposes. In effect, however, it suggests "not the immediacy of 'reality,' but rather the distancing of art, the sense that the apocalyptic event can only be alluded to, legendized or figured as doomsday through the diffusion and mediation of images."[28] What begins as a further development of the crisis structure, editing for conflict, transforms into a conflict of styles, with Herzog deploying one documentary trope (recycling archival images) against another (filming what happens).

Back on the slopes of La Soufrière, Herzog and his team have finally located the man who had refused to be evacuated. Their encounter is interesting for several reasons but especially because it shows how crisis and character relate to each other in cinema verité. Throughout the Drew films, Mamber observes, crisis is defined by a person's reaction to it and vice versa. "In each of the stories," according to Drew, "there is a time when a man comes against moments of tension, and pressure, and revelation, and decision. It's these moments that interest us most."[29] And this interest obviously has implications for the filmmaker's choice of subject. "The ideal Drew subject," as Mamber describes it, is "active," "positive," and self-assertive—an American-style hero indeed.[30] By contrast, Herzog chooses a situation in which almost everyone has already acted decisively and literally fled the scene. What reactions will there even be to witness and record? When Herzog and his team locate their man, he is asleep under a tree. "He had to be woken up first." They also encounter two other men whose behaviors and attitudes are similar. Rather than evacuate, they each decide to remain and do nothing out of the ordinary. "You know it's really very dangerous around here," Herzog

"It is an actual photo, not a painting." A found image from *La Soufrière* (1977).

says to the first man, after waking him from his sleep. "You're sitting on a powder keg!" "Sure we are," he replies, "but so are all of us. It's God's will. Why should I leave? I would only have to come back. Where should I go?" Spoken as part of the voice-over, Herzog's translation creates the sense that these are last words, the verbal equivalent to the aerial views coded as "last images." Curiously, as he speaks, the man becomes more and more animated on the subject of "waiting for death" and finally demonstrates his approach: "You see, this is how I am waiting." He lies down in the grass, closes his eyes, puts his arms by his sides, and turns the palms of his hands upward, preparing himself as though he were a living corpse and staging himself before the camera. Thus the subject of Herzog's documentary literally acts out the film's subtitle, "Waiting for an Inevitable Catastrophe." Here, as in the Drew films, the crisis and the subject define each other in circular fashion. And yet it would be difficult to find a subject more different from that of "the Drew hero." The same can be said of the filmmakers themselves. While Drew Associates would absent themselves from the film (what Leacock calls "the pretense

of our not being there"), Herzog and his team can be seen and heard conducting interviews, and again near the crater, where they flee from a cloud of "toxic gas."[31] Because they are embodied—and Herzog's vocal presence plays into this dynamic—we witness the filmmakers' reactions to the situation, ranging from excitement and apparent recklessness to embarrassment and admitted failure.

And then the film ends, abruptly. Herzog's final voice-over refers as much to the crisis structure as it does to the image of the mountain: "The volcano did not explode. Days came and went. The signs of a catastrophe began to diminish. . . . It will always remain a mystery why there was no eruption. Never before in the history of volcanology were signals of such magnitude measured and yet nothing happened." Here, as in the Drew films, "the moment of crisis is not only the goal of shooting. It also marks the story's conclusion."[32] As soon as that moment either passes or dissipates, there is nothing left to film. *La Soufrière* thus ends, as it begins, true to form. Not surprisingly, though, Herzog gives himself the last word. "There was something pathetic for us in the shooting of this picture. And therefore it ended a little bit embarrassing [*sic*]." Reversing the film's subtitle, he adds, "Now it has become a report on an inevitable catastrophe that did not take place." The image of the volcano, still belching ash and smoke, is accompanied by the tragic chords of the funeral march from Wagner's *Götterdämmerung*.

Herzog's film works toward this anticlimax, and it does so deliberately, for an effect. In the Drew films, as in drama and storytelling, "the primary justification for the crisis structure is that it provides a vehicle to discover a kind of truth about people."[33] Under intense pressure, inner character should reveal itself to the observational camera. "But by choosing to follow them in crisis," Mamber explains, "the filmmakers judge them according to their level of achievement, a complicity with the very forces that expose these people to failure."[34] Herzog joins in this complicity, but for another reason entirely. Here, too, we are confronted with a truth of failure, only in this case it refers not to the inner character of the subject but rather to the method of filmmaking, what he calls cinema verité. The alignment of the volcano and the crisis structure extend all the way to their failure.

Herzog's documentary short represents a full-blown parody of American-style cinema verité.[35] And that is the function of landscape here.

The volcano provides a visual form both for mimicking an essential characteristic of the Drew films and for staging their catastrophic failure. In interviews, Herzog often ridicules cinema verité, expressing his "wish to be one of its grave diggers."[36] *La Soufrière* enacts this very scenario in grand style. The ethos of criticism shifts from ridicule to mock embarrassment, but it remains a funeral act. Ultimately, however, the function of landscape in this film tells us something new about Herzog's relationship to documentary. A key form of intertextuality, parody relies for its existence on the target of its critique. No matter how vigorously Herzog opposes his work to that of cinema verité, their competing stances actually implicate one another. They even have certain affinities, which have yet to be acknowledged, much less explored.[37] Not only their differences but also their similarities explain both the intensity of Herzog's resistance to cinema verité and the acumen of his parody.

Testimony

Here is an apocryphal vision: "The collapse of the stellar universe will occur—like creation—in grandiose splendor." This is the epigraph to *Lessons of Darkness*, and on-screen, it is attributed to Blaise Pascal, the seventeenth-century physicist, mathematician, and religious philosopher. Tellingly, Pascal never wrote it (Herzog did); the attribution is false, which makes it all the more suggestive. And what it suggests, quite apart from Herzog's willingness to mislead his audience for an effect, is nothing less than a postapocalyptic landscape of utter devastation. The images that we see, however, depict the burning oil fields in Kuwait, filmed just a few months after the Persian Gulf War had ended. Throughout this fifty-minute documentary, the literal and the metaphorical collide to great effect and some controversy.

Its production history is important. Like millions of other television viewers around the world, Herzog literally watched the war through an almost constant stream of cable news updates. As media outlets cooperated with military censorship, the war's continuous presence on television resulted, paradoxically, in very few images of battle and almost no images of human suffering.[38] In this context, the extreme separation of fighting and viewing not only exacerbated but also reproduced along visual lines an experiential and emotional gap between the targeted people and the

public audience—a gap that enabled the latter to watch the war without confronting any of its disastrous consequences. As historian Marita Sturken explains, "most of what the American audience saw were maps, still photographs of reporters, and live images of reporters in Israel. CNN's round-the-clock television coverage of the war offered only the illusion that viewers could see everything. The few images that were produced did not accumulate in cultural memory but rushed past in a succession of replays."[39] Recalling his own experience of the television coverage, Herzog makes an almost identical claim about the numbing effects of media saturation on collective memory, only to describe it as a motivation for his response: "I knew I was watching something momentous that had to be recorded for the memory of mankind."[40] When a German television station (Premiere) asked if he would make a film about the Texan oil well firefighter Red Adair, Herzog passed on the subject but declared his interest in making a different type of film in Kuwait, which the station then accepted.[41] Still burning, yet already in the process of being extinguished, the fires gave urgency to this project. To avoid bureaucratic delay, Herzog and a television producer sought a partner who already had a shooting permit, and they found one in British filmmaker and cinematographer Paul Berriff. Known for his action documentaries of air and sea rescues, Berriff, too, was preparing to make a film about the heroic work of the firefighters in Kuwait, and he had already assembled a crew, including an airborne team he considered to be "the best in the business." He met with Herzog and agreed to collaborate. "The crew arrived in north Kuwait in October 1991 (a month before the last oil-well fire was put out) and the entire film was shot in just under a week."[42]

The resulting film can best be seen as an apocryphal documentary. This is not to say that it is either fake or fictitious, although the term does capture the "invented" quality of certain elements (such as the epigraph). Rather, the term is apt and worth using because it highlights the film's specific combination of extremes, namely, mythical frameworks and historical events, apocalyptic visions and documentary images. Its title, *Lessons of Darkness*, suggests an imparted knowledge of humanity's dark side and even of death itself.[43] However vague the title may be, the film itself harkens back to premodern traditions of apocryphal visions and shares with them specific patterns and iconographies. Even

before he began filming, the televised images of the more than six hundred burning oil fields had evoked for Herzog a "vision of hell."[44] This apocalyptic vision both informs and shapes the film, its eschatological focus, and its landscape views in particular.

Lessons of Darkness represents an otherworldly journey, a mythological pattern that derives from a form of apocryphal literature known as "cosmic tours" or "tours of hell." As the names suggest, the tours deal primarily with the sights that one sees in the course of a journey through the cosmos, though some take place within narratives of events on earth.[45] *Lessons of Darkness* invokes this tradition and transforms it cinematically. One section, titled "Pilgrimage," recalls the most familiar development of this tradition in Dante's *Inferno* and the narrator's otherworldly journey. Only here we see firefighters and earthmovers working against massive fields of fire, much of it shown in slow motion.[46] An eyewitness report from hell and beyond, *Lessons of Darkness* unavoidably culminates in a vision of everlasting fire.

The film's trajectory as a cosmic tour implies a metaphorical transposition: an image of somewhere made at a certain moment doubles as an image of somewhere else at another time. This movement from one frame of reference to another is first established by the voice-over. In this case, Herzog's vocal presence is minimal, disconnected, and singularly grave in tone. He speaks with an emotional remoteness that counters some of the landscape's expressive elements, as if they were too much to bear. The opening words are exemplary: "A planet in our solar system. White mountain ranges, clouds, the land shrouded in mist." In the first section proper, adopting the visionary role, Herzog speaks of "a city that will soon be laid waste by war. . . . Nobody has yet begun to suspect the impending doom." Clearly the event has already taken place, as the viewer well knows. The following section is titled simply "The War." In it, Herzog recycles less than a minute of footage from CNN, the famous "night-scope" images of the air attack on Baghdad. Tinted green and highly pixelated, they depict what Susan Sontag, writing of the television coverage, describes as "the sky above the dying, filled with light-traces of missiles and shells."[47] In this very moment, however, Herzog uses the voice-over to open up a longer view, shifting the emphasis away from the topic of war and toward that of its legacy: "The war lasted only a few

hours. Afterwards, everything was different." Herzog thus quickly and powerfully establishes the film's key coordinates: its planetary framework, its narrative form of a journey, its temporality of apocalypse, and its visual focus on landscape. The contrast to *La Soufrière* is striking. Unlike that film, "which tries to document a natural catastrophe," according to Herzog, "*Lessons of Darkness* is a requiem for a planet that we ourselves have destroyed."[48] Intertextuality in this film works to put landscape in the service of memory.

As the requiem metaphor would seem to suggest, music and sound play an integral role in *Lessons of Darkness,* acoustically shaping the landscape. In his detailed analysis of the film's score—musical examples from Grieg, Mahler, Pärt, Prokofiev, Schubert, Verdi, and Wagner—Roger Hillman identifies the narrative disparity between the music and the apocalyptic imagery. What unites the musical examples, however, and what governs their relation to the landscape is their theatrical setting and function, taken as they are from the opera, the church, and the stage.[49] Transported to Herzog's film, the music dramatizes the landscape as a spectacle in its own right. That the music runs almost constantly throughout the film suggests another point of comparison to opera. In places, it gives way to ambient sound, which is equally significant and significantly louder than the music. As Herzog says in interviews, "the real event is the sound," referring to that of the fires, geysers, and explosions, all recorded on location and processed with Dolby stereo technology. "And if you don't have this huge volume Dolby stereo really shaking you in your seat, you haven't seen the film."[50] Here is another way in which landscape "moves" the film audience. Neither still nor silent, it powerfully reverberates.

But the images dominate in *Lessons of Darkness,* the otherworldly spectacle that unfolds on-screen. By means of spectacle, Herzog's film draws on the history of hell imaging, taps into its visual power, and trades on its cultural authority. Throughout art history, scholars have noted, the landscape of hell is characteristically barren, jagged, blackened, filled with battlements, and overhung with smoke. Its central motif is fire and agonizing heat. With remarkable continuity, depictions of hell envision it as an inhospitable place of endless fiery punishment.[51] This is the landscape Herzog evokes in the context of documentary. For Jim

An apocalyptic vision, *Lessons of Darkness* (1992).

Hoberman, "the tortured vistas of *Lessons of Darkness* recall the surrealist Max Ernst's celebrated doomsday canvas *Europe After the Rain*," from 1942.[52] For Scott MacDonald, they summon the entire history of hell imaging—"most especially perhaps, Pieter Brueghel's *The Triumph of Death* (1527)."[53] Herzog's landscapes not only invoke this tradition, they add to it in ways that are characteristic of the film medium. The movement of flames, the flow of geysers, the texture of the terrain, the gurgle of boiling oil, the cadence of pneumatic drills, hammers, and excavators—almost every scene in this film draws attention to the visual and acoustic rhythms of the landscape by means of sound, editing, composition, and camera movement. Hence the repeated (and for Herzog highly unusual) superimposing of one landscape over the next, a move that attempts to synthesize the rhythms of the world with those of the film itself.[54]

Here, as in much of Herzog's work, the rhythms of the world and of the cinema are mediated above all by aerial views. *Lessons of Darkness* consists largely of aerials filmed as traveling shots, many of them in long takes, which slowly enter into and pass through sites of mass ruination. Instead of filming from an extremely high vantage point, which would have reduced the terrain to a planar image of bomb patterns, the airborne vision of this film is low, oblique, and mobile. It may even be directed,

but Herzog's role in this regard needs comment. "I was never actually in the helicopter," he explains; "the footage was shot two days before I arrived in the country. The cameraman, an expert in aerial photography, knew what I wanted: as many unbroken travelling shots of the landscape as possible. But I would not have been able to plan every single one of the shots even if I had been up there," he adds. When "flying into a burning oil field the pilot has to make his own choices for safety reasons."[55] Not only the movement of flames but also the shifting air currents above and around the fires are among the rhythms of this film, affecting as they do the pattern of flight that determines much of the camera movement. The extraordinary experience of motion here involves the viewers physically and emotionally, moving them in a way that news coverage of the war and its aftermath had effectively prohibited.[56] This heightened sense of involvement persists even as the landscape view refers back to the camera and to the vehicle of actual transport. In one scene, part of an early section called "After the Battle," the helicopter's shadow is made to pass over the landscape, a flattened oil tower. The enormous scale of this ruin only becomes clear by comparison with the shadow. Seeing a trace of the helicopter in effect orients the audience to the camera and, by extension, to the airborne crew as well as to the means of making (and destroying) the landscape. Aerial imagery thus becomes a form of reconnaissance, to be seen and witnessed by a public audience after the war has ended.[57]

The most obvious forms of testimony appear in the scenes that interrupt and thereby frame the film's landscape views. A section titled "Objects Found in Torture Chambers" opens with a macabre display of torture instruments. Arranged on tables for public display, many of the objects are visibly stained, burned, and warped. Every stain, burn, and mark metonymically attests to the missing bodies—tormenter and tormented—that imprinted themselves on the objects. The mutilated objects not only provoke visceral reaction but also invite the spectator either to imagine the absent people and the original scene or to hold off such horrifying thoughts. Moving around a room with the handheld camera, his footsteps echoing on the sound track, the cameraman very briefly shows that atrocity photographs (including at least one image of a tortured human body) are mounted on a chalkboard. Rather than

Aerial view, *Lessons of Darkness* (1992).

linger on these pictures, the film camera discreetly acknowledges their existence and returns to the found objects. Themes of witness and physical torment continue in the following scene: an interview with an Arab woman who was kidnapped by soldiers and forced to watch as her two sons were tortured to death. As a result of this experience, she lost her ability to speak, and yet "she still tried to tell us what had happened." In a later section of the film, titled "Childhood," a mother holding her young son recalls how a soldier stepped on the boy's head, turned, and then shot and killed the boy's father. "Look at this little fellow," she says, "he hasn't spoken a word since." Each of these passages reminds us that testimony involves not just seeing but also saying. And yet the articulation of traumatic experience is fraught; it defies representation. Under these conditions, silence and speechlessness become articulate forms in their own right. More interviews were planned but unrealized, in effect putting even more pressure on the film's use of landscape to bear mute witness of its own.[58]

The testimony of landscape, though less obvious than that of the interviews, surfaces throughout the film, principally in the form of ruins. Lumps of wreckage, bunkers reduced to rubble, oil fields on fire—the landscapes in this film operate much as the "objects found in torture chambers," evoking sharp emotions and conjuring absent bodies, while

appealing to the memory and to the imagination of the film viewer. As the aerial camera glides above marks made in the desert sand, Herzog comments, "We found only traces left." Clearly the filmmaker puts stock in documentary's character as witness, even though he refuses to leave it at that. Indeed, the primary function of landscape here is to foreground the search for material traces as a process of witnessing that is fraught but nonetheless important. The most interesting example comes from a section of the film called "Satan's National Park." An extended aerial passage shows a blackened shimmering landscape, while Herzog speaks the commentary: "This was once a forest. Now it is covered with oil. Everything that looks like water is in actuality oil. Ponds and lakes have spread out across the land. The oil is treacherous *(tückisch)* because it reflects the sky. The oil is trying to disguise itself as water. This lake too, like everything else, is black oil." Other commentators single out this sequence for its visual potency, for its latent critique of war, and for its environmental consciousness.[59] What most interests me, however, is the role of demonstrative explanation, how it attributes agency to the depicted surfaces (describing what they do), so that the reflexive verb "to disguise itself" becomes another way of asserting the subjectivity (even the sentience) of landscape. In this example, landscape not only testifies to that which happened but also obfuscates it and thereby complicates the situation of the film viewer, who is absent from the events in time and place but still has access to them via recording. Only the imagination allows us to witness what has happened to others in another time and place. Through landscape, then, Herzog's film appeals to the imagination as a counterforce to the sense of witness that cable news broadcasting had promised but failed to provide.

Lessons of Darkness was received enthusiastically in Britain and North America, but the film provoked sharp reactions in Germany. At the 1992 Berlin Film Festival, critics condemned the film for what it either fails or refuses to do, namely, to identify Kuwait, to declare its political stance, and to assign responsibility for the war and for its environmental aftermath. "The criticisms demand a different work entirely to that produced by Herzog," according to Keith Beattie, "and if taken to their extreme would lead to the banning or censored exclusion of a work such as *Lessons of Darkness*."[60] In terms of documentary, as Brian

"The oil is trying to disguise itself as water," *Lessons of Darkness* (1992).

Winston put it, critics reproached the film "for so departing from direct cinema's 'reality' norms."[61] The filmmaker himself came under attack. In response, Herzog only fanned the flames of controversy: "They accused me of 'aestheticizing' the horror and hated the film so much that when I walked down the aisle of the cinema I was spat at. They said the film was dangerously authoritarian, so I decided to be authoritarian at my very best. I stood before them and said, 'Mr. Dante did the same in his *Inferno* and Mr. Goya did it in his paintings, and Brueghel and Bosch, too.' You should have heard the uproar."[62]

The key terms of this controversy—art and authenticity—are also the terms of documentary film and obviously predate it. The history of other forms such as photography is therefore instructive. In *Regarding the Pain of Others,* Susan Sontag addresses the issue in a passage worth quoting at length:

Transforming is what art does, but photography that bears witness to the calamitous and the reprehensible is much criticized if it seems "aesthetic"; that is, too much like art. The dual powers of photography—to generate documents and to create works of visual art—have produced some remarkable exaggerations about what photographers ought and ought not to do. Lately, the most common exaggeration is

one that regards these powers as opposites. Photographs that depict suffering shouldn't be beautiful. . . . In this view, a beautiful photograph drains attention from the sobering subject and turns it toward the medium itself, thereby compromising the picture's status as a document. The photograph gives mixed signals. Stop this, it urges. But it also exclaims, What a spectacle![63]

A similar "exaggeration" frames the controversy over Herzog's film in Germany, where it resonated with historical debates about the relationship of aesthetics and politics and about the legacy of Nazism in particular. It seems to me, however, that *Lessons of Darkness* demands ethical response even as its infernal images activate the power of spectacle. An apocryphal documentary, it reports on the grisly details of hell and apocalypse for the sake of those who are still alive. Here, once again, is Sontag: "photographer–witnesses may think it more correct morally to make the spectacular not spectacular. But the spectacular is very much part of the religious narratives by which suffering throughout most of Western history has been understood. To feel the pulse of Christian iconography in certain wartime or disaster-time photography is not a sentimental projection."[64] *Lessons of Darkness* invokes this iconography and adds to it, envisioning cinematically an everlasting fire of punishment without purgation. Elsewhere, Herzog does in fact gesture toward redemption and transcendence, but not in this film. To understand that dimension of his work, we need to look at different material, while noticing the function of landscape as it varies.

Allegory

Sacred landscape has become a central part of Herzog's work, one that he has explored almost exclusively in the documentary mode (the exception being *Where the Green Ants Dream*, 1984). His approach to this topic is as worldly as it is transcendent. Herzog travels around the globe, filming other people in various acts of religious devotion, often at well-known sites of pilgrimage, from Mount Kailash in Tibet to the Guadalupe shrine in Mexico. What all these places have in common is the belief that each represents a juncture of the material and the immaterial, the exterior

and the interior, the visible and the invisible. In exploring this juncture, Herzog's documentaries both follow on and depart from more traditional means of evoking the sacred in art, literature, and architecture.

A sacred landscape is a paradox: a place defined by its transcendence. In his fascinating study of Tibet in Western travel writing, Peter Bishop explores the Western creation of sacred landscape as a form of "imaginary geography." Drawing on the work of Mircea Eliade and Victor Turner, among others, Bishop observes that "sacred space has been defined in terms of its separation from the profane world, by the limited access accorded to it, by a sense of dread or fascination, by intimations of order and power combined with ambiguity and paradox. Sacred places also seem to be located at the periphery of the social world."[65] At the same time, however, they are historical destinations for travel and meaningful centers of social activity. According to Bishop, Western travelers did not "discover" Tibet; they created it (visually, discursively, and socially) in the form of sacred landscape. In developing this argument, he distinguishes between sacred places and utopias as two different kinds of imaginary constructs. Utopias, by definition, lie outside of time and space (e.g., they are designed to accommodate future dwelling, not regular visits by actual pilgrims), whereas sacred landscapes are grounded in geographical place and situated in time. Moreover, utopias serve to resolve contradictions, instead of emphasizing their mysterious incommensurability, as sacred spaces tend to do.[66] In this sense, Herzog explores sacred landscapes and how other people engage them. Traveling around the world, he films actual places and lived spaces that are treated by others as sacred.

The supreme example is *Wheel of Time,* a feature-length documentary revolving around the notion of sacred landscape. Its occasion was the making of the Kalachakra sand mandala, also known as the wheel (or cycle) of time, which is traditionally assembled over a period of two weeks, viewed by masses of pilgrims, and then destroyed. In early 2002, the ceremony began in Bodhgaya, India, only to be suspended on account of the Dalai Lama's deteriorating health. It was performed again later that year in Graz, Austria, home to the largest Buddhist community in Europe. Herzog is again present, and this time he conducts a brief interview with the Dalai Lama, who describes his wish for a politically

and environmentally harmonious world. Referring to the sand mandala—an idealized topography, whose concentric squares mark ever more interior and thus sacred spaces—Herzog asks, "Do we have to understand it as a blueprint for a three-dimensional structure, as if it was not just a flat surface?" The Dalai Lama agrees and elaborates in his own words, but it is Herzog's leading question that provides an interpretive key to the film. The two ceremonies in turn frame a third event: a ritual pilgrimage around Mount Kailash in Tibet.

Wheel of Time actually mimics the special relationship between the venerated mountain and the sand mandala. As Herzog has noted elsewhere,

> the focal point of the Kalachakra Initiation is a highly symbolic and complicated sand mandala which is laid out around the symbol of Mount Kailash, the center of the world. The mountain itself is not only a very impressive pyramid of black rock with a cap of ice and snow on its top, it immediately strikes the voyager as something much deeper—an inner landscape, an apparition of something existing only in the soul of man.

Thus the sand mandala "should be visualized as a pyramid with its tip resting on the summit" of Kailash, extending the idea of the mountain as axis mundi, a physical connection between heaven and earth.[67] While the mandala serves during the initiation as a picture of consciousness, the "inner landscape" is all that remains after the painting has been dismantled, its sand scattered in the wind. Wheel of Time explores this ancient idea and gives it a new twist, flaunting both the assertive stance of documentary and the spatial, kinetic, evanescent qualities of the cinematic image. Structurally, the entire film is organized around the ritualistic creation and destruction of landscape pictures, with fleeting images of Mount Kailash at the film's symbolic center. Iconographically, the mountain provides a potent visual metaphor for Herzog's project. Here is an exterior landscape that already inspires and models an interior one. Like the mountain, Wheel of Time situates the mandala in the physical world. By this process, spirituality becomes equated with visual imagery and landscape becomes a diagram; the abstract idea of the

Telephoto shot of Mount Kailash, *Wheel of Time* (2003).

soul in turn becomes concrete, physically extended in time and space.

By treating the mountain in this way, *Wheel of Time* partakes in the Western fascination with Tibet as a "visual display," which is according to Bishop what distinguishes this area from other, predominately textual constructions of "the Orient." Tracing this idea through a range of media (painting, drawing, cartography, travel writing), Bishop shows that landscape images gave Tibet its imaginary coherence throughout the nineteenth and early twentieth centuries, until China's invasion and the resulting exile of the Dalai Lama. Since then, it is no longer landscape that organizes Western fantasies of Tibet but rather its esoteric religion.[68] This history of travel images also informs *Wheel of Time*.

And yet the film not only exemplifies but also complicates the trajectory from landscape to religion. On one hand, the framing sections concentrate on the physical practice of Buddhism outside Tibet, in keeping with Bishop's account. The Austrian section is particularly interesting (this being only the eighth time in history that the Kalachakra ceremonies have taken place in a Western city) because it gives voice to the political agenda of Tibetan exiles and their efforts to exert pressure on China through outside channels (which is probably the reason why the Dalai Lama's office invited Herzog to film this event in the first place). On the other hand, *Wheel of Time* is emphatically not a documentary

about either Buddhism or politics. Instead, the film recalls and continues the earlier tradition of apprehending Tibet as a sacred landscape. The historical shift from landscape to religion is momentarily reversed.

If the ceremonies provide the occasion, the landscape (literally) provides the ground for Herzog's project. In an interview he says of Mount Kailash: "This, we have to believe, is not just a sacred, symbolic cosmography like the mandala, but it has to do with a landscape that is felt to be sacred for the Buddhists and the Hindus and others, as well." The assumption that Herzog urges us to make ("we have to believe") could also be used to describe the film's treatment of landscape as a moving image of consciousness. Asked about his motivation for making the film, he replies, "It was a deep curiosity to show a *truly* sacred landscape. This was one of the reasons why I wanted to shoot Mount Kailash by myself. I was my own cinematographer for these sequences."[69] Emphasizing his control of the camera implies an especially close—indeed, physical—connection between the sacred landscape and the cinematic image. It reduces the imagined distance between the viewer and the site of pilgrimage as mediated by the body of the filmmaker himself.

The use of multiple lenses and perspectives further highlights different aspects of Mount Kailash, while telling us more about landscape's function in this particular film. In some passages, the mountain appears in isolation as a monolithic peak; in others, it is shown as part of a larger panoramic grouping. Sensuous images of Lake Manasarowar, a sacred landscape in its own right and the mountain's legendary "female consort," are rhythmically interspersed with views of Mount Kailash. Herzog elsewhere describes the scene as a "solemn theater of ecstasy."[70] The result is a cinematic ensemble, in which elements of different landscapes are silently dramatized and seem to interact with one another. The intensity of their interaction is enhanced by images of pilgrims circumambulating the mountain, especially those traveling on hands and knees. We witness their excruciatingly slow, deliberate, repetitive movement and the toll it takes on their bodies over time. Like the interaction of different landscape elements, the pilgrims' rhythmic movement renders visible the idea of symbolic action; it conveys the action of spiritual belief. But the image is evanescent. The film returns in its final passage from Austria to Tibet. Through a single, long take, we see the reflected sunlight as it flickers

and pixelates on the surface of Lake Manasarowar. Here is a mirage that points from the natural world toward the supernatural.

Wheel of Time thus returns us to the visionary landscapes of *Fata Morgana*. Each film uses many of the same techniques of stylization, to be sure, and what matters in each is the possibility of seeing what is not literally there. But the function of landscape varies. Instead of inducing a trance, instead of refusing significance, as in *Fata Morgana,* landscape here gives form to religious feelings and thereby opens up a world of meaning. Even as it depicts the natural world, landscape in *Wheel of Time* refers to objects that are both abstract (the soul) and supernatural (the sacred) and attempts to render them visible. In so doing, the function of landscape becomes the equivalent of what we used to call "allegory."[71]

This is a problem in the context of documentary studies, where allegory has been lumped together with fiction and oversimplified as another word for invention, distortion, and falsification.[72] To complicate matters, Herzog himself uses some of these terms in positioning his work against a hackneyed notion of documentary cinema. What both sides of the argument obscure, unfortunately, is that many different (even competing) styles, meanings, and effects can operate at once—not just in Herzog's work but in documentaries across the board. In *Wheel of Time,* then, allegory functions alongside mimetic representation (or what film scholars call "realism") and observational discourse. Noticing this combination is different from saying that Herzog fictionalizes documentary. The interesting point is more subtle: his is an approach to documentary that allows for the possibility of making the invisible visible by showing and emphatically stylizing images of the world around us. With Herzog's landscapes, it is never easy to distinguish the abstract quality of the film from its exploration of the physical world. When, we may ask, does the image of the mountain become an abstract idea, and when does it refrain from abstraction and become an actual landscape? Herzog's documentaries not only maintain this ambivalence between the concrete and the abstract, between the natural and the supernatural, they make it a source of wonder.

3 ECSTATIC JOURNEYS

The dramatic use of landscape, the unlikely figures that traverse it, the peculiar ways in which they travel—these are among the most alluring, distinctive, and memorable features of Herzog's films. The previous chapters endeavored to flesh out the central role of the human body and its environment. Going a step further, this chapter investigates the intensely physical and spiritual relationship of the body to the landscape. Not only the landscape but also the body and its movement can function allegorically. *Wheel of Time,* for example, calls our attention to the physical ordeal of pilgrimage. Among the many pilgrims in Bodhgaya, the camera singles out a man named Lama Lhundup Woeser, who comes from "such a remote area that his dialect had to be translated via two separate interpreters." He traveled in prostrations more than three thousand kilometers to attend the Kalachakra initiation. Several close-ups show "nodes" that grew on the bones of his hands and an unhealed wound on his forehead from "touching the ground a couple of million times." The tactility of Herzog's documentaries (discussed in chapter 1) has an interesting corollary in the context of religion. In this context, as we shall see, the focus of visual interest is very often the body in motion, the effect of that motion on the body, and what it might tell us about the nature of spiritual belief and devotion.

The following discussion examines the interrelationship of spirituality and documentary in Herzog's body of work. The films to be discussed—*Huie's Sermon, Bells from the Deep,* and *Pilgrimage*—are not particularly well known, partly because they are documentaries, and as such, tend to be neglected, but also, I suspect, because of their subject matter. Individually, these films engage the persistence of popular religiosity in specific situations. Collectively, they represent a diversity of

Traveling in prostrations, *Wheel of Time* (2003).

religious forms—conventional and unconventional, Western and non-Western, mainstream and marginalized. Herzog's documentaries are sensitive to religious meanings, but they are not in themselves religious. They represent other people's beliefs with a mix of fascination, detachment, irreverence, and empathy. From this perspective, we find "a rupture" in the relationship of the documentaries to the fiction films.[1] Whereas the "visionary classics" such as *Aguirre, The Enigma of Kaspar Hauser,* and *Nosferatu* (1979) condemn institutionalized forms of Christianity, the documentaries show a marked interest in hybrid forms of Christianity and other religions from around the world.

Herzog's documentaries engage the contemporary situation that other commentators have characterized as "postsecular," "post-traditional," and "religio-secular."[2] They capture and reflect some of the same phenomena that define this instance of blurring, namely, the sense of spiritual resurgence, uncertainty, and exploration in contemporary life and society; the awareness of challenges to secular, rational constructions of reality; and the search for alternative, visionary epistemologies. In certain ways, Herzog's documentaries even contribute to this phenomenon: by producing images of kinetic presence and framing them in explicitly religious terms; by clearing a path for the ecstatic, the sacred, even the miraculous in the world that is projected on-screen; and last, but not least, by

questioning and redefining what counts for knowledge in documentary cinema. Herzog may be irreverent toward certain forms of spirituality, but he is even more skeptical of secular, rational frameworks of understanding. Indeed, this is precisely the reason why he denigrates documentary for propounding "the accountant's truth," its claims to factual accuracy and mere observation, in favor of stylization and imaginative forms of understanding or what he calls "the ecstatic truth."

Herzog's films are admittedly informed by his early conversion to Catholicism, but he also says in interviews that he no longer belongs to the church and that he is not religious.[3] Beyond that, he remains elusive about his own beliefs. Consequently, the social actors encountered in all these films are open to possibilities that the director himself hesitates to embrace. These are films of faith made by a skeptic, but one who is nonetheless interested. As Herzog has stated, referring to *Wheel of Time,* "I had a physical curiosity to depict spirituality, and it can be done on film."[4] His is an aesthetic project based on an obvious paradox: that of representing the unrepresentable. It is an ancient topos, one that Herzog explores through the modern medium of film. But there is more to this material than just the aesthetic treatment of spiritual themes. It is obviously an extension of his concern with interiority and with the visionary quality of images. There is also what he calls "a physical curiosity," a type of interest (even desire) that emanates from the body and involves it in the process of learning and knowing. It is this aspect of Herzog's documentaries that most interests me here.

The idea of "a physical curiosity" pulling Herzog to the topic of spirituality is directly connected to his enthusiasm for pilgrimage as a type of long-distance physical journey.[5] In an essay he wrote for *Pilgrims,* a 2004 collection of photographs by his wife Lena, which includes some of her work as still photographer for *Wheel of Time,* Herzog acknowledges the metaphorical quality of pilgrims, how they are widely seen as representing the very idea of life figured as a journey. "But, walking with them," he writes, "climbing a 19,000-foot high pass in a hailstorm, left alone with one's breath, aching chest and laden shoulders among all the others equally reduced to breathing and praying, makes one thing beyond the metaphor clear: this is life, life in its quintessential form—*pura vida.*"[6] Herzog makes a similar move in his documentaries on the topic: they, too,

retain the figurative quality of pilgrimage, while privileging its literal, physical, and interactive qualities in particular. Pilgrimage here refers to the performance of a routine set of practices (and not to a set of teachings). In this regard, as we shall see, it is closely related to a conception of religion as physical rather than scriptural. Throughout this material, pilgrimage serves as the principal structure for filming spirituality, providing at once a figure in motion, a ritualized form of movement, and a paradigmatic form of piety that is entirely bound up with the body.

Herzog's concern with pilgrimage needs to be seen within a larger history of travel on foot and especially within the revitalized pilgrimage movement of the late twentieth century.[7] In Germany, for example, foot pilgrimage witnessed a remarkable upsurge in interest during the 1970s, and the practice continues to thrive.[8] The example of Germany is only one small part of a growing popular worldwide phenomenon, which today involves more than 280 million people a year, the majority being Christians, Muslims, and Hindus. In Europe alone, about 30 million Christians, mostly Catholics, spend their holidays on pilgrimage every year, and total annual visitors at sites of religious pilgrimage regularly exceed 100 million.[9] Curiously, although church attendance has declined across Europe since the 1960s, the practice of pilgrimage is on the rise. This dramatic inversion may be one reason why Herzog explores the renewed sensibility to religion as he does, by way of pilgrimage.

Within this context, the filmmaker's enthusiasm for pilgrimage has an interesting and eventful history of its own. At the age of fourteen, after hitchhiking from Germany to Greece, he walked along the border of Albania, which was then behind the Iron Curtain. That same year, he converted to Catholicism and claims to have understood even then its basis in rituals such as pilgrimage.[10] If the verities of his youth have long since passed away, his pedestrian endeavors continue. On certain momentous occasions, he says, going on foot is not just appropriate, it's absolutely necessary. The paradigmatic instance is his six-week-long sojourn from Munich to Paris in winter 1974. The circumstances are well known: Lotte Eisner lay dying in Paris. The exiled art historian, whose symbolic authority conferred legitimacy on a new generation of German filmmakers, was Herzog's friend and mentor.[11] In the preface to his travel diaries, *Of Walking in Ice* (*Vom Gehen im Eis*, 1978), Herzog sets the scene:

"I said that this must not be, not at this time, German cinema could not do without her now, we would not permit her death. . . . I set off on the most direct route to Paris, in full faith, believing that she would stay alive if I came on foot."[12] The religious analogy, the imitation of Christ by means of pilgrimage, cannot be missed: Herzog himself would endure physical suffering so that Eisner might live. In another, less well known instance, he planned to walk the entire perimeter of West Germany, a "project" he undertook in 1982. At the time, he described it in terms of unification: "I have the feeling that Germany still consists only of borders *(Ränder),*" without a symbolic center or point of orientation, "and it is only the culture and the language which really hold us together; it seems to me that only the poets can save Germany over the long run."[13] Departing from his village of Sachrang in upper Bavaria, he followed the borders with Austria, Switzerland, France, Belgium, Luxembourg, and Holland, where he fell ill and ended his journey, having already walked more than two thousand kilometers.

Throughout his long career, Herzog has projected and maintained a public image of himself as a traveling director who characteristically goes on foot, no matter what the actual circumstances may be. Referring to *Fata Morgana,* he avers, "My time in the desert is part of a quest that has not yet ended for me, and even though we were in a car, the spirit of our journey was like one made on foot."[14] A promotional photograph for the film attempts to offer visual support for this claim. In interviews, he speaks of going on foot as a creative act analogous to filmmaking. He claims to envision entire films while walking, as if in a trance state.[15] On another level, as we have seen, Herzog also celebrates nomadic ways of life, which he imagines to be disappearing. Occasionally, he even assumes the role of seer and predicts the return of walking as a future article of faith.[16] In each regard, his notion of pilgrimage is clearly informed by (but not restricted to) the romantic topos of the *Fussreise* or travel on foot.[17] He also puts the idea of going on foot in the service of constructing cultural hierarchies, in keeping with the modern discourse on walking.[18] Hence point 7 of the Minnesota Declaration, which reads, "Tourism is sin, travel on foot virtue." In making this distinction, Herzog plays into a familiar dichotomy, whether or not he is aware of it.[19] The commonplace idea that pilgrimage can be understood in terms of tourism,

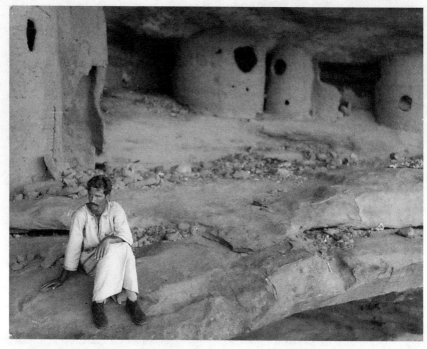

Herzog in the desert. Publicity photograph for *Fata Morgana* (1971).

and vice versa, never emerges; this is one distinction he never blurs.

While the Herzog lore is familiar ground, what needs more attention is how the filmmaker's pedestrian endeavors relate to his documentaries.[20] This chapter therefore begins with a brief look at *Huie's Sermon,* an observational documentary focusing on the body of the believer and on the intensity of movement generated by faith. The discussion of *Bells from the Deep* marks the core of this chapter. It shows how pilgrimage serves as the quintessential form of ecstatic journey for Herzog and how that journey is imagined in terms of body, vision, and movement. The chapter then closes with an analysis of *Pilgrimage,* a rare compilation film, and reflects on the interaction of music and moving images.

"Step to Jesus"

Huie's Sermon is the result of an encounter the director had while traveling abroad. As Herzog explains, the film "was shot in Brooklyn, New

York. I just bumped into Bishop Huie Rogers," the charismatic minister of the Greater Bible Way Temple, "and asked if I could make a film about him." According to Herzog, "the film needs no discussion. It is a very pure work about the joys of life, of faith, and of filmmaking."[21] But *Huie's Sermon* hardly speaks for itself. Two points need to be made explicit. First, *Huie's Sermon* concentrates on the body and its intensity of movement as a way of exploring both spiritual and documentary practice. Second, and contrary to what one might expect, given Herzog's bias against cinema verité, this is a film made almost entirely in the manner of direct cinema, or American verité, complete with its rhetoric of purity, transparency, and immediacy.

Huie's Sermon represents an ordinary religious event that takes place in an African American church. As *New York Times* critic Vincent Canby describes it, "the film is a direct recording of one lively, upbeat Sunday service, from the processional, 'Step to Jesus,' through the minister's sermon, 'God Still Has Control.'"[22] As the choir enters the sanctuary, the cadenced processional invokes at once the metaphor and the movement of pilgrimage, which in Christianity is "the way of the cross" *(via crucis),* only here it serves as a warm-up for the sermon. When the bishop gets going, his sermon becomes a form of song and dance, involving singers, musicians, and worshippers all around. His repeated inquiry "can the church say Amen?" is met with responsive shouts from the congregation, which enervate the bishop even more. Together, they generate a "feedback loop," of which the film is also a part.[23] The passionate preaching, singing, and playing, the responsive shouting, clapping, and embracing—all these actions draw the bishop and the congregation closer together, and the film conveys a strong impression of this process.[24]

From an outsider's perspective, however, the film depicts not a routine church service but rather unfamiliar forms of piety and passion. For a German audience, that is, *Huie's Sermon* represents a type of journey film, based in the director's foreign travel and encounter.[25] Once travel is recognized as a key context, the film's observational techniques become more significant. Although Herzog usually violates the norms of cinema verité, or parodies them (as shown in chapter 2), this film positively mimics them. Indeed, as Carl Plantinga points out, *Huie's Sermon* "comes relatively close" to an "observational extreme."[26] For one thing, it refuses

to offer discursive information of any kind; the film has no explanatory titles or interviews and no voice-over commentary (which makes it almost unique in Herzog's body of work, the only other example being *Pilgrimage,* of which I'll have more to say later). For another, Herzog mainly films what happens during the service; there are no retakes, and no blatant attempts are made to direct or control the action. Two camera setups are used inside the church (one on the main floor, the other up in a balcony), tracking every gesture, convulsion, and footstep of the bishop as he moves around the room. At forty-two minutes, the film's length is edited for television, but there are very few cuts within the flow of images. "Some editing occurs at the beginning, as the congregation files into church, and at the end, when the elders bless children and we see baptisms performed. Aside from these shots, the temporal structure of the film is commensurate with the structure of the sermon."[27] Thus Herzog diverts attention away from the filmmaker's presence, taking a behaviorist and noninterventionist approach characteristic of observational cinema in America. *Huie's Sermon,* then, represents an encounter with cinema verité on its own turf.

While the film "comes relatively close" to an "observational extreme," as Plantinga rightly observes, it also comes up short of that extreme, and the difference is absolutely crucial. As the service begins, for instance, the film cuts from a long shot of the church's front door to an illustrated Bible displayed within the church. The book has been opened to "Jacob's Dream," the illustration of which shows a ladder connecting heaven and earth, with angels climbing and descending on it. The film then cuts from the visionary image to the procession, "Step to Jesus." There are two other exceptions near the end of the film. One is actually a pair of traveling shots taken from a moving car, with the camera directed away from the street and toward the adjacent buildings. Each passage shows a derelict environment (deserted sidewalks, empty lots, abandoned houses, burned-out storefronts), seemingly devoid of people. These moving landscapes are suggestively juxtaposed to the minister's sermon, which we continue to hear over the traveling shots. Each abrupt cut from the sermon to the street immediately opens up a space of interpretation, allowing for many possible readings (not just one). For example, when the minister speaks of his congregation "disappearing," of suddenly

ascending to heaven and leaving this world behind, the empty streets of the city seem to visualize the aftermath of this apocalyptic scenario, in the manner of Jacob's dream. At the same time, *Huie's Sermon* issues a series of juxtapositions—between word and image, interior and exterior, religious hope and urban blight—all of which can be read as social commentary. With each abrupt cut, the film departs from the observational ideal and broadcasts the director's voice instead.

The other exception to the observational rule is the film's closing shot. The service has ended, worshippers are filing out of the church, and the bishop, now in street clothes, stands with one hand on the pulpit, silent and motionless, looking straight into the camera. "Far from the classical summing up and contextualization within a moral or political framework," writes Plantinga, "*Huie's Sermon* ends on this bizarre and enigmatic shot, subject to a wide variety of interpretations." If the shot is "discomforting," as Plantinga describes it, then the effect can be explained by a combination of factors, namely, the subject's direct look into the camera, his unwavering gaze, his return of the camera's quasi-ethnographic look, the shot's concluding position, and its marked difference from the film's observational aesthetic.[28] But there is no reason to overstate the strangeness of this shot. Its duration is actually shorter than other takes throughout the film. Nor is the image baffling. It comes from a different but related documentary aesthetic, that of portrait sitting, and as such it's not particular to Herzog.[29] Seen through a performance lens, the closing image shows another routine part of the church service, what Schechner would call a moment of "cooldown," a necessary transition "leading from the focused activity of the performance to the more open and diffuse experiences of everyday life."[30] *Huie's Sermon* takes notice of this process and then stages it for film and television viewers making a similar transition in terms of what they've just experienced.

With performance in mind, I think the intrusive moments of *Huie's Sermon* can best be understood as Herzog's answer back to the claims of American verité—claims that, at the time, had "a certain evangelical quality" of their own.[31] What makes this film so interesting is how it simultaneously veers toward and diverges from an observational extreme. In each way, *Huie's Sermon* locates the observational aesthetic and its related model of behaviorism within a larger range of styles, attitudes,

and possibilities. It also demonstrates Herzog's proximity to the ideal, which he usually makes a show of dismissing—a point I interpret as an interesting connection to his other films (and not an internal contradiction). The film, then, confirms the need to situate Herzog and his work in relation to documentary cinema and not simply outside of it.

A similar point can be made for the focus on embodied action as a performance process that characterizes all the films under discussion. The bishop's energetic preaching is obviously not the same thing as a pilgrim's act of walking or traveling in prostration. What connects these different bodies and behaviors, however, is the fervor and feeling of repetitive movement. In filming this movement, Herzog does not merely observe it; he interprets it as allegorical. Recalling his famous walk in a more or less direct line from Munich to Paris, Herzog makes this point explicit: "Of course, when you travel on foot with this straightness and intensity, mostly it isn't a matter of covering actual ground; it's always a question of inner landscape."[32] His documentaries, too, treat the body in motion as both a site and a conduit for picturing ecstatic experience.

Image and Pilgrimage

The persistence of pilgrimage, its continued vitality as a cultural practice spanning various religious contexts, despite the gradual process of secularization, has generated considerable fascination. In their landmark study, *Image and Pilgrimage in Christian Culture,* Victor and Edith Turner ask whether pilgrimage survives because it is so effective at creating and framing the sensation of total bodily involvement.[33] The exhibition of shrines, relics, and other cult objects, they suggest, is central to pilgrimage as an act that engages not just the physical sense of vision but all the senses at once. For his part, Herzog regards pilgrimage as the quintessential form of ecstatic journey. In some of his recent documentaries, the journey itself is represented as an embodied type of viewing practice shared by religious travelers and film spectators alike.

The most important example is *Bells from the Deep*, a sixty-minute film with two sound tracks, German and English, each narrated by Herzog. Following the collapse of Soviet communism and the retreat of an aggressively secularist Marxism, this film explores the revival of spiritual

practices in Russia, from Orthodox Christianity to highly unorthodox forms of mysticism and shamanism. Though hardly well known, *Bells from the Deep* offers one of the finest examples of Herzog's approach to documentary, especially his use of scripted dialogue, fabricated details, and staged scenes. None of these devices are marked within the film. It is only because of the director's performance in extrafilmic venues, such as interviews, that we ever learn of their use.[34] Nevertheless, Herzog is aware that his comments circuitously inform the reception of his films. For this reason, it becomes all the more important to imagine a range of interpretive positions, with different ratios of knowledge and naïveté, skepticism and interest, detachment and affiliation.

Herzog's project of "filming spirituality" necessarily involves staging, inventing, and fabricating. In a way, spirituality is the ultimate testing ground for Herzog's notion of truth in documentary cinema. More, the act of staging here connects the filmmaker to the figure of the shaman and to the theatricality of religious practice more generally. This connection may even explain the ritualistic framing of *Bells from the Deep,* how it begins with a native shaman, who blesses the film itself, and ends with a benediction from a man claiming to be the returned Jesus.

Yet acting and staging in documentary are generally regarded as illicit and thus need comment. When it comes to these issues, the scholarship on Herzog and documentary alike has been driven by what Schechner, writing in another context, has identified as a widely held set of cultural assumptions about theater as "illusion" and acting as "deception."[35] Clearly Herzog plays into these assumptions, but he also plays against them. It is important to recognize, for example—and this is a point that's nowhere mentioned in the literature—that Herzog not only stages certain scenarios but also shows other people staging themselves. *Huie's Sermon* provides a good example. Entire passages of *Bells from the Deep* are devoted to professional performers such as Alan Chupak, a Russian television celebrity turned faith healer, who specializes in "the transmission of cosmic energy." And then there's "The Redeemer," as he is called, the man claiming to be Jesus.[36] What's interesting about this figure is how he cultivates not just a certain look of Christ but an entire repertoire of bodily poses and hand movements, all followed intently by the camera. At the other end of the spectrum, there is the anonymous

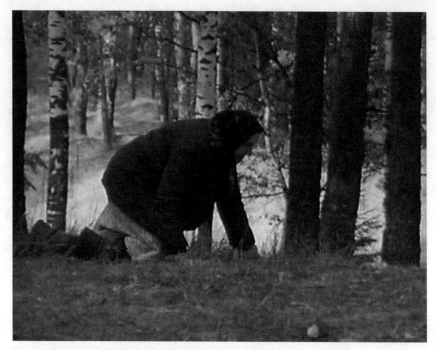

"Now I'll crawl around some more, OK?" *Bells from the Deep* (1993).

old woman, who, after crawling on her hands and knees to a place of pilgrimage, and explaining its religious meaning, looks directly into the camera and says, "Now I'll crawl around some more, OK?" In such moments, *Bells from the Deep* invites reflection on the role of performance, what Schechner calls *restored behavior,* in everyday acts of faith.

Rather than explore ways of suggesting the appearance of the divine on screen, Herzog foregrounds the embodied aspect of religious devotion as displayed by other people. The camera in *Bells from the Deep* tends to single out individual bodies, faces, and gestures, while the editing and the music suggest connections among the different images that appear on-screen. We see churchgoers crossing themselves; worshippers drinking consecrated water and venerating relics; pilgrims crawling on their hands and knees; "The Redeemer" touching the disfigured hands of a follower; a group of middle-aged women sobbing, some of them screaming, as an exorcist goes about his work on stage. In each instance, the camera is trained on the body of the believer, the film's prime source of visual knowledge and pleasure. What matters in this

film is the patterned repetition of ritualistic acts. Showing these patterns, and thus exploiting the film medium's own basis in repetition, becomes a strategy for making visible what Diana Taylor has described in another context as "performance's capacity to forge . . . belief through reiterated behaviors," an idea she supports by parenthetically recalling "Pascal's famous 'Kneel and you will believe.'"[37] In this sense, *Bells from the Deep* involves observing, staging, and showing others in the act of kneeling.

Here, and throughout the films under discussion, Herzog himself displays a Catholic emphasis on the body as the incarnate form of the spirit. It is based on the assumption that spiritual beings are corporeally present in human life and that the human body is a locus of spirituality. This is also the underlying assumption of *Huie's Sermon,* whose title refers not so much to the words of the given homily as it does to the image of the preacher's body in motion. The observational camera transforms this movement into a truth claim. In contrast to the Protestant separation of body and soul, and its privileging of the latter, the human body in Catholicism is par excellence the form of divinity on earth. Consequently, according to one scholar, the body serves as a unifying principle of pilgrimage throughout the Catholic world.[38] In this context, pilgrims seek what Turner describes as "the tactile transmission of grace."[39]

Drawing on this tradition, Herzog treats spirituality not as strictly interior or private but as physically experienced and exteriorized. It can be seen and shown, made available to the senses. More, the filmmaker employs certain representational strategies that have a rich history in Christian iconography. Writing of visual art in seventeenth-century Spain, Victor Stoichita notes that painted scenes of mystical, visionary experience are often accomplished without depicting the vision itself, by focusing rather on the mediating figure of the visionary. The object of devotion, by contrast, is deliberately obscured and rendered ambiguous. In baroque paintings adopting this strategy, the beyond is rhetorically present in the form of an immense ellipse.[40] Herzog follows a similar path in *Bells from the Deep.* Take, for example, the passage filmed at the Zagorsk monastery, the spiritual center of the Russian Orthodox Church, known today as the Trinity Lavra of Saint Sergius. The cathedral houses (among other things) the relics of Saint Sergius and a collection of medieval icons and frescoes. The sound track in this passage

Touching the shrine, *Bells from the Deep* (1993).

features sacred music sung by the monastery's choir. The image track shows worshipers of different ages all crossing themselves and pressing their lips and noses against shrines and paintings. Or rather, we see them touching the visible covers that shield the famous relics and icons from too much contact. The objects themselves are never shown to the film audience.

In each case, Herzog foregrounds the sensuous relationship between the physical body of the believer and the venerated image.[41] Spirituality is exteriorized, made sensuous and tangible, through the believer's interaction with the unseen image. It is this relationship that constitutes the actual subject of the film. Theoretically, ecstatic experience occurs within the film when the physical presence of an image seems to take hold of the viewer's body. Here we can also identify the principle of selection governing both the camera work and the editing: Herzog privileges ecstatic forms of popular religiosity that incorporate visual imagery into the everyday lives of believers—tombs, relics, icons, altarpieces—objects that serve in context to create a sense of living presence.

Framing spirituality in terms of ecstatic viewing has certain implications for how the film in turn positions its audience. Most remarkably, *Bells from the Deep* addresses the film viewer in the manner of a Christian shrine. I take my bearings here from historian of religion Peter Brown and his work on the cult of saints. Writing of pilgrims and their encounter with holy relics, Brown explains that "the art of the shrine . . . is an art of closed surfaces. Behind these surfaces, the holy lay, either totally hidden or glimpsed through narrow apertures. The opacity of the surfaces heightened an awareness of the ultimate unattainability in this life of the person they had traveled over such wide spaces to touch."[42] Historically, he explains, the shrine as a form of visual display is modeled on pilgrimage as a visceral experience. Shrines operate "by playing out the long delays of pilgrimage in miniature," heightening the viewer's sense of distance and desire by manipulating the field of vision. Brown calls this the effect of "inverted magnitudes." Herzog works to achieve a similar effect in documentary cinema. In this context, too, the spectator is implicated in a viewing situation that is clearly modeled on the ordeal of pilgrimage. Although Brown doesn't mention it, music, too, has a role to play. In *Bells from the Deep,* music provides more than just a metaphor for the sacred; it establishes the film's prevailing mood of exaltation. Like the visual emphasis on gesture and movement, the music is directed toward the emotions of the audience, forging yet another connection between the embodied presence of the film viewer and the ecstatic bodies on-screen.

The film's key scene pushes to the extreme this idea of depicting spirituality. It is discursively marked off by an intertitle that reads, "Pilgrims on Thin Ice Seeking a Vision of the City of Kitezh." The name refers to a legendary city that, when threatened by Mongol invasion, was miraculously submerged under the waters of Lake Svetloyar. There the old ways of life and worship have been eternally preserved and continue without interruption. To this day, the story goes, the most pious individuals can see the lights of religious processions on the bottom of the lake and hear tolling bells emanating from the deep. The lake is in fact a pilgrimage destination for mystics as well as for Orthodox Christians. And the legend survives in various forms—spanning medieval chronicles, songs, epics, nineteenth-century novels, and twentieth-century opera.[43] *Bells from the*

Deep draws from this tradition and adds to it through film and television.

There are actually five distinct scenes that revolve around Kitezh; the most important one is also the most visceral and problematic scene in the entire film. It is winter, so the lake is covered in ice. We see a man slowly making his way across the lake's frozen surface, traveling in prostrations. Now and then he stops, rises to his knees, crosses himself, and continues on his way. Soon he is joined by a second man, who, curiously, spends much of his time fixed in one place, prostrate and motionless. The weight of their bodies seems to create a weird pinging sound, which the film discursively locates in the physical world, "on thin ice." The sound itself, however, is strongly reminiscent of sonar. Indeed, these men are figured as searching for signs of life underwater. Lying face down on the ice, they cup their gloves around their eyes, as though yearning for a vision of the sunken city. What emerges, instead, is only the most vivid example of Herzog's project. All the key elements I have identified are here employed and further intensified: the miraculous apparition and its acoustic counterpart; the sensuous relationship of viewers to the unseen image; the opaque surface that visually obscures the object of their devotion; the physical hold that the image seems to take over their bodies.

What makes this example so interesting (and irritating for documentary purists) is how it becomes complicated over time, both intrinsically and extrinsically. Intrinsically, within the scene itself, we are soon confronted with a surplus of information from a questionable source. At one point, an old woman shuffles out onto the ice until she's standing directly between the camera and the pilgrims. She begins crossing herself and chanting, when suddenly, she pauses to ask the filmmakers, "Is this OK?" I take this question to be fair warning of staging on various levels. What follows is so absurd and seemingly unrelated that it has the effect of destabilizing our apprehension of the documentary image. Speaking as though she were being interviewed, the woman tells an elaborate story about how she injured her hand while fending off a rabid pig. Following that, we hear a translator ask if she has ever "encountered supernatural beings" at the lake. "Yes, I have," she says, and she goes on to recall having witnessed a miraculous apparition and heard "bells from the deep." The camera returns to the pilgrims, but the sound track noticeably changes. We begin to hear the distinct sound of

"Pilgrims on Thin Ice Seeking a Vision of the City of Kitezh," *Bells from the Deep* (1993).

tolling bells. As film viewers, of course, we never see an image of Kitezh, but we aren't entirely shut out of the other world either—not acoustically, at least. The use of music implicates the audience in the spectacle and its emotional intensity.

Extrinsically, this example is further complicated by public interviews with the director, who admits to having staged the entire scene. As Herzog explains it, during the summer, he filmed pilgrims crawling around the lake, but when he returned in the winter, there were none to be found. Absent pilgrims, he recruited two drunks from a local pub and put them on the ice with instructions on how to move and what to do there.[44] It is a thorny problem to realize that much of the staging gets elided in the final image so that claims to fakery or deception rely on discursive, nonvisual, and extrafilmic evidence (such as interviews). It seems to me, however, that this elision makes the attempt at staging in documentary all the more interesting, for so much history lies in this place of pilgrimage and such great effort went into filming this scene in the first place. Staging in this case may seem to be illicit, but it is

entirely consistent with a performance-based approach to religion. It's also congruent with the film's project of elliptically visualizing the abstract ideas of religious belief and ecstatic feeling by representing other people engaged in sensuous relationships with unseen objects of devotion. Or better, it is the extreme version of this model—extreme in every respect, from the frigid conditions of filmmaking to the depiction of physical suffering to the use of extreme artifice.

Music and Repetition

This chapter closes with a discussion of *Pilgrimage*, not only because the eighteen-minute film deserves more attention but also because it recycles and thereby transforms some of the material already discussed to produce a new effect. Herzog's website describes it as "a film about the pilgrimage to the Virgin of Guadalupe, to the tomb of Saint Sergei in Zagorsk/Russia and other places around the world, but mainly a film (and music) about the deep spirituality, religious fervor and profound human suffering of pilgrims." It was one of four short films, all collaborations between leading filmmakers and musicians, commissioned by the BBC for a series called *Sound on Film*.[45] For his part, Herzog worked with John Tavener, Britain's most celebrated living composer. Their collaboration was nominal (as it was in every case); they met once but worked separately. Nevertheless, it is an interesting duo, especially given the composer's outspoken aversion to secular art in favor of sacred tradition.[46] Indeed, the mere association with Tavener, a devout Orthodox Christian whose career has been largely devoted to sacred music, only bolsters the filmmaker's claim to being particularly good at working with religious subjects.[47]

The resulting film has no voice-over commentary but rather continuous music, a point of distinction within Herzog's body of films (and an interesting connection to his operas). It features a single, extended song titled "Mahámátra," performed by the BBC Symphony Orchestra, with vocal accompaniment from the Iranian singer Parvin Cox and members of the Westminster Cathedral Choir.[48] We hear a low female voice over sustained orchestral strings, with tubular bells and choral interjections that gradually spiral upward in pitch, gaining intensity with each

repetition. As Prager notes, the song "consists of two words: *Mahámátra,* which is Sanskrit for great mother, and *Theotokos,* which is Greek for mother of God." The combined effects of lyrical and musical repetition are unmistakable: "they are intended to produce a trance."[49]

Whereas the song is an original work composed for this particular film, the image track systematically recycles and reframes preexisting material. In this sense, *Pilgrimage* is a compilation film, the only one of its kind in Herzog's oeuvre.[50] Many of his documentaries recycle footage and other archival material from various sources, but *Pilgrimage* alone bases itself entirely on preexisting films, all of which derive from Herzog's personal archive (no new footage is shot for the occasion). The most obvious source is *Bells from the Deep,* particularly the scenes of worshippers at the tomb of Saint Sergius and of "pilgrims on thin ice," both of which are reedited to the rhythm and movement of Tavener's music. In this context, action begun by one figure (the same "pilgrim" that Herzog identified as a drunkard in a staged scene) appears to be continued and completed by another, situated in a different time and place. The music and editing thus combine to further emphasize the ritual character of the images, creating a total iconography of body, scene, and composition. A genre based on recycled footage, the compilation film, according to Patrik Sjöberg, "draws attention to the way in which the depicted returns as the same, but different."[51] In this case, the scene of "pilgrims on thin ice" becomes stabilized as documentary footage because recycling and reframing here diffuse any underlying tensions of staging and self-staging. Herzog's use of an invented epigraph is thus a notable holdover. The epigraph reads, "It is only the pilgrims who in the travails of their earthly voyage do not lose their way, whether our planet be frozen or scorched: they are guided by the same prayers, and suffering, and fervor, and woe.—Thomas à Kempis (1380–1471)." The attribution, erroneous but suggestive, deserves brief comment. A Catholic mystic, Thomas à Kempis is historically associated with *The Imitation of Christ,* one of the most widely read books of Christian piety, aimed to encourage private prayer and devotion.[52] By trading on the authority of religion, then, the epigraph establishes the film's mood of solemnity, and does so in terms that also resonate with Herzog's body of work. In a way, *Pilgrimage* is Herzog's answer back to critics who stress his irreverence

toward religion, without accounting for the attitude of solemnity that is also present—or, in this film, pervasive.

The key scenes of *Pilgrimage* derive from yet another project, *God and the Burdened* (discussed at length in chapter 4). The footage was shot on digital video at the Guadalupe shrine in Tepeyac, near Mexico City. The basilica there is among the world's busiest sites of pilgrimage, receiving as it does nearly one and a half million visitors per month. As Turner wrote, referring to the cult of Guadalupe in particular, "Pilgrimage *lives* in Mexico."[53] Finally, the transitions between the different scenes and sites of pilgrimage are accomplished via landscape views of wild, uninhabited shorelines, footage shot on Christmas Island during preproduction for *Invincible* (2001). At the London premiere of *Pilgrimage,* one commentator observed that the landscape images bear no obvious relationship to the theme of pilgrimage.[54] As the present study contends, however, they function as allegory, evoking the belief and passion of pilgrims while visually connecting the different images of ritualized movement.

The governing principle of compilation evinces a synchronic approach to pilgrimage as both a metaphor and a practice. It literalizes Schechner's notion of performance as restored behavior by treating acts of pilgrimage "as a film director treats a film strip of film."[55] The resulting film offers a visual compendium of bodies, faces, and gestures, set to a continuous score of sacred music and coded in terms of religion. The categorical treatment of this material also captures the idea that pilgrimage as a practice involves leveling social and cultural hierarchies (Turner's famous notion of *communitas*), reducing life to its bare essentials, and asserting them as universal ideals.[56] Lifting these images out of their original contexts becomes a strategy for enhancing the model of affective, corporeal, connective viewing that I have outlined, while taking it one step further.

Pilgrimage fits within Herzog's aesthetic project of "filming spirituality" as a sensuous relationship between a viewer's body and an object of devotion, without depicting the object itself. Herzog himself emphasizes this point, referring to the footage from the Guadalupe shrine in Mexico: "It was important never to show exactly who or what the thousands upon thousands of pilgrims are actually venerating, or even where they are."[57] What makes this move so interesting is that the

Guadalupe shrine is historically motivated by and organized around the production of visual imagery. The relevant picture is actually hiding in plain sight and not simply hidden in Herzog's film. Although the camera never shows the object of devotion, mass-produced images of Our Lady of Guadalupe are prominently displayed on the white T-shirts worn by many of the pilgrims on-screen. This visual motif directly recalls the Virgin's miraculous appearance, in 1531, as a painting on the cloak of an Aztec shepherd.[58] By now it should come as no surprise that the apparition itself is nowhere mentioned within the film. The reference (not the story, but its mere association) only becomes available to film viewers who are aware of it and likewise regard the depicted body as a focus of visual interest. Instead of showing the miraculous picture that hangs inside the basilica, the camera draws attention to the bodies— especially the faces—of individual pilgrims and to the range of emotions they register and externalize. Whether grimacing in pain or staring as if transfixed, the different faces seem to share a certain look, which we might call a devotional gaze. All the pilgrims seem to be looking onward and upward, their eyes fixed on an object (the hillside basilica) elided by the camera. Despite this elision, and precisely because of it, the faces of pilgrims become living signs of devotion. They do not function as mirrors for the film spectator, but they are sequenced and shown in such a way that constructs a visual relay between the film viewer and the venerated image.

This relay of gazes is further developed by the film's penultimate sequence. It features a series of tightly framed bodies and faces as they pass in front of the unseen image, creating a strange and powerful effect of circumambulation. Herzog and his cameraman here exploit the actual circumstances of Guadalupe as Mexico's most popular shrine and the church's effort to accommodate thousands of pilgrims at a time. The film camera is situated at a forty-five degree angle to an unseen moving walkway that literally streamlines the circulation of pilgrims through the basilica, conveying them in large numbers before the miraculous painting without stopping before it.[59] The final passage in *Pilgrimage* thus focuses on the tension of stasis and motion. What the film audience sees is a seemingly endless procession of pilgrims as viewers, who are both fixed in place and being moved at the same time. Though a static image,

A virtual procession of bodies and faces, *Pilgrimage* (2001).

the above photograph conveys at least a sense of the basic structure, the dramatic interaction of viewers and images within the film. Again and again, we encounter the idea of "moving icons," in every sense of the term.[60] The visual rendering of physical motion here alludes to transformation. The flow of images, like that of the individual faces and bodies being transported across the frame, signifies a force of movement, an act of being carried away from one place to another, which is also a transport of mind.

Toward the end of their journeys, at precisely the point when pilgrims are extremely fatigued and thus equally vulnerable to sensory impressions, according to Turner, the path becomes gradually more circumscribed by religious images such as painting, statuary, architecture, and stained glass. "The pilgrim, as he is increasingly hemmed in by such sacred symbols, may not consciously grasp more than a fraction of the message, but through the reiteration of its symbolic expressions, and sometimes through their very vividness, he becomes increasingly capable of entering in imagination and with sympathy" into the depicted experiences.[61] In a way, the sensory experience of immersion, repetition, and overload that Turner finds operating in pilgrimage as a long-distance physical journey could just as well describe the viewer's experience of Herzog's short film. Both the cyclical patterning of the images and the

rhythmic, escalating movement of the music create a powerful impression of kinetic presence, while fostering an imaginative engagement with the sensory world of pilgrims on-screen. Ultimately, the orchestra cuts out, leaving the voice to finish by itself—cooling down, as it were. The accompanying image shows a snow-covered valley, which is also the final scene in *Bells from the Deep*. We see three tiny figures, at first holding hands and then letting go, as they cross a narrow footbridge and, beneath it, a frozen river.

4 BAROQUE VISIONS

The scholarship on Herzog passionately suffers from what is, of course, a more widespread problem of methodology. Again and again, that is, we almost habitually frame the material in terms of certain paradigms as opposed to others and thus see only particular aspects of the films, which consequently become all that there is to see in them. Now that these paradigms—in this case, romanticism and expressionism—are firmly entrenched in the literature, it becomes interesting to explore Herzog's work through other, less familiar categories and to see what a difference it makes.

The baroque provides one example. Asked about key "influences" on his work, Herzog often emphasizes his interest in seventeenth-century poetry, music, and painting, naming specific and mostly forgotten figures in each area.[1] When describing his sense of cultural identity, with reference to such diverse phenomena as the castles of King Ludwig II and the films of Rainer Werner Fassbinder, he has spoken of "a quintessentially Bavarian dreaminess and exuberance," which he also describes as a "baroque imagination."[2] Clearly he is conversant with baroque art, music, and literature as well as with some of the circumstances of their production. Rather than emphasize the idea of a "Bavarian baroque" (a phrase that immediately conjures images of stucco angels and pilgrimage churches), I think it would be more interesting to situate Herzog's work in relation to the larger, transatlantic revival of the baroque in twentieth-century art and literature, which is what this chapter aims to do.

To this end, I employ a number of terms and figures that are widely associated with the baroque but not with Herzog.[3] Nor are they part of the scholarship on documentary, where issues of style and aesthetics tend to be discussed in narrower terms, without regard to larger historical

contexts of visual culture. In film and media studies more generally, the adjective *baroque* has at least been used to connote the auteurist flair of specific directors, including that of Herzog. One commentator has described the seemingly endless proliferation of yarns by and about Herzog as a "baroque phenomenon."[4] The adjective has also served to describe the spectacular qualities of individual films as a way of highlighting their blatant theatricality, visual luxury, technological extravagance, or other forms of stylistic excess.[5] Each use is in keeping with only part of the term's sprawling etymology, itself a topic of considerable discussion and disagreement.[6] Even when they refer beyond the historical baroque, the term's various uses in the context of film may well serve to remind us that the baroque as a particular style of artistic expression was first and foremost an aspect of visual culture, originating as it did in architecture and painting. In that context, the baroque has been widely debated in terms of style and historical period.[7] Its status as a concept of literary history is equally fraught and nonetheless fruitful, to say the least.[8] Beyond its link to specific disciplines (such as art, literature, and architecture), or to a particular style, the baroque has been understood as an epoch in European history that roughly coincides with the seventeenth century and is constituted by an awareness of impending crisis and radical change in all spheres. Congruent with both political absolutism and religious Counter-Reformation, the baroque in this sense has been characterized as a "culture of spectacle," to emphasize the central role of visual display in the service of church and state.[9] At the same time, the baroque has also been theorized as a transnational phenomenon, with divergent lineages spanning Europe, Latin America, and the Caribbean, where it is also associated with a cultural politics of resistance. The *New World baroque* and (later) *neobaroque* represent a transatlantic space of encounter and exchange, where multiple different epochs, languages, and cultures intermingle.[10]

This is not the place to rehearse any of these arguments in detail, but I would like to at least point to some of the more striking affinities between Herzog's work and baroque art generally. Above all, in many instances, spectacle reigns supreme. Herzog's documentaries, for example, are characterized by their highly stylized, all-encompassing sense of performance, often involving specific historical traditions of spectacle (sport,

opera, theater, festival, and procession), with the key example being that
of the cinema itself. Here, as in much of baroque art, the image often
seems to (literally) overflow its aesthetic framework.[11] Striving for the
Sublime and the spectacular, proclaiming visions that almost overwhelm
rational comprehension, striking an attitude of wonder and ecstasy,
expressing intense emotions, and stirring them all in the viewer—these
are some of the motivating impulses of Herzog's work. His is a fantasy of
transforming the cinema into a "cathedral" of sensuous images and rap-
turous music. Spectacular effects have a rhetorical function as well. This
is especially true of the documentaries, which aim to be not just visually
potent but also persuasive, even when the specific argument being made
would seem to be either idiosyncratic or self-contradictory. And in such
cases, the experience of contradiction itself points to yet another affinity.
The predominant form assumed by the relationship between appear-
ance and reality in baroque art, contradiction is a major concern and a
general condition of Herzog's work as well. In each context, the visible,
phenomenal world is imbued with metaphysical mystery, while the in-
visible, sacred realm is made available to the senses and the underlying
paradox is offered up for contemplation. As this reference to the sacred
would seem to suggest, Herzog's baroque allegiances can also be found
on the level of theme. I have already discussed the preoccupation with
spirituality (see chapter 3). Here I'll simply mention the themes of dream,
illusion, obsession; "the madness of the world"; and last, but not least,
"the end of the world." All these themes are as central to Herzog's films
as they are to baroque art and literature. In each context, moreover, the
notion of catastrophe becomes a source of creative production. Hence
the relentless images of a world in ruins, a world of loss, the "waste-
land" scenes of *Fata Morgana, Lessons of Darkness,* and *Encounters at
the End of the World.* All these films reconstitute a worldview that has
its historical origins in the seventeenth century: an acute awareness of
life's transience. What Herzog seeks throughout his work, according to
Prager, is "a standpoint that looks at a world filtered entirely through
death."[12] At the same time, conversely, recurring images of ruin, decay,
and destruction in the films serve double duty as moving images of life.

In terms of the baroque, there is one element of Herzog's project that
needs fuller discussion up front, and that is his notion of "the ecstatic

truth." It is a catchphrase that he has employed since the 1970s, and in recent years with increasing emphasis, to describe his own project, especially in the context of documentary. The ecstatic truth is also a phrase that has gradually been adopted by critics and scholars, who use it in various ways to discuss Herzog's work.[13] Among scholars, most notably, Prager takes it as a sign of the filmmaker's "poetic" vision in a broad sense and of his romanticism more specifically.[14] To other critics who see in Herzog's romanticism certain affinities to Nazi cinema, even to the point of rekindling its irrational energies and monumental visions, the idea of espousing an ecstatic truth would presumably strengthen their conviction. It seems to me, however, that Herzog's notion of ecstatic truth is strongly reminiscent of the baroque, evoking a concept that was promoted far and wide during the Counter-Reformation: that of truth found by faith and not by reason. Critics seem to forget that romanticism and Nazism are not the only historical or available forms of counterreason. The baroque offers another, anticipating developments not only in the nineteenth century but also in our own time.[15]

Consider, for example, Christine Buci-Glucksmann's theory of baroque visuality, which she calls "madness in vision" (*folie du voir*, also translated as "madness of vision" and "folly of vision"). Building on the work of Maurice Merleau-Ponty, which for her offers a way of reinterpreting seventeenth-century culture, Buci-Glucksmann develops a model of vision as embodied, mobile, visceral, and thus opposed to the prevailing visual order of scientific reason. On this model, "vision is understood to exceed sight, to be an aspect of the visual that is liberated from the context of the optic-representative."[16] The target of criticism is a rational model of visuality based on mathematical perspective and the disembodied Cartesian subject who knows the world by viewing it from afar. On the other side of the spectrum, she argues, baroque vision celebrated the disorienting, ecstatic implications of the age's visual practices, the confusing interplay of form and chaos, surface and depth, transparency and obscurity. According to Martin Jay, "it dazzles and distorts, rather than presents a clear and tranquil perspective on the truth of the external world. Seeking to represent the unrepresentable, and of necessity failing in this quest, baroque vision sublimely expresses the melancholy so characteristic of the period—that intertwining of death

and desire trenchantly explored by Walter Benjamin."[17] As the reference to Benjamin would seem to suggest, Buci-Glucksmann's concept of madness in vision derives from an interpretation of seventeenth-century material but is also part of a larger "archaeological" project, tracing the irrational roots of modernity back to the baroque.[18]

In this chapter, I argue that the baroque, defined in aesthetic terms by hyperstylization, provides an interpretive key to Herzog's work. Above all, it characterizes his vision of documentary as well as his particular contribution to it. My point here is not that Herzog "stylizes" and thereby "fictionalizes" documentary (which is a truism in the scholarship). What the baroque allows us to see, more precisely, is how he co-opts historical forms of expression in the context of documentary and enriches both in the process. Herzog is well known for his visionary claim to search for "new images." What is less well known, and less obvious, is the central role of anachronism (historical forms of vision) in the fulfillment of that search. What is more, "madness in vision" provides a framework for understanding both Herzog's skepticism toward the rationalizing tendencies of documentary and his efforts to redirect and expand that category by transgressing its traditional claims to truth and authority. Herzog's documentaries explore various manifestations of the baroque past and present in Europe as well as in the Americas. Understood as a transatlantic topos, the baroque gives new meaning to Herzog's movement as a traveling director and its relationship to his documentaries in particular. So this chapter necessarily covers significant ground, exploring a series of different yet interrelated versions and visions of the baroque.

Cinematic Hagiography

In 1973, speaking at a communal cinema in Stuttgart, where *Aguirre* had just been screened for a small audience of critics, students, and cineastes, Herzog announced that his next film would be "a pure documentary [*ein reiner Dokumentarfilm*], a report about the Swiss ski jumper [Walter] Steiner," who was then the reigning world champion. To this he added, "It is a film about the fear of dying, among other things."[19] The film begins, notably, with a profane image of apotheosis: a ski jumper

An image of apotheosis, *The Great Ecstasy of Woodcarver Steiner* (1974).

rises from the bottom of the screen, ascending in extreme slow motion through an all-white frame, his uniform fluttering in the wind. He soars past the camera, which pivots to capture his graceful arc through the air, before he flies out of the frame. *The Great Ecstasy of Woodcarver Steiner* has been regarded as a milestone in the history of sport film, primarily for its use of multiple super-high-speed cameras, which allowed for an uncommon diversity of speeds and perspectives, transforming a sporting event into a sensuous flow of images.[20] Reviewing Herzog's film for the *Frankfurter Allgemeine,* one commentator exclaimed, "Here is a rare example where the catchphrase, 'changing our habits of seeing,' gains substance."[21] From our different historical perspective, however, the film does not offer a "new" way of seeing. It recovers an older, specifically baroque model of vision and transforms it in interesting ways.

The Great Ecstasy of Woodcarver Steiner was produced for a West German television series called *Border Stations (Grenzstationen),* a name that evokes not only the political landscape of the Cold War and then-divided Germany but also the idea of marking, testing, and overcoming limits

in a metaphorical sense.[22] Herzog described it as a series "on extreme human situations."[23] His contribution explores the physical, emotional, and ethical limits of "ski flying" *(Schifliegen)*, a version of ski jumping so extreme that few venues can accommodate it. Herzog and his crew filmed at three of the world's five ski-flying hills (in Austria, Germany, and what was then Yugoslavia) and at two international competitions in 1974. Although the film is based on specific events in the life of Walter Steiner, these do not include the high points of his career (his 1972 world championship is not even mentioned). At issue for Herzog is obviously not coverage but rather the condition of extremity and its living manifestation.

The notion of extremity in this film comes from the Christian tradition of hagiography, the writing of the lives of saints. Among the oldest known documents in Western culture, saints' lives as a type of literature or legend originated in the "acts" or "passions" of martyrs. Objects of display, such as relics, icons, sculptures, and paintings, contributed to hagiography by visualizing its rhetoric of sensuality and self-sacrifice, which already vacillated between the extremes of cruelty and heroism, suffering and sanctity, immanence and transcendence.[24] To this tradition, the seventeenth century added what art historian John Rupert Martin describes as "a deepened interest in the psychology of pain and suffering." Even in the context of sacred art, he explains, visual representations of interiority exceeded the boundaries of religious sensibility. Thus death and martyrdom function in baroque art as "a vehicle for the portrayal of extreme states of feeling."[25] Not surprisingly, baroque revivals in painting and literature often rework the tradition of hagiography and its iconography of sanctified suffering.[26]

Herzog's film, too, builds on this tradition. Consider the film's peculiar title, how it frames the documentary subject as an artist or artisan and does so in terms of ecstasy. It immediately recalls the titles of religious paintings and sculptures from the historical baroque, most notably, Caravaggio's *St. Francis in Ecstasy* (1596) and Bernini's *The Ecstasy of St. Teresa* (1645–52). If *The Great Ecstasy* adds a further touch of hyperbole, then *Woodcarver Steiner* brings it back down a few notches, replacing the saint with the artisan. But the two figures are not opposed to one another, as the film's opening scene makes clear. Steiner appears in his

studio, chiseling and contemplating a large, twisted piece of wood.[27] A sculptor from Wildhaus in Switzerland, Steiner describes the piece's bowllike shape as resulting from an internal "explosion" of "energy," which the wood somehow captured. This scene, together with the film's title, introduces the analogy of aesthetics and athletics that Herzog has employed ever since—an analogy that refers back to his self-styled image as a passionate filmmaker who, like the subject of his work, characteristically endures physical extremes. The image of the brooding artist further evokes the topos of melancholy, which the baroque temperament shares with the Renaissance: the chronic disease of the creative genius, whose brilliance is imagined as compensation for suffering.[28] In this case, the genius is literally an athlete who competes at the highest level of an extreme sport, and he suffers from the immense pressures and expectations imposed on him by others, who wish to see him fly farther and farther. As Vincent Canby wrote in his review for the *New York Times,* "Mr. Steiner is deprived of an ordinary man's peace of mind by being possessed by his talent, the demonstrations of which in this film are as spectacular as anything I've seen on the screen."[29] The triad of artist, saint, and ski jumper is visualized from the very beginning, when Steiner holds up a miniature carving of a gaunt Christlike figure with outstretched arms and sets it in motion before the camera, slowly turning the tiny sculpture to show its many sides. In every way, the sculpture prefigures the film's portrayal of Steiner, how it shows *him* in ultraslow motion from multiple different angles and thus creates out of him a moving icon of human desire and fragility. The body of Steiner works allegorically on-screen, but whereas in baroque art, the body of Christ refers to the cosmos, that of Steiner refers back to himself and, by extension, to the filmmaker.

Herzog's role in this film is even more conspicuous than Steiner's. Throughout this forty-five-minute film, he frequently appears on camera, microphone in hand, commenting on the various stations of Steiner's path to victory. The intrusive presence of the filmmaker becomes a spectacle in its own right. Filmed in 1973–74, when Herzog's star was also on the rise, *The Great Ecstasy of Woodcarver Steiner* marks the first time the director voices his own commentary and only the second time he appears on camera.[30] Each move would later become central to his

performing identity as a documentarian. Referring to this film in particular, Paul Arthur wrote of Herzog, "he anticipated by more than a decade the current vogue for first-person appearances" in documentary cinema.[31] At the time, however, the German television series *(Border Stations)* simply required that a commentator appear on camera, as an integral part of each show, to unify and narrate the depicted events— a convention of presenter-led television, as in so many shows about cooking, travel, and motoring as well as in sport broadcasting. Herzog took an existing television convention and transformed it into the occasion for an unconventional performance, by which I mean both the director's staging of himself and his reworking of certain documentary conventions. The specifically dramatic quality of presenter-led television is obvious, owing to the on-camera presence of a speaker who directly addresses the camera and, by extension, the audience. Herzog treats the presenter-figure as a persona, a mask to project certain aspects of his own performing identity, which are selectively deployed for an effect.

When Herzog appears on camera (interviewing Steiner, describing the snow conditions, etc.), he is not just playing the role of a television presenter but also revising it in certain ways—a point stressed by scholars who discuss the film in terms of sport.[32] The parody of broadcast journalism needs discussion, but it is important to emphasize that the parody here works by going beyond journalism and beyond the context of sport. Two examples will have to suffice. First, there is what I call Herzog's catechistic style of questioning, which is strongly reminiscent of Catholic liturgical practice. By that I mean his peculiar habit of beginning a question with the participant's full name ("Walter Steiner, is this really too far for this hill?"), even in the middle of an extended interview, and no matter when the interview takes place within the film. This ritualized style of speech becomes even more conspicuous when compared to the speech of a professional reporter from ABC television who, vying for Steiner's attention, calls out to him as simply "Walter" or "old boy," as if they were good friends (Steiner's reserved comportment suggests otherwise). According to one scholar, the American reporter views Steiner "as only a celebrity (never a wood sculptor)."[33] Herzog's intervention goes beyond simply regarding the athlete as an artist. It frames him in religious terms—indeed, it frames him as a type of martyr

(and I'll return to the point later). Second, Herzog parodies the discourse of journalism by pushing it to the extreme, wildly swinging between analysis and hyperbole. The use of hyperbole is interesting because the ski-flying events are unexpectedly characterized by their very lack of drama—a point Herzog himself makes in the film. As David Davidson points out, "he admits, for instance, that the absence of East German, Soviet, and Japanese skiers from the Yugoslav meet leaves Steiner without his chief competition, including those who consistently jump farther than he does." And yet he continues to assert Steiner's "unbelievable superiority."[34] Davidson interprets such hyperbolic claims as evidence of "Herzog's bias" and the "subjectivism of his portrait of Steiner."[35] But hyperbole can produce various effects (and does not necessarily indicate bias). In this case, it functions as the discursive equivalent of the spectacle, an extreme sport noted for its awe-inspiring performances. Extreme exaggeration becomes a verbal strategy for representing Steiner as a performer of miracles, despite all evidence to the contrary.

For his part, Herzog interprets the role of the television sports announcer as a twentieth-century hagiographer. If the cult of saints originated in the ancient cult of gods and heroes, Herzog suggests its continued visibility in the glorification of athletes as media stars.[36] The filmmaker himself obviously participates in this modern ritual of hero worship, as evidenced by his "reverential tone" when speaking of Steiner and his jumps.[37] Indeed, Herzog has often said that the film has an autobiographical layer, referring as it does to his own teenage ambition of becoming a great ski jumper and his admiration for Steiner in particular.[38] Within the film, however, and more interestingly, Herzog stages himself as Steiner's rival, competing as it were for screen time. All hagiographers seek their own glorification, their own access to the divine, by depicting the lives of saints; in this respect, Herzog is not alone. He even suggests his own canonization as a filmmaker, complete with his own attribute. Hence the choice of costume: a royal blue track suit emblazoned with a big white star. More than just a sign of the filmmaker's self-aggrandizement, the blatant and self-reflexive theatricality of his attire is fitting for his role as hagiographer.

From the beginning, then, *The Great Ecstasy* is as much a testimony to the filmmaker's distinctive style as it is a portrait of another person.

Herzog as hagiographer, *The Great Ecstasy of Woodcarver Steiner* (1974).

The subject of Herzog's commentary and the focus of visual interest are constantly shifting between the drama of the ski-jumping competition, which is admittedly found to be lacking, and the process of filmmaking, which is actively filled with drama. This back-and-forth movement begins with Steiner's summer preparations in Austria. Filming on a grassy slope, Herzog prepares his audience as well, training them in how to see the sport as they have never seen it before. Through a potent mix of staging and commentary, he imbues with emotion the series of meter marks running from the top of the hill to the bottom of the landing strip. In another scene, Herzog and his crew literally measure the run-off area to locate the point where ski flying becomes "inhuman," exactly 179 meters below the ramp, and mark it with a big wooden post hammered into the ground. If Steiner were to cross this point, Herzog avers, it would mean certain death. And yet this is precisely what a record-obsessed culture of sport would seem to demand. By pinpointing the supposed threshold of life and death, Herzog not only literalizes the idea of the "border station" (the television series's theme) but also dramatizes the creative process

of filmmaking. "It might sound strange," he says to the camera, "but I'm standing exactly where the film had its point of departure for me." The rational discourse of measurement here is put to an absurd end, as though Herzog could literally map the creative process and its specific phases onto exact locations. The upshot, however, is an act of symbolic precision, and it is absolutely central to Herzog's practice of documentary filmmaking. The index, in other words, becomes a metaphor. In this case, he suggests, the drama of film production began at the very point where the life of his subject would presumably end, where the graceful body of the ski flyer would fall and land as a corpse. Later, when Steiner crashes in a practice run, Herzog looks directly into the camera and declares, "This could be the end of our film." The comment is remarkable not only for its combination of subjective mood and matter-of-fact delivery but also for its conflation of subject and object. Clearly Herzog shares in the baroque fascination with the crossing points between life and death, between self and other. The baroque famously envisioned life as a play; for Herzog, life is a film.

Another effect of his appearance on camera is to foreground the mediation of visual images. Unlike sport broadcasting, where the cameras remain unseen, Herzog calls attention to the role of image-making technology as both part of the spectacle and separate from it. At the ski-jumping competition in Yugoslavia, for instance, he and his team operate at least four different camera setups, including one at the top of the hill and one at the bottom. In addition, he says, "We've got two super-high-speed cameras on the job. They take slow-motion pictures that slow the action down ten or twenty times." Mounted on each side of the hill, these are the cameras that produce some of the film's most compelling and memorable images: tightly framed shots of take-offs and aeriallike perspectives of landings. The issue of framing is particularly interesting for its affinities with baroque art, especially when one considers that the super-high-speed cameras are extremely heavy and difficult to maneuver. Each time Steiner takes flight, writes one commentator, "he floats with his body thrust forward in a straight line that runs almost parallel with his skis, moving farther away from the camera and always threatening to break completely out of the framed image."[39] As the frame is being pushed outward and opened up, the relation between the object of

vision (Steiner in flight) and the subject of vision (the roving camera eye) is shifting, by definition. Add to this the images shot from the cameras mounted at the top and bottom of the hill and a unifying vision begins to take shape: a multiplicity of viewing speeds and perspectives, which address the spectator by means of repetition and variation. In a way, *The Great Ecstasy* creates the cinematic equivalent of sculptural narration, where a story unfolds as the viewer physically moves and thereby changes his or her perspective. The film spectator in turn is compensated for his or her immobility by the intensification of the moment, which the film achieves by continually tracking back and forth between images of stasis (ultra-slow motion) and images of movement (shifting mobile perspectives). The viewer is offered a vision of what transpires above or below the threshold of perception, and the resulting image is moving in every sense of the word.

What is "new" here, if anything, is the representation of a modern sport spectacular in the form of a baroque martyr–drama. Seventeenth-century martyr plays featured protagonists who, threatened with persecution and death for their beliefs, resisted both threats and often joyously embraced death.[40] Herzog co-opts the iconography of martyrdom in the secular context of sport. The conceit of hagiography provides a framework for corporeal images of agony and ecstasy. Spectacular jumps and crashes transform into scenes of ritual punishment, which are repeatedly shown in extreme slow motion so as to emphasize the drama of suffering. And then there's the internal tension of Herzog's commentary, which is mundane in content and reverential in tone. It lifts the body into a hagiographical framework, highlighting both the extravagance of the mundane and its transcendence, at the same time. When Herzog introduces the final day of competition in Yugoslavia, for instance, he characterizes Steiner as a living cult object. "Fifty thousand people turned out . . . and it looked a bit like a great pilgrimage. People had seen Steiner's astonishing flights on television the day before." Thus Herzog not only foregrounds the mediation of images but also puts them in relation to live performance, a move that implicates his audience to a degree.

Witness the body of Steiner, which is exactly what this film urges us to do. The flow of images for each jump is slowed down to such a degree that even the smallest movements—the billowing of Steiner's clothes,

the rippling of his cheeks—become enlarged and exaggerated on-screen. Slowing down the body, technologically, has the effect of making it visible and therefore intelligible on an unprecedented level, or at least producing the appearance of intelligibility. The use of repetition and multiple camera perspectives adds to this effect and develops it more fully. Details that might otherwise go unnoticed become exhibited for all to see and thereby seem to obtain meaning. Consider the ski jumper's gaping mouth, which is held open so wide and for such a long duration of time that it foregrounds the image's emotional values, evoking pain as much as pleasure and fusing them together. Rather than elicit our pleasure in seeing a sport well executed, the slow-motion images of Steiner in flight serve to excite our wonder.[41] Here, once again, is Canby: "You have the feeling that on any one of these jumps, Mr. Steiner is going to take off and never again set foot on earth. At least, not alive."[42] To encourage this sense of wonder, the slow-motion images are either accompanied by music or replayed in silence. Prager aptly describes the music (by Popol Vuh) as "a synthetic score that recalls cathedral choirs."[43] The use of silence, though less frequent, creates an air of sanctity and arguably serves as an acoustic sign of transcendence, silence being a widely used allusion to the state beyond this life.

Ultimately, *The Great Ecstasy of Woodcarver Steiner* transforms its subject into a martyr. It is a figure that crystallizes in an image of Steiner's bleeding face, raw and unhealed, soon after a crash that, all agree, threatened to end his career. On the final day of competition in Yugoslavia, Steiner flies beyond all the meter marks and crash-lands in the runoff area. Herzog describes him as having suffered "great shock." Although it was only a practice run, the crowd is reportedly amazed, and with good reason. "You've exceeded all expectations," says the doctor who examines him after the jump.[44] Despite his injuries, and although Steiner has already secured first place in the competition, we are told, "the judges" pressure him to jump again, for "the people" have come to see him. In his commentary, Herzog figures the judges as sadistic authorities who use the spectacle of sport as a means of social control. Steiner, for his part, becomes a sacrificial hero, the baroque protagonist par excellence. Afflicted by the cruelty of others, he courageously overcomes his own pain, and his suffering confers sanctity on him. "This was his moment

of great crisis," reports Herzog. "Later, he said that people demanded too much of him, trying to force him into setting a new world record or see him bleed. He said, 'I feel I'm in the arena with fifty thousand people waiting to see me be smashed to pieces.'" Herzog's commentary, which either quotes Steiner or speaks for him, conjures a mental image of ancient Roman spectacle and its bloodthirsty crowd. But the stress is placed on Steiner's agony, in both the ancient and the modern sense of the word, the idea that he is struggling and suffering at once. That he jumps again, despite his internal fears and external pressures, defines him as a martyr–hero. Pain, as Herzog portrays it, is more than just physical. It is transformative. Steiner's lonely heroism is based on fortitude and endurance (rather than achievement). Returning to the competition, his next jump is accompanied, logically, by a liturgical piece of organ music.

To a certain degree, as noted earlier, Herzog and his audience are implicated in the spectacle that is the film. In his role as reporter, however, he distinguishes between the performance genre of sport and the process of filmmaking. Rather than shut down the "feedback loop" of live performance, film becomes a means of diagnosing it.[45] In effect, Herzog's film appropriates another performance genre, reframes and enlarges it, much as John MacAloon has theorized the role of spectacle in modern societies.[46] The point is almost made explicit by Steiner's final monologue. In it, he tells the sad story of his childhood friend, a lonely raven, who was "tortured by his own brothers, because he could no longer fly."[47] Steiner winces and looks away from the camera when he recalls having to kill the badly injured bird out of mercy. An abrupt cut returns us to the final slow-motion sequence, accompanied by a solo piano, which echoes the film's opening image of apotheosis. Other scholars have noted the parallels to Steiner and ski flying as well as the story's religious form, describing it as a "homily" and "a kind of parable."[48] As I have shown, however, the entire film is devoted to the drama of martyrdom. In the tradition of saints' lives, the raven story has an allegorical function. It projects a moral quality of virtue onto a visible figure who accompanies the protagonist on his journey through trials of violent cruelty, before leading to a final act of mercy.

The film ends, true to form, with a poetic vision of the end of the world. An epigraph reads, "I ought to be all alone in the world. Just

me, Steiner, and no other living thing. No sun, no culture, just me, naked on a high rock. No storm, no streets, no banks, no money, no time, and no breath. Then, at least, I wouldn't be afraid."[49] In other words, the film ends with a martyr's vision. Prager describes it as an "ascetic desire for isolation." His psychoanalytically informed discussion leads him to emphasize the Freudian "death drive" that characterizes Steiner's monologues.[50] Rather than imagine the film as a psychoanalytic case of self-expression, I have suggested that the unceasing vacillation between boundary conditions (life and death) can also be understood as baroque. Thus the epigraph not only figures Steiner as a sacrificial hero but also invokes the quintessential baroque topos of the end of the world—and it does so in a way that registers a larger tragedy of civilization, an awareness that marks its contemporary standpoint. Shuttling between ecstasy and annihilation has a history, and it is powerfully summoned by the film. Referring to seventeenth-century literature, one scholar observes that the baroque "is incapable of imagining a world without imagining also its dissolution."[51] Benjamin would have agreed. In his words, which could also be used to describe the moving images of Steiner in flight, "the baroque apotheosis is a dialectical one. It is accomplished in the movement between extremes."[52]

Extreme Artifice

Death for Five Voices explores a subject of the historical baroque: the life and work of Italian composer Carlo Gesualdo, Prince of Venosa (1560–1613). At the same time, the film participates in the contemporary phenomenon of baroque revival, not least by featuring two ensembles of singers devoted to the interpretation of early music and performance styles.[53] The turn of the seventeenth century was an important time of experimentation in melodic chromaticism, and Gesualdo was a leading figure in this development.[54] His contemporaries admired him as a master composer with a passionate interest in affective song and technical extravagance. To historians in the nineteenth century, his use of unprepared dissonance and abrupt chromatic shifts, as well as his blatantly violent and eroticized poetry, exemplified the baroque's excessive tendencies.[55] To modernist composers, Gesualdo was a visionary whose ultrachromatic

experiments anticipated twentieth-century expressionism and atonality. It comes as no surprise, then, that Herzog frames his subject as a "visionary" and a harbinger of "expressionism," as he does from the beginning of this documentary short. *Death for Five Voices* not only engages the historical baroque but also, of course, interprets it. Though the process of interpretation is largely effaced, it can at least be suggested by comparison with *The Great Ecstasy of Woodcarver Steiner*. Like that film, *Death for Five Voices* represents another case of extremism, another portrait of obsession. But the focus in this film dramatically shifts—from saints to sinners, from the passions of martyrdom and heroic self-sacrifice to the astonishing acts of incest, necrophilia, murder, and madness. There is also a marked shift in mood, from pity to fear, which is, however, constantly being undercut by a shift in tone, from solemnity to humor.

By all accounts, of which there are many, Gesualdo lived an extraordinary life. A member of the high nobility, he was born into the class of patrons (not artists), and the web of royal families defined his social standing, as one would expect. His grandfather was granted the title Prince of Venosa by King Philip of Spain; his paternal uncle, Alfonso, was Cardinal of Santa Cecilia in Rome and Archbishop of Naples; his mother, Geromina Borromeo, was the daughter of Margherita de' Medici, niece of Pope Pius IV and sister of Cardinal Carlo Borromeo, Archbishop of Milan and a leader of the Counter-Reformation, who was canonized in 1610. Of all the highly ranked people of his time, however, Gesualdo was alone in his accomplishment as a composer.[56] His youth was devoted to music, but this was not to last. Urged to produce an heir, he married his first cousin Maria d'Avalos, whose beauty and sexual appetite had long been the subject of gossip. Although just twenty-five years old, she was already twice a widow, her first husband having died, the story goes, from an "excess of connubial bliss."[57] This time, however, she would fall victim to her husband's violent jealousy. On October 16, 1590, Gesualdo killed Maria as well as her lover of two years, Fabrizio Carafa, Duke of Andria. The double aristocratic murder was widely publicized and discussed at the time and later romanticized by poets and novelists.[58] Expecting reprisals, Gesualdo took refuge in his hilltop castle and reportedly had all the surrounding trees cut down, to avert a surprise attack (which never came).[59] When there no longer seemed

Detail of a chapel painting (anon., ca. 1592). It contains the only known portrait of Gesualdo, who appears in the lower left corner, kneeling before the Redeemer (not pictured here) and accompanied by specific angels and saints, all interceding for him. From *Death for Five Voices* (1995).

to be any likelihood of revenge, he sojourned to the court of Ferrara, where he became a central figure of the musical avant-garde and began publishing his famous books of madrigals for five voices. He also married Princess Leonora d'Estes. After a period of relative calm, it is said that he began abusing her. Rather than accompany him back to his castle, the princess began an incestuous relationship with her brother, who was also a cardinal. Toward the end of his life, Gesualdo suffered from growing "melancholy" and reportedly submitted himself to ritualized punishment. According to one chronicler, "he was assailed and afflicted by a vast horde of demons which gave him no peace for many days on end unless ten or twelve young men, whom he kept specially for the purpose, were to beat him violently three times a day, during which operation he was wont to smile joyfully."[60]

In its treatment of this information, *Death for Five Voices* follows certain well-trodden paths in the literature on Gesualdo. First, the film puts emphasis on the composer's life, which is regarded as both the motivation for his music and the initial framework for understanding it.[61]

Second, and within this biographical framework, *Death for Five Voices* concentrates almost exclusively on the lurid, the pathological, and the macabre, as the film's title would seem to suggest.[62] Finally, it follows the pattern of twentieth-century commentary that overemphasizes the idea of Gesualdo's singularity to such a degree that it seems to justify detaching the music from its historical context and linking it to future developments such as Wagner's chromaticism, Schoenberg's expressionism, and Stravinsky's atonality.[63] To literary scholars, the reference to expressionism is further reminiscent of early-twentieth-century theories of a genealogical link between baroque poetry and German expressionism, which also marked the emergence of the baroque as a concept of literary criticism.[64]

By pointing to so many foreseen routes, I do not mean to suggest that the film is derivative in its treatment of Gesualdo. On the contrary, it seems to me that Herzog's portrait of the artist is in many ways his own. The "story" of Gesualdo, as it unfolds here, anticipates not so much the music of Schoenberg or Stravinsky (which we never even hear in the film) as it does the cinema of Herzog and its most familiar themes and concerns. And the terms that serve to frame this material—expressionism, vision, genius, solipsism, murder, and madness—these are also the terms of Herzog's oeuvre. Indeed, the entire film works to create a sense of harmony between two historically remote figures and projects, the music of Gesualdo and the cinema of Herzog, so that we cannot imagine the one without also thinking the other.

There is, however, a further twist, which makes *Death for Five Voices* even more interesting both as a documentary film and as a baroque object in its own right. Unlike other personal portraits that Herzog has made, all claims to the contrary notwithstanding, this film's basis in biographical fact is about as solid as it can be. Curiously, although the details of the composer's life are well known, and are represented here quite faithfully, they come to seem almost incredible on-screen—partly as a result of its treatment and partly by association with Herzog and his reputation as a filmmaker. In making this observation, I want to query the received idea that *Death for Five Voices* is his "most stylized work" and one that is "wholly fictionalized."[65] The director himself supports this idea. Of all his documentaries, Herzog comments, "*Death for Five Voices* is the one that really runs amok."[66] And yet historians of music who are familiar with

this material would be surprised to hear that the stories are "complete fabrications," as Herzog describes them in interviews.[67] Even the most lurid details about the murders and the composer's mental and sexual life derive from reports by historical witnesses and local authorities and are readily accessible in the literature on Gesualdo.[68] In this case, unfortunately, Herzog had little need to invent.

Why has this point not been made by other film scholars? It is almost as if the director's reputation for fabricating precedes him to such an extent that the very notion he might be "telling the truth" doesn't even occur. Although he usually takes a playful and irreverent approach to documentary, on this occasion, he does so from an unexpected angle. *Death for Five Voices* choreographs a host of expert witnesses and material evidence to dramatize events which, by all accounts, actually took place. Problems of historical representation are at stake in some of Herzog's other documentaries (see chapter 6) but not in this one. At issue here, rather, is the use of artifice and what it might tell us about Herzog's relationship with documentary cinema.

The use of artifice not only riffs on Gesualdo's artifice-laden style but also forges a certain relation to it. In his 1972 essay "The Baroque and the Neobaroque," Severo Sarduy proposed the concept of "artificialization" as that which links the baroque past and present. A Cuban intellectual who lived in Paris, where he was closely affiliated with the *Tel Quel* group, Sarduy takes a semiotic approach to the baroque, which is informed by structuralism, Russian formalism, and particularly the work of Roman Jakobson. From this perspective, Sarduy's concept of artificialization foregrounds the elements of play, excess, and self-reflexivity in language, while downplaying its functions of communication.[69] His essay identifies the tactics of metonymic displacement—substitution, proliferation, condensation, among others—most frequently put in the service of "extreme artificialization."[70] Although it is primarily used as a literary term, Sarduy's discussion extends to film and the arts. In each area, the baroque sign appears as "the apotheosis of artifice," which foregrounds its representational nature and thereby asserts the contingency of such historical constructs as truth, fact, and reality.[71] Neobaroque art, then, resumes and intensifies the process of epistemological destabilization that was initiated by the historical baroque.

Artificialization, according to Sarduy, is an aesthetic strategy of de-realization that deliberately "wastes" the resources of language rather than put them to other uses. These would include not only the "work" of communication, mimesis, and illusion but also such counterstrategies as "defamiliarization," which Sarduy would have known through the Russian formalists, and "estrangement," as conceived by Bertolt Brecht. One might reasonably expect a director such as Herzog to be congenial to Brechtian estrangement, as were other proponents of the New German Cinema, but the didactic impulse and dogmatic pedagogy of the Brechtian tradition have apparently prevented him from embracing it. For this reason, too, Sarduy's model of extreme artifice offers a framework for understanding Herzog's films and their insubordinate play-attitude toward the documentary tradition. It also helps identify the representational strategies that Herzog employs in *Death for Five Voices*. Although he uses different technical artifices than those emphasized by Sarduy, they work to achieve a similar effect.

Take Herzog's use of interviews. While authorities on Gesualdo are consulted, they appear alongside a collection of odd and unlikely sources: the groundskeeper of Gesualdo's decrepit castle; a couple of old cooks in a local restaurant (one of whom repeatedly shouts her view of Gesualdo: "the devil!"); a porter at the building in Naples, where the murders took place; a doctor, who interrupts the seemingly tactless and unmotivated filming of a "mental patient." The interviews are conducted by an Italian-speaking interlocutor, whose voice can be heard off camera, while the commentary is spoken by Herzog, who paraphrases the conversations in English. The act of interpretation is made explicit, as the director translates the dialogue into his own words. Interspersed with these conversations are what musicologist Susan McClary describes as "exquisite full-length performances of several madrigals as well as musicological commentaries from the directors of the featured ensembles: Gerald Place with the Gesualdo Consort of London and Alan Curtis with Il Complesso Barocco."[72] It is an interesting division of labor. Experts tell the composer's story in all its lurid details, while nonexperts stand witness to its key locations in the present (and their casual use of deictic language is important): here is Gesualdo's castle; the murders took place in this bed; the bodies were found on the steps over there, and so

on. This surplus of witnesses, this excess of bodies becomes a source of disruption and amusement, which verges at times on farce.

The most revealing example is the interview with a "madwoman." Since the film is not well known, this passage is worth describing. As the camera roams through the ruined castle, we hear a woman sing the words "Carlo Gesualdo, Principe di Venosa." A voluptuous woman with long red hair and red lipstick suddenly appears in a stairwell. On seeing the camera, she flees, and the filmmakers give chase through a series of rooms and corridors. "Excuse me, Senora," the interviewer calls. "Who are you, and what are you doing here?" Cornered, as it were, she turns and declares, "I am the reincarnation of Maria d'Avalos, Gesualdo's wife. . . . The last time he spoke to me, about ten days before the murders, he said, 'Death alone can kill.' He didn't say a word after that. He just sang eerie songs. Would you like to listen to one?" Fumbling with a portable stereo, the woman begins playing "the wrong one" before she finds "Beltà, poi che t'assenti . . . ," a madrigal that is familiar to the film audience because it was performed in the previous scene and associated with Stravinsky's "Monument to Gesualdo." Instead of listening to the piece, the woman interrupts it: "Stop! What strange music!" Asked for her contact information, she answers, "Well, I live in heaven, but you can find me with a helicopter if you fly around the big chandelier in the La Scala opera house in Milan. In the second row, right by the pillar, there is a box all clad in red damask. That's where I live." What is striking about this interview is its mix of absurd dialogue and sensual corporeality. The "reincarnation" of Maria d'Avalos highlights the cinematic interplay of presence and absence, while introducing the idea of the body as regained and made visible again. Standing in for the missing body of Maria d'Avalos, however, is not just anybody but the popular Italian actress and singer named Milva.[73] To a European audience, she is easily recognizable as a celebrity and a performer, known as much for her extraordinary physical presence on stage and on camera as she is for her voice and music. The camera's tight framing of her upper body is excessive to the point of being obscene. It gives the interview an erotic charge, compounded by Milva's performance. And that is precisely her task: to foreground signs of performance by means of excessive embodiment and by association with other performance genres such as opera.[74]

Spectacle is the other tactic of artificialization I want to highlight.

"I am the reincarnation of Maria d'Avalos, Gesualdo's wife" (Milva), *Death for Five Voices* (1995).

Death for Five Voices invokes many traditions of spectacle, spanning opera, theater, painting, museums, fireworks, wedding processions, and festival entertainments. Of particular interest here is the museum because the "documentary" foundation of that institution and its underlying tension of knowledge and pleasure make it an interesting site of meta-commentary on documentary cinema. Thus many of Herzog's documentaries include images of museum showcases and display objects—a point that other scholars have either overlooked or neglected—much as circus and fairground spectacles appear in many of the narrative features.

Death for Five Voices harks back to a range of early museums, from the cabinet of wonder to the chamber of horrors. In each case, the institution is implied by the way in which material objects—metonymic signifiers all—are discursively figured through anecdotes that seem to resituate the objects in the context of Gesualdo's life. The anecdotes are probably what Herzog really means when he says that passages of the film are "completely fabricated." On this point it is worth quoting him at length:

> Take, for example, the scene shot in the castle of Venosa where there is a museum. In one of the glass showcases there was one piece—a clay disc with enigmatic script-like symbols on it—that really engaged my mind with puzzlement and gave me sleepless nights. I very much

wanted to use the object in the film, so I wrote for the director of the museum—in actuality the dean of Milano Law School—a monologue about the disc that he should speak whilst standing next to the show-case. He presents a letter from Gesualdo to his alchemist, enlisting aid in deciphering the mysterious signs on the disc. "The prince had spent sleepless nights trying to unravel the secret of these strange symbols," the professor explains. "In the course of this activity, he became lost in a labyrinth of conjectures and hypotheses. He almost lost his reason in the process."[75]

It is an ironic moment of emblematic play, complete with a visual im-age (the disc and its signs), a verbal narrative (spoken by the museum director), and a text (the forged letter), which is shown to the camera. The entire scene works to transform visual signs into hieroglyphics, which await an interpretation that never arrives and whose deferral is literally maddening. More than just a means of reiterating the theme of madness, the discourse surrounding the museum object foregrounds the status of the film itself by invoking the paradox of the labyrinth, what Omar Calabrese has called "its constructed undecidability."[76] The structure of the labyrinth is visually supported by the display of multiple lenses (the "museum director" wears two pairs of eyeglasses, a move that is repeated by other characters in the film, and each time recalls the histrionic use of opaque goggles in Herzog's early films) and reflec-tions (from the showcase glass, which increases the number of museum objects that are visible on the film screen and gives them a hallucinatory quality). Herzog's account is further interesting for what it tells us about the unifying role of the filmmaker, which can also be seen as transform-ing the historical role of the collector. Susan Stewart has described the seventeenth-century *Wunderkammer* as "a world of meaningful things attached to the particular history of the collector."[77] With its delightful confusion of categories and its head-shaking sense of wonder, Herzog's documentary follows in this tradition.

The sense of wonder here attaches to a scattering of visible evidence so that the metaphors of the labyrinth and the museum themselves seem to merge. Objects of display are strategically deployed to create a trail of visible evidence that circles around what is ultimately missing. Sarduy's

definition of "proliferation" as a baroque artifice might equally refer to the series of display objects in Herzog's film: "a chain of signifiers that progresses metonymically and that ends by circumscribing the absent signifier, tracing an orbit around it, an orbit whose reading—which we could call a radial reading—enables us to infer it."[78] In *Death for Five Voices,* the logic of display renders visible the process of metonymic displacement that results in artificialization. Already (at least) once displaced from the physical world, objects of display are put in the service of substituting for the missing bodies of Gesualdo and company, creating in effect a superabundance of visible evidence, where little in fact remains.

The display of human corpses offers a case in point. A cinematic reproduction of a *vanitas mundi* tableau, it is introduced by an interview with a porter who works in the Naples building where the murders took place. According to the porter, Gesualdo was "a demon and an alchemist" who "experimented on human bodies." His testimony is obviously scripted and inconsistent. First, he says that Gesualdo left the bodies and fled the scene (a point that is later echoed by Gerald Place, who adds that a passing monk "despoiled" Maria's body). Then, the porter says that Gesualdo prepared the corpses for postmortem display by injecting them with a "serum." The use of such detail recalls the history of anatomical display. Indeed, Herzog interprets, "The porter thinks the victims' skeletons are still on exhibit today, in San Severos Chapel, just around the corner." The camera descends a stairway and approaches a set of two glass showcases, each containing a human corpse, which is framed by a gilt mirror. As it scans the body of one skeleton, that of a woman, the camera reveals another large skull, which appears to be lodged in her womb. It is a grotesque proliferation: corpse begets corpse. And yet the camera's movement is even more vulgar, panning as it does from the skull–womb to the genital area of the skeleton in the adjacent vitrine, a move that visually evokes the idea of illicit paternity (which will later become a topic of the film).

The elements of this scene are combined in a manner that Sarduy would describe in terms of "condensation," a device he links to the film medium and describes as the "unification of two signifiers that come together in the exterior space of the screen."[79] Rather than revert to "superimposition," which is Sarduy's prime example, Herzog employs

The traumatized corpse of Maria d'Avalos or the incarnation of Death? *Death for Five Voices* (1995).

more subtle ways of fusing cinematic signifiers—in this case, through the coordination of music, camera work, mise-en-scène, and commentary. The voice-over describes the setting as a church in Naples, without explaining how or why these corpses landed there (the porter suggests that they were originally displayed as trophies in an alchemist's laboratory). Here, as elsewhere in the film, logical ellipses open up a space of interpretation without resolution. What exactly are we supposed to "see" when confronted with these cinematic corpses: dead people or incarnations of death? If the corpses can be said to have a referential function, do they refer back to the victims, as suggested by the commentary? Do they not conjure a third image: that of the murderer as monster? What type of display are we seeing, and where exactly is it located? Is it part of a church, as stated, a moralizing display to inspire fear in the spectator? Or do these skeletons belong to a local anatomy museum? The mix of associations here is theoretically interesting because the church and the museum are historically related as forms of spectacle. On one level, the European church as a site of visual display provided a model for

early museums.[80] On another level, the baroque theme of *vanitas,* which reminded the viewer of life's transience and death's inevitability, linked religious art with the secular concerns of anatomy and pathology.[81] While the image track invites such historical thinking, the sound track undercuts it. Musically, that is, the entire scene is coded in the style of a vulgar horror film.

The conspicuous role of "movie music" is so rare for Herzog that it demands comment. Here, and in two other moments of suspense, the film mimics a musical artifice of horror-film scores: rapid flurries of eerie strings, horns, and crashing cymbals, building in volume and register and coordinated with the spectacle of corpses on-screen. The dramatic use of film music becomes even more noticeable when juxtaposed against the madrigal performances. At one point, however, the distinction between sound track and performance is blurred for an effect. Soon after committing the double murder, we are told, Gesualdo became obsessed with the paternity of his youngest child and had him swung to death in his cradle. There is good reason to question the veracity of this event, but its iconic power is clear. Herzog merely takes it up a notch by adding a musical element.[82] Standing at the scene of the crime, in the courtyard, which is now empty and visibly deteriorating, the groundskeeper states that this macabre scene was accompanied by choirs singing "a madrigal about the beauty of death." The operatic impulse behind this artifice flows directly into a filmic technique. A sound bridge then links the imagined scene of infanticide to the performance of "Beltà, poi che t'assenti," introducing the madrigal as the sound track of a horror film. Reduced to this level of technical artifice, music and image conduce to disbelief, undercutting the scene's realism while heightening its emotional effect.

The film ends with a device used in seventeenth-century drama to communicate a baroque vision of life, "the world as theater." It originates from an attitude toward the phenomenal world as an illusion and its corollary, "life as a play." In the film, we see a boy being outfitted with angel wings and a sword, harnessed to a wire, and pulled from one building to another, high above a crowd of spectators. A subtitle elliptically recalls the role of allegory in baroque spectacle, with its thematic opposition of absolutes: ". . . the Struggle between Good and Evil continues." Indeed, *Death for Five Voices* continues that tradition. Older forms of spectacle

do not disappear in Herzog's film. They are integrated and transformed in terms of the new medium. The last scene takes place at a medieval festival. We see a variety of carnival entertainments (pageantry, jousting, street theater) and costumed performers.[83] The camera approaches a foot-man, who is talking on a mobile phone. Herzog translates: "Listen, Mom, don't keep calling. I told you before, I'll take the rider and horse back, and then I'll come home for lunch. The Gesualdo film will be finished any moment now, anyway." The footman then turns and looks directly into the camera, which holds for a long take—long enough for the final line to resonate in the mind of the viewer. The blatant use of artifice both conceals the status of documentary as performance and defines it as such. *Death for Five Voices* proliferates in forms of spectacular excess and artifice, urging the spectator not only to wonder at the curious happenings on-screen but also to wonder whether any of this is true.

New World Encounters

Clearly Herzog is aware of the baroque's colonial origin and legacy in Latin America. I scarcely need mention two of his best-known films, *Aguirre* and *Fitzcarraldo,* and images of Spanish conquistadors, missionaries, indigenous laborers, and worshipers immediately come to mind. And yet I must at least mention these films because neither of them has ever been explored from this perspective.[84] In a way, however, Fitzcarraldo's dream of building an opera house in the jungle is a colonial fantasy that only makes sense in a baroque New World. The same could be said of Fitzcarraldo's spectacular failure, how his colonial project is successfully co-opted in the context of indigenous culture.

In Latin America and the Caribbean, the concept of the baroque has referred not only to seventeenth-century European culture but also to its many successive adaptations. The recent notion of a "New World baroque" offers a key example. Since the mid-twentieth century, building on the work of Spanish and Latin American modernists before them, a range of artists and intellectuals have again turned to the historical baroque, both in its European and colonial forms, reclaiming them for the stated purpose of creating a new hemispheric discourse of cultural autonomy. Known in the 1970s as "neobaroque," this discourse has since

developed into what Lois Parkinson Zamora describes as "a self-conscious postcolonial ideology aimed at disrupting entrenched power structures and perceptual categories."[85] Its key theoretical formulation belongs to José Lezama Lima, another Cuban writer, who redefined the baroque as "an art of counterconquest."[86] The formulation is telling, for it not only puns on the title of a famous art historical study, Werner Weisbach's *The Baroque as Art of the Counter-Reformation* (1921), but also captures the idea of an alternative, disruptive cultural identity, one that is emphatically independent of Europe, its institutions of church and state, its tradition of Enlightenment, and its singular, normative concept of "modernity."[87] This idea of a rebellious alternative to modernity, where indigenous and European forms mix in playful (even subversive) ways, where civilization's cast-offs reappear as witnesses to a forgotten future—this idea would almost certainly fascinate Herzog as a filmmaker who, in the 1970s, began voicing his own skepticism toward technological civilization and exploring forms of counterreason in various contexts, including the Americas.

God and the Burdened provides a good example. It may be a minor film, but it is also a fascinating act of provocation. Here, once again, Herzog works both within and against the framework of a television series. *God and the Burdened* originated as part of a mini-series called *2,000 Years of Christianity (2000 Jahre Christentum)*, a coproduction of Germany's public television network (ARD) and Tellux-Film, a branch of Germany's Roman Catholic Church. Instead of commissioning artists, as it had in the Counter-Reformation, the Church today establishes its own production companies and engages people working in film, television, and new media. Whether or not Herzog should be entrusted with the Church's message is another question entirely. Referring to ARD, he recalls, "the network asked me to contribute to a series about 2,000 years of Christianity. I told them I wanted to do something about the church in Latin America, but that they should not expect anything encyclopedic because I knew I wanted to go to a very specific place. The main sequences are shot . . . at a shrine to the Mayan god Maximón in San Andrés Itzapa in Guatemala."[88] Herzog's contribution to the television series explores the effects of cultural transfer in a specific situation and suggests their historical implications for religious life in Latin America more generally.

Unlike Herzog's other documentaries, this one makes an explicit argument. With the Spanish Conquest of Mesoamerican people, Herzog states on the voice-over, "the Catholic faith was forced on . . . a whole nation."[89] Christianity was a "burden" to be (literally and figuratively) shouldered by colonized people, and it remains so to this day—an idea made vivid by the episode's opening scene. It is Holy Week in Antigua, the ancient capital of Guatemala. We see images of the city's famous Easter procession, accompanied by nondiegetic music from Gounod's *Sanctus*. The editing creates a visual analogy between the costumed worshipers, who carry the figure of Christ bearing the cross, and the porters and vendors, who shoulder enormous loads of goods. As the film suggests, however, the Conquest resulted not only in traumatic loss and oppression but also in creative acts of appropriation and transformation, which in some cases, paradoxically, enabled the survival of the same indigenous myths and rituals that the church had sought to replace. From the start, then, the episode unfolds in conflict with the series of which it is a part. For all the rhetoric of coercion, Herzog foregrounds the continued visibility of "pagan" beliefs. The stakes of this film are thus made plain: they are the persistence of native identity and memory in the face of overwhelming European power and the resulting emergence of new syncretic forms of religious practice and cultural expression. If this brief description sounds a bit too prosaic or "politically correct" for a Herzog film, there is indeed more to it.

For instance, there are presently three distinct versions of this film in circulation (all produced in 1999 but released in various years), and each has a different title. Not surprisingly, the variations have created some confusion, so a few words of clarification should be helpful. First, there is *New Worlds: God and the Burdened (Neue Welten: Gott und die Beladenen)*, which aired on German television in 2000 as part 9 of the aforementioned mini-series but was not released on DVD until 2007. This is the only version in which the voice-over is spoken by Herzog himself. It's also the one that most interests me.[90] What I am calling the "second" version bears the shorter English-language title *God and the Burdened*. It was produced for an export version of the same series, which went straight to DVD and was released in 2002. In this case, a translation of the commentary is spoken not by Herzog but rather by

the narrator for the entire English-language series (Donald Arthur, who also incidentally voiced the English narration for *The Dark Glow of the Mountains*). A "third" and somewhat shorter version, *Christ and Demons in New Spain,* is distributed by Herzog's company and is only available on VHS. This version dispenses with the framing sequences (historical reenactments of a conventional kind) as well as with the didactic material (including a computer-animated map of Columbus's journey), all of which belong to the television series. Interestingly, however, it also jettisons the voice-over and replaces it with a combination of intertitles and subtitles, rendering a "silent" version of the same film.[91] The protean nature of this material creates a rather tricky interpretive situation. And yet the multitude of versions, none of which is definitive, can be seen as a baroque phenomenon in its own right. Bearing this idea in mind, I want to concentrate my remarks on the first version of the film, which aired on German television, while using the variations to suggest the dynamics of proliferation, permutation, and multiplicity that characterize all this material.

Herzog's film engages the baroque as a key topos of Latin American culture, but it does so from a distance, in passing. Unlike indigenous artists and Third World intellectuals, Herzog is obviously a cultural outsider. A travelogue with a religious theme, the film in turn situates the director, the documentary subjects, and the spectators in a certain relationship to one another. At the risk of oversimplifying this relationship, we could describe it as follows: Herzog speaks about "them" to "you."[92] In the televised version, he speaks with a voice that is clearly identifiable as his own and with an authority that derives from his status as an important director who is known for working abroad. Filming at various shrines and churches, he describes the worshippers as separate and culturally different. "They" are always at a remove from the filmmaker, who speaks "about" them and not "for" them. At one point, Herzog even highlights the violent opposition that he and his crew encountered when filming a Mayan ritual. "We seem to be unwanted here," he says. "Any moment now, one of the pilgrims will attack our cameraman and knock him down." The attack is then shown in slow motion, an effect that not only accentuates the act of resistance to the filmmaker's intrusive presence but also dramatizes the act of filming, charging it with a momentary sense

of risk and danger. Filming continues with a brief explanation, which hints at off-camera negotiation: "When some of the pilgrims themselves take pictures, however, they also accept us." What is interesting about this scene is that the attack is cut from the version released by Herzog's company. Yet this version, too, insists on its outside position, as it does when the voice-over is replaced by intertitles, offering little if any context for the depicted rituals and events. However divergent they may be, all three versions address an audience that is separate from the filmmaker as well as from the documentary subject. This separation, as Nichols observes in another context, has historically defined documentary as an institutional framework, which constructs and regulates the various forms of relationship among filmmakers, subjects, and spectators.[93] Herzog, then, works both within and against the institutional framework of documentary as a strategy for creating a spectator position that is widely familiar and seems to be self-evident. "You" as a spectator are posited as the one to whom the filmmaker speaks about other people. At the same time, "you" are also lumped together with other spectators as a group for whom this topic bears importance. As Prager observes, "the film is undoubtedly meant to be marketed to European Christian audiences."[94] While the practice of representing others is problematic (as the attack on the cameraman makes all too clear), Herzog's mode of address, though less obvious, is equally fraught because it implicates "you" in the legacy of Christianity, which is depicted not as a cause for celebration but rather as an agent of spiritual conquest and domination. What all this material suggests is that Herzog's engagement of the baroque is cross-cultural in scope but insistently Eurocentric in perspective, motivation, and address. It aims to provoke certain audiences as opposed to others.

From beginning to end, *God and the Burdened* asks a series of hypothetical questions that call on audiences to speculate in response. In a way, the entire film coheres around the act of querying. It is a stylistic strategy that activates viewers by appealing to their powers of imagination. The film opens with an intertitle, which asks, "If Jesus came again, would he appear in the New World? Would we recognize Him at all?" Instead of recruiting audiences to an argument, the act of questioning calls up a set of received ideas, perceptions, representations, and frameworks of understanding. The strategy is repeated throughout the

film. Some lines of inquiry are clearly meant to provoke: "And who are the baptized today? So deep was their fall in the collapse of their world that they seem like disturbed individuals to this day, as if they were in a state of shock. What is concealed behind their puzzling silence, their disturbed state?" The corresponding image, however, is ambiguous (we see a series of men, hooded participants in a religious procession, each with glazed-over eyes and a blank stare on his face); whether it supports or belies the commentary is left for the viewer to decide. At issue here is what we might call the trauma of spiritual conquest and its lasting effects or legacy. Herzog's treatment of this issue is as fraught as it is contradictory. To confront the audience with the madness of Christianity, for example, he pathologizes the very people he depicts as victims of spiritual conquest. The confrontational stance is tempered throughout by the use of repetition, almost to the point of exhaustion. Most questions come abruptly, beginning either with "And" or with a simple interrogative: "And, once again, who is the man on the cross, the one they are carrying on their shoulders? Who is Jesus to them? And what exactly is the Church in the World?" At this point, a simple rejoinder would seem to be obvious: why not just ask them? This is to assume, however, that the film is at all concerned with either acquiring or imparting factual knowledge "about them," which is obviously not the case. With each repeated question, Herzog reaffirms the spectator's desire to know (a motivating force of documentary), only to refuse or divert it in unexpected ways.

Significantly, *God and the Burdened* frames its many questions of reason and counterreason in terms of bodies and images. The strategy may not be new, but it obtains new meaning in the context of documentary film and television, which is precisely the reason why the episode begins as it does.[95] First, we see a number of intricate flower carpets *(alfombras)* being trampled. They are immediately reminiscent of the cinematic image and analogous forms in other films (such as the sand mandala in *Wheel of Time*). Then we see a church, where people are interacting with a religious image known as a *cristo sangrante* (literally, "bleeding Christ"). A sculpture made of dried maize leaves, cornstalk paste, and human hair, it depicts Christ on the cross, with particular emphasis on the bleeding and suffering body. During Holy Week, the figure is traditionally removed

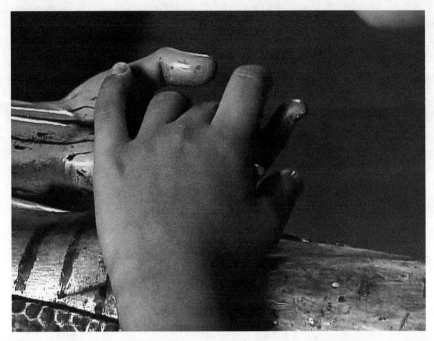

"He is within the grasp of his believers," *God and the Burdened* (2000).

from the church wall and placed in an aisle or in front of an altar so that the sacred wounds can be reached and touched by worshipers.[96] This sensuous image in turn evokes a particular form of religion that was imported to Latin America: the Catholicism of the Counter-Reformation, a form that aggressively employed various forms of spectacle—plays, dances, bonfires, and processions—in its program for native conversion. In this context, the spectacle's power seems to have actually increased as a result of its displacement. "Christ is palpable here," says Herzog, as the camera shows a girl resting her hand in that of the *cristo*. "In the most profound sense, he is within the grasp of his believers." The close-up shot of interlocking hands not only enlarges and foregrounds the act of touching but also makes vivid the idea of physical presence, of having a bodily relationship to god, which is enabled and mediated by images. To this idea of physical presence Herzog adds a cultural juxtaposition: "here," in the "New World," where the filmmaker has traveled to capture such moments on film, Christianity assumes different forms than it does elsewhere, that is, in the "Old World," whose name remains unspoken.

Herzog's main example is the cult of Maximón, also known as San Simón. Part Mayan god, part Catholic saint, Maximón–San Simón is a figure of mixed indigenous and European origin, the resulting fusion of elements from two syncretic traditions. More than just a vestige of the distant colonial past, the figure of Maximón–San Simón has a living function in contemporary Guatemala. Its rituals and representations are fluid and constantly changing.[97] In the commercial town of San Andrés Itzapa, the Chapel of San Simón has particularly wide appeal. "The pilgrims come from far away," says Herzog, "and many seem to have traveled from the capitol of Guatemala City." This is Herzog's destination, too, the shrine he wanted to visit when he took this commission. As the film crew enters the chapel, he describes the burning of candles as similar to other sites of Catholic pilgrimage. "But the saint is strange: a display window mannequin dressed as a powerful Spanish ranchero, with a tie, a sombrero, and a staff." We see the figure seated in a silver-framed altar, which is open and elevated above the worshipers. In his left hand, he holds a wad of cash. The surrounding walls are covered with ex-voto images left by pilgrims attesting to specific miracles and giving thanks to San Simón. "But in reality," Herzog remarks, "the saint is an ancient Indian deity, Maximón, who is being worshipped here." In making this comment, Herzog also makes an interpretation, of which I'll have more to say later. For now it is enough to emphasize that the film offers a view of post-Conquest religious performance as unorthodox and rebellious. To worship Maximón becomes an act of subversion, which also involves the displacement of Catholic tradition. The effect of displacement, too, is on display, visualized as it is by the spatial arrangement of saints in relation to each other as well as by the rituals that take place around them. "And here," says Herzog, as the camera pans away from the altar, "totally off to the side, in the glass case, is the Christian Saint Simon, the carpenter. The Catholic Church quite simply adopted the heathen cult as the worship of a Christian saint. The saint thus becomes a witness to strange events."

What follows, then, is a spectacle of cultural difference that has been recorded, transformed, and reconstituted for a particular audience. Long passages of the film are devoted to acts of physical excess. We see pilgrims smoking gigantic cigars and fumigating the pagan god,

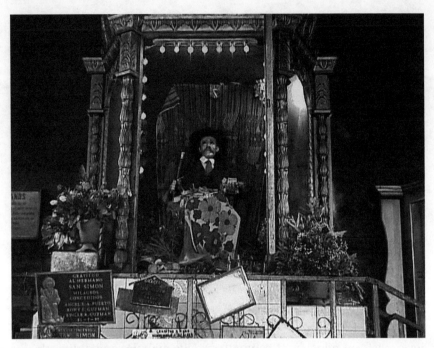

"But the saint is strange," *God and the Burdened* (2000).

snapping their fingers and rapping their knuckles on tables, all to attract his attention. We see healers dousing pilgrims by spitting and spraying alcohol over them and patting their bodies with handfuls of candles and shrub branches. Visually, the focus of interest here is the performance of a "strange" purification ritual, its sensuous nature, and the experience of religious fervor it inspires. Discursively, Herzog places emphasis on alterity and transgression—that is, transgression against the Roman Catholic Church. Indigenous peoples are depicted as creative, resistant subjects who adopt and modify selected aspects of Catholicism for the local purpose of preserving Mayan tradition.

The depiction of religious performance culminates in a dramatic scene of conversion, which, under the circumstances, is probably not staged but whose narration and interpretation seem to be mischievously calculated. In the version released by Herzog's company, the scene is introduced by a subtitle, which reads, "Conquest reversed: The Demons convert the Christians." It concentrates on two figures, each allegedly Catholic and in a privileged social position. One is a woman who "turns out to

be a judge on the civil court" in Antigua and is shown worshiping "the god of pilgrims, an ancient god of the Mayans." The other is a man who "arrived in a Mercedes, and quite obviously belonged to the country's Catholic upper class." Herzog's narration bears repeating: "His rosary beads clearly identify him as a Catholic. But here, in this chapel, it seems that Catholicism not only absolves pagan rituals, as is the case with the Easter procession, Christmas, and the worship of Mary. Here it seems as though a conversion is taking place in the reverse direction: from the Indians to the Spanish intruders." As Herzog speaks, we see this man lighting candles, kneeling before the shrine (its elevated position being another sign of Catholic influence), washing his leg with water from the altar, and descending from it by walking backward, as is customary here (another visible form of "reversal"). In converting from Catholicism to the cult of Maximón, the man who "arrived in a Mercedes" is not alone. The following scene features "a busload of pilgrims," including numerous "women from the Hispanicized part of the population," all of whom have travelled many miles to partake of the Mayan purification ritual.[98] Catholic culture, with its tradition of pilgrimage, has inadvertently created a context for travel to the chapel of San Simón. This practice, too, is coded as a transgression against Catholicism, against the official culture that helped bring the chapel into being.

"Conquest reversed" is Herzog's interpretation. It is also an act of provocation. Rather than emphasize the syncretic power of Mayan religion to incorporate Catholic objects (and vice versa), Herzog frames this material in mythic and remarkably binary terms, as a scenario of encounter unfolding in the present. The colonial fantasy of "conquest reversed," of "Indians" converting "Spanish intruders," describes a New World indeed—one the intended audience of this series might find troubling. Like all interpretations, this one has its limits. In many respects, Herzog's staging of conversion obscures more than it reveals about the cult of Maximón. For instance, it ignores the everyday practice of holding multiple affiliations and beliefs (e.g., Pentecostal converts who continue to take occasional offerings to the Mayan god and maintain some relationship with him), for the sake of staging a mythological encounter and its unexpected reversal. The conversion model, as Herzog develops it, reduces the number of possible combinations and

adaptations, restricting the forces of multiplicity and transformation that have allowed the cult to thrive.

Herzog's treatment of the shrine's central icons is equally reductive. Dig a little deeper, beyond the film, and it turns out that both of the central icons in this particular chapel are representations of San Simón, and neither of them is Maximón, whose physical appearance is noticeably different.[99] In other words, the depicted chapel houses two opposing representations of San Simón, each of mixed indigenous and European origin, each with a different combination of elements, each with a different emphasis, arranged and displayed in a form of cultural hierarchy that (literally and figuratively) elevates the folk saint over the official one. Instead of delving into the complexities of local mythology, regional variation, and mestizo culture, Herzog simply calls the central figure "Maximón" and the adjacent one "Saint Simon," creating in effect a scenario that has a powerful appeal and a proven track record with Western audiences, that is, a Manichean struggle between saints and sinners, demons and angels, heathens and Christians. Only here the action of evangelism is dramatically reversed. Let me be clear on this point: the figure of San Simón has multiple and simultaneous referents (Catholic and Mayan) and is open to divergent interpretations. He is also related to Maximón, by all accounts. My point is that Herzog reduces and concentrates the numerous deities and their innumerable representations into a single Mayan god. Given the show's intended audience, Herzog errs on the side of simplicity, familiarity, legibility, and comprehensibility, which is consistent with the epic television series in which it appears. At the same time, he trades on a Manichean dualism not only as a means of engaging Christian viewers but also—and here is the strategy—as a way of envisioning a New World in which the Indians recruit the Christians and the latter are eager to join. Although it is intended for a Western audience, and precisely for this reason, Herzog's film engages the baroque and its transformation as an "art of counterconquest" (Lezama Lima).

God and the Burdened concludes by returning to the Holy Week events in Antigua, a move that makes explicit the film's underlying connection between the Mayan and Christian gods. It does so by means of a bookend structure: here, as in the film's beginning, we see a procession of passion figures, but it ends with the figure of Death, who is carrying a scythe in

A *cristo sangrante, God and the Burdened* (2000).

one hand and a globe in the other. Again, we see a *cristo sangrante,* only now it appears to be a transcultured figure merging Mayan and Catholic traditions. It immediately conjures the indigenous tradition of the "image as presence," the ancient idea that the visible image literally incarnates spirit and thereby makes it physically present for the viewer to experience.[100] This is also the context in which San Simón and Maximón claim the privileges of the body: they smoke, drink, and work miracles like living saints and gods. At the same time, the *cristo sangrante* also evokes the Counter-Reformation tradition of "transubstantiation," the idea that the Eucharist is the literal conversion of Christ's body and blood into bread and wine.[101] To these traditions, I suggest, Herzog adds a third, totally unorthodox one: that of documentary cinema. However anachronistic the religious iconography may seem, the sensuousness of the flowers, saints, and *cristos* evokes as well the iconic, corporeal, tactile, and transient properties of the film medium. Ultimately, Herzog offers "film" as the metaphorical extension of the syncretic religious image.

Addressing the crowd of more than ten thousand people, a church

leader speaks into a microphone: "Let us now witness the Descent from the Cross, at the side of the Blessed Virgin. Brethren, to this day some people denounce the Catholics as idolaters, but these people do not understand the value of conveying a message through visual means. In this moment, without any words, we will receive a message."[102] There the dialogue ends. The camera, by contrast, holds to show the *cristo* being arranged on pillows, before an altar, ending with a tightly framed image of the figure's open hand. In the final shot, the hand appears to move (however slightly) on its own, as if animated by the spirit that it is believed to contain—a movement that is captured by the camera and thus made visible for others to see. Like the "message" that is visual and unspoken, the movement of the hand itself gestures toward a question: who exactly is the spirit animating this image?

Herzog produces documentary images that trade on the power of religious iconography, even while undercutting the latters' cultural authority. Seen as part of the television series coproduced by the Roman Catholic Church, *God and the Burdened* represents an act of provocation. It not only urges viewers to question some of their most basic assumptions and fundamental beliefs but also urges them to consider the disruptive, provocative, and resistant power of visual images.

As Zamora reminds us, however, the Church has long developed its own policy and its own cultural practice of syncretism.[103] This is also true of its current media policy, as evidenced by the *2000 Years of Christianity* series. Indeed, the closing frame sequence (omitted from the version released by Herzog's company) reappropriates the imagery as well as the language of Herzog's episode, especially its final word, "message" *(Botschaft)*, which is repeated and reframed, as if to contain and control its possible meanings. The series narrator thus concludes:

The message of Christ, the message of love: it has been received by Christians in every century, in every part of the world, in ever-new forms. Ever-new approaches to religiosity have developed from this single source, including the strangest forms of Christian devotion. History has allowed them to grow like colorful flowers, and has always combined ancient traditions with new ones, thoroughly personal forms of Christian faith, which have often become involved in conflicts with

one another. No one, however, may claim the right to pass judgment on these serious forms of personal faith. For love and tolerance form the very core of the Christian message.

Nothing in the preceding forty-five minutes leads to this conclusion. On the contrary, it directly contradicts the film's argument about coercion, the fascination with forms of resistance, and the proliferation of questions. The abrupt and apparently willful reinterpretation of the frame sequence is even more striking on the English-language sound track because there the entire commentary is spoken by the series narrator, who now seems to blatantly contradict himself by "changing his story" at the last minute and for no apparent reason. Again, the point of noticing such variations and inconsistencies is to suggest the complexity of perspective that is an integral part of this material. The series and the episode operate at cross-purposes, issuing not one but multiple, divergent, even contradictory "messages," which the audience is left to negotiate.

5 CULTURAL POLITICS

"The Case of Herzog"

In recent years, Herzog has frequently revisited certain political concerns of his earlier work, including the charges of environmental and human rights abuse that were leveled against him throughout the 1970s and 1980s, the most famous incident being Herzog's altercations with indigenous Peruvians during preproduction of *Fitzcarraldo*, a concern that received wide attention at the time, both in print and on film.[1] The various rumors, allegations, and stories that circulated in the press became known in West Germany as "The Case of Herzog."

Filming in a remote location near the contested border of Ecuador, Herzog ventured into a political jungle filled with rival factions, each with a certain interest in the area, including multiple different native councils, intertribal organizations, religious missionaries, social scientists, political activists, oil and lumber companies, federal ministries, and government soldiers. The preparations for and production of *Fitzcarraldo* have been chronicled at length from many different and often conflicting perspectives.[2] Only the briefest summary will have to suffice. In 1979, while negotiating with certain members of the Aguaruna community in the northwest of Peru, "Herzog found himself in the middle of an internal power struggle between members of the community in favor of working for the film and an inter-tribal group fighting for control over Indian affairs in that area. When Herzog refused to negotiate solely with this latter group, rumors of persecution of the Indians began to spread. The stories got sensational press, in Peru as well as in Europe" and the United States.[3] The various charges leveled against Herzog—though alleged and meant to provoke controversy—offer a sense of the chaos that preceded

the film's production. They include violations of native sovereignty, attempted bribery, slave labor, breach of contract, gun running, armed intimidation, and false arrest and imprisonment (with support from local police and military forces). In the words of his most outspoken critic in Germany, Nina Gladitz, who also accuses Herzog of "fascism" and compares him with adherents of the Third Reich, "Herzog's behaviors can in no way be distinguished from the policies of an occupying power that corrupts the natives in order to secure and expand its sphere of influence."[4] In his defense, Herzog maintains that he was a convenient target for various organizations whose previous resistance against larger forces of political, economic, and cultural domination had proved to be ineffective. Although the controversy would mark his fall from grace in the eyes of many film viewers, his visibility in the international press as a celebrated young German filmmaker now became a liability. In this case, ironically, it was the director who accused his critics of fabricating stories, inventing evidence, and producing false witnesses (not the other way around). Amnesty International cleared him of all charges concerning human rights violations, but the accusations and suspicions of abuse have stuck to the director ever since.

In a way, the case of Herzog has never closed. Or rather, it has been reopened again and again—not by historians of German cinema, most of whom later ignored Herzog, whether out of disdain or embarrassment, but rather by the filmmaker himself. He is, understandably, sensitive to the stigma that attached to him as a result of this controversy, and he responds to it in his films as well as in interviews.[5] This movement of reopening characterizes much of his endeavors since *Fitzcarraldo*, especially (but not exclusively) his work in documentary.[6] As I will show, Herzog appropriates documentary conventions and forms of truth telling and puts them in the service of reenacting and thereby reworking his own cinematic past. My key examples are *The White Diamond* and the lesser-known short *Ten Thousand Years Older*. The project begins much earlier, though, with the film he made immediately following *Fitzcarraldo*, namely, *Ballad of the Little Soldier*. Each of these films rehearses certain stock situations of cultural encounter, which also refer back to the entangled legacies of Herzog and *Fitzcarraldo*. The result, I suggest, is a form of double rehearsal that conducts politics via

performance. It is a familiar move in the context of performance studies, but the idea of "doing politics" in this sense has yet to be explored in Herzog's documentaries.

The topic of colonialism, by contrast, is well-trodden ground in the Herzog scholarship, particularly with regard to *Aguirre* and *Fitzcarraldo*. Lutz Koepnick, for example, has shown how each film deconstructs colonial practices of vision, imagination, and representation on the textual level, only to reinscribe and reinforce those same practices on the level of film production. Koepnick thus focuses on the textual contradictions between the expression of political critique and the impossibility of transcending the terms of one's cultural and epistemological context.[7] Working from a similar insight, John Davidson has emphasized the context of "neocolonialism" (or a new phase of Western domination operating primarily by economic means) as shaping both the production and the reception of Herzog's films. Part of a larger, more intricate argument about the formation of the New German Cinema and its cultural politics, Davidson's readings of *Aguirre* and *Fitzcarraldo* serve to support his claim that Herzog uses the appearance of colonial criticism in the service of continued domination.[8] It seems to me, however, that the practice of affecting a critical pose (as perhaps Herzog does) in the interest of continued domination (as Davidson and others have argued) corresponds well to the idea of performance, of which I will have more to say later. At this point, it is enough to emphasize the shared impression that Herzog might be "doing" one thing while "saying" another. It is this relationship (which can assume various forms, including irony, allegory, duplicity, and ambivalence, to name just a few) that urges us to consider the interesting possibility of performance as a framework for analyzing Herzog's films and their relationship to cultural politics. After all, as Philip Auslander has observed in another context, performance is of necessity "an elusive and fragile discourse that is always forced to walk a tightrope between complicity and critique."[9]

The role of performance as a strategy for political expression can already be seen in *Burden of Dreams* (1982), a documentary by Les Blank and Maureen Gosling. It is usually treated as a straightforward example of a making-of film, one that "observes" the production of *Fitzcarraldo* from a critical distance and "reveals" the psychology of its obsessive,

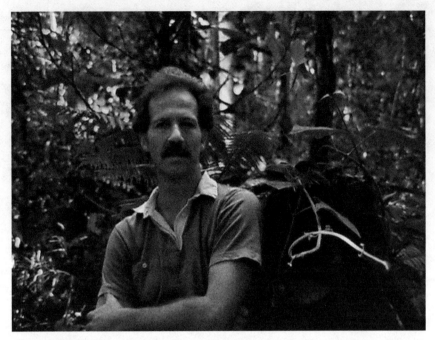

Herzog addresses the camera in *Burden of Dreams* (1982; dir. Les Blank).

overreaching director. This is somewhat odd, however, especially given the fact that Herzog invited the American filmmakers on this particular occasion, helped secure advance financing for their project, and negotiated with them through every phase of the project.[10] For these and other reasons, *Burden of Dreams* can best be understood as a relational performance engendered by the interaction of various filmmakers and social actors, who are each served by the film in different and sometimes conflicting ways. For his part, Herzog consciously stages himself as a means of provocation. In one interview, for example, he claims that *Fitzcarraldo* might be "one of the last feature films with authentic natives in it," before the latter fall victim to American-style consumerism and cultural homogenization.[11] "They are fading away very quickly," he says of tribal peoples in the Amazon, "and it's a catastrophe and a tragedy that's going on. And we are losing riches, and riches, and riches; we lose cultures, and individualities, and languages, and mythologies." As he speaks, the image track shows native actors posing for the camera in historical costume, followed by a set worker who is wearing a "Mickey

Mouse Disco" T-shirt, which reads (in Spanish) "Don't Stop the Music." Herzog's polemic not only idealizes native peoples and trades in cultural stereotypes but also recites the exact argument that critics used against him in protesting the production of *Fitzcarraldo* and its impact on local cultures.[12] He echoes and employs the words of his critics for an effect— in this case, to promote his new movie. The actual consequences of his performance as a filmmaker, however, were always beyond his control.

The making of *Fitzcarraldo* was an event so ideologically charged that Herzog has knowingly reenacted it, again and again.[13] In so doing, he is not alone; indigenous performance offers an unexpected connection, which is also worth recalling. On December 1, 1979, shortly after Herzog and his crew began filming in the jungle, their camp was burned to the ground by an armed group of Aguaruna Indians, who saw the camp within a longer history of foreign invasion and occupation. As Gosling reports in a published journal entry from 1981, "the camp was actually burned twice, the second time by Aguarunas who hadn't been in on the first burning! And to this day, at the conclusion of their community assemblies, they repeat a theatrical representation of the burning of the camp, as a reminder of their success at expelling outsiders, Herzog's and another group 50 years before."[14]

Fitzcarraldo with a Difference

Herzog's films are neither politically oriented nor politically inert. As such, they are especially vexing to politically minded critics, as the filmmaker is well aware.[15] It is significant, then, that his (authored) documentaries sometimes foreground a passage, even a mere detail, of blatant sociopolitical significance, just long enough either to foreclose the subject or to let it seem to drop out of the picture, abruptly and without explanation.[16] Conventional means of politicizing documentary are intimated but cut short. What remains is a clear sign of self-awareness (Herzog is not naive, despite all claims to the contrary), a vague sense of irony (some might say evasiveness), and a lasting impression of strategy (especially if the detail is taken to be a red herring). There is indeed a method to Herzog's madness. Regarded as performance, the supposedly apolitical documentaries become specifically political, though in terms

that are unlike those favored by the more explicitly politicized examples of the New German Cinema. The fact that he mostly operates outside of Germany allows him greater latitude in his practice and makes him a different type of political filmmaker than most discussed by scholars of German film. His is not a kind of issue-oriented political sensibility (which is peripheral to his work), nor does Herzog investigate the larger political formations that engender the specific situations that concern him. The register of political analysis here is not the content of a film's commentary (as it is in social-issue documentaries) but rather the role of embodiment and reenactment. The politics of performance lies in its understanding of documentary as a means of provocation, even self-provocation.

The salient issue thus becomes one of generative repetition. It helps to recall Schechner's model of performance as *restored behavior,* which he also describes as *twice-behaved behavior.* Both formulations define performance as behavior that is constructed, reproduced, and subject to revision (they do *not* imply that performance somehow recovers an "original" act). To explain what he means by this concept, Schechner draws an analogy to film editing and the use of found footage, which also bears repeating: "Restored behavior is living behavior treated as a film director treats a strip of film. These strips of behavior can be arranged or reconstructed; they are independent of the causal systems . . . that brought them into existence. They have a life of their own. The original 'truth' or 'source' of the behavior may be lost, ignored, or contradicted—even while this truth or source is apparently being honored and observed."[17] The theoretical separation between the performing self and the behavior performed makes performance transmissible and thus intelligible and available to others. Furthermore, the notion of restored behavior offers a way of theorizing reenactments that refer back to events that never actually happened because it acknowledges that the repeatable form of any event is necessarily a construction. It also helps explain how performance is at its core a way of knowing, a form of epistemology that can be reshaped over time. In the words of Elin Diamond, "performance marks out a unique temporal space that nevertheless contains traces of other now-absent performances, other now-disappeared scenes."[18]

It is from this perspective that Herzog's documentaries can also be

seen as performances based on other performances. The creative dynamic is one of reenactment in a new context. The effect is one of repositioning. Herzog uses the documentary mode to reposition himself for a new generation of media-savvy spectators who are deeply interested in reality formats and remarkably accepting of their theatricality—spectators who recognize the strategic function of "claiming the real" and acknowledge it as a construction.[19] The wide-scale release of his latest documentaries (through various channels, including film festivals, commercial theaters, cable television, DVD sales, and video-sharing websites) means that their appeal, while certainly including those viewers who already "know their Herzog" (and therefore bring with them certain expectations of and associations with the filmmaker and his past), also extends beyond them to reach other viewers who are encountering his work for the very first time.[20] Appealing to such diverse audiences simultaneously is perhaps the only way for Herzog to both reposition himself in relation to the past and stake a new claim for his films in the present. The formative experience of spectatorship, then, cannot be stressed enough. As Diamond has written in another context, "while a performance embeds traces of other performances, it also produces experiences whose interpretation only partially depends on previous experience."[21] The productive dynamic of reception reminds us that Herzog's documentaries not only reinscribe earlier performances but also reinvent them.

The strategy in each film, as we shall see, is to rehearse (more than once) a stock situation of cultural encounter or what performance theorist Diana Taylor calls a "scenario." By that she understands a dramatic structure "that is formulaic, portable, repeatable, and often banal because it leaves out complexity, reduces conflict to its stock elements, and encourages fantasies of participation."[22] What makes this structure useful for the purpose of my analysis is that it captures the important role of repetition (even cliché) both within and across Herzog's films, while insisting on a multiplicity of possible versions, perspectives, and interpretations. It is the specific mixing of triteness and multiplicity, of repetition and reflexivity that characterizes the scenario as a *multicoded performance,* a term Taylor uses to describe certain indigenous practices but one that also builds on theories of postmodern aesthetics.[23] Because scenarios are so widely understood, they are particularly susceptible to

parody, resistance, and subversion. A major example is the act of "discovery" and its vital role in the history of intercultural performance in the Americas. Inherently theatrical, as Taylor and others have shown, discovery scenarios have been rehearsed and revised for more than five hundred years.[24]

To clarify my approach to this material, and spare readers of unnecessary confusion, I need to address a few issues up front. One has to do with the direct and indirect citation of Herzog's films. The issue of citation is typically framed in terms of authorship and understood as a textual strategy for maintaining the director's status as an "auteur."[25] From this perspective, one could certainly argue that Herzog's films always refer back to his earlier work, perhaps especially to those films for which he first achieved an international reputation. What I am suggesting, however, is that we use a different analytical framework—that of performance—to analyze the politics of citation and the "work" it does in specific films. The act of citation can be seen as part of a larger performance, which is equally devoted to producing effects in the present and forging a new relationship to the past. In a hybrid medium such as film, issues of textuality and performance are always intertwined and cannot be neatly separated. They can, however, be studied in relation to one another, and Herzog's documentaries offer rich ground for this endeavor. The second issue has to do with intentionality. The material under discussion does not suggest another case of what Freud called a *repetition compulsion*. It is rather the strategic, differentiated use of repetition, and the desire to repeat, that interests me. Intentions, much less those of a wily director such as Herzog, are never clear. Nor must they be, however, for us to explore his work through a performance lens.

Although it is not surprising that Herzog has often revisited the contested terrain of *Fitzcarraldo,* it is interesting that he has done so both in the context of documentary and by rehearsing certain well-known scenarios of discovery. Performance as reiterative behavior becomes a way of reinventing his cinematic past, while promoting its rediscovery by an ever-changing audience. To emphasize performance as an analytical framework is to gain an outside perspective and bring it to bear on the films. What emerges from this perspective is the central role of performance in Herzog's documentaries as both a postcolonial method and a

political strategy. Michael Chanan has recently called for new approaches to the politics of documentary and how documentary films intervene in public debate, emphasizing the need to rethink the possibilities in each regard.[26] The subsequent discussion contributes to this project by exploring the case of Herzog and its many reopenings.

Guerilla Tactics

To make a film about the oppression of Miskito Indians in Nicaragua, even as Herzog himself was still being attacked in the press for his treatment of natives in Peru, was a "combative decision," as Timothy Corrigan aptly describes it. *Ballad of the Little Soldier* was practically "begging for a political scandal."[27] In spring 1985, after being broadcast on West German television, where the film was denounced by intellectuals on the left, most notably Günter Grass, it went on to appear in a number of art house theaters around the United States. Here George Paul Csicsery reported,

> The film has become a controversial element in the propaganda struggle between the Sandinistas and the US-backed Contra rebel groups fighting to overthrow them. At the center of the controversy is the Sandinista accusation that *Ballad of the Little Soldier* is damaging to their cause because it can be exploited by their enemies—the Contras and the CIA. Herzog has countered that he is not against the Sandinistas, but simply for the Miskitos.[28]

In this case, and in stark contrast to the situation he had encountered in Peru, the defense of Indian rights was construed by his detractors as a *counter*-revolutionary position and thus a tacit endorsement of the Reagan administration and its covert operations in Nicaragua and throughout Central America. It was a political myth, to be sure, but a powerful one, with a live function in cultural politics at the time.[29] Critics focused almost exclusively on discrediting Herzog and on defending the reputation of the Sandinistas, while largely ignoring the film. Its apparent one-sidedness appears to have precluded close analysis, while provoking criticism that was even more one-sided as a result. That

critics rushed to the defense of the persecutors (and not the victims) raises some thorny ethical and political questions of its own. What interests me, however, is the film's use of native testimony and how that testimony in turn produces a surplus of memories in the present.

Ballad of the Little Soldier begins with a performance of a most unusual kind. We see a young boy in military uniform holding an automatic rifle and sitting beside a cassette tape player. He presses the "play" button and sings along to a popular love song in Spanish. That the lyrics are neither glossed nor translated serves to foreground the singer's body, gesture, and voice. As he sings before the camera, the child appears to be "almost affectless," an impression that is only strengthened as the camera zooms in on his face. "It is as if something speaks through him," writes Prager, invoking the idea of "ventriloquism."[30] An audiovisual emblem, the opening scene immediately poses the question of voice in the sense of agency, authority, and experience. Whose voice or voices are we hearing? It is a question that, once raised, must also be asked of Herzog's documentary. The film's title, which is briefly superimposed over the image of the singing boy, echoes the issue of voice and gives it a lyrical inflection. Ballad is a fitting term for a film that, on one level, gathers evidence, transforms it, and represents it in a poetic key.

On another level, as a war documentary, *Ballad of the Little Soldier* also lays a certain claim to history. This is the level at which Herzog most directly intervenes. Voicing the commentary, he begins, "Nicaragua, spring 1984. A Miskito Indian village in the jungle on the Atlantic coast, in the east. The area is at present a combat zone, and it took us three weeks on foot, through jungle and swamps, constantly behind enemy lines, to reach a little settlement with our cameras." Thus the commentary immediately produces a sense of drama, of trespassing on dangerous ground, a vague area of reference that is never clearly delineated. Its porous and shifting boundaries create within the film a space of contestation—indeed, a space of interpretation—open to projected memories, meanings, and associations. Herzog in turn styles himself as insurgent, a guerilla filmmaker engaged in a covert operation, ever wary and on the move. The following passage even depicts a "commando raid" on a military convoy—an event Herzog narrates in a way that stresses his physical presence on the scene. Almost as soon as it begins, however,

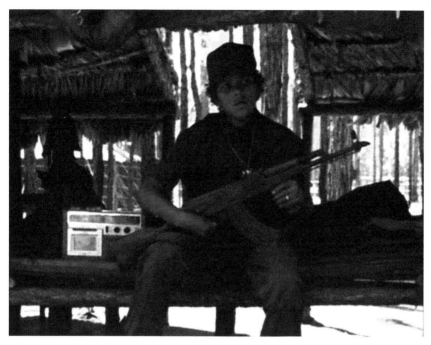

The opening song, *Ballad of the Little Soldier* (1984).

the drama of guerilla warfare becomes a futile detour through the jungle, devoid of action and heroic achievement. A physical ordeal that abruptly ends in failure, it is an unmistakable sign of the filmmaker's involvement.

In this operation, Herzog is not alone. He is accompanied by Denis Reichle, "who has been living among the Miskitos for several months, and has prepared our work." A photojournalist for *Paris Match, Der Spiegel,* and other news services, Reichle worked extensively in war zones and former colonies, including Angola, Cambodia, and East Timor, as well as in Nicaragua. There, as Herzog explains in an interview, Reichle "had started to make a film about child soldiers and got stuck with the project, and he asked me to help."[31] The resulting film calls attention to its hybrid, collaborative status, bearing as it does the traces of two different yet intersecting projects. On one side, it engages the practice of training and mobilizing children for war. On the other side, the film becomes a guerilla operation in its own right, a counterattack by Herzog on his critics at the level of the film's address. The two projects connect by means of voice: through song, narration, and testimony.

The voice-over frames the material in terms that resonate with both projects at once. Consider how Herzog situates the Miskito people historically and politically:

A military camp of the Miskito underground army, the Misura. The Miskitos have always been badly treated. Somoza's soldiers plundered their villages. In the revolutionary struggle of the Sandinistas against Somoza and the CIA, the Miskitos sided with the Sandinistas. Today, because of the failure of the Sandinistas to deal with them any better, many of the Miskitos are fighting the new rulers of the country. The Indians have no illusions. They know they will always have to defend themselves, regardless of who succeeds the Sandinistas. What is of historical importance is that, for the first time since the Spanish conquest of Latin America, an Indian tribe has taken to armed resistance.

In a few brief lines, Herzog frames the present situation of the Miskitos within a history of colonial encounter. In this case, native peoples are discursively figured as historical victims of atrocity, now actively fighting in resistance.

From the beginning, *Ballad of the Little Soldier* puts emphasis on the atrocity of conquest and frames it in terms of a particular scenario: that of the Indian massacre, a scenario that Csicsery describes as "an essential outcome of every Indian insurrection recorded since the days of Bartolomé de las Casas (1474–1566), the first European champion of Indian causes."[32] In the context of Herzog's work, this scenario is reminiscent not only of *Aguirre,* which depicts an episode of the Spanish conquest, but also of *Fitzcarraldo* and its production, the latter being a very recent event in which Herzog was personally implicated. Here, as in other versions of this scenario, according to Diana Taylor, "the native body serves, not as proof of alterity, but merely as the space on which the battles for truth, value, and power are fought by competing dominant groups."[33] *Ballad of the Little Soldier* revises the Indian massacre as a collection of survivor testimonies, a move that in turn enables a process of witnessing—for the filmmakers as well as for their subjects. This use of firsthand testimony relates back to the making of *Fitzcarraldo.* As Herzog said to journalists at the time, "You weren't there. I don't possess the

truth either, but I do have one advantage over you: I am an eyewitness."[34]

With this film, Herzog momentarily refashions himself as a political thinker, engaging the work of committed documentarists and directly addressing their audiences. Writing in 1984, the year in which *Ballad of the Little Soldier* was first released, Thomas Waugh observed that "documentary continues to be a privileged medium—indeed, *the* privileged medium—for committed artists and their publics, and a resource of first priority for the political activist."[35] Its growing importance in political disputes could be measured not only in terms of state propaganda but also in its use by revolutionary undergrounds and their international networks of support. In the 1970s and 1980s, independent documentarists from the Europe and the United States were traveling to combat zones around the world, including much of Central America.[36] Notable productions include *From the Ashes: Nicaragua Today* (1981; dir. Helen Sollberg Ladd) and *Nicaragua: Report from the Front* (1984; dir. Pamela Yates and Deborah Shaffer), in which Yates and her cameraman (Thomas Sigel) accompany a Contra unit on a raid against the Sandinistas. Both reports were broadcast on national television in the United States. The latter also appeared in theaters along with *When the Mountains Tremble* (1983; dir. Pamela Yates and Thomas Sigel), a more important and controversial film about the war against insurgent peasants and natives in Guatemala, featuring native activist Rigoberta Menchú, who tells her story—and that of others—on camera. Collectively, these films represent the conventions of war documentary that Herzog appropriates and repurposes in *Ballad of the Little Soldier*. They also helped shape the reception of Herzog's film among the political Left in the United States and beyond.[37] For the purpose of this discussion, they offer a useful framework for comparison and contrast.

All these reports involve a mix of interviews, camp scenes, jungle marches, combat sequences, and atrocity testimonials—a potent mix that remains a sort of baseline for war documentaries today. All of them emphasize the adventurous activity of the filmmakers as daring risk takers; in this regard, too, Herzog is not alone. Unlike these examples, however, *Ballad of the Little Soldier* offers an absolute minimum of political context. As Herzog says in an interview, "it does not matter what political content there is when you have a nine-year-old fighting in a

war. Child soldiers are such a tragedy that you do not need every single detail of the conflict."[38] Unlike the other films, moreover, *Ballad of the Little Soldier* is not (so to speak) preaching to the choir. If anything, as we shall see, the film orchestrates a choir of its own voices. The salient question here is not only who is speaking but also—more important, perhaps—who is listening. Finally, in sharp contrast to the other reports, *Ballad of the Little Soldier* appears to be blatantly one sided, without, however, explicitly advocating a certain political view. It never pleads for action of any kind, though it certainly plays into the argument of Herzog's opponents.

The appearance of bias leaves the film wide open to even the most basic criticisms of fairness in reporting. Writing in *The Nation,* one critic bemoans the fact that "Herzog made no effort to talk with representatives of the Nicaraguan government or to visit settlements where Miskitos have not sided with the contras."[39] In this case, however, journalistic notions of fairness and balance are not only beside the point; they are implicitly rejected as misleading and not conducive to meaningful political analysis (as if there were only two sides to consider). The point can be made more vivid by example. In one passage, Herzog accompanies a teenage girl and an older man, both soldiers of the Misura, who return to their former villages of Sang Sang and nearby Asang. In early 1982, each of the villages was razed, its inhabitants either killed or maimed and left to die. "*Probably,*" says Herzog with noticeable emphasis, "the Sandinistas wanted to rapidly advance the Miskitos into modern forms of socialism. That meant having to destroy the old village structures." The emphatic use of qualification doubles as a marker of self-awareness. Because he decided not to give the Sandinistas a voice within the film, Herzog can only guess what the motivation for such an act of violence might have been.

And yet *Ballad of the Little Soldier* can hardly be described as propaganda for the Contras. The point seems obvious in retrospect. Consider how the filmmakers engage with the drill instructors, some of them, we are told, former members of Anastasio Somoza's National Guard. Near the end of the film, Reichle appears again on camera, this time at a Misura training camp, where he speaks (in English) with a gregarious drill instructor. When Reichle proposes that the training of children in warfare

is tantamount to "brainwashing" them, the instructor frankly agrees. Another example is worth mentioning: an earlier scene of a motivational speech addressed to the young soldiers. After only a few moments, Herzog interrupts his own running translation to comment, "The instructor is lying because of the camera. The camp is in Honduras, not Nicaragua." What begins as propaganda is "revealed" to be a deception, intended to make the rebels appear to be more central and powerful than they really are. In playing to the camera, the instructor makes certain assumptions about the politics of the filmmakers and their project. Rather than play along, Herzog gives the lie to the instructor's speech, and he does so conspicuously, to be witnessed by the film audience. According to Csicsery, a documentary filmmaker in his own right, "the technique is designed to hold the audience's trust in Werner Herzog's integrity, a trust that Herzog seems aware is to be severely tested by this film."[40] Ultimately, it is *our* relationship with the filmmaker that is at stake here (and not the counterrevolutionary cause). In this sense, the film itself is not just a provocation to Herzog's critics, but also a way of testing and modifying his own public image as a filmmaker. In later years, documentary would become even more central to his work, not least because it foregrounds an ethic of responsible filmmaking, the violation of which Herzog had come to embody in the eyes of his critics.

All claims to the contrary notwithstanding, Herzog both recognizes the existence of other perspectives on the Miskito uprising and appreciates the social value and historical importance of Nicaragua's revolution. In a June 1985 letter to Csicsery, responding to the latter's interest in Herzog's response to his critics, he writes, "Looking at the history of Nicaragua and looking at the needs and hopes of the people, one must be out of his mind if he does not see and feel the achievements of the Sandinista movement. I simply am not blind in the other eye."[41] The accusation of critical blindness is also the defense that Herzog employed against his critics during preproduction of *Fitzcarraldo*. From this perspective, then, *Ballad of the Little Soldier* creates the impression of one-sidedness for an effect, while operating on multiple different levels of reference at the same time. This should hardly be surprising from a film that assigns priority to embodied experience.

Ballad of the Little Soldier consists largely of folk songs and native

testimonies. Together, they give voice—indeed, a chorus of voices—to the victims of atrocities against native peoples past and present. The singing of love songs, in particular, evokes at once the pleasures of living and the tragedy of child soldiers who might not live so long as to enjoy such experiences. An even more emotionally potent strategy of representation is the use of survivor testimony, which has the effect of summoning not only a scenario of colonial violence but also a process of witnessing. In a court of law, as Shoshana Felman has emphasized, testimony is generally summoned in response to a "crisis of truth," when the facts of a case are in doubt, when historical accuracy is challenged, or "when both the truth and its supporting elements of evidence are called into question."[42] The crisis situation in this film is doubled: though testimony is provided regarding the Sandinistas and their crimes against the Miskitos, there remains a crisis of truth surrounding "the case of Herzog." The native voices we hear in this film are not only different from the voice of Herzog's commentary but also put in relation to it. While the voice-over serves to identify the Sandinistas as perpetrators and the Miskitos as victims, testimony supplies the evidence. It is a form of evidence that does not so much prove anything as "transmit" by means of affect, silence, and body language. At the same time, the survivors in this case (men, women, and children) are not speechless; they speak out and use the film as a way of being heard by others who might be listening. Documentary film thus catalyzes survivor memory, creating the conditions for witnessing as an act that takes place in the present.

The performance of each testimony embodies a unique experience of what happened in the past and makes that experience imaginatively and viscerally available for others to witness in the present. At a refugee camp in Honduras, one man describes a Sandinista attack on his village and his desperate escape from Nicaragua in early 1982. He not only speaks on camera but also shows the remaining scars that cover much of his body. A group of women from the same village tell of their children being shot and killed. Each testimony is multiply translated: once (into Spanish) by an interpreter who appears on camera, again (into German and English, respectively) by Herzog's narration, and yet again by the recording technology (into a mutable and reproducible format). It is important to emphasize that Herzog, too, assumes the figure of witness by audibly

posing questions off camera. The sound of his voice registers his physical presence on the scene, creating a spatial relation to the subject that is different from that which is suggested by the voice-over as a device, which he alone controls. "Did she see how her children died?" he asks, referring to the experience of one woman in particular. The translator is also a part of this ethic of witnessing, making it explicit by literally embodying the process of mediation and interpretation. Filming at a different location—a Misura training camp—Herzog and Reichle speak with a group of child soldiers, and the shift in perspective (from that of the mothers) is striking. A ten-year-old boy tells of seeing his two younger brothers murdered by government soldiers: "They just killed them for fun." Of his mother he says in the same monotone voice, "They cut her up like a piece of meat, and then they shot her. Then I came here [to the camp] all by myself." Although he projects a cold, almost detached attitude to such extreme suffering and death, the reproduction of his testimony, including the very coldness of his affect, implicates the body of the film viewer in the act of witnessing. Here and throughout the film, testimony urges the viewer to imagine what happened to others, and to do so in one's own body, creating an intensity of visceral experience that is usually afforded only by direct proximity or involvement.

In this case, the survivor memories catalyzed by the camera further evoke a displaced victimhood: that of Reichle's own. Beyond his role as a war photographer, he, too, bears witness to a childhood trauma in the film's penultimate scene. Only then does the viewer learn of this displacement from the professional to the personal. Standing behind a row of children in uniform, Reichle describes his experience of being drafted into the *Volkssturm,* a division of the German army comprising all ages and charged with serving as Hitler's last line of defense:

It reminds me of a very sad story, when I was myself fourteen and was involved in Berlin and in Germany, in the last hours, in the last weeks of fights against the Russians. And we also believed we got to save the country, and many of us stayed there, died. . . . In the age of thirteen, fourteen, if somebody tells you, you're a man and you've got to fight for the country, you automatically believe it and you go. And that's what I see here again. It happened to us forty years ago, and it

happened around the world, all over, every time. I can't put [it] out of my mind, when I see all these kids. For me, I see them practically dead.[43]

Though haunted by World War II, and Reichle's traumatic experience of it as a boy, the entire film is not "orchestrated" around this revelation.[44] Apart from the drama of revelation, there is no compelling reason to emphasize Reichle's testimony over that of the film's many other witnesses. Their memories here intermingle, without simply canceling each other out and without being reduced to a single, all-encompassing structure of meaning.

Indeed, *Ballad of the Little Soldier* foregrounds the interconnectedness of all this material, or what Michael Rothberg has elsewhere described as "the multidirectionality of memory." By that he means "the interference, overlap, and mutual constitution of seemingly distinct collective memories that define the postwar era and the workings of memory more generally."[45] Rather than imagine a zero-sum game with different legacies vying for dominance, Rothberg suggests a more encompassing model of memory that allows for the cross-referencing of histories and the intersecting of contexts, however disparate they might seem on first inspection. This is also a productive way to think about Herzog's film, its surplus of witnesses, and their different voices, perspectives, and contexts. In many ways, *Ballad of the Little Soldier* enacts the process of witnessing as a provocation: to military regimes, to documentary filmmakers, to political activists, and to Herzog's critics as well. Above all, by means of testimony, the film produces an image of defiant victimhood: that of others and that of his own. Herzog as victim? The very idea would seem to contradict the sensationalized stories that one could read about him in the press concerning the making of *Fitzcarraldo*. Indeed, this is precisely the point. The entire film works to create an alignment between victims, past and present, real and imagined.

The Politics of Time

The documentary short *Ten Thousand Years Older* is Herzog's contribution to *Ten Minutes Older,* an omnibus project in which each filmmaker has a mere ten minutes to reflect on the theme of time.[46] Despite its extreme

brevity, and precisely because of it, the film is worth discussing with regard to Herzog's past. Its treatment of the discovery scenario is no less remarkable. In this case, Herzog employs a repudiated concept of time to shift the focus of visual interest from the mythical moment of intercultural encounter to its historical, social, and physical consequences for the "discovered." He spends the first five minutes of the film reconstructing a past event and the second five minutes showing another, more recent encounter. Adhering to a binary before-and-after structure heightens both the visual potency and the temporal abruptness of the juxtaposition.

Set in the Amazon rainforest of Brazil, the film begins—crucially— with the use of found footage. The first image shows a foggy jungle landscape that immediately recalls the opening shot of *Fitzcarraldo*. In this case, however, the image quality has been conspicuously degraded to connote "the past," giving clear indication of Herzog's intervention in the present. The degraded image (which is pixilated and has a cold blue-green tinge to it) results from rescan distortion, an effect produced by playing footage on a conventional television and recording the screen with a video camera. The picture has also been considerably enlarged to produce digital "noise" (little dots that appear to be different colors). As the pixilation resolves, more and more of the rainforest becomes visible. And it is rapidly being destroyed. Dramatic images of deforestation flash before our eyes: fires blazing through the jungle, gold diggers on the move. From the opening shot to the voice-over commentary, the entire setup rehearses the beginning of *Burden of Dreams*, which likewise quotes the opening shot of *Fitzcarraldo* but does so for the purpose of reframing it. In *Ten Thousand Years Older*, as in *Burden of Dreams*, a narrator—in this case, Herzog—sets the scene, describing the jungle's continuous invasion by settlers, miners, loggers, and soldiers and thereby creating a political context for intercultural encounter. The issues that attached to the production of *Fitzcarraldo*—colonization, capitalist expansion, environmental destruction, and cultural imperialism—are also at stake in this documentary short.

In a few sweeping lines, Herzog sketches a minimal yet efficacious version of the discovery scenario and situates it historically. "In the remotest parts of the jungle, a mysterious nomadic tribe, the Uru Eu Wau Waus, defended their territory against advancing settlers. In 1981, this last of the hidden tribes was finally contacted." A government-sponsored

Rescan distortion. The opening image of *Ten Thousand Years Older* (2002).

expedition was sent out, accompanied by a British–Brazilian film crew. "A hidden camera records the first contact." We see grainy color images of mostly naked men and women, who are visibly wary of ambush but unaware of being filmed. Anthropologists offer metal pots and utensils as gifts. Two of the Uru Eu men are visually singled out and identified by name: Tari, the group's "war leader," and his brother Wapo. Speaking from an omniscient position, Herzog interprets this fleeting moment of "contact" as a temporal transformation of the most radical kind: "What they do not know is that these minutes will propel them forward ten thousand years. It will be a progress into the void. A grim fate awaits them." The image track shows men, women, and children being treated with Western medicine. "Within a year or so," we are told, "the majority of the tribe is wiped out by chicken pox and the common cold—lethal diseases for them. They had missed out on the thousands of years during which they could have developed resistance."

Throughout his narration, Herzog employs a concept of time first developed in the context of anthropology, where it has served both as a means of constructing cultural difference and as an instrument for implementing power. As Johannes Fabian argues in his well-known

study, *Time and the Other* (1983), the project of modern anthropology aims to create temporal distance between "us" and "them." The primary technique has been to locate non-Western peoples either outside of time or in earlier periods (Herzog uses the term *Stone Age*). Fabian describes this technique as "the denial of coevalness," which is his translation of the German term *Gleichzeitigkeit,* by which he means being in time together.[47] A contrasting model of intersubjective time would collapse the distance between "us" and "them," precluding the notion of absolute difference. The denial of coevalness is more than just a rhetorical move. Above all, Fabian emphasizes the role of vision and visual forms of representation (such as illustrated travelogues, museum displays, and ethnographic performances) in creating a "synchronic" or timeless object that can be readily seen, studied, and known.[48] To control the coordinates of time and space in this way, Fabian contends, is to determine the conditions of domination. The assumption that the Uru Eu exist in another time is clearly a point of departure for the Brazilian expedition of 1981, as evidenced by the gifts of metal that the anthropologists bring with them. It is also a technique Herzog employs in recycling the footage of this event. Even when the long process of evolution is simply bypassed, he suggests on the voice-over, the cultural practice of othering is swift, severe, and relentless. But the politics of time are not as clear-cut as it might appear in the first half of the film, which consists entirely of found footage. For this "discovery" of a lost tribe was not in fact "the last event of its kind in human history," contrary to Herzog's narration.[49] Indeed, to identify the last in a long line of discovery scenarios is to perform a new act of discovery, which is either the one after the last or the beginning of a new series.

The found footage is thus immediately followed by new material, shot in 2001, showing Herzog with a few of the surviving Uru Eu. He is accompanied by a translator, who also appears on camera, and by "the same Brazilian cameraman, Vicente Rios," who worked on the ethnographic film. The cameraman's presence, like the voice-over commentary, creates a sense of continuity that links the new footage to the old. The location, as Herzog describes it, is equally significant: "We set up a meeting just outside the reservation at the hut of a rubber tapper." In other words, "we" are back in *Fitzcarraldo* territory, once again.

If the continuous reenactment of the discovery scenario has a numb-
ing effect, the image of its aftermath is vivid enough to be startling. Tari,
the tribe's former war leader, now suffers from tuberculosis and undergoes
treatment in a distant city. His brother Wapo appears to be physically
healthy, but his clothes tell another side of the story: the painter's hat
and T-shirt that he wears are imprinted with Portuguese slogans from
commercial advertising and local politics (not unlike the Mickey Mouse
shirt from *Burden of Dreams,* only here the signs of cultural transfer
are specifically Brazilian). The voyeurism of the hidden camera, which
mediated the scene of first contact, is exchanged for the apparent direct-
ness of a formal interview and the embodiment of native performance.
In contrast to the found footage, however, the new material emphasizes
the continued role of indigenous performance in conveying memory and
perhaps in coping with (if not healing) the so-called wounds of time.

The key passage shows Tari and Wapo each performing a type of rit-
ual, which is coded within the film as traditional but is clearly generated
by intercultural circumstances and made to be filmed on this occasion.
Herzog introduces the passage in terms of nostalgia, which presents the
performers in a manner that reflects back on his own practice: "They
love to evoke the glorious time, when they waged war against the white
man." Tari begins, chanting aloud and pacing back and forth, with bow
and arrows in hand. "His chant is a ritual reenactment of how he shot
a man, and how the victim wailed." From a fixed position, the camera
swivels right and left, repeatedly, following and emulating the move-
ment of the performer—that is, until Tari abruptly stops; the effects
of his tuberculosis prevent him from going further. Wapo steps in and
reenacts a different scene—this time, an attack on two white settlers
encroaching on Uru Eu territory.

There is a long history of showing tribal peoples as "last survivors,"
a practice traced by other scholars in terms of museum display, popular
entertainment, and ethnographic film.[50] The footage from 1981 offers
only a more recent example. In reworking this material, Herzog at once
contributes to the tradition of ethnographic display and comments on it
from within. The added material, from 2001, takes the temporal conceit
to its logical end and shows the outcome, which is predictable but usu-
ally goes unseen—especially in the context of ethnography. The diseased

performer, the native in Western attire, these are figures that preclude the possibility of showing "untouched nature" and "prehistoric" peoples, as ethnographic spectacles so often claim to do. Indeed, such visible signs of intercultural contact and exchange are precisely the conditions that ethnographic film and its nineteenth-century predecessors would systematically work to conceal. Rather than soft-pedal the social consequences of "discovery," Herzog puts them on display. "What will happen to the Uru Eu?" he asks in conclusion. "Tari has no illusions." And there the film ends. To show this situation is, for Herzog, to revisit the production of *Fitzcarraldo* and its surrounding controversy. *Ten Thousand Years Older* offers neither a revision of nor an apology for Herzog's cinematic past. It does, however, work to reposition Herzog as a filmmaker who confronts head-on the consequences of colonial encounter, and it does so by means of footage that was made for another purpose.

On Good Behavior

The spectacle of encounter, like that of suffering, foregrounds not only the temporal but also the ethical dimension of all this material. Clearly "the case of Herzog" raises a number of questions about the ethics and ethical implications of filmmaking and of Herzog's work in particular. In recent years, questions of ethics have been dramatically promoted from the margins of documentary studies to occupy "center stage."[51] Ethical debate here usually proceeds from certain distinctions between documentary and fiction film production, concerning the different assumptions, expectations, and working conditions they involve, even as commentators acknowledge that such differences are shifting and by no means fixed or absolute. Brian Winston thus claims that fiction films in general operate on "principles of 'amoral efficiency'—or inefficiency, as with Werner Herzog during the making in the Brazilian jungle of his movie *Fitzcarraldo,* memorialized in the documentary *Burden of Dreams.* . . . The amoral jocularity of Herzog's motto, *'a película ou morte'* [sic]: 'The Film or Death,' is undercut by his actual endangering of his extras' lives."[52] Added in passing to the second edition of Winston's book, the case of Herzog is supposed to provide an obvious counterexample to an ethics of responsible filmmaking in the context of documentary, grounded in

the filmmaker's moral and social obligations to those who participate in the production. What makes this use of example interesting, however, is that Herzog actually reflects and comments on this issue during the production of *Fitzcarraldo* (without, however, distinguishing between fiction and documentary). "You don't make a film alone," he says in one interview. "You can write alone. But when you make a film, you work with other people and enter a distinct field, in which specific categories of behavior—including moral categories—are necessary and have to be enforced. You can't just go around them. As for me personally, for example, I'd never ask somebody else to do something that I hadn't tried out myself in advance."[53] The point here is neither to mitigate nor to excuse the filmmaker's behavior but rather to question it more carefully, and to do so within the context of documentary debate. Ethics feature more prominently in Herzog's documentaries than critics have yet to acknowledge. And in this context, they tend to be understood in normative terms as a set of rules and moral choices, especially (but not exclusively) in the encounters between the filmmaker and his various subjects. So it is hardly surprising that some of these films should also reflect back on *Fitzcarraldo*. Nowhere is this dynamic more fully developed than it is in *The White Diamond*, a film that also deserves more attention in its own right. As I contend, *The White Diamond* represents a transformation of *Fitzcarraldo*, a self-critical rethinking and rehearsal of that film, at a distance of more than twenty years, by a Herzog whose evolution as a filmmaker, if Winston's study is any indication, has yet to be explored.

This film, too, begins with found footage. We see images of early aviation pioneers, experiments with various flying machines, "actuality films" of catastrophe—the Hindenburg dirigible in flames. They function as the point of departure for a movie about "the age-old dream of flying," as Herzog introduces it on the voice-over. As the use of found footage would seem to suggest, *The White Diamond* entails a virtual voyage of rediscovery. The scientific genre of the film expedition serves as Herzog's vehicle for returning (once again) to the South American rainforest as a site for exploring the memory of his cinematic past. Though many of the director's standard themes and previous films are referenced here, the project revolves around the making of *Fitzcarraldo* and, by extension, *Burden of Dreams*. It does so, however, without showing a single

outtake from either film. Instead, *The White Diamond* rehearses selected moments from those productions in a new context, experimenting with different variables and outcomes. The various flights, simulations, and expeditions that take place in the film are aptly described as "tests." *The White Diamond* is neither a serious scientific expedition nor a fake one. Rather, it is a self-conscious performance of a documentary film that requires the participation of social actors, even if they are completely unaware of Herzog's past or present concerns.

The efficacy of such a performance hinges on the embodiment of documentary subjects, by which I mean the potential of social actors to either occupy or be staged and seen in multiple different roles. The central figure is Dr. Graham Dorrington, a contemporary British aerospace engineer, who designs a miniature helium balloon that can carry two passengers and is specially built to maneuver around "the largely unexplored treetops of the rainforest," what Dorrington calls "the prospecting element of this project," referring to the film expedition. He, too, is haunted by the past: the death of German wildlife cinematographer Dieter Plage, who crashed in 1993, when flying an earlier version of Dorrington's airship over a jungle in Sumatra. "For Dorrington, the trip to Guyana becomes a confrontation with the past," according to the film's press kit. "Ever since Plage's crash he has struggled with feelings of guilt."[54] Though immediately situated as the subject of his own story, Dorrington is also staged as a double of Brian Sweeney Fitzgerald (aka Fitzcarraldo) and—most especially—of Herzog himself as director of *Fitzcarraldo*. Dorrington's dream of flying an airship over the rainforest activates a new scenario by summoning the past, namely, Fitzcarraldo's dream of bringing opera to the jungle and Herzog's dream of pulling a steamship over a mountain. In the process, Dorrington receives the expected treatment, figured as he is in equal parts mad, brilliant, eccentric, and ridiculous. What makes this combination so potent, however, is its shifting relationship to Herzog and to his mythical role as a filmmaker. When Herzog uses voice-over to comment on Dorrington's project, he simultaneously comments on the making of *Fitzcarraldo*.

At one point, Herzog makes a dramatic entrance onto the scene, abruptly shifting the register of his presence from the sound track to the image track. He does so, we are told, to "confront" Dorrington about

"issues of responsibility and principles" relating to the Dieter Plage story line. And yet Herzog's walk-on and the ensuing "argument" also refer to the ethics of irresponsibility that attached to his public image as director of *Fitzcarraldo*. By appearing on camera and confronting Dorrington on-screen, Herzog in effect stages himself at odds with his double.[55] The scene is played for humor, as indicated by the dialogue. At issue here is whether a cinematographer should be allowed to man an untested airship, as Dorrington had allowed Plage to do. Herzog intervenes and fundamentally dismisses such a practice as unprincipled—this, from a director who is notorious for taking unnecessary risks, often at the expense of others. Nevertheless, Herzog's intervention reiterates the very claim to morally principled behavior that he ascribed to himself as a filmmaker during the production of *Fitzcarraldo* ("I'd never ask somebody else to do something that I hadn't tried out myself in advance"). Thus the act of ethical decision making is put on display, lifted out to a degree from its immediate context and related back (albeit indirectly) to his contested public image as a director. Turning the issue around, he proceeds to question Dorrington about the wisdom of flying the airship *without* a cameraman. "There is such a thing as follies," Herzog remarks, using a term that many critics have used to criticize the making of *Fitzcarraldo*. "I accept that." Dorrington, however, objects: "This isn't a folly!" "No," says Herzog, "it is not a folly, but it would be stupid . . . to accept that you are flying without a camera on board." The scene culminates in an absurd bit of dialogue, as only Herzog can deliver it: "There are dignified stupidities, and there are heroic stupidities, and there is such a thing as stupid stupidities. And that would be a stupid stupidity not to have a camera on board. I am going to fly," he concludes. "I am going to fly with you." Laughing, Dorrington asks, in a final rhetorical gesture, "Do I have any options?" The scripted dialogue obviously works to put Herzog in the airship, where he can act out his reputation as a daring risk taker and simultaneously be seen as a filmmaker who physically endures everything that is shown on-screen. In this case, rather than put a cameraman at risk, he literally takes the camera into his own hands and thereby enacts the standard of professionalism, code of conduct, and obligation to others that he has claimed to uphold throughout his career. The entire scene flaunts the complexity of Herzog's recent work

Herzog confronts his double, *The White Diamond* (2004).

in documentary and its relationship to the ethical issues that cleave to his cinematic past. That relationship is constituted by the embodiment of Dorrington as multiple different figures and by Herzog's dramatic interaction with them before the camera. A performance lens allows us to recognize the different roles played by the director and his double: Herzog is at once the parodist and the parodied, the hero and the villain, the ethical and the unethical, the dreamer and the demystifier of his own dreams.

The White Diamond is a joint venture in documentary, with Herzog and Dorrington each having a different stake in the project.[56] Theirs is an expedition that is organized, rehearsed, and staged for the sole purpose of being filmed. In other words, the film is the occasion for the flight and not the other way around; without the film, this particular expedition would never have taken place. When Herzog states on the voice-over, "*We chose* the area of Kaieteur Falls, deep in the rainforest of Guyana in South America,"[57] the phrasing stands out because it signals not only the constructed nature of the event but also the collaboration it involved.

The rainforest in this film (as opposed to the jungle in *Fitzcarraldo* and *Burden of Dreams*) is discursively figured through a trope of idyllic nature, usually associated with earlier periods of maritime exploration and colonial expansion. "Here," as Herzog narrates, "untouched

landscape and a diversity of flora and fauna are found in perfect unity." Nature as paradise? What happened to the director's infamous assertion of the jungle's murderous aspect? The image track mostly reinforces this idea of paradise, not only by the use of landscape pictures and aerials shot from the slow-moving airship but also (more subtly) by the occasional images of jungle wildlife. One passage—a seemingly unmotivated series of close-ups on insects and frogs as well as a snake and what looks like a huge iguana—playfully reenacts the most cited passage from *Burden of Dreams*: what I like to call Herzog's stump speech, in which the German filmmaker describes nature as "vile and base." While he speaks, the film cuts to show a variety of jungle insects and animals, the effect of which seems to either confirm or refute Herzog's view of nature (critics differ sharply on this point of interpretation). *The White Diamond* mimics the image track of this scene, without the famous monologue, and thereby achieves a rather different effect: conjuring an image of pristine nature that is the film's mythical setting.[58] There is, however, another passage that undermines this image, one that Herzog carefully prepares for the film viewer by describing it as "a complete change of setting." It is a brief visit to a local, Brazilian-owned diamond mine. Here, by contrast, the forest has been cleared, the ground stripped bare and reduced to a landscape of mud. What makes this exception so interesting is how it recalls and thereby implicates *Fitzcarraldo* in a visual critique of environmental destruction. The scene ends abruptly, without explanation.

Not only the setting but also the role of social actors within the film engenders a sense of "*Fitzcarraldo* with a difference." A former British colony and the only English-speaking country in South America, Guyana is an interesting destination, especially for those who can choose where they go.[59] Its colonial legacy is foregrounded by a passage that is strongly reminiscent of various scenes from *Fitzcarraldo*, from *Burden of Dreams*, and from the larger history of colonial iconography and travel literature. We see a line of men, hired as porters, carrying on their backs the component parts of Dorrington's airship and setting up camp for the film expedition. Herzog explains, "British colonial rule brought Indians from India and Africans from the Caribbean. The native Amerindian population has shrunken to a mere three percent. Many of these

men here are Rastafarians. This rough-and-tumble lot normally works as diamond miners." Former colonial subjects, they provide the film with its central metaphor, "the white diamond." And it is in conversation with local inhabitants that Herzog choreographs various scenarios of discovery.

One of the scenarios is widely familiar and has often been repeated in other contexts. It refers to the first Pacific voyage of Captain James Cook, an event synonymous with the great age of scientific discovery. Dorrington tells this story twice: first speaking directly to the camera, and later as part of a staged dialogue with Mark Anthony Yhap, a Rastafarian who is also a member of the film expedition. When Cook first approached New Zealand in 1769, his ship was in a sense invisible to the island's native inhabitants.[60] Because the European ship existed outside of their cognitive universe, so the story runs, the Maoris were unable to see it.[61] In yet another act of embodiment, Dorrington puts himself in the role of the explorer, and the residents of a local mining village are cast in the role of the Maoris. The scenario is actually rehearsed numerous times throughout the film, and the variations are significant. In one instance, Herzog and his crew appear to rouse a man from his hammock and ask him what he sees floating on the horizon, where the airship is clearly visible. "A white diamond?" the man replies quizzically, pausing and looking just past the camera (as if seeking either approval or guidance from the film crew) before he repeats the line. Instead of seeing a strange airship, or seeing nothing at all, he seemingly assimilates it to a category of local knowledge.

The ultimate site of discovery in *The White Diamond* is Guyana's famous Kaieteur Falls. It is here that the film returns to the central scene of *Fitzcarraldo*. In Herzog's words, "there was one dangerous dream lingering: to fly the airship over the falls." Why? How does that relate to canopy prospecting, the film's supposed project? The idea is floated for another reason altogether, if the parallels to *Fitzcarraldo* are not already clear: the waterfall evokes at once the jungle mountain that must be overcome in that film and the deadly falls, the so-called Pongo das Mortes, which cannot be avoided. It is a familiar scenario that plays out, however, as a farcical version of Fitzcarraldo's risky engineering project. In Herzog's words, "prudence demanded a test." From an overhang at

the edge of the falls, Dorrington, Yhap, and another man launch a series of colored party balloons, each carrying a flute of champagne, and each test demonstrates the effects of a powerful downdraft in action. The test is, of course, ludicrous (especially compared to the earlier scenes of high-tech simulations and experiments that are filmed in Dorrington's laboratory), but it is not played for comedy. This is one voyage that is emphatically not undertaken. Instead, the process of making an informed decision, the test itself, is dramatized and repeated by Herzog's film. His is an ethical enterprise—that's the upshot, anyway.

The act of holding back, as Herzog does repeatedly within the film, implicates the spectator in the ethics and politics of documentary. There is another version of the discovery scenario in *The White Diamond,* one that is similarly suspended but plays out in a different manner. The destination in this case is an enormous cave located directly beneath the Kaieteur Falls. The cave has several functions within the film: it is a nesting place for more than a million swifts, a sacred place for local Amerindians, an echo chamber emanating quotations from Herzog's previous films and exploits, and a mythical space reminiscent of Plato's cave; it is also a site of performance. The sequencing of this scenario is crucial. First, we see a shot composed of rock and water, the scale of which is unclear. Suddenly, the camera swings out over a precipice, revealing its location at the crest of the waterfall and transforming what was (in retrospect) a close-up on bedrock into a vertiginous aerial view. The camera movement creates a sort of bungee-jumping sensation, with all its cultural associations of physical daring and adventure. From an overhead angle, we see a lone climber suspended on a rope below and hear his fading screams as he descends, only a few feet away from the falling water. "Out of curiosity," Herzog comments,

our physician on location, an expert mountain climber, decided to have a look for himself. He wanted to see the mysterious nesting place of the swifts. From the bottom of the falls, the gigantic cave is inaccessible, and has resisted all attempts by explorers. We lowered a camera to him, hoping to gaze into the unknown. Later, we decided not to show his footage. We will show only the image from the spinning camera, as we pulled it back up on a rope.

Because the camera is aimed downward, it shows a receding spiral of rocks and water, the sound of which rises and falls with each revolution. The effect is yet another twist on the circular-moving camera, what Prager describes as "Herzog's single most consistent formal gesture."[62] While authorship and style are certainly at stake in this scene, there are other salient issues such as play, desire, and participation.[63] The spinning camera produces a dizzying effect, temporarily disrupting the stability of perception, which in turn comments on the viewer's presumptive desire to know the secret contents of the cave. Documentary thrives on *epistephilia,* a term Nichols coined to denote both a "desire to know" and a "pleasure in knowing."[64] Withholding the image at once conjures and spoils this pleasurable curiosity. A brief interview with the climber doubles the act of withholding, as the dialogue is left in the original and neither glossed nor translated. For viewers who do not understand German, it adds to the cave's mystery; even for speakers of German, though, the interview offers no insight into the contents of the cave.[65] Either way, the audience is put in the awkward position of questioning the filmmaker's decision not to show the supposed footage and searching for a reason behind it.

Cut to another interview, this one shot with the waterfall as a backdrop. Herzog asks "an Amerindian former tribal leader," named Anthony Melville, "how he views the cave." If he had wings, Melville says, he would fly into the cave and see what lies inside of it. Herzog tells him of the videotape, "Now, one of our climbers went down on a rope and looked into it, with a camera. He saw what's in there." "OK, OK," Melville replies, "I don't think they should ever publish it. I mean, what you see is yours; you keep it to yourself. But I don't think it should be published as a whole, to say, OK, this is behind there. The whole essence of our culture tends to die away. We'd lose it." In a visual economy where visibility implies loss, the act of withholding obtains positive value in itself. Native testimony thus provides both a narrative motivation and what is presently an indisputable cultural rationale for the filmmaker's stated decision not to show the footage (despite all the physical effort and risk involved in obtaining it). The act of withholding is underscored both discursively and musically by the film's last scene. It closes with an extremely long take of Kaieteur Falls, followed by a title, which offers a

Consulting "an Amerindian former tribal leader," *The White Diamond* (2004).

blessing ("May the Secret Kingdom of the swifts be around till the end of time, as the lyrics to this song suggest"), and what is presumably a piece of local Amerindian music.[66]

The final scenario of discovery explores a number of interrelated questions. Ethically, it raises the question of Herzog's responsibility in representing the cave: is there any compelling reason why he ought to show the footage (assuming it is even usable), despite the Amerindian objection? It also begs the question of accountability: to what authority should the filmmaker be obliged to answer? Politically, the act of withholding raises the question of representation as a social issue: if Herzog were to go ahead and show the images as part of a film, what might be the consequences for the local Amerindian community? By virtue of withholding, then, Herzog stages himself as heeding an ethical imperative, presumably for the sake of both natural and cultural preservation, while at the same time producing an effect of secrecy that obtains within the film. The act of withholding can actually be traced throughout his documentaries (e.g., as we saw in the films about spirituality). Here it is just inflected to evoke an ethics of responsibility in an intercultural context. Make no mistake: his is a performance that mimics the act of preservation, instead of simply advocating it.[67] If there were any doubt about its status as performance, it is erased when Anthony Melville, the

"former Amerindian tribal leader," later appears working as part of the film crew. He, too, plays a role—more than one, in fact. The dialogue about the cave was presumably scripted, the footage was probably useless. For his part, Herzog acts out the role of a filmmaker from the outside who knows how to behave on location. His conspicuous display of cultural sensitivity is neither sincere nor disingenuous. It is a highly self-conscious performance of ethics and politics in the context of documentary cinema. The question remains whether this act of mimicry challenges (or even subverts) the ethics that underwrite "good behavior" as ideology.

In all the films here discussed, Herzog puts documentary in the service of reenacting and thereby reconfiguring his own cinematic past. Within this context, I have also identified a penchant for rehearsing certain well-known scenarios of discovery, which Herzog undertakes as a way of promoting rediscovery of his work. In each instance, the event to be reimagined via documentary is the making of *Fitzcarraldo* as a formative experience in the director's life and a pivotal moment in his career. The argument might be further extended with only slight modification to account for the publication of Herzog's *Conquest of the Useless* (*Eroberung des Nutzlosen*, 2004; in English, 2009), a collection of diary entries and prose sketches written before and throughout the production of *Fitzcarraldo*. In one passage, he reflects on 1979 as "a year of catastrophes," naming specifically the burning of his camp by the Aguarunas, the "criminalization of my person by the media," and "a grotesque tribunal against me in Germany." Nevertheless, work on the film continued "in the knowledge, perhaps even only in the hope, that time would straighten things out; that the facts about all this would in the long run prevail."[68] With regard to such reflections—and this one is set in italics, which would seem to indicate that it was recently added—it is important to stress that the diaries themselves make no apparent effort to "straighten things out," nor can they be said to present "the facts"; rather, it is the subjective immediacy and evidentiary power of written testimony that add considerable nuance to "the case of Herzog" and thereby contribute to its reopening. This movement of reopening creates an important connection between the book and the films, but the latter are distinguished by their visual aspect as well as by their structure of double rehearsal. *Ballad of the Little Soldier, Ten Thousand Years Older,*

and *The White Diamond* each reenact stock scenes of cultural encounter from multiple different contexts and perspectives. In so doing, they foreground the efficacy of performance as a framework for negotiating a new relationship to the filmmaker's own past.

Herzog's documentaries do not merely repeat old situations of encounter; they also produce new ones. The present scenarios do not serve to promote a culturally sensitive colonialism, which is kinder, gentler, and consequently more insidious than ever before. In other words, they do not provide further evidence of "neocolonialism." They do, however, mimic that position for an effect. The effect can be playful and humorous, as it is at times in *The White Diamond,* but it can also be painful and unsettling, as it is in *Ballad of the Little Soldier* and *Ten Thousand Years Older.* The assessment of this effect depends not only on the filmmaker's use of certain representational strategies and critical postures in a given situation but also on the role of spectatorship. Whatever critical potential *Fitzcarraldo* might have held at one time has since been lost in the polarity of postcolonial shame. On the matter of Herzog's legacy as a filmmaker, however, both the central importance and the productive dynamic of his work in documentary have become increasingly clear.

6 REENACTMENTS

Lately, the practice of reenactment has made a certain comeback in documentary filmmaking. By reenactment, I mean the staged reconstruction of a past event, which creates a new and necessarily different event in the present. Claude Lanzmann's *Shoah* (1984) and Errol Morris's *The Thin Blue Line* (1987) offer only the most well-known examples. Although on one level, their projects are incomparable, both films were taken to signal the resurgence of documentary as a form of historical representation and understanding, owing in part to their innovative and contentious approaches to reenactment.[1] Once widely accepted, as evidenced by such canonical films as *Nanook of the North* (1922; dir. Robert Flaherty), *Misère au Borinage* (1934; dir. Joris Ivens and Henri Storck), *Night Mail* (1936; dir. Harry Watt and Basil Wright), and *Native Land* (1942; dir. Leo Hurwitz and Paul Strand), each of which employs a different type of reenactment, the practice lost much of its appeal and cultural authority with the advent of observational cinema and the latter's definitive claim to capture "life as it is."[2] Since then, many of the filmmakers who have challenged that claim—Lanzmann and Morris, among others, including Herzog—have occasionally done so by reimagining the practice of reenactment as a means of stylization, an approach to historical reconstruction, and indeed, a way of knowing. Its epistemological instability, its many uses and returns as a device that seems to be constantly falling in and out of favor, have established reenactment as a major perennial issue in documentary theory.

Within this particular arena, however, the discussion has too often been framed in narrow and mostly ahistorical terms. What we need, going forward, are broader and more open perspectives. Many commentators imagine reenactment in terms of verisimilitude, an aesthetic

category closely associated with realism. At stake in this discussion, however, is a rather different issue: that of documentary's "indexical" character. According to Bill Nichols, "documentaries run some risk of credibility in reenacting an event: the special indexical bond between image and historical event is ruptured. In a reenactment, the bond is still between the image and something that occurred in front of the camera but what occurred *for* the camera. It has the status of an imaginary event, however tightly based on historical fact."[3] This observation itself is based on certain assumptions that need to be made more explicit. First, Nichols assumes that actors serve to represent others (as opposed to historical participants representing themselves). The use of actors in documentary is a common enough phenomenon, especially for the purpose of portraying events that took place before film cameras were invented, or more recent situations in which camera access has been denied, and for evaluating the nature of conflicting evidence.[4] Under these circumstances, the choice of reenactment is not surprising (it may even be expected), and the use of actors is simply understood. Second, Nichols puts emphasis on the documentary image and assumes that its indexical relationship to the historical world is necessarily compromised by the staging of actors before the camera. Issues of recorded sound (as in speech and oral testimony), which can also be framed in terms of indexicality, and typically involve a temporal delay of one kind or another, are not considered. Finally, Nichols would seem to assume that historical reconstruction should represent an event exactly as it occurred, as though this were theoretically possible. Each of these assumptions remains open to debate and needs to be explored in specific situations. Ivone Margulies has done just that in a recent essay on reenactment films such as *Close-Up* (1990; dir. Abbas Kiarostami)—a film, incidentally, much admired by Herzog—and *Sons* (1996; dir. Zhang Yuan), where historical subjects themselves reenact certain events from their own lives. Even in such cases, she argues, reenactment obtains its evidentiary force not in terms of verisimilitude but rather by means of a performance that takes place for the camera. Under these conditions, "reenactment radically refocuses the issue of indexicality. The corroborating value of reenactment does depend on our knowledge that these particular feet walked these particular steps," she writes. "But it is the intentional and fictional

retracing that *enacted* lends to these faces and places an authenticating aura. This aura, the indexical value of reenactment, is present but at a remove."[5] The upshot, instead of likeness, is a performance that is obviously distinct from the past event but able to reference, reshape, and interpret it in the present. Reenactment can provide alternatives to representation that are not simply located outside of it.

For this very reason, I suspect, the practice of reenactment has received more trenchant discussion in a different arena: that of performance studies. This is especially true of Richard Schechner's work, in which performance means restored behavior or twice-behaved behavior. Unlike other theorists, who imagine performance in terms of its supposed uniqueness, Schechner approaches it as fundamentally recursive. At the most basic level, he explains, "performance means: never for the first time. It means: for the second to the *n*th time."[6] Indeed, it is the reiterative quality of behavior that allows it to be transmitted at all. Behavior may be prepared to appear authentic and unrehearsed, as it is for certain types of acting in film and theater, but the rehearsal process in such cases only corroborates Schechner's claim. Reiterative behavior necessarily assumes many possible forms, not one. The point can be illustrated by historical materials, where performance can mean "a restoration of a historically verifiable event," but more often, it means restoring "a past that never was."[7] Rather than imagine representing history "as it really happened" (to borrow a formulation from German historian Leopold von Ranke), Schechner understands a dynamic process of reconstruction that is secondary, mediated, subject to change, and ineluctably part of the present. Repeatable forms of behavior are necessarily different from their contexts of reference. This difference—or "twiceness," as he calls it—extends to documentary. Drawing on Erving Goffman's concept of a cognitive frame, Schechner writes, "Documentary film imposes an acting frame around a nonacting circumstance. Documentaries like Curtis's *In the Land of the Head Hunters* or Flaherty's *Nanook of the North* combine people sometimes going about their ordinary tasks, sometimes restoring behaviors of a recent past, and sometimes acting for pay in fictive situations in an 'on-location' set wearing costumes and saying lines written for the occasion."[8] In this sense, Herzog's films, too, involve a mix of recursive structures, but they have yet to be explored as such.

The practice of reenactment comes from a history of performance, to which the documentary film is indebted, even though this history tends to go unnoticed by film-specific accounts. In the West alone, reenactments have many antecedents and cousin forms—passion plays, historical pageants, war simulations, living history museums—all involving theatrical mediations of one type or another.[9] Most recently, reenactment has become a focus of contemporary art exhibitions and performance art. There it has been understood not just narrowly, as a specific artistic strategy or genre of historical commemoration, but also more broadly, as a conceptual framework for exploring the recursive and mediated nature of truth, memory, experience, and witnessing.[10] The reflected, provocative, self-conscious qualities of reenactment in the arts have much in common with, and in some instances are directly inspired by, the films of Morris and Lanzmann as well as those of Harun Farocki, Jill Godmilow, Chris Marker, Peter Watkins, and others. Clearly, however, the most influential source for the contemporary fascination with reenactment, and the key context of both production and reception, is that of popular television.

Of particular interest here is the emergence of reality programming and its various formats.[11] To give only one example, a typical scenario of A&E (accident and emergency services) programs involves a mix of strategies: first, the survivor of an accident, disaster, or traumatic event of some kind appears on camera and discursively sets the scene; then a reconstruction is shown, with actors playing all the parts; followed by some post-traumatic reflection from the survivor. In some instances, archival footage and reenactment are combined with "live" in-studio reunions of the rescue workers and those they assisted.[12] The proliferation of reality formats, particularly those emphasizing the affective and dramatic structures of risk, danger, rescue, and escape, creates an unexpected context for some of Herzog's more recent work in documentary film and television.

This chapter investigates Herzog's use of reenactment as a documentary technique. It concentrates on two films made in close succession, namely, *Little Dieter Needs to Fly* and *Wings of Hope*. The first recounts the experience of Dieter Dengler, a German-born pilot in the U.S. Navy who was shot down over Laos on his very first mission, in 1966. He was captured, tortured, and held prisoner for nearly six months before escaping and eventually being rescued. The second film retraces the footsteps

of Juliane Koepcke, the sole survivor of a 1971 plane crash deep in the Peruvian jungle.[13] Both films were shot on Super 16mm, edited for television, and broadcast by the German network ZDF. They are a further instance of television providing a specific format as well as an institutional framework for Herzog's intervention in a documentary practice. In this case, he was invited to contribute to a documentary adventure series called *Journeys into Hell (Höllenfahrten)*, which actually stipulated the use of reenactment scenes. Although the series title sounded promising, he claims to have had an immediate aversion to doing reenactments, sneering at the popular format as "the kind of stupid thing you can see on television worldwide." By his account, the network "actually wanted me to make a film about myself, all the stuff about landing in prison in Africa and the problems on *Fitzcarraldo*. 'This was difficult work,' I [said], 'but they were not voyages into hell.'"[14] A similar comment could be made of the earlier programs in the series depicting such historical events as the wreck of the Batavia (a seventeenth-century Dutch trading vessel), the hardships endured by Mormon pioneers in winter 1856, and the African expeditions of David Livingstone.[15]

Herzog's first contribution to the series was initially called *Escape from Laos (Flucht aus Laos)*, which is also the title of Dengler's memoir. The television program represents the first pass at material that the director would later expand and revise as *Little Dieter Needs to Fly*. Every program in the series mixes landscape views, reenacted scenes, expert witnesses, and voice-over narrators. Though elsewhere he disparages the use of reenactments, which he seems to associate with the spread of trivialization, Herzog doesn't simply break with prior forms. Nor does he create a program that fits exactly with the standard expectations of the series. The difference lies in his approach. Instead of employing actors, as the network requested, he engages the survivors themselves and returns with them to locations associated with the events, which they proceed to recount on camera, while interacting with the surrounding landscape and people. While *Little Dieter* establishes the basic model, *Wings of Hope* provides an interesting meta-commentary on Herzog's project as well as another instance of it, with certain striking differences.[16] And that is not all. There is a further repetition, yet another difference that needs to be acknowledged. This chapter, then, closes by looking

briefly at *Rescue Dawn* (2007), a feature film "inspired by true events in the life of Dieter Dengler."

All this material foregrounds behavior that has been restored to be filmed. For each event, its future as a television program and (later) a film would reshape its past as an experience. The depicted events are staged, practiced, shot, edited, and revised in different lengths, formats, and languages, creating a dizzying array of variations. Retroactively, however, the many versions and their subjects can also be seen as parts of another series that is Herzog's body of films.

Herzog's reenactments both epitomize and expand his relationship to documentary as a mode that he dismisses and nonetheless engages. In this case, his intervention is not original but rather fundamentally derivative, recursive, and therefore interesting on a comparative level. As I argue, Herzog co-opts reenactment in the context of his own work, where it serves as both a cinematic strategy and an epistemological claim. He also puts renewed emphasis on its testimonial function in particular. Each of the documentaries under discussion is admittedly stylized, which raises certain problems not only in terms of truth but also in terms of witness. At issue, however, is more than just the effect of invention or fabrication. It is the effort to ground the filmmaker's vision in the body and in the firsthand testimony of another person who had the experience that is the supposed bedrock of evidence. This move, which is a strategy of embodiment and attestation, has become a hallmark of Herzog's work, and it specifically derives from his performance of documentary. Herzog needs documentary and its contested associations with reality and knowledge to authenticate his own films, to anchor them in the historical world, and to offer them up as an attractive (or repulsive) counterexample to the documentary status quo.

Once More, with Herzog

Little Dieter Needs to Fly is a survival film. Although the story takes place during the Vietnam War, it never presents itself as a war film in a generic sense.[17] Instead—and this is a point that other commentators have yet to discuss—Herzog's film operates within a tradition of survival stories that characteristically focus on individuals who somehow remain alive

after natural disasters, shipwrecks, or plane crashes. Paradigm examples take place in exotic locations that excite the imagination and offer up individuals of skill, courage, fortitude, and sheer luck—people whose actions and mentalities in the face of intense personal suffering inspire wonder, even admiration.

The first in a cycle of survival films, *Little Dieter Needs to Fly* establishes not only Herzog's approach to reenactment but also a specific narrative pattern, which is later repeated and modified in *Wings of Hope* and (once again) in *Rescue Dawn*. On the most basic level, each film involves a German who abruptly lands in a foreign jungle, where he or she struggles to remain alive. The jungle may be the ultimate topos of death in Herzog's films, but in the reenactments, it becomes a site of survival.[18] Each film, then, begins with a plane crash, evoking at once the fate of an accident and the suddenness of a fall (the German term *Unfall* captures both ideas). The survivor goes on to confront a succession of ordeals including starvation, exhaustion, exposure, and dangerous wildlife— in Dengler's case, it also includes war, imprisonment, and torture—all coded as either obstacles to be surpassed or conditions to be endured. At some point, the survivors have a visceral encounter with death: that of their own and that of others. In each case, it points toward the limits of what can be known and recounted. While the films primarily refer to physical and mental endurance, they also operate on another level, as an extended metaphor for survival in an existential sense. Finally, all three films find closure through redemption, a basic trope of survival narratives that has ancient origins and mythological connotations.

The itinerary of each film is determined as much by Herzog as it is by the individual survivors. So the journey structure operating here is at once actual and metaphorical, biographical and autobiographical, temporal and geographical, contemporary and historical. In the documentaries, at least, the structure is nonlinear, shuttling back and forth in time while moving from place to place (this is not the case in *Rescue Dawn*, as we shall see). All the narratives are dramatically streamlined to foreground a "sole survivor," whose solitude forges continuity across the disparate scenes, the living embodiment of an extreme condition of existence.[19] Isolating the individual is part of a narrative strategy to simplify the story line, while fostering in the spectator an empathic

relationship to the survivor. To a certain degree, the survivor in each film is also transformed into a "Herzog character." Other commentators have enumerated the affinities between the director and the subjects of these particular films—a point made by Herzog himself. Of Dengler, for example, he states in one interview, "Like me, Dieter had to take charge of his life from a very early age, and, because as children we both knew what real hunger was, we had an immediate rapport."[20] Indeed, all this material both originates from and proceeds to integrate forms of repetition that already exist. As a result, viewers might reasonably wonder in certain passages of each film: whose past is being reenacted here? The different frames of reference interact in various ways, ranging from appropriation to collaboration. Herzog's reenactments explore not just the complex relationship of past and present but also that of self and other. And *Little Dieter Needs to Fly* offers only the first example.

The film begins in a way that may seem familiar to Herzog viewers: an epigraph introduces the figure of death. Only in this case, contrary to what one might expect, death appears to be on the retreat. The epigraph bears repeating: "And in those days shall men seek death, and shall not find it, and shall desire to die, and death shall flee from them. *Revelation 9:6.*" From the very beginning, then, the primary concern is actually survival, not death.[21] Or rather, survival is represented as a fate that may be worse than death. The opening scene frames this idea of survival visually as well as discursively. Dengler walks into the San Francisco store of tattoo artist Ed Hardy. One look at his drawing for a new tattoo, a vision of death, leads Dengler to object:

> Well, actually, I couldn't have that on my body, because . . . it was somewhat different. In fact, there was quite a big difference. You have to understand, I was just crawling along, I had one day to live, I was on my knees, and I was hallucinating. And then those enormous doors opened up, and lots of horses kept galloping out, and it wasn't death that was driving those horses. It was the angels. And I had this vision. Death didn't want me. Death didn't really want me.

As the opening scene would seem to suggest, *Little Dieter Needs to Fly* is stylized on many different levels. On one level, that of language, the

material was shot twice: once in German and again in English. This "twiceness," an essential character of films made in multiple language versions, becomes a condition of reenactment as a specific device. On another level, that of performance, much of the filmed behavior is literally rehearsed. According to Herzog, "there is hardly a scene in the film that was not shot at least five times until we got it exactly right."[22] Some of the material is even invented for the film, though the entire story—and it is obviously a story, one that Dengler himself had already put in narrative form—and most of the details can be easily verified by comparison with Dengler's memoir. The opening vision of death offers a good example. Twice in his memoir, Dengler describes seeing "golden doors" in the sky opening up, first with skiers and second with horses racing out toward him. Drawing on the second image alone, Herzog adds the supernatural figures of death and the angels (which are nowhere mentioned in Dengler's memoir) and renders the image visually as the design for a tattoo.[23]

Reenactment is a key context for Herzog's practice as a documentarian because it explains both the impetus for stylization and its governing logic in specific situations. As Herzog comments in one interview, "everything in the film is authentic Dieter, but *to intensify him* it is all reorchestrated, scripted, and rehearsed."[24] And yet, given the extreme nature of Dengler's experience, why should there be any need "to intensify him" at all? Rather than simply repeat Herzog's mantra of "the ecstatic truth," we would do better to pursue this line of questioning in terms of reenactment, how it visualizes the past in a way that mobilizes affect through the *viewer's* experience of intensity. Indeed, stylization is precisely what drives the received idea that reenactment can improve on the past by creating an intensified, more streamlined version of it. This version of the past obviously belongs to the present, but it also makes a claim to history. By rendering the past visible, so the logic runs, reenactment opens up certain perspectives on it, which might have otherwise remained unavailable.[25]

Herzog's stylizations follow the governing principle of cinematic reenactment: they create a model subject. As Ivone Margulies has shown, reenactments typically create figures of exemplarity or what she calls "exemplary bodies."[26] In this sense, Dengler, too, provides an example.

He appears in the film as a particular instance of a general principle: that of survival. His reported thoughts, attitudes, and behaviors under dire circumstances make him exemplary in a further sense, as deserving of emulation.[27] And yet, whether or not he is aware of it, Dengler becomes more than just an exemplary figure for viewers to admire. Ultimately, he provides a prototypical instance of Herzog's vision as a filmmaker. It is as if the documentary subject lends reality to the director's stylization.

Dengler's exemplary status is established by the voice-over, which is notably multiple and shared—an interesting strategy in its own right and an assertion of shared authority. Whereas Herzog speaks in the third person and remains unseen, Dengler speaks in the first person both on and off camera. Speaking off camera, he helps advance the story (with a narrative economy that is noticeably succinct, as compared to his on-camera statements). The image track to the first voice-over shows Dengler driving a vintage automobile in present-day California:

HERZOG: Men are often haunted by things that happened to them in life, especially in war or other periods of great intensity. Sometimes, you see these men walking the streets or driving in a car. Their lives seem to be normal, but they are not.

DENGLER: When I am driving my car, I often hear the voices of my dead friends. Sometimes, my friend Duane Martin calls me and tells me that his feet are cold. Because of this, even on a warm sunny day, I keep my convertible top up.

From the beginning, the voice-over relates with the image in ways that also connect the extraordinary to the ordinary, the past to the present, with Dengler serving as go-between and embodying this relationship. In this passage, Herzog describes the general state of things ("Men are often haunted . . ."), Dengler speaks from personal experience (". . . I often hear the voices of my dead friends"), and the latter statement is understood as attesting to the former. Dengler's exemplarity derives in part from his status as a survivor, as one who continues to live after the death of others.

Beginning with the trope of haunting, the notion of psychic trauma and the return of the past feature prominently in the film. This is also the

case in *Wings of Hope,* as Koepcke recalls having dreams, blackouts, and resurgent memories. And yet, however tempting it may be to advance the idea of trauma as the organizing principle of Herzog's reenactments, it is important to notice that his framing of traumatic events and traumatized victims actually suggests otherwise.

Even as Herzog mobilizes the discourse of trauma and some of its prevailing metaphors, his films cannot simply be used to support the received idea about the relationship of trauma to repetition. For scholars oriented to psychoanalytic theory, reenactment usually denotes a form of compulsive repetition, which is understood symptomatically, indicating that the traumatized victim remains as yet caught in the past. Paradoxically, however, instead of embracing memory, traumatic reenactment holds it at bay, operating in effect as a way of forgetting. What makes this situation even more complex is the possibility that the traumatic event was, in a sense, never lived. As Cathy Caruth explains, drawing on Freud, the event "is experienced too soon, too unexpectedly, to be fully known and is therefore not available to consciousness until it imposes itself again, repeatedly, in the nightmares and repetitive actions of the survivor." She adds, "trauma is not locatable in the simple violent or original event in an individual's past, but rather in the way that its very unassimilated nature—the way it was precisely *not known* in the first instance—returns to haunt the survivor later on."[28] On this model, reenactment is reduced to compulsive repetition (which is in turn exclusively identified with trauma) and located outside of representation altogether. Furthermore, it defies all comprehension.[29] Unable to witness or represent what they underwent, survivors obsessively and unknowingly repeat it, against their will. Because trauma can only be "transmitted," and not formatted in symbolic terms, so the logic runs, markers such as gaps, silences, repetitions, and body gestures assume new meaning and therefore require certain methods of decoding and understanding.[30]

Curiously, the supposed crisis of representation, which is a truism of the scholarship on trauma and reenactment, is nowhere to be found in Herzog's "trauma documentaries."[31] Quite the opposite, what is striking about these films in particular is how much the survivors have to say about their experiences, even in the moment of reenactment and at the

site of memory. What makes their loquaciousness even more remarkable is that a loss of language features prominently elsewhere in Herzog's work, including such documentaries as *Land of Silence and Darkness* and *Lessons of Darkness*. By contrast, Dengler and Koepcke appear to be remarkably game and garrulous when it comes to recounting their experiences. Each of them was literally stranded for a time in a foreign jungle, but neither remains stranded in the past. The traumatic event would seem to be owned by the individual and not compulsively relived.[32]

The reenactments in *Little Dieter Needs to Fly* proceed from this assumption of psychic stability and self-awareness, which is also the case in *Wings of Hope*. Apparently, the survivor has more or less recovered from and learned to cope with the stress that he or she suffered as a result of the traumatic experience. What it means to work through this experience and related questions of psychology go unasked. Loss and grief are acknowledged but never emphasized. Instead—and here's the key point that I want to make—Herzog's reenactments are coded as knowing acts of repetition and performed as such by the consenting survivor, who occasionally comments on them, makes sense of them in the present, and does so explicitly for the film viewer's benefit. Arriving at his home in northern California, Dengler gets out of his car and enters the house, repeatedly opening and closing the doors of each. "You see," he remarks to the camera, "this really seems strange to most people, but to me it's very important. It denotes freedom, to be able to open or close a door. When I was a prisoner, I couldn't open the door, and later on, when I was dying, those big doors in the sky would open up. And so, most people don't realize how important it is, and what a privilege we have to be able to open and close a door. So, anyway, that's a habit I got into, and, uh, so be it." Dengler's commentary suggests a form of repetition that is not as simple as it may seem. For repetition here denotes self-awareness (not pathology). The repeated opening of doors is framed as a ritualistic gesture, supposedly invented by Dengler himself to commemorate his liberation as well as his imprisonment. The casual manner of his explanation makes it seem all the more convincing. The act of repetition is prepared so that it seems authentic, unrehearsed. As such, it cannot be reduced to a repetition of traumatic suffering. Nor is it a simple memory.

Indeed, the entire scene turns out to be invented by Herzog—a point that he readily admits. For this reason, it offers a good example of the filmmaker's working method and the nature of his collaboration with Dengler. The scene is allegedly based on and inspired by Dengler: a casual remark that he made about the feeling of opening doors, the visions of doors that he recounts in his memoir, the paintings of open doors that hang in his house and appear in the following scene.[33] For his part, Herzog appropriates this material and literally dramatizes it as repeated behavior for Dengler to exhibit and discuss on camera. Even without this knowledge, which is external to the film, the interaction of Herzog and Dengler can also be surmised on a textual level. As Prager suggests, "one has the impression that the two, the director and his subject, are working synthetically to recount Dieter's story."[34] What is more, repetitive action such as opening and closing doors becomes a theme that effectively doubles the recursive structure of reenactment and thereby makes it visible, calling attention to its difference from conventional approaches to reenactment.

Trauma in Herzog's documentaries denotes more than a psychic or inner phenomenon. It extends into the physical world. Hence the long traveling shots of rubble ruins in defeated Germany, the landscape views of fog-covered roads in northern California, the aerial footage of jungle canopies in Laos, Vietnam, Peru. Landscape here obtains for a very specific purpose: it lays the groundwork for Herzog's reenactments.

The relationship between landscape and reenactment is established by the film's (repeated) use of aerial imagery. Dengler's narration prepares the first instance: "I never wanted to go to war. I only got into this because I had one burning desire, and that was to fly. But that there were *people* down there who suffered, who died, only became clear to me much later, when I was their prisoner."[35] The voice-over anticipates a radical shift in perspective, from air to ground, which also hints at a moral transformation. The image track, by contrast, cuts to archival footage—damage assessment films of bombing raids—shot from some of the same airplanes that released the bombs. Though the specific targets remain indiscernible to the film spectator, the fiery explosions become a kinetic spectacle that is astonishing in every sense of the word. A record of mass destruction made by the destroyers, Herzog co-opts

this footage in a particular context and replays it for an effect. Above all, aerials here serve to visualize the detached, disembodied—indeed, cinematic—relationship to the other as an object of spectatorship that is, in an important sense, unseen. Here is how Herzog frames the second instance of aerial footage: "But from the air," he says on the voice-over, "Vietnam didn't seem real at all. For Dengler, it was like a grid on a map. He had suddenly found himself not only a pilot but a soldier caught up in a real war. But even though it was all very real, everything down there seemed to be so alien and so abstract. It all looked strange, like a distant barbaric dream." With its displaced use of music (throat singers from Siberia), the sound track underscores the apparent strangeness of the images, their remote relationship to the world they show under attack. As Jennifer Fay has suggested, it is only from such a distance, only through such a disembodied perspective, that one could possibly endure the spectacle of violence that this footage so vividly represents.[36] At the same time, however, aerial imagery in this film has a particular—and particularly important—function, that is, to create by means of juxtaposition a visual basis for the reenactment of lived, embodied experience. Aerials prepare the act of witnessing, which takes place in the present and on the ground.[37]

Herzog's reenactments feature the survivors themselves recounting their experiences in place and reliving them in the present. Dengler revisits locations in Germany, the United States, and Thailand (instead of Laos, where Herzog says they were not permitted to film). The body of the survivor refers us "back" in time as well. The nuance of this move becomes clear when we contrast it with Jean-Louis Comolli's analysis of the history film as a genre. In Comolli's memorable formulation, "the historical character, filmed, has at least two bodies, that of the imaginary and that of the actor who represents him for us. There at least two bodies in competition, one body too much."[38] Not so in Herzog's reenactments. Here the survivors perform as themselves being stretched across the present and the past—a movement that is even visualized by *Little Dieter Needs to Fly*. In one scene, filmed at a California air base, which also has a museum of flight, Dengler puts on a Vietnam-era helmet and flight suit and climbs into the cockpit of a vintage airplane. Before he dons the uniform, however, it is carefully removed, piece by piece, from

The traumatized body of the solider, *Little Dieter Needs to Fly* (1998).

a plastic mannequin whose broken head and hollow body are visually emphasized by the camera. Undressing the mannequin reveals, where we least expect it, the traumatized corpse of the soldier. The clothes are then transferred from one body to another, creating both a physical and a symbolic relay between Dengler and the mannequin. Only the latter stands for the dead, the body of which is, in an important sense, missing. At the same time, the transfer of clothing, because it is coded as historical costume, calls attention to the survivor's presence, marking not only his difference from the mannequin body but also his connection to it. The interpretive key to this scene is not the idea of corporeal excess, as it is in Comolli's discussion of the history film, but rather the choreographed relationship between Dengler and the mannequin.

The most fraught scenes in *Little Dieter Needs to Fly* are those filmed in Thailand, where Dengler interacts with various locals. Here it is worth distinguishing between two groups of people. First, there are the anonymous villagers who are dramatically used at cross purposes. When they appear in the background of a scene, they serve to create a stereotypical sense of "exotic locale." When they appear in the foreground, by contrast, they silently assert their presence while attesting to the intrusiveness and strangeness of the filmmakers "on location." This function is marked by long takes of individual faces in close-up, as the depicted villagers glare at the camera. The second group consists of locals who

Dieter Dengler and Thai "extras," *Little Dieter Needs to Fly* (1998).

are cast to play minor roles in Dengler's story. In this context, we could certainly speak of "bodies too much." The ragtag group of young men who play Dengler's guards, for example, stands in for several distinct ethnic and political identities, including both the Vietcong and the Pathet Lao. Outfitted with rifles, ammunition belts, and military-green clothes, the group is sullen, anonymous, and mostly silent. After tying Dengler's hands behind his back, the guards and their prisoner take off running down a jungle trail, the handheld camera trailing them as they go. Though visibly coded as actors, and staged as historical placeholders for Dengler's captors, the silence, anonymity, and identity assigned to these extras is simply offensive to some viewers.

The scene is fraught from Dengler's perspective, too, but for a different reason; that is, Herzog's approach to reenactment ushers in the possibility of inciting a "secondary trauma" as a result of having the survivor not just recount but also in a sense relive his experience on camera.[39] As Dengler later explained, "when we were running around in the jungle for this movie, and I'm all tied up with four or five Thais following me with rifles, I said, 'Jesus, Werner, this is too close for comfort! I really don't like this!' And Werner would say, 'That's exactly what I want you to say!'"[40] To this comment, which Dengler indeed repeats on camera, Herzog adds on the voice-over, "Of course Dieter knew it was only a

film, but all the old terror returned as if it were real." The resulting scene, however, conflates the experience of secondary trauma, which is what Dengler seems to describe, with the supposed return of "all the old terror," as Herzog simply interprets it. His is, of course, a dramatic interpretation and not a psychoanalytic one. In a further twist, all these issues are gathered and reworked in a later scene, with Dengler simultaneously playing the role of his captors (in the past) and the role of Herzog (in the present). Standing beside a villager, Dengler recalls one incident in which the Vietcong chopped off the finger of an old Laotian man—an act of violence in which Dengler was complicit, albeit inadvertently. In reconstructing this event, he turns to the extra, grabs one of the man's fingers, and makes an abrupt chopping movement. The man, though silent, grows visibly uneasy. In response, Dengler wraps an arm around him, squeezes, and says to him in English, "It's just a movie. Don't worry about it. And you still got your fingers and everything." Dengler then turns his face away from the camera, but the anonymous villager remains still, his gaze locked on that of the camera. His direct look and awkward presence inadvertently remind us that documentary impinges on the lives of other persons, who are not just characters in a story. What this scene offers, instead of reassurance, is a reflection on Herzog's approach to reenactment. It is layered, problematic, and it implicates the filmmaker as well as the subject and a host of others.

Commenting on the process of filmmaking is more than just a sign of self-awareness, and it should not be confused with "Brechtian distantiation" on the part of either Dengler or Herzog.[41] Seen through a performance lens, process represents an experiential way of knowing as well as educating. Consider the film's demonstration of survival skills. *Little Dieter Needs to Fly* is obviously not a how-to guide for jungle survival, but it does provide bits of practical knowledge spoken from the mouth of a survivor. How to build a fire in the jungle, how to trap and cook insects for food, how to pick the lock on a pair of handcuffs—these are just some of the skills Dengler acquired from experience (e.g., by observing his guards) that he now displays to the camera, using direct address and still in the context of his own recounting.[42] These scenes, too, have the status of reenactments. Indeed, the film treats the entire prison break—when Dengler and his fellow captives escape from a

Pathet Lao camp—as one extended process, complete with a diagram and stepwise narration, from planning to escape and eventual rescue. "Next problem was to get out of the handcuffs," says Herzog. "It's quite simple," Dengler continues. "And nowadays, everybody ought to know how to open a handcuff. If you come a little closer with your camera, I can show you how to do that."

While the demonstrations add to the reconstruction of Dengler's past, they also support an ongoing argument that is particular to Herzog, his ideas about filmmaking, and how it ought to be learned and taught. From early in his career, he has voiced opposition to academic approaches in favor of hands-on experience. As if to demonstrate this point, he claims to have stolen from the Munich film academy a 35mm camera, which he then used to make his first eleven films.[43] To this day, speaking only half facetiously, he encourages would-be filmmakers to go out and do the same. His own ideas for an alternative school provide the basis of *Film Lesson* (*Filmstunde,* 1991), a playful, eight-part series made for Austrian television. Each lesson takes place in a circus tent, where he and a special guest use the lecture format to model and explain certain "decisive skills" that, in Herzog's view, every aspiring filmmaker ought to have.[44] In lesson 1, for example, tightrope walker Philippe Petit (now of *Man on Wire* fame) demonstrates how to pick a handcuff lock using only a paperclip. This is exactly what Dengler does in *Little Dieter Needs to Fly*.[45] The repetition in *Film Lesson* depends, of course, on the spectator's familiarity with the original material, which in this case is admittedly obscure. Even so, it neatly demonstrates my own point about Herzog's reenactments: they ground the filmmaker's vision in the embodied experience of others and reframe it as a strategy of survival.

Herzog's reenactments share a certain purpose, namely, to witness. The ability to provide witness is a discursive claim of reenactments across the board. Herzog just pushes the claim further so that the testimony of others about what happened to them also extends to the filmmaker himself. As he speaks and appears on camera, for example, Dengler bears witness: to the traumatic event as having taken place; to his physical and emotional experience of it; to survival, and to living differently, a changed person as a result of his experience; and—last but not least—to Herzog's own vision as a filmmaker. Because of the painful

things he has suffered, Dengler commands a degree of authority that is otherwise unavailable to Herzog as narrator and auteur. For this very reason, however, Dengler's on-camera performance makes him an ideal representative, one who appears to embody some of the same ideas and experiences that already define Herzog's films.

At once staging and bearing witness, *Little Dieter Needs to Fly* embraces an uneasy combination of elements. In a way, every act of witnessing is intersubjective and representational, involving at least some degree of staging as well as self-staging. Likewise, the act of listening and observing—even at a remove, by means of recording—inevitably shapes the act of witnessing, and vice versa. Herzog's film provides a blatant example. And yet one might reasonably ask whether his approach in effect undercuts the power of witnessing. Jonathan Kahana touches on this question in his discussion of oral testimony and the practice of listening in documentary cinema. His answer is notably ambivalent. On one hand, he says, Herzog's use of location "accentuates the magical power of the testimonial voice, its capacity to (re)cover great distances in space and time and to spirit the viewer to another place and time than the one seen in the present image." On the other hand, the reenactment scenes, as when Dengler is bound and made to run through the jungle, "have the opposite effect: they undermine the voice's agency and aura, placing the documentary power of the image in conflict with that of the voice."[46] In making this last observation, however, Kahana brackets off the importance of the face and the body in motion, which he tacitly regards as visual distractions—this, within a film that relies for its effect on the physical as well as the vocal presence of the survivor. For the purpose of framing his own argument, which concentrates on rather different material, Kahana privileges the recorded voice and the listening situation it creates, even though the face and the body may be integral to testimonial practices involving film or video more generally. The sound–image relationship needn't be imagined as a zero-sum equation. And yet the critical stance of ambivalence toward the testimonial voice in *Little Dieter Needs to Fly* provides a telling example of its own. When Dengler begins running through the jungle, he simultaneously begins speaking on the voice-over, commenting on the process of reenactment and thus bearing witness to his experience of the present (not of the past). The

testimonial function of reenactments is necessarily encumbered by the various displacements of technological recording. This is further complicated by Herzog's penchant for stylization, which can either squelch or amplify the testimonial voice with equal force. Witness if you will the final scene in *Little Dieter Needs to Fly*.

Whereas the testimonial act takes place on the ground in this film, its closing passage takes to the sky. This upward movement is prepared by an intertitle, which reads, "Heaven for pilots." The last shot, an extended aerial, slowly ascends and pulls away from Dengler, who remains on the ground, to show him surrounded by hundreds and thousands of airplanes.[47] This, we are told, is Dengler's ideal image of safety. From one perspective, that of the filmmaker, it is a cinematic act of redemption, one that Herzog would take even further in *Wings of Hope*. From another perspective, that of reenactment, it is a serial image of repetition captured within a single frame that appears to be ever expanding. As Herzog claims Dengler said to him, after seeing the completed film, "Werner, this is unfinished business."[48]

Bodying Forth

Here is an opening title: "In 1971, a plane with ninety-two passengers aboard disappeared into the Peruvian jungle without a trace. After ten days, the intensive search was abandoned. On the twelfth day, Juliane Koepcke, a seventeen-year-old girl, emerged. She was the sole survivor." Koepcke and her mother had been traveling from Lima, where she attended the German high school, to the town of Pucallpa, on the Rio Ucayali, where her father ran an ecological research station. It was Christmas Eve. Not long after take-off, they flew into a severe lightning storm, and the plane disintegrated in midair. Koepcke, still in her seat, went spiraling downward for some time before losing consciousness. When she awoke, she found herself lying on the jungle floor, having somehow survived the fall with only cuts and a broken collarbone. After searching in vain for others—her mother, above all—she realized that she was alone. Instead of waiting for a rescue team, she set out on foot, not knowing anything about her exact location but knowing a great deal about the jungle, having grown up at the research station. Along the way,

she encountered various kinds of wildlife, some of them dangerous, but her suffering was due to hunger, exhaustion, and delirium. Ultimately, after following various streams and rivers, she stumbled on a group of lumbermen, who brought her by boat to the nearest village.

The second in a cycle of survival films, *Wings of Hope* follows the model established by *Little Dieter Needs to Fly*. Once again, Herzog takes as his subject a German individual stranded in a jungle. Like Dengler, Koepcke demonstrates amazing competence and perseverance in the face of loss, death, and suffering. She, too, becomes an exemplary figure, at once unique and representative. On the voice-over commentary, which is likewise multiple and shared—only this time gendered as male and female—Herzog describes her experience of the plane crash as "a nightmare of each and every one of us." Here, too, the film takes the structure of a journey. Revisiting the crash site almost thirty years later, Koepcke bears witness to the catastrophe, to her experience of it, and to her seemingly impossible survival.

In certain ways, *Wings of Hope* reenacts a reenactment. What distinguishes this film, however, is not its structure of mise en abyme, but the creative situation that shapes this structure from the beginning. It is a situation in which Herzog is constantly trying to outdo himself, while at the same time experimenting with certain differences and substitutions—especially (but not exclusively) in terms of gender. Referring to these two films in particular, Herzog characterizes their relationship in familial terms: "It's like brother and sister."[49] As the sibling analogy would seem to suggest, *Wings of Hope* both is and is not a repetition of *Little Dieter Needs to Fly*. This relationship of similarity and difference can best be understood by examining specific elements of the film, namely, the treatment of bodies, the participation of the filmmaker, the status of evidence, and the use of conjecture. None of these elements is original to *Wings of Hope*, but all of them are expanded, developed, and stylized in ways that set this film apart from its predecessor. Thus *Wings of Hope* not only reiterates Herzog's approach to reenactment but also clarifies it in the process.

The film begins with a dream sequence, which is admittedly invented. It turns on a pair of contrasts. "In her dreams," Herzog avers on the voice-over, "Juliane often sees herself on the streets of a city. Shops,

display windows, bargains: everything seems normal. And then, all of a sudden, the faces she encounters are broken." A handheld camera, trailing Koepcke as she wanders past storefronts, fixes on a series of dressed mannequins, their plastic bodies visibly damaged and held together by tape. "The heads are smashed, disfigured, but strangely enough she is not afraid." Already, the film repeats multiple elements of *Little Dieter Needs to Fly*—the oneiric invention, the everyday situation that only appears to be "normal," the broken mannequin that stands in for the traumatized corpse. In this case, the latter proliferates to show Koepcke surrounded by mannequins. And this is only the beginning. Later scenes, filmed in Munich's Zoological Museum, show Koepcke silently touching and interacting with entire collections of different taxidermy forms (pinned butterflies, stuffed animals, mounted antlers, dried skins). The important thing to notice in each example is how *Wings of Hope* frames the survivor's body in relation to other, adjacent forms of corporeal display. It is a strategy Herzog uses to deal with a predicament created by his own approach to reenactment (his reluctance to hire actors), that is, how to help spectators "see" the missing bodies of the other passengers and "feel" the presence of their absence as it bears on Koepcke's lived experience.

What connects these display forms is the practice of effigy, the production of lifelike corporeal images and their effects. The idea of effigy has received lengthy comment elsewhere, but it's particularly relevant for the practice of reenactment in documentary cinema. "Reenactment uses the body as a medium for reproducing the past," writes art critic Jennifer Allen. "While a reenactment may depend upon historical documents and artifacts—from newspaper reports describing an event to the clothing worn by key figures—the body remains the vehicle that can carry the past into the present."[50] Indeed, this is precisely the function of effigy in Herzog's film. *Wings of Hope* even recalls the now-obscure transitive verb form *to effigy*, meaning "to body forth."[51] It is this buried use of the term that I want to revive and employ, for it captures the idea of Koepcke hurtling through the sky as well as Herzog's technique of evoking the missing plane and passengers by way of their metonymic traces. Regarded as a comparative term, bodying forth describes the movement from *Little Dieter Needs to Fly* to *Wings of Hope*, the way Dengler is continued and

"Alas de Esperanza," *Wings of Hope* (2000).

transfigured by Koepcke. Furthermore, it suggests the idea of proceeding from the physical body to an imaginary position outside of it, almost (but not quite) to the point of leaving the body behind. Above all, bodying forth offers a way of conceptualizing Herzog's vision of documentary cinema, especially his notion of the ecstatic truth. It hardly needs to be said that this notion of truth as rapturous transport is only available to the film viewer and not to the survivor.

Visually, the movement of bodying forth is first evoked by an unusual piece of statuary. In Pucallpa, Herzog comments, "Right next to the airport, a monument of plaster has been erected. A crashing plane is depicted, all in plaster, and from there a dotted line follows the course of a river. An inscription explains that this was Juliane's route out of the jungle." As the statuary makes clear, the monument remembers not only those who died (some of whom, we are told, lay buried in traditional niches around the monument). It also remembers the one who survived. On the left side of the frame, a grieving angel lays a cross on the ground, marking the place of death. On the right side, a plaster

effigy depicts Juliane as a young innocent—indeed, a martyr—kneeling, praying, looking upward, where an angel points the way to heaven. The monument thus reenacts the moment of rescue in perpetuity. It bears the allegorical title "Alas de Esperanza" (Wings of Hope). Visiting this site for the very first time, Koepcke recites "the highly emotional inscription" of a plaque mounted on the side of the monument: "Brethren, we are united here through our longing to reach the warmth of the sacred hearth of home. Christmas 1971, we were on our way thither, but instead we were cast into dark eternity." In another context, the baroque monument and its form of sentimentality might be labeled "kitsch," but the film never condescends to it in this way.[52] At once solemn and theatrical, literal and allegorical, secular and religious, the sculptural reenactment provides both a visual framework and an interpretive key to the film. Its framing function becomes clear with the sequencing of the following scenes, which begin in Lima and then return (once again) to Pucallpa. Its interpretive function comes into view later, at the end of the film, when Herzog's narration makes clear that this is a drama of consolation, redemption, and—ultimately—transcendence.

Herzog's part in this film is not just implied or restricted to his vocal presence, as it is in *Little Dieter Needs to Fly*. This time around, he plays several distinct roles—narrator, filmmaker, and secondary witness—with each one asserting his personal relationship to the material. As narrator, he introduces a notion of latency to suggest that this material had previously been internal to him. "This is a film that lay dormant in me for many years, because I myself had almost been part of this very tragedy." He and his crew were traveling from Lima to a location in the jungle, where they were about to film *Aguirre*. "Only later would I learn that we were fighting our way through the jungle just a few rivers away from Juliane, as she, during these very same days, was fighting for her life." The use of personal pronouns on the voice-over may be less conspicuous, but it is no less effective. On many occasions, Herzog speaks in the "we" form to emphasize his connection to Koepcke and the present act of collaboration with her. In one of the dream sequences, he literally speaks for her, using the "I" form as though he were reciting her thoughts at the time. While Herzog employs his vocal presence to great effect, his walk-ons are perhaps even more consequential. He

makes several different appearances. At the airport in Lima, he stands beside Koepcke and recounts his own experience of that fateful day in December 1971. Herzog was not only there, in the airport, but he was trying to board the same flight as Koepcke and her mother, only to be removed from the passenger list at the last minute. He tells this part of the story on camera as a way to establish his physical proximity to Koepcke as well as his crucial distance from her. In this scene, Herzog plays himself as a filmmaker, restoring his own past behavior. In the jungle, by contrast, he performs the role of secondary witness, who not only listens to Koepcke's testimony as she speaks but also actively searches the jungle for the visible signs of her past. This aspect of the filmmaker's performance is, of course, based on extensive preparation. Though the crash site was "still vaguely known," Herzog says on the voice-over, it took four different expeditions simply to locate it during preproduction. This is the literal groundwork that must be done for the survivor to be able to witness "at the place of the catastrophe," while interacting with the jungle, the wreckage, and the filmmaker.

With preproduction completed, Herzog says on the voice-over, "There was only one question: Would Juliane be prepared to repeat all the stations of her odyssey with us?" It is a rhetorical (and metaphorical) question, the answer to which has already been given. Nevertheless, as they prepare to board another plane in Lima, a moment that is already emotionally charged, Herzog asks her once again, this time on camera, "Do you dare? Do you really want this?" Phrased in this way, and spoken on camera, the question clearly recalls the many scripted moments of dramatic tension that are the stock-in-trade of reality TV shows such as *Survivor*—an echo of which may have pleased the German television network that broadcast *Wings of Hope* but is probably not what the director had in mind. By repeating the rhetorical question, as he does, Herzog would seem to be more interested in staging a drama of informed consent so that viewers see and hear him as he asks the appropriate question and the survivor as she answers in the affirmative. What results from this exchange, however staged, is indeed consequential.

From this point onward, the film issues a series of repetitions, which marks not only their connection to the past but also their difference from it in the present. After giving her consent, for example, Koepcke says it

is important for her this time around to be accompanied by her husband, who provides "moral support." During the flight, Herzog emphasizes that they take "the same route," and Koepcke sits in "the same seat" as she had twenty-seven years earlier, only now they are flying together on "a different airline."[53] When she lands in the jungle—this time "softly," we are told—the environment, too, has changed. Herzog comments, "Everything seemed to be as always. All reminiscences returned to Juliane. And yet everything was different. It started with the newly constructed road through the jungle, the Amazon Marginal Highway. Hour after hour, there was nothing but deforestation, dead trees, and smoldering fires." What appears to be a bit of social criticism made on the fly can also be understood to support a more sustained commentary about the process of reenactment itself. Marking difference as well as similarity, emphasizing the present as well as the past, becomes a way of asserting that historical reconstruction is not an arrangement of facts that are simply given. Rather, it is (literally and figuratively) what one makes out of the traces, images, and memories.

Wings of Hope provides various forms of evidence—verbal, staged, and physical. All of them are evoked by Dr. Juan Zaplana Ramirez, the leader of the search team and thus a historical witness, who has this to say about the crash site: "We found the widespread fragments of the wreckage, and there we saw trees hung with the belongings of the travelers. Suitcases had opened in midair and the presents hung in the branches, as if these were trees decorated for a sad holy night, as if they were adorned for the relatives of all those who never came home." Interestingly, the film goes on to explore such as-if scenarios, of which I will have more to say later. Mixed among the verbal accounts such as this one are the remains (literal effigies) of the crash: a child's coin purse, a twisted row of seats, fragments of an instrument panel, pieces of the fuselage. They appear on-screen as metonymic traces of an absent whole. They are also evocative objects. Their power as such derives from having been in contact with a source body, touched by the missing people. Revisiting the crash site, Koepcke interacts with these pieces as they are found, literally touching them again—this time for the camera. When she holds up the coin purse, for example, it evokes the absent child, not as a human image, of course, but rather by means of effigy, in the empty

Leaning against a mangled row of seats, Juliane Koepcke recounts the plane crash in *Wings of Hope* (2000).

space that is created around the object as an effect of its visual display.[54]

The effect can be haunting, to be sure, but whether it succeeds—and what it would even mean to succeed—is another question entirely. According to Herzog, "the German network which financed [*Wings of Hope*] hated the film because they wanted to see [Koepcke] breaking down in emotions when she touches these pieces of the wreckage."[55] Instead, she projects a "cold, analytical affect."[56] Here is a good example of television as an informing context of Herzog's practice. In revising the material for theatrical release, he not only makes a point of addressing this issue of affect but also offers an explanation for it. Referring to the first piece of fuselage they discovered, he comments, "Her nightmare . . . had become so concrete that it was finally palpable. And yet Juliane seemed to be emotionally untouched by all of this. This shell, she later said, was a necessary protective device, part of a technique she developed to lead a somewhat normal life." Herzog thus calls attention to the issue of emotional detachment and puts it in relation to the emotional intensity of

relics. Revisiting the past in this way becomes a threshold experience, with its own internal dynamic. As the evident traces increase in size and number, Koepcke is said to have a belated realization—a comment that clearly invokes the discourse of trauma. "We almost overlooked the largest piece of the plane, which had become engrafted in the landscape, here filling the frame from left to right," Herzog says on the voice-over. "For the first time Juliane appeared deeply affected by the sight of this. Only now did the catastrophe and her solitude acquire real dimension."

Wings of Hope offers an extended meta-commentary on historical reconstruction as a vain process of searching for pieces of wreckage. The entire film works to make the past visible (even palpable) in the form of fragments, large and small. If the historical event can be imagined in terms of a centrifugal logic—the wreckage in this case is literally strewn across a vast area of jungle floor and canopy—its reenactment follows a centripetal logic that aspires to gather up all the fragments and piece them back together. In a move that is quite typical of historical reenactments, *Wings of Hope* portrays its subject as searching for a lost totality.[57] In his final narration (recalling a dream sequence in *Little Dieter Needs to Fly*), Herzog says of Koepcke, "She wants to continue her search, she wants to find all the fragments of the plane, and lift them from the ground, and resurrect them. She wants to reassemble the whole thing, but it dawns on her that nothing can be reversed, that nothing can be annulled. Did she sit behind one of these windows? Was she perhaps hurled into the void through this exit?" There is no way of knowing. What emerges, instead, is a model of reconstruction as partial, transitory, subjective, contingent, and imaginative—shaped and reshaped by the imagination of the filmmaker and by his negotiation with the subject who is performing this history of her own.

For all the time and effort that goes into reconstructing an event that is historically verifiable, bringing the survivor herself back to the crash site and searching for physical traces of the wreckage, it is significant that *Wings of Hope* alights as it does on mythic terrain. In grammatical terms, underlying the film's indicative structure is a subjunctive "as if."[58] In a way, as Mark J. P. Wolf has shown in another context, this grammatical situation is true of documentary forms generally "because all are subjective and incomplete, reconstructing events to varying degrees through

"Was she perhaps hurled into the void through this exit?" *Wings of Hope* (2000).

existing objects, documents, and personal recollections."[59] Herzog just calls our attention to the fact that documentary can conjecture. Thus *Wings of Hope* repeatedly refers not to what "was" (the so-called facts of the matter) but rather to "what might have been" (the potential, the conditional, the counterfactual). Such moments are explicitly coded as subjunctive, though they vary substantially in their fictive status. On one side of the spectrum, for example, the analytical Koepcke discusses "three possible explanations" for how she could have survived falling from such a height. On the other end of the spectrum, there is the un-named film actress who behaves "as if" she were the young Juliane in a ripped-from-the-headlines Italian film, which Herzog describes as "extraordinarily bad."[60] What is more, the survivor herself dramatically mimics and mocks her fictional counterpart. Fiction thus provides a handy counterexample, a past performance that would seem to deserve nothing but ridicule.[61] Somewhere in the middle of this spectrum lies the use of conditional statements in what we might call demonstrations of the counterfactual. "If she had only a machete and a lighter," Herzog

comments, "her survival would have been much easier. She could have built a simple shelter. She could have taken out the soft core, the heart of a certain kind of palm, and eaten it." As Herzog speaks, in a further twist on *Little Dieter Needs to Fly,* we see these and other survival skills demonstrated by native Peruvian extras. In a way, these scenes restage the training film that is a target of parody in *Little Dieter Needs to Fly,* where the parochial lessons of survival school prove to be "totally useless." Only in *Wings of Hope* do such hypothetical scenarios become enlisted in a dramaturgy of survival that visualizes the decisive role of contingency itself. The subjunctive "as if" becomes a cinematic strategy for evoking and vivifying the very random aspect of survival, without any pretense to realism.

What remains, paradoxically, is a documentary project that aspires to transcend the contingencies of this world. This is the upshot of the film's closing scene. Speaking in the present tense, Herzog narrates an extended dream sequence in which Koepcke "sees herself" from various outside perspectives. Each perspective is enacted by the camera. First, "she sees herself left behind in the jungle." Repeating a move from *Little Dieter Needs to Fly,* an aerial slowly ascends, pulling away from Koepcke, who is still visible for a moment, before the camera tilts upward to show the vastness of the surrounding jungle. Then the scene repeats itself from another perspective. Herzog's narration is so excessive that it needs to be quoted at length:

> Juliane sees herself again during her flight into the void. Alone, strapped to her seat, she sails on further and further. Around her there is nothing but a yawning abyss. She flies on for weeks. Then it becomes dark. As it becomes bright again, she sees a way out, a door of deliverance. She walks through the door, and all of a sudden she beholds an angel engulfed in light. All fear departs from her, all screaming falls silent. She does not breathe anymore, overwhelmed by bliss, her heart stands still for an entire minute. And she knows that a boat will come, slowly and softly, to carry her away, to rescue her at last.

The final image shows the now-frail man who rescued her, emerging from a boat with the help of several women. We have seen this image before,

in a passage reenacting Koepcke's original encounter with the lumber-men. This time, however, the shot is so overexposed that the depicted figures lose their definite outlines, blurring as they do with the sunlight that bathes the entire scene. And then it fades to black.

Wings of Hope may be "exaggerated and hyperbolic," but the effect of such extreme stylization is neither "to mock Juliane" nor "to test the limits of our acceptance of the idea that she was traumatized."[62] On the contrary, the final scene works to elevate her in every sense of the word. It is the cinematic equivalent of the allegorical monument shown at the beginning. In closing, the film does not literally return to this monument but rather gives it a new form. Although the film is stylized in a way that is particular to Herzog, its dramatic conversion of the subject is a stock move of reenactments, where it has previously been discussed in terms of enlightenment and moral uplift.[63] Herzog's version is charac-teristically baroque. It culminates in a dramatic turn of ascension and transfiguration. Hence the film's trajectory: from "heaven" to "hell," and back again. Bodying forth, as it does, *Wings of Hope* concludes by suggesting a final movement out of the body and into the light. While some viewers may find the metaphysical connotations of this movement either suspect or exhilarating, from a materialist perspective, they capture the transmutation that the documentary subject undergoes in the realm of the cinema. On one level, Herzog's project relies on the body of the survivor absolutely. On another level, once recorded, the body becomes superfluous, displaced, mediated, and reconfigured. It also becomes subject to a repetitious and seemingly endless proliferation. Even when an image of transcendence is floated, as it is in Herzog's voice-of-God narration, *Wings of Hope* does not assert the religious (i.e., Protestant) notion of the spirit over the body. For in this realm the body—that of the survivor, that of the director, and that of the film spectator—is also the inescapable medium of imaginative transport.

"Unfinished Business"

The cycle of survival films continues. *Rescue Dawn* offers yet another variation on the documentary material first aired as *Escape from Laos,* only now in the mode of fiction. This time around, the director returns

to Thailand with a group of actors (including, most notably, Christian Bale) and a different crew (the key exception being cameraman Peter Zeitlinger, who also shot the documentary) as well as with outside producers. Other documentaries in the history of film have been remade as features, but this is the first time that Herzog has fictionalized one of his own documentaries. If ever it were needed, here is proof that gives the lie to Herzog's well-known claim that, for him, the boundary between fiction and documentary simply does not exist.

Given this claim and the number of related documentaries already in existence, one might reasonably wonder, why should Herzog rework this material at all? When asked this question, Herzog addresses it in terms of "unfinished business."[64] This is an interesting phrase. Presumably, it refers to the plan that he and Dengler had to make a feature based on the latter's story—a plan that had to be set aside for lack of funding. On this level, Herzog now presents himself as simply making good on a promise. Indeed, *Rescue Dawn* plays at times like a heartfelt tribute to the memory of Dengler, who died in 2001. On another level, the phrase suggests a relationship of complementarity between *Little Dieter Needs to Fly* and *Rescue Dawn,* as though the documentary prepares the feature, and the feature somehow completes the documentary. If only it were that simple. It seems to me, however, that there is yet another, more interesting way to think about "unfinished business," as referring to the status of reenactment itself. In closing, then, I'll briefly discuss *Rescue Dawn* not for its own sake but rather as a way of drawing out the chapter's key points.

Rescue Dawn takes a past performance—that of Dengler in *Little Dieter Needs to Fly*—and puts it in the service of making a narrative feature. Adding the fourth wall changes the relationship of filmmaker, subject, and audience, and it does so in countless ways. A few of them are worth mentioning because they stand out against those elements that epitomize Herzog's approach to reenactment as a documentary technique. They are structure, theme, and acting. Structurally, *Rescue Dawn* adds a number of characters, conflicts, and details, most of which derive from Dengler's memoir.[65] Bringing these elements to the screen is partly what Herzog means when he speaks of "unfinished business." Such details, however, are not only added but also subtracted, producing a narrative

structure that is relatively narrow in focus (showing only the action of escape and rescue from Dengler's perspective) and much more linear than that of *Little Dieter Needs to Fly* (which toggles between the past and the present). The many voices, comments, flashbacks, interruptions, temporalities, and locations—all these elements, which characterize the documentary material—are purged in favor of dramatic action and suspense. These changes in turn have thematic consequences. Above all, the process of narrative streamlining totally eliminates the themes of psychic stress, memory, repetition, and testimony. In this regard, a simple formulation for the status of reenactment in *Rescue Dawn* might be "once more, without trauma."

Last but not least, *Rescue Dawn* redefines the practice of reenactment in terms of professional actors. The use of actors, which Herzog had resisted in making the documentaries, returns us to the issues of effigy and performance, but with very different results. Lost is the on-camera negotiation with the subject of documentary, the meta-cinematic commentary on the process of reenactment. In a way, the entire film works to compensate for the absence of Dengler by constantly foregrounding the physical effort and self-discipline of the film's leading actors. Now we can speak of bodies "too much."[66]

For all these differences, which are considerable, it is interesting to note how *Little Dieter Needs to Fly* informs and shapes the production of *Rescue Dawn,* especially in terms of preparation. Instead of taking a course in jungle survival, as another actor might have done to prepare for the role of Dengler, Bale repeatedly watched and listened to the documentary film, which in this case literally provided the model for him to follow or not follow.[67] Reenactment's exemplarity thus doubles back and becomes a paradigm for film acting, even though Dengler performs on camera without knowing how his image, voice, and behavior would later be used. A record of a performance that exists apart from Dengler, the documentary permits an actor such as Bale to study it, to extract certain elements, and to make them his own. The task, however, was to inhabit the role and not to become it—a point Herzog made explicit to Bale. "Werner said, 'We can't get hung up on impersonations. We *are* making a movie, you know. We're *not* making a documentary now.'"[68] At this point, unexpectedly, the relationship between fiction and

documentary, so fluid in the Herzog scholarship, becomes fixed by the director himself. It turns out that his intervention in the practice of reenactment is more specific to documentary than one might just assume, based on the director's reputation alone. But this reputation has obscured a more interesting phenomenon that only becomes visible through studying the films in terms of documentary; that is, Herzog's reenactments function as a form of testimony by staging the historical witness as a participant in the process of reconstruction and by exploring the process itself as partial, unfinished, and subject to change.

7 AUTOBIOGRAPHICAL ACTS

For decades, Werner Herzog has projected a public image of himself as a director frankly opposed to acts of self-exploration, whether imaginative or therapeutic.[1] The image serves in part to deflect the once frequently leveled charges of narcissistic self-absorption or "ego mania." Indeed, Herzog even claims to avoid his own gaze in the mirror. "Let me make it very clear," he remarks in an interview on the subject of *Grizzly Man*. "I don't look at my own navel when I make movies. It's never a journey of self-discovery. To this day, I don't even know the color of my own eyes. If I shave in the mirror, I evade my own gaze."[2] Ironically, the emphatic claim to rigorous self-evasion encourages the very questions of psychoanalysis that Herzog wishes to sidestep. At the same time, however, and with even greater persistence, he has also projected an image of himself as a visionary director who creates "inner landscapes" and trains an unflinching gaze on others. When the subject is the filmmaker himself, it seems that Herzog's maxim ("the poet must not avert his eyes") is either suspended or conveniently forgotten.

And yet, over the years, Herzog has experimented in various forms of self-inscription, often within a single film. The predicament he has created for himself is, essentially, how to look inward without being seen as navel gazing. It is a question of performing autobiography without giving off the appearance of excessive self-regard. His engagement with autobiography provides the ultimate example of this book's larger argument, that documentary is for Herzog a repudiated mode of filmmaking, to which he nevertheless contributes and thereby works to revise, according to his own agenda. The task here is to identify the autobiographical strategies that he has employed in the context of documentary. None of them have previously been discussed in the Herzog scholarship, where

the emphasis has typically been put on the feature films and on issues of auteurism and self-reflexivity, which are different from issues of autobiography and self-reflection.

Whether or not he is aware of it, Herzog's approach to autobiography foregrounds some of the very issues of cinematic displacement that literary scholars have found to be most vexing. Elizabeth Bruss, most notably, points to the historical emergence of film as marking in effect the end of autobiography. As Bruss observes, the visual economy of film distinguishes between subjectivity and subject matter and renders that distinction physically as a multiplicity of bodies. In her words, "the autobiographical self decomposes, schisms, into almost mutually exclusive elements of the person filmed ([who is] entirely visible; recorded and projected) and the person filming ([who is] entirely hidden; [and] behind the camera eye)."[3] Proceeding from the idea of the "autobiographical pact," the perceived identity of the author, narrator, and subject matter of a written autobiography, Bruss confronts the impossibility of such a pact in the cinema, assuming as she does a narrative film, the use of actors, and the physical displacements of technological recording. The idea of film as an autobiographical mode of expression thus appears to jeopardize what she calls the "classical" autobiographical self and its traditional forms of narration. In so doing, however, it also suggests alternative models and expressions of subjectivity, which Bruss, writing in 1980, describes as "an entire culture now irrevocably committed to complex technologies and intricate social interdependencies."[4] Apparently, Bruss was unaware of then experimental work being done in film and video and the discussions it had already engendered among her contemporaries.[5] She also makes certain assumptions about filmmaking that don't necessarily hold, but her larger point does; that is, the medium of film not only undercuts the model of a unified subject but opens up a space for imagining new models of subjectivity and new ways of representing them. The body's dispersal and plurality in film, which previously appeared to signal the end of autobiography, have since made the cinema a key site for reinventing autobiography under changed historical conditions.[6]

Herzog exploits the cinema's profusion of bodies and does so in various ways, almost as if it were a division of labor that can be organized and reorganized, depending on the situation, to meet the changing needs

of the filmmaker's identity in each successive present. Metonymic traces of an autobiographical self are spread out across his entire body of images, spanning a wide diversity of films, genres, figures, and contexts. The traces are emphatically corporealized—sometimes by the filmmaker himself but more often by fictional characters and social actors. This is also the reason why he describes the figures in all his films as comprising a "family," a major context and constituent of autobiographical discourse.[7] Indeed, says Herzog, "the people in my films—particularly the real-life ones—are for me not just mere characters; they are a vitally important part of my life. The more I have progressed as a filmmaker, the more I find it is real life that I have been filming, *my* life."[8]

This chapter explores a series of documentaries, each from a different decade of Herzog's career, namely, *I Am My Films*, *Portrait Werner Herzog*, *My Best Fiend*, and *Grizzly Man*. What unites these documentaries is their privileging of film and the filmmaking process as key sources of self-definition, with particular emphasis on the use of recycled footage. Each is made by a small team of filmmakers and not by Herzog alone. Nevertheless, in every case, Herzog is the focalizing narrator, whose position and authority as such organizes the material and its presentation. Taken together, they exhibit the persistence of autobiography in Herzog's work, especially since he first gained international recognition in the mid-1970s. Thus they not only reflect but also contribute to the diversification of autobiographical forms in post-verité documentary film and in video more generally.[9] The autobiographical acts to be discussed in this chapter are specific to Herzog, to his films, and to his sense of himself "as" his films. They involve the work of actors, both professional and nonprofessional, but they also encompass such diverse strategies as the filmmaker staging himself in front of the camera, manipulating his vocal presence, representing others in relation to himself, recycling footage from his own body of work, and reframing the work of other filmmakers.

Self-Biography

It is only fitting, then, that a discussion of Herzog and autobiography begin with a personal portrait film made by somebody else. *I Am My Films* is structured as a formal interview with Herzog, alternating with

footage from the making of *Stroszek* (1977) as well as from some of his earlier films. There are also occasional shots of the production team, asserting their role as filmmakers. The interview, conducted by Laurens Straub, takes place in Herzog's Munich apartment, as if to give an "inside" look at a star director of the New German Cinema. Access is further suggested through a mix of long takes, straightforward camera work, and a frontal mid-range composition that emphasizes the subject's face and hands as loci of meaning and intensity. For much of the interview, Herzog sits on a couch, head bowed, furrowing his brow, wringing his hands, and generally creating the impression that he is reluctant to appear on camera at all. What most interests me about this film, however, are the subtle and not-so-subtle ways in which Herzog exerts control over a film made by others. *I Am My Films* appears to be a personal portrait, but the power dynamic between the star director and the relatively unknown filmmakers Christian Weisenborn and Erwin Keusch is such that Herzog effectively co-opts this film for his own agenda.[10] And in so doing, he employs documentary for the very first time as a way of framing his entire body of work and thereby unifying the terms of its reception. Ever since this production, documentaries made by other filmmakers have become a key site for Herzog's performance of self.[11]

The film's subtitle notwithstanding, *I Am My Films* can best be described as a "self-biography," a hybrid form combining elements of biography and autobiography, the origin of which Audrey Levasseur traces back to the early 1970s. In her words, self-biographies are "film and video biographies whose subjects exert significant control over the content and tone of the biography, but who do not direct, edit, or perform the technical aspects of its production."[12] Notable examples include *Sartre by Himself* (1972; dir. Michel Contat and Alexandre Astruc), *Marlene* (1984; dir. Maximilian Schell), and *The Life and Times of Allen Ginsberg* (1993; dir. Jerry Aronson). The subject in each instance is a well-known public figure with a highly developed sense of his or her celebrity, a sense of identity that is profoundly influenced by the perceptions of others. Each film in turn provides the subject with an occasion to reshape his or her public image. Self-biographies are often used by celebrity figures who feel that they have been misrepresented by the press. In *I Am My Films* (which is not discussed by Levasseur),

the star director takes umbrage with the media's portrayal of his relationship with the actor Klaus Kinski, a figure who was then a living icon of celebrity in West Germany. Herzog may resist the criticism of excessive self-regard, but he evidently looks at others looking at him, and much of his work engages the views of others about himself. Interviews, such as this one with Straub, make clear how much of Herzog's identity as a filmmaker is bound up with the notion of "being misunderstood" both previously and in present company.

The central issue in self-biography is the degree and consequence of the subject's involvement in the telling of his or her own story (as opposed to the documentarian's intervention in the life of the subject, which raises a different set of issues). The high degree of participation that distinguishes self-biography from other genres makes it particularly vulnerable to charges of hagiography. This is certainly the case in *I Am My Films*. The point can best be illustrated by comparing the film with the more recent and widely known English-language volume of interviews, *Herzog on Herzog,* edited by Paul Cronin. Herzog's one-line preface to that volume describes his involvement in terms of "collaborating," playfully evoking a sense of treason, as though he were cooperating with a supposed enemy. The motivation is admittedly to manage his public image.[13] In certain ways, *I Am My Films* marks the cinematic origin of *Herzog on Herzog.* Each not only occasions a rehearsal of Herzog's childhood memories (e.g., encountering "God"), aesthetic provocations (denouncing cinema verité), and production anecdotes (directing Kinski) but also consolidates them within a single, coherent form: that of the extended interview. A documentary filmmaker in his own right, Cronin gathers up Herzog's favorite stories about himself, his films, and his relationship with others and transforms them into a single-volume publication. Although the paperback has greater circulation and is certainly more influential in terms of shaping public perception, the film introduces a model of autobiographical discourse that Herzog has employed ever since, and does so via documentary. In it, the filmmaker himself follows a script that he has been rehearsing for decades now, encouraged as he is by critics and journalists, who continue to ask him the same questions that they have heard him answer before. In a further step, *I Am My Films* has even been absorbed by Herzog's corpus of images. It is advertised on

his official website, distributed by Werner Herzog Film, and included as part of the six-volume DVD edition, *Werner Herzog: Documentaries and Shorts,* released by his production company. In this case, the subject's involvement in his own biography has not just continued since the film was made but has become even more consequential over time.

The degree of Herzog's involvement in his own biography also defines the film. Specifically, it brings out what Levasseur calls "the performing identity" of the subject, by which she means "the created persona, an artifact turned out with calculated artistry."[14] The making of the film itself occasions a performance of that identity before the camera. "Unlike biography, where the subject is present only in photographic stills, family movies, archival film footage, and excerpts from past writings, in self-biography the subject's most powerful instruments are his or her performing identity and present self-performance."[15] In an early scene from *I Am My Films,* the interview abruptly stops, when Herzog takes issue with its superficial tone and content. "This is too much like a talk show," he comments, shaking his head, looking away from the interviewer, and addressing one of the filmmakers off camera. A long silent pause ensues, followed by a cut and another moment of reflection, before Straub concludes, "We can't get out of this talk-show dilemma." At this juncture, Herzog suggests they take a break from shooting, which they do. When filming resumes, he clearly has control of the interview, and now he claims to "be" his films. In so doing, he provides Weisenborn and Keusch with a title for their film and a means for constructing it: by recycling and reassembling selected footage from Herzog's body of work.

The idea of a specifically autobiographical relationship between the director and his work is proposed within the film by Herzog himself. Referring to the interviewer's line of questioning, he remarks, "People are always looking too hard for a person 'behind the scenes,' but it's actually not at all important. I could've made my films anonymously, and still people would know me pretty well after watching my films. That is entirely what I am, the films [*Das ist das, vollständig, was ich bin, das sind die Filme*]." Thus begins the first retrospective series of titles, dates, and clips. Every single Herzog production to date is represented in chronological order, and excerpts from the major films are shown without commentary. At this point, *I Am My Films* could be said to

resemble a compilation documentary, which gathers up existing footage and reedits it to represent the filmmaker's individual history. Following a scene from *Stroszek,* whose production overlapped with that of *I Am My Films,* there begins yet another series of clips, this one organized topically and interspersed with new footage of the interview. In each case, the recycling of footage enacts the shift that Herzog here proposes: away from the man-behind-the-work line of inquiry and toward the idea of the director "as" his work.

In the film scholarship, Herzog's claim to "be" his films has always been understood in terms of authorship, because it resembles a patent move already associated with other auteurs, such as Ingmar Bergman, Federico Fellini, and Jean-Luc Godard, who blur the distinction between their films and their selves.[16] With Herzog, however, as Timothy Corrigan explains,

> this claim becomes fully the contrary of the auteurist position that it seems to suggest: for Herzog, he is his films only as a medieval artisan, the figure who disappears into that work and is ultimately dwarfed by the larger weights and energies it testifies to. This author becomes most real in his industrial and artistic projections, and the most effective way to preserve that aura of the auteur is to make him the concrete work of images, not personality.[17]

But there's more at stake than authorship. Herzog's claim to "be" his films also needs to be resituated in the context of autobiography. The shift in framing categories requires in turn a methodological adjustment. Rather than imagine the director as disappearing into his own work, we need to analyze the dramatic effects of his appearance in the work of others.

In this case, Herzog's claim has the effect of narrowing the analytical perspective and critical distance of his biographers, while rendering the film increasingly univocal. To be sure, the interviewer does what he calls his "duty," coaxing the director into telling his story, even pushing a bit when he senses resistance. At one point, for example, he insists that Herzog disclose a personal "secret" that might reveal an underlying motivation for filmmaking (the director, for his part, acknowledges the supposed existence of such a secret and characteristically refuses

to divulge it). None of the interviewer's efforts, however, results in a counterargument or critical perspective that might question, or even challenge, Herzog's performance. On the contrary, the film concludes with an extended monologue by the star director, who now sits alone and looks straight into the camera. The interviewer is not just absent; he has been replaced by a tape recorder, which Herzog operates by himself. The substitution of a talking machine for the interviewer gives visible form to the film's univocal quality, while providing yet another instance of recording. Instead of calling attention to the act of filmmaking, the machine produces one last piece of evidence, further attesting to Herzog's autobiographical claims, only now in his own prerecorded voice. "This is a recording that was secretly made during the shooting of *Aguirre,*" Herzog explains. "Neither Kinski nor I were aware of it; the sound engineer recorded it. I'll play it for you." What follows is an acoustic show of strength and vulnerability in equal parts. We hear a sound recording of the young director, who is relentlessly harangued and humiliated by the older, more famous actor and nonetheless manages to hold his ground. Listening, we watch Herzog's face as he winces and smiles, reacting on camera to the sound of Kinski's outbursts while setting the scene for a new performance of his own: that of having the last word.

Landscape for a German Filmmaker

Portrait Werner Herzog is a formal self-portrait that merits not only comparison with *I Am My Films* but also more attention in its own right. Each is shot on 16mm and made with a small production team—only in this film, the other team members never appear on camera. Instead, it creates an illusion of self-determination, all evidence to the contrary notwithstanding. The director tells his own story, says who he is, where he comes from, and what he has accomplished. In the process, he recycles excerpts from several of his major films, as in *I Am My Films,* only now this move operates on an explicitly autobiographical level. There is a stylistic development worth noting here as well. In *Portrait Werner Herzog,* the director voices his own commentary for the purpose of reframing his own work—a strategy he would later employ in *My Best Fiend* (and, on another level, in all his films released on DVD with audio commentary).

Herzog and the tape recorder, *I Am My Films* (1978).

Despite its short running time of twenty-nine minutes, *Portrait Werner Herzog* tries to encompass the larger arc of the director's life, from early childhood to the present, much in the manner of *I Am My Films*. Unlike that film, however, Herzog's self-portrait is organized spatially and not chronologically. It is a difference that goes to the core of this material.

Portrait Werner Herzog bases itself on the idea of returning to places of origin. When Herzog speaks of his past in this film, he appears in situ, whether standing outside of his childhood home or driving along a foreign coastline. Each location is characterized as a landscape that has fundamentally shaped his life and work. In the process, he (literally and figuratively) puts himself back in relation to place and makes himself a figure to be seen within a landscape view. To some degree, landscape, too, is put in the service of performing a sense of place and identity, which is different from Herzog's more pronounced tendency to divorce landscape from place (discussed in chapter 2). The difference, which is one of degree, can be accounted for by the controlling framework of

self-portraiture. Drawing on classical rhetoric and the historical art of memory, Michel Beaujour has suggested that the literary self-portrait is first and foremost "an imaginary perambulation through a system of places, around a depository of memory-images."[18] As this formulation makes clear, however, "places" in this system primarily refer to the inner world of memory, emotion, and imagination. They map the self by projecting it onto locations that have already been turned into images. James Olney's study of autobiography also comes to mind. To speak with Olney, we might say that landscape in this film is "intentionally or not, a monument of the self as it is becoming, a metaphor of the self at the summary moment of composition."[19] This holds particularly for a film such as *Portrait Werner Herzog* because it projects the illusion of a fully sovereign self.

Although it is not formally innovative, *Portrait Werner Herzog* deserves notice for its effort to map the director's identity onto landscape. In this case, landscape functions as a form of self-understanding and a site of autobiographical performance.[20] What makes this film even more interesting is its relationship to German landscapes in particular. Because it was made in the course of the New German Cinema's demise and before Herzog's move to the United States, the film can be seen in hindsight as marking the end of his "German career." Never again would he so insistently foreground the historical and cultural origins of his work as he does in this self-portrait.

Here is the opening scene: it is Oktoberfest in Munich. At one of the many beer tents, we see Herzog in lederhosen raising a glass with friends—all from the film industry, we are told. Initially, the voice-over moves at a rapid pace, skipping from one observation to another, like a ride at the nearby fairground. Indeed, the following scene shows Herzog strapped into a giant Ferris wheel, pointing with his finger at the massive crowd below. The commentary is worth quoting at length:

> It's my city, where I live and work, like most of the film directors in my country. Munich has always had something imaginative, baroque, something special that has made it a cultural metropolis in Germany. Festivals here in Bavaria are celebrated more colorfully than they are elsewhere in Germany. . . . In good weather, more than half a million

people stream together here. But deep in my heart I am someone who doesn't feel comfortable being among so many people. I come from an isolated mountain valley.

Abruptly, then, Herzog appears sitting before a pilgrimage church in upper Bavaria, lacing up his boots, as he recalls his famous walk around the inner-German border. Thus the film quickly establishes its characteristic movement of returning to places of origin and staging the director in situ.

Once established, this pattern of movement is developed in various ways. In one passage, for example, Herzog returns to the site of an old ski jump, where he first became fascinated with the sport of ski flying. There he recounts his dream of becoming a world-class ski jumper and his friend's near-fatal accident. His memories cleave to this place, even though it has obviously changed over time (what was once a functional ramp is now an overgrown pile of wood and rubble). Narrating these memories in situ performs a part of the filmmaker's identity since the ski jump is also a place of origin for a film, namely, *The Great Ecstasy of Woodcarver Steiner*. Then twenty-two years old, world champion ski flyer Walter Steiner appears (once again) soaring through the air, filmed as he is in extreme slow motion. "To be like him," Herzog adds, "is my dream still today." The bridging commentary virtually relocates the selected film and its source of narration. It is as if that film were being projected anew from the site of Herzog's present self-performance. The following passage repeats this pattern of return and reflection in the context of *Fitzcarraldo*. With each return, the filmmaker puts landscape in the service of performing identity: that of his own. The final destination of this autobiographical pilgrimage is not a particular location, nor is it even landscape per se, but rather the self *in* the landscape. *Portrait Werner Herzog* works to *place* the director's body (in every sense of the term), to make him an integral part of a landscape view, while urging spectators to see him as such.

The constitutive moment of Herzog's self-portrait is therefore not the making of his first feature, as one might expect. It's the moment of returning to and walking through the landscape. Walking here doubles as an autobiographical act.[21] An early scene depicts him striding across a verdant hillside, the folds of his traditional cape trailing behind him

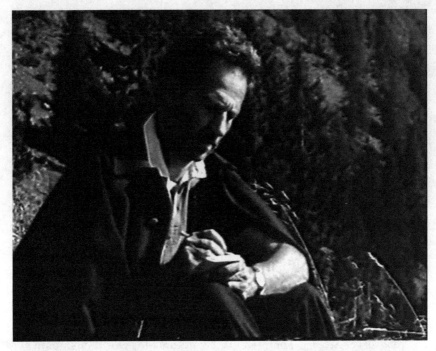

The filmmaker as romantic poet, *Portrait Werner Herzog* (1986).

as he moves. "These mountains are the landscape of my childhood," he narrates. "Even though I have shot almost all my films—there are twenty four as yet—in far-flung places of the world, I always come back here again. Walking, I have the most intensive moments of fantasy, of making plans. And then I write a lot, work on projects, on screenplays." The camera then pans from a receding series of mountains to a medium close-up of Herzog, who is sitting on the ground and writing in a notebook. In this scene, he is literally acting out the idea of "making plans" while going on foot. This is Herzog performing his identity as a German-born filmmaker, a singular romantic poet who defines his own identity.

The film ends with a series of still photographs, the last of which, taken on the set of *Cobra Verde* (1987), shows the director at work, his eyes cast downward, his gaunt upper body twisted in on itself. "And looking at me here," Herzog says of the photograph, "you can see how strenuous it can be to work on a film, but that is my life. I do not wish for any other." Reflecting on a series of works in video, Raymond Bellour has argued that "the self-portrait bases itself above all on the experience

of the body, of the author's own body as site and theater of experience. As such, the self-portrait has something in common with performance art and can in part be created in relation to it."[22] This is true of all the films under discussion in this chapter. The final image of *Portrait Werner Herzog* refers to the body as both a site of autobiographical knowledge and a form of evidence, on which the traces of lived experience are made visible. The fascination with scars, wounds, and stigmata, which can be traced across Herzog's entire body of work, here refers back to the body of the filmmaker himself. In a way, the body of the filmmaker is a final frontier, a landscape in itself. Moreover, as this particular image would seem to suggest, figuring the self is also an act of disfiguration. More than just a physical approach to filmmaking, this image of the body suggests in its disfigurement an almost tangible sense of the director's life.

What is missing from this early self-portrait is a sense of Herzog's relation to others and their role in the formation of his identity as a person and as a filmmaker.[23] Herzog returns to places of origin that are experienced and inhabited but strangely devoid of other people. His is, apparently, a landscape of isolation. Only by blocking out the presence of others can he stage himself as a heroic individual who seems to thrive when he is utterly alone in the landscape. But missing persons have their own ways of returning, of making their absence felt. In *Portrait Werner Herzog,* the key technique of absence is the use of still images. The closing series of photographs thus includes a family portrait. In it, we see Herzog at age eighteen, along with his mother and his two brothers. The remaining images are production stills depicting Herzog with actors, cameramen, and other crew members, none of whom are discussed or even named. Elisions of this type are not at all surprising for a short self-portrait film, but they do raise questions about the intersubjective nature of Herzog's identity as a filmmaker, about the extent to which the self is constituted in relationship with others, and about how such a relational identity might be configured cinematically.

Relational Autobiography

While the romantic topos of isolation in Herzog's work is well studied, in terms of autobiography, the solitary self represents only one aspect

of the director's shifting identity. There are other important aspects
that only become visible in relation to other people. This dynamic can
best be understood by borrowing some terms from Paul John Eakin,
specifically, his notion of a "relational life" and its literary equivalent,
which he calls a "relational autobiography." By that he means an iden-
tity developed in collaboration with another person and articulated
in the process of telling that person's story. Unlike the memoir or the
autobiography in a traditional sense, both of which create the illusion
of self-determination, in relational autobiography, "the stress is on the
performance of the collaboration and therefore on the relation between
the two individuals involved."[24] On this model, the relational quality of
lives and stories manifests by means of narrative. Structurally, that is,
"the story of the self is not ancillary to the story of the other, although
its primacy may be partly concealed by the fact that it is constructed
through the story told *of* and *by* someone else."[25] Here, as in autobiogra-
phy more generally, identity takes shape through the arrangement and
process of narration within the text. What gives this model purchase is
the theoretical distinction it draws between the story that is being told
and what Eakin calls the "second story" or "the story of the story." The
upshot is not a postmodern sense of mise en abyme but a complex model
of self-inscription, in which the second story plays the decisive role.
It is important to note, as Eakin does, that the story of the individual
who is *telling* the story always has the upper hand—a situation that
only becomes more conspicuous when the other is deceased. Indeed,
what makes the relational paradigm so compelling is how it locates the
representation of self not only in the telling of another person's story
but also in relations of power, which tend to be asymmetrical. Not only
social interaction but also the interrelationship of different forms, genres,
and media are at issue. In this regard, the relational paradigm extends
beyond literature to include film, video, photography, performance art,
and other media, both historical and emergent.[26]

 Herzog's film *My Best Fiend* offers a case in point. On one level, it pays
tribute to the late German actor Klaus Kinski, who was—and remains—
best known for his performances in Herzog's films, namely, *Aguirre*,
Nosferatu, *Woyzeck* (1979), *Fitzcarraldo*, and *Cobra Verde*. Kinski died
of a heart attack in 1991. On another level, *My Best Fiend* represents a

cinematic self-portrait of Herzog as refracted through the prism of his love–hate relationship with the actor. The film's title in English as well as in German *(Mein liebster Feind)* announces the relational structure and thereby makes it explicit. The word "My" inscribes the first-person voice of autobiographical documentary, suggesting a sense of identification with (even possession of) an "other," while preparing the obvious pun on the word *friend.* Whereas the English title figures the other as a monster or wicked person, the German original suggests an intimate and privileged relationship, while framing the other as an enemy or adversary.

Compared with the examples of self-biography *(I Am My Films)* and self-portraiture *(Portrait Werner Herzog),* each of which necessitated the subject's presence, involvement, and sense of autonomy, *My Best Fiend* develops a more complex model of selfhood based on the absence of another, developed in terms of their past relationship and performed anew by only one of them in the present. Throughout the film, Herzog describes his relationship with Kinski in terms of "destiny," "coincidence," "collaboration," "conflict," and "role reversal," culminating in the well-known story that they were simultaneously "planning each other's murder." In this case, "the story of the story" (Eakin) is constructed through a mix of narration, interviews, recycled footage, and reenactment, with Herzog playing himself as well as his absent friend and foe. For much of the film, he appears on-screen either directly addressing the camera or interviewing other people. The act of storytelling is indeed decisive. Kinski may be half the film's subject, but Herzog plays the determining role. His point of view is ascribed to the camera, to the editing, and to the voice-over. Other agents of interpretation appear on-screen—such as Italian film star Claudia Cardinale and Swiss photographer Beat Presser—adding a few minor details and occasionally a different perspective. Mostly, however, they confirm Herzog's account and provide him with an on-camera audience, serving in effect as witnesses to the retelling of his story in the present. The subjective status of his account is made explicit not only by the film's title but also by the mise-en-scène. When Herzog returns to Peru, he is met at the Lima airport by a man (another actor from *Aguirre*) carrying a sign that says "Herzog's Kinski."

To say that Kinski is important to Herzog's life story is not saying

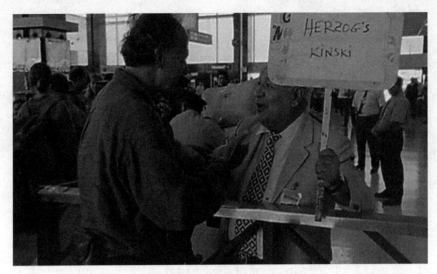

Signposting "Herzog's Kinski," *My Best Fiend* (1999).

much. They have often been described as each other's doppelganger or alter ego, and *My Best Fiend* exploits this familiarity. Furthermore, Herzog has a certain interest in Kinski. Their cooperation established his international reputation as both a master filmmaker and a megalomaniac, one whose work characteristically portrays men of supposed genius and madness, their obsessions and failures, as exemplified not least by Herzog and Kinski themselves. At stake in this film is nothing less than Herzog's legacy. Not surprisingly, then, it forges a new image of the Herzog–Kinski duo that serves the present needs of the director.[27] That *My Best Fiend* reduces Kinski's story to its intersection with Herzog, and brackets off Kinski's background and personal life, is noted by most critics as if it were an obvious shortcoming of the film. But this arrangement is precisely the point. Once we acknowledge the film's relational structure, Kinski's role obtains new meaning.

My Best Fiend begins with an extraordinary performance, which is captured on low-grade video: Kinski reciting the New Testament at Berlin's Deutschlandhalle on November 20, 1971. Inhabiting the role of Jesus Christ, Kinski addresses an audience of several thousand. "First," he shouts in the film's opening passage, "cast out the beam out of thine own eye; and then the mote out of mine!"[28] Provoking the audience, he challenges one man to confront him on stage. Later, in one of several

indefinite suspensions that characterized the event, he refuses to speak until another man leaves the arena. Responding as they do, the spectators, too, shape the live performance. The one man takes the microphone and makes a solemn speech about the "real" Jesus, thus providing Kinski with an occasion to further mock him. In another instance, by contrast, the man who was ordered to leave the arena is not even given a chance to speak. All of a sudden, Kinski emerges from back stage, rips the microphone out of his hands, pushes the man aside, tosses the microphone stand in the other direction, and walks back stage again.[29]

Beginning in this way creates a biographical context for *My Best Fiend,* in which Kinski appears as a raving lunatic in so many different guises. At the same time, the footage refers to the arena of performance as a context of autobiography. Throughout his life, Kinski sought financial stability independent from film and theater by reciting the works of famous authors (Shakespeare, Goethe, Rimbaud, Nietzsche, and Brecht, among others) in the sound studio as well as on stage. In some instances, he not only recited canonical texts but also inhabited one of the roles or characters involved. His repertoire included solo performances as Villon, Paganini, and Dostoyevsky's Idiot. He even begins his autobiography *Kinski Uncut (Ich brauche Liebe,* 1991) with a first-person account of the Deutschlandhalle performance, told in the present tense and set in italics to indicate its special status as a "slice of life."[30] Herzog's footage actually corresponds to the exact moments of this performance, which Kinski himself recounts. Here and elsewhere, as we shall see, *My Best Fiend* quotes from selected passages of Kinski's autobiography, shifts the narrative perspective, and revises the scene accordingly. In the film, which was made eight years after his death, replaying the image of Kinski as Christ suggests an act of resurrection. As Herzog put it in one interview, "I wanted to let him come back to life."[31] Speaking in terms of resurrection obviously evokes the idea of the cinema's supernatural power to animate a depicted object—indeed, to reanimate the dead. However interesting the metaphor of resurrection may be in this context, it is more important to understand that Herzog is also putting himself back in relation to Kinski by means of his audiovisual effigy. The film-maker stages a new performance of his own, based on various recordings of Kinski's past performances. Presumably, *My Best Fiend* begins with

footage from "Jesus Christ Savior" because it was the last performance that Kinski gave before he began working with Herzog. The rest is "Herzog's Kinski," or so the logic goes. At the same time, and from the beginning, Kinski serves primarily as a figure for Herzog to imitate, contradict, and revise, according to his own agenda.

Parallels to performance draw even closer when the artist and the director begin collaborating on films. At this point, interestingly, the interaction of self and other is doubled as the interaction of filmmaking and performance. During preproduction of *Aguirre,* as Herzog recalls on camera, Kinski "arrived at our location as a derided, misunderstood Jesus. And with this role he had completely merged, and he continued to inhabit it. Often, it was difficult to talk with him, because he answered as Jesus."[32] Later, Herzog describes himself as an "animal tamer" and Kinski as a "wild beast." A related image of wildlife filmmaking is conjured when Herzog recounts the apocryphal story of directing Kinski with a loaded rifle. The problem of performance is most fully developed at the end of *My Best Fiend,* when Herzog suggests that Kinski's "self-stylization" as Paganini introduced "a foreign element" into the production of *Cobra Verde* and fatally contaminated the film (as if that could explain the latter's critical and box-office failure). The narrative pattern is clear: in each case, elements of performance are introduced by Kinski, then harnessed and made productive by Herzog for the purpose of filmmaking. What emerges is more than just the notion of film as containing and controlling performance, although there is something profoundly true about this idea in Herzog's body of work. Representing the other, here construed in terms of Kinski and performance, allows Herzog to perform that which is most him: being a filmmaker.

When it comes to Herzog himself, however, performance obtains a positive role as an embodied form of narration. In this respect, perhaps the most telling strategy he employs is that of impersonation. Acts of impersonation rely on the filmmaker's physical behavior, while opening up a space for blatantly humorous performance. When *My Best Fiend* had its German premiere in 1999, commentators focused on the film's unexpected humor, especially in those places where the anecdotes being told seemed to confirm certain received ideas about each extraordinary figure.[33] Impersonation as such went unmentioned, but it is easy to see

how the film's sense of humor and playfulness are established by means of impersonation. In the first scene proper, Herzog returns to the Munich boardinghouse where he lived as a teenager along with his mother and brothers as well as eight other occupants, including, for a time, Kinski. This coincidence provides Herzog with a privileged occasion for narrating an early memory of Kinski, "who had stylized himself as a starving artist," while at the same time figuring himself as historical witness and claiming the authority of personal experience. The experience in turn renders the location an evocative site of reenactment. For what was once a low-grade pension is now a richly appointed house, owned by a baron and a baroness, whose visibly uncomfortable presence on camera becomes part of the scene's humor.

Herzog takes the couple on a guided tour of their own home as it appeared when he and Kinski lived there. Along the way, he plays not only the role of tour guide but also that of himself as the director of a documentary, that of his younger self as historical witness, and that of the absent Kinski. The camera work in turn alternates between medium close-ups of Herzog and wider shots to show the couple's reaction. Throughout this scene, he plays for a double audience: we observe the baron and the baroness, who listen and watch—eyes wide, cheeks flushed—as Herzog recounts a series of increasingly bizarre and socially inappropriate stories.[34] Indeed, the filmmaker gives a vivid description of the domestic interior as it had been earlier, only to verbally defile and demolish it, room by room. He begins in what is now a sparkling white guest room, where he and his entire family once lived "in some poverty." The tour gains momentum when he enters the adjacent bathroom. In his words, "Kinski locked himself in this bathroom for two days and two nights . . . and, in a maniacal fury, smashed everything to smithereens." Moving on, Herzog shows the couple where Kinski once slept, outlining with his hands a "tiny closet" in what is now their spacious kitchen. On one occasion, he recalls, Kinski became so upset that his shirt collars had not been properly ironed by his landlady that he burst out of his room, knocked down an interior door, and landed in her room, literally foaming at the mouth and screaming at the top of his lungs, "You stupid pig!"

Here and elsewhere in the film, Herzog mimics the voice and manner of Kinski. It is a subdued performance, to be sure, one that juxtaposes

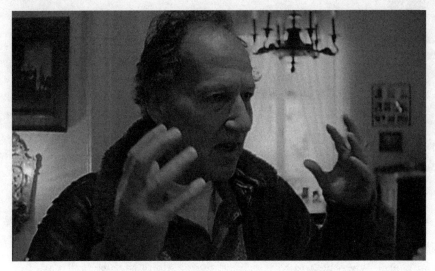

Mimicking Kinski, *My Best Fiend* (1999).

the crudeness of the material with the control of its retelling. Rather than scream as Kinski had, Herzog speaks in a hushed voice, squints his eyes, and shakes his fists in the air. The extreme—indeed, scatological—character of Kinski's language and behavior allows Herzog to give a physical performance of his own and have it go almost unnoticed as such. It is based on a dramatic reversal: just as the actor spoke lines written by Herzog, so the director appears on camera envoicing words either spoken by Kinski or attributed to him in the present. Relational autobiography reminds us that the narrating self must necessarily speak as and through others. Herzog's impersonation of his younger self and of Kinski literalizes this idea, while foregrounding the body as an autobiographical medium in its own right.

It is part of the Herzog lore that one of his cameramen (Thomas Mauch) once commented, somewhat facetiously, that the director ought to play all the characters in his films himself.[35] "I do actually function pretty well as an actor," Herzog adds, "and in many of my films I could have played the leading character if need be," a claim he makes particularly about the films with Kinski.[36] Indeed, this is exactly what Herzog does in *My Best Fiend*. Rather than appear in character, for obvious reasons, he imitates the language and behavior of Kinski as a celebrity whose story is partly bound up with that of his own. And if there were any question

as to what extent Kinski has a voice in this film, impersonation provides the answer. Almost all Kinski's utterances are spoken in character and are thus literally scripted by Herzog.

More important than the role of impersonation, the key representational strategy in *My Best Fiend* is the use of recycled footage. Throughout this film, Herzog reframes Kinski's life and death through the films on which they collaborated. The recycling of footage reauthorizes Herzog as director and extends that authority to his present role as narrator of Kinski's life story. The use of recycled footage is by now familiar: selected passages are reframed as acts of autobiography, with Herzog voicing the commentary. An image from *Aguirre*, for example, a long take of the rapids at flood stage, becomes a "metaphor" for their "turbulent relationship." Here, as in *I Am My Films*, recycled footage serves to configure the "life" that is being narrated and projected, only now through a more elaborate series of displacements. According to the relational structure of *My Best Fiend*, recycled footage serves double duty, constructing at once self and other, identity and difference, presence and absence (with emphasis always on the former term). The effect is one of virtual interaction between Kinski's past performance in various fictional roles and Herzog's present self-performance both on and off camera.[37] Another example from *Aguirre* deserves mention: in the final scene, having killed off his entire crew and stranded himself on a raft that is spinning its way down the Urubamba River, Aguirre asks, "Who is with me?" Without missing a beat, Herzog, on location once again, looks directly into the camera and replies, "I was with him. Kinski and I completed each other in a peculiar way." What Herzog suggests in dialogue is reinforced by the editing, which levels the distinction between fictional character and historical figure, while creating an interface of self and other that is specific to the medium of film.

As this example neatly demonstrates, *My Best Fiend* combines recycled footage with new material showing Herzog himself in action, revisiting certain locations for the films he made with Kinski. Appearing on location creates a strong visual connection between the image of the director and that of the actor, when he was alive. "I wanted to retrace some of our steps," Herzog comments, invoking (once again) the trope of walking as a way of remembering lived experience. It helps to recall

that his earlier self-portrait similarly interspersed recycled footage with images of the filmmaker walking in the landscape. In a way, *My Best Fiend* can be seen as a later version of *Portrait Werner Herzog,* retold in relational terms, focused on a specific period, and routed through the figure of Kinski. In this context, to "retrace some of our steps" means returning to points of convergence and intersection as well as separation and divergence.

The key moment of convergence takes place, tellingly, when both subjects are involved in the preparation of Kinski's autobiography. It is a clever move on Herzog's part, especially since autobiography was the one literary genre for which Kinski was known or, rather, notorious. Over the span of his career, he wrote and published four life narratives, freely inventing large parts of each.[38] Standing in the landscape near Kinski's home in northern California, Herzog gestures toward a large tree and identifies it as the place where Kinski sat and composed his final autobiography, "which of course is largely fictive." Holding up a paperback copy of the German original, Herzog begins to recite a passage in which Kinski describes him in a series of increasingly vulgar and vituperative terms.[39] Reading aloud from Kinski's autobiography has the potentially disruptive effect of introducing into the film a different perspective. It also marks a momentary shift from showing and viewing to reading and listening, while reversing the configuration of self and other that was previously established by the film. What follows, then, is doubly unexpected. After reading a few lines, Herzog lowers the book, looks up at the camera, and discloses part of a secret: "I actually had a certain hand in the creation of part of this book." He goes on to describe their conversation, adding detail to this revelation, as it continues. Speaking as Kinski, he explains, "Werner, nobody will read this book if I don't write bad stuff about you. If I wrote that we get along well together, nobody would buy it." At this point, Herzog imitates his manner of speaking: "'The scum always wants to hear only the dirt.' I came with a dictionary, and we tried to find even fouler expressions."[40]

The truthfulness of Herzog's account has been disputed.[41] For the present discussion, however, it makes no difference whether this encounter actually took place. The salient issue in relational autobiography is not that of accuracy; it is "the performance of the collaboration" between self

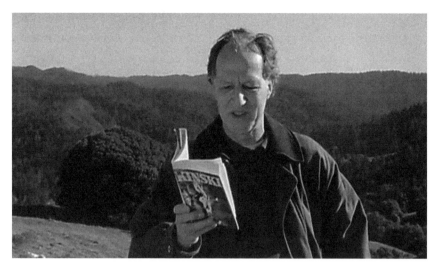

Reading Kinski's autobiography, *My Best Fiend* (1999).

and other, which is exactly what Herzog here stages. [42] In this case, the autobiographical act is doubled, for Kinski's story is apparently revealed by the telling of Herzog's story. The second narrative is what Eakin calls "the story of the story." And what it suggests here is a powerful sense of the interaction and reciprocity that not only produce the first story but are also suppressed by it. "Narrative structure," according to Eakin, "is telling us something fundamental about the relational structure of the autobiographer's identity, about its roots and involvement in another's life and story." [43] Even if Herzog invented this scene (and I suspect he did), the upshot would remain the same: it is the performance of identity through the telling of another's story. His penchant for fabrication only reminds us that fiction plays an integral role in filmic autobiography, as it does in the literary genre. What makes this example even more interesting—and quite typical of Herzog's approach—is its staging as a secret once shared and now revealed. As philosopher Sissela Bok has observed in another context, "the person who unveils a secret gains a measure of control over how others see it. The partially shared secret mystifies and tantalizes; as the revelation continues, the speaker establishes his identity in the eyes of the listeners, coming to matter to them in a new way. . . . He is set apart, unique through what he has revealed." [44] Secrecy and disclosure thus momentarily reshape but ultimately reinforce the

relations of power between the two levels of narration within the film.

Of course, Herzog also stages the more familiar situations of crisis and conflict and sometimes dramatizes his on-screen performance to distinguish himself from Kinski. He does so, above all, in terms of "nature." Sitting on a riverbank, near one of the locations for *Fitzcarraldo*, Herzog looks into the camera and states, "Between Kinski and me there was something almost completely unbridgeable, and that was Kinski's feeling for nature." At this point, we see footage from *Burden of Dreams*. To visualize Kinki's sense of the jungle as "erotic," Herzog shows him rolling around on top of a fallen tree as if he were "copulating" with it. What he is really doing, Herzog says, is "posing" for a fashion photographer who remains unseen. This move, which is the revelation of another person's performance in front of a camera, is followed by more footage from *Burden of Dreams,* namely, Herzog's diatribe against sentimental views of nature. Although he doesn't describe it in these terms, Herzog's stump speech can also be understood as an instance of posing for the camera and performing a notion of self. The recycling of this footage, which is lifted out of its original context, further magnifies the point. Returning to the Peruvian location, retracting their footsteps, recycling film footage, and rehearsing lines from his speech—all this suggests not a political strategy (as I argued in chapter 5) but an act of autobiography.

The telling of Kinski's story concludes by reversing the structure of resurrection that marked the film's beginning. Ultimately, Herzog employs Kinski's moving image to represent the latter's death. He does so by recycling the death scenes from two different features: first from *Cobra Verde* and then from *Nosferatu*. The representation of death in each instance is long, drawn-out, and visually explicit, a move which is only permitted because it shows a fictive death, not a real one. And yet the reframed footage clearly invites the audience to interpret Kinski's performance now as biographical—indeed, as biological. To see each character's death on-screen becomes tantamount to witnessing the end of Kinski's life. Herzog thus exploits the fact that in a certain sense, one can interpret any film as documentary. But he also attempts to shape this interpretation. Referring to the famous death scene of *Cobra Verde,* in which the title figure is being tossed about by the waves, Herzog alleges on the voice-over that Kinski actually died as a result of his intensity and

exhaustion "from this scene alone," even though his death occurred much later, elsewhere, and off camera.[45] In making this claim, as one scholar has noted, Herzog retroactively assigns himself a degree of responsibility for Kinski's actual death.[46] Why should he do so?

Critics have interpreted this move on Herzog's part in radically different ways, from a solemn act of grieving to a symbolic act of violence.[47] The polarity itself is telling. For one thing, it reproduces the two ways of responding to the loss of a loved one that Freud famously defined as mourning and melancholia. For another, it mirrors at the level of criticism the film's thematic opposition of allegiance and betrayal. There is no need to recapitulate the details of each interpretation to imagine that evidence can be marshaled to support both of these apparently opposing positions; they coexist within the film. What strikes me, instead, is the ambiguous, ever-shifting nature of relational identity in general as well as in this particular film. Rather than create ideal models of autonomous selfhood, Nancy Miller suggests, "we would do better to imagine more perplexing figures whose intimate and violent dialogues with living and dead others perform the bedrock of self-construction itself."[48] Herzog offers a glowing example, and not only in relation to Kinski.

Video Diaries and Defacement

A relational approach to autobiography makes sense for a director such as Herzog, who not only claims to "be" his films but also tends to make a show of his repugnance for self-discovery. His is an autobiographical project that mobilizes the life and work of other people to represent his own identity as a filmmaker, routing the self through the other and re-configuring both along the way. The key example, which in many ways also marks the high point of Herzog's work as a documentarian, is *Grizzly Man*. As the title suggests, it is a hybrid work combining elements of the nature film, the expedition documentary, the personal portrait, and other genres. But autobiography? The very idea would seem to be incompatible with the wildlife documentary, which is the primary genre and frame of reference through which the film has been received. And yet *Grizzly Man* incorporates the private history and video diaries of another filmmaker and puts them in the service of delineating Herzog's

self-image. Its function as autobiography fundamentally depends on somebody else's life and videos.[49]

A brief synopsis of the film suggests the relatedness of bodies, lives, and images. In this case, Herzog's subject is the late Timothy Treadwell, an amateur wildlife preservationist who recorded his life among grizzly bears in Alaska on more than one hundred hours of videotape. During his lifetime, Treadwell became a controversial public figure for his practice of living in close proximity to wild animals, for his unconventional methods of interacting with grizzly bears—giving them cute-sounding names (like Downy, Booble, and Mr. Chocolate) and addressing them in a voice that other people might use with children—and for broadcasting this behavior to mass audiences outside of Alaska. Treadwell was an aspiring media star who appeared in celebrity magazines, on television talk shows, and on documentary specials as well as in the videos he made in Alaska. The videos had several different functions, but they generally purported to represent his life among grizzlies in a way that could be seen by other people. In October 2003, Treadwell and his companion, Amie Huguenard, were killed and devoured by one of the bears. The sound of that grim event was captured by a camcorder, which ran (with its lens cap on) until the end of the tape. This and other footage from Treadwell's personal archive, as well as his written diaries, provide the "raw material" for Grizzly Man.

It is important to recognize how this material was already marked as relational before Herzog ever got hold of it. Treadwell's entire project in Alaska can be described as inventing a type of relational identity, where the other is not a human being but rather an animal. Take, for instance, the book that he cowrote with Jewel Palovak, and first published in 1997, which is titled Among Grizzlies. It belongs to an American genre of autobiographical nature writing that is also based on a relational paradigm but expressly devoted to creating nonhuman attachments. In this genre, as one scholar has shown, the narrative subject typically undertakes a quest for physical, emotional, or spiritual healing, and does so by forging a direct connection to the natural world.[50] Treadwell's book is true to form. In it, he describes his early troubles with drugs and especially alcohol, writing from the perspective of a new, reinvented self. For a start, he changed his last name to Treadwell from Dexter. But only by dedicating his life to protecting Alaska's bears was he able to

stop drinking.[51] The extended idea of a relational identity keyed to the natural world also informs the first-person videos that Treadwell made during his last five years in Alaska.

Grizzly Man takes this material and pushes the relational paradigm even further, for Herzog tells a relational story that is not backed up by a relational life. In *My Best Fiend,* he had worked extensively with Kinski, collaborating as they did on five major films over the course of a decade. By contrast, Herzog had no relationship whatsoever to Treadwell during his lifetime, not even a professional one. Instead, he appropriates material that was already marked as relational and transforms this corpus of video into his own cinematic self-image, without any pretense to collaboration. In this case, it is Treadwell's use of a camcorder that provides Herzog with the requisite lens, angle, distance, and perspective to explore the self, without being seen as navel gazing. As he is made to appear in this film, Treadwell at once embodies and undertakes the search for self on Herzog's behalf. A radical experiment in filmic autobiography, *Grizzly Man* pushes the limits of embodiment and referentiality in the performance of self.

The autobiographical act as it is figured in this film can best be understood in terms of *defacement*. The term, of course, comes from Paul de Man and his well-known argument against autobiography's claim to be a literary genre. Questioning the assumption of a referential self and its mimetic relationship to the autobiographical narrator and subject matter, he asks,

> Are we so certain that autobiography depends on reference, as a photograph depends on its subject or a (realistic) picture on its model? We assume that life *produces* the autobiography as an act produces its consequences, but can we not suggest, with equal justice, that the autobiographical project may itself produce and determine the life and that whatever the writer *does* is in fact governed by the technical demands of self-portraiture and thus determined, in all its aspects, by the resources of his medium?[52]

For de Man, the referential subject is absent from autobiography as it is from literature generally. In this case, the mimetic correlation of subjectivity and subject matter is but a delusion maintained by writers and

readers alike. Thus, he concludes, "autobiography veils a defacement of the mind of which it is itself the cause."[53] Instead of the social and historical world, de Man imagines a purely figural world of language as the only available context of reference.

The key rhetorical figure in autobiography is prosopopoeia, the representation of an imaginary, absent, deceased, or voiceless entity as alive and capable of speech and action. De Man frames the issue with customary insight:

> Voice assumes mouth, eye and finally face, a chain that is manifest in the etymology of the trope's name, *prosopon poien,* to confer a mask or a face *(prosopon).* Prosopopoeia is the trope of autobiography, by which one's name . . . is made as intelligible and memorable as a face. Our topic deals with the giving and taking away of faces, with face and deface, *figure,* figuration and disfiguration.[54]

In Wordsworth's *Essays upon Epitaphs,* for instance, the dominant figure is "the fiction of the voice-from-beyond-the-grave."[55] Reflecting on the epitaphs of others becomes an epitaph in its own right, what de Man calls "the author's own monumental inscription or autobiography."[56] Rather than a genre with distinguishing traits and conditions, autobiography should be understood as a "figure of reading or understanding that occurs, to some degree, in all texts."[57] While I appreciate the value of de Man's intervention, what most interests me here is the unforeseen possibility that the very contradictions and displacements he mobilizes to deconstruct autobiography as a literary genre might just as well become—in another context—a full-blown creative principle.

The rhetorical figures that de Man emphasizes in autobiography— voice, mouth, eye, face—are also the figures of Herzog's film. Prosopopoeia is indeed the central trope of *Grizzly Man.* And this is not the first time that Herzog has experimented with it.[58] An early prose work gives voice to a series of found images, namely, still photographs of Jean Renoir and his family. One image, a self-portrait of the filmmaker, shows him bald and middle-aged, looking directly into the camera. "Yesterday evening," the text begins, "I had intended to make a film of my great Irish wolfhound, Timur Lenk, but he turned his head away;

he seemed strangely shy of looking at the lens." The next morning, "I looked straight into the lens of the camera" and "realized with a shudder that death was staring out at me from the camera, the cold, pitiless eye of death staring me in the face: the unfeeling, detached and chilling face of death."[59] Though awkward and redundant, Herzog's early experiment in prosopopoeia obtains new relevance when read in relation to *Grizzly Man*. It is a rhetorical strategy that shapes the film on many different levels. On one level, for example, Treadwell appears on camera speaking "as" a bear, "for" the bears, and "with" the bears around him. Such acts of ventriloquism (literally and figuratively) give voice to a "sentimentalized view" of nature that Herzog finds objectionable. On another level, however, the entire film works to create a face or mask that both conceals and reveals the aspect of Herzog, the half-hidden subject of *Grizzly Man*. When Herzog himself appears on camera, as we shall see, he never shows his face. Our topic, too, involves "the giving and taking away of faces." And in this case, the autobiographical subject, like the filmmaker in Herzog's prose piece, is confronted with the face of death.

Grizzly Man involves both literal and metaphorical acts of defacement. Literally, the term refers to the violent dismemberment of the filmmaker's body. It is visually suggested in many ways and verbally described at great length, and in horrific detail, by the Alaska state coroner who examined Treadwell's and Huguenard's remains. In this sense, Herzog's treatment of this material is in equal parts clinical, excessive, macabre, and tinged with morbid humor. Metaphorically, the giving and taking away of faces describes a cinematic technique for envisioning subjectivity. Of particular interest here is the dramaturgy of extreme close-ups that derives from Treadwell's videos but transforms, develops, and further enlarges in Herzog's film. Defacement in this sense refers not only to the autobiographical act of figuring and disfiguring the self but also to the detached attitude that makes these operations possible—the separation that Herzog has from this material, which enables him to manipulate it and put himself in a certain relation to it. *Grizzly Man* recomposes the scattered fragments of an autobiographical self through the life and work of somebody else, somebody who was physically dismembered in the process of staging his subjectivity in front of the camera. What I am proposing, however, is not just a discussion of the film "as"

autobiography (I am reading de Man against the grain, not arguing by analogy). It is rather my contention that *Grizzly Man* represents an autobiographical act that is specific to Herzog, to his lifework, and to the recording-based technologies of film and video.

In this case, the autobiographical project starts with viewing videotape. More than one hundred hours of footage had to be scanned and examined with specific criteria in mind. It was a collective activity, as Herzog acknowledges in an interview: "I had four intelligent people sifting through the material. They were very precisely instructed by me what to look for. . . . I ultimately saw between 15 and 20 hours of Treadwell's footage myself."[60] To this material Herzog and his team added new footage shot on location in Alaska, California, and Florida.[61] The crucial phase was that of postproduction. Referring to the different media, materials, and perspectives that had to be assimilated, he states, the film "became a real dynamic composite in the editing."[62] The mixture of video and film offers a good example. According to Herzog, "It's about half Treadwell's footage, and half mine."[63] That said, the video from Treadwell's archive must also pass through Herzog's film and, consequently, becomes part of it.

Grizzly Man begins, paradoxically, with a haunting discourse on death. The first scene introduces Treadwell, the dates of his life (1957–2003), the diary format, its first-person perspective, and—last, but not least—the ominous figure of death. Treadwell walks out from behind the camera, kneels down in the grass, turns his back to a nearby pair of bears, and begins speaking to the camera. He launches into an impassioned monologue about the need to be absolutely fearless of death. "If I show weakness, if I retreat, I may be hurt," he explains, casting a quick glance over his shoulder to check the bears behind him. "For once there is weakness, they will exploit it; they will take me out; they will decapitate me; they will chop me into bits and pieces. I'm dead. But so far," he adds, "I persevere." In his own cavalier style, Treadwell situates himself at the invisible boundary between life and death and appears to derive pleasure from the experience. "I am right at the precipice of great bodily harm," he comments, "even death." As he walks off camera, leaving only the bears in frame, Treadwell declares with great relish, "I can smell *death* all over my fingers." What gives this scene its particular charge is the viewer's knowledge that Treadwell is in fact dead and that

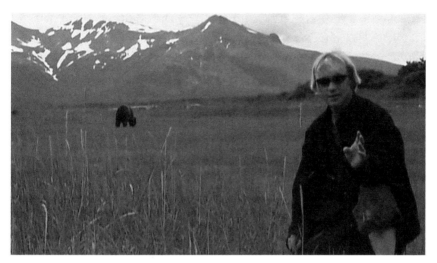

"Fearless of death," from the opening scene of *Grizzly Man* (2005).

he was actually killed in much the same way that he describes and, to some degree, anticipates. In the context of a Werner Herzog film, the dramatic pose of fearlessness also recalls the director's reputation as a daring risk taker, the tragic endings that critics predicted for him, and his legendary knack for putting and finding himself in harm's way.[64] Confronting death is a pose that Herzog, too, assumes, a mask he dons to separate himself from others who seemingly fail in this regard. It is tempting to emphasize the apparent resemblance of the two filmmakers more generally. Indeed, their affinities are legion.[65] For this very reason, however, it needs to be emphasized that Treadwell is not simply a stand-in for Herzog. Theirs is a more complex relationship, as the following scene makes clear.

In it, the two filmmakers are identified and distinguished by the types of sounds and images they produce. Referring to a succession of bears shown in close proximity, Herzog begins speaking: "All these majestic creatures were filmed by Timothy Treadwell." Attaching a name to this footage is more than just a way of introducing the film's subject. It differentiates Treadwell's videos from Herzog's film, while at the same time creating a relation between them, with video located internal to the film and appropriated as a cinematic signifier. Whereas the video diary signifies the present, for instance, the film transforms it into the visible past

(a move that is discursively supported by the addition of life dates in parentheses). In terms of sound, the emphasis lies on the tonal contrast between the high-pitched, singsong voice Treadwell uses to address the bears versus the deep, accented, masculine-sounding voice Herzog uses to address his audience through the commentary. Vocal presence not only helps establish the identity and difference of self and other but also positions Herzog as the film's source of narrative authority. He provides the controlling perspective. "What Treadwell intended," he continues, "was to show these bears in their natural habitat. Having myself filmed in the wilderness of jungles, I found that, beyond a wildlife film, in his material lay dormant a story of astonishing beauty and depth. I discovered a film of human ecstasies and darkest inner turmoil."

By framing the material in this way, Herzog makes a number of consequential moves. First, he acknowledges that authorship is multiple. With Treadwell deceased, however, the power relations between the two filmmakers are lopsided, and that remains unsaid.[66] Second, Herzog locates Treadwell's subjectivity deep within the corpus of videos that appears within the film. At the same time—and this is the third move—Herzog invokes his own performing identity as a star director who needs no introduction. It is his personal experience as a filmmaker that enables him to identify a "film" hidden within the videos, one that must be "discovered," assembled, narrated, and released to be seen as a film. Fourth, and perhaps most important, the spoken commentary not only puts emphasis on Herzog's vocal presence but also connects it to Treadwell's body of images. Throughout the other films discussed in this chapter, Herzog frequently appears on-screen and addresses the camera directly. In *Grizzly Man,* by contrast, he appears on-screen exactly one time, for about twenty-five seconds, with the camera behind him, obscuring his face. In this case, the strong impression of his physical presence is mostly produced as an effect of his voice. The opening narration, for example, situates Herzog as viewing and responding to Treadwell's tapes. It is Herzog's vocal presence that forges a common point of view with the film viewer, who is situated in an analogous position and engaged in similar activities. Finally, by reframing the video material as reaching "beyond a wildlife film," Herzog opens up a wide horizon of formal and generic possibilities and puts them all at his disposal. *Grizzly Man* is

now a video diary, now a wildlife film, now a personal portrait, and so on. Later, Herzog even suggests that Treadwell worked in various genres and modes such as "his action-movie mode." It is an interesting move on Herzog's part because it gives a rationale for the generically hybrid aspect of *Grizzly Man*—an aspect shared by all his films but nowhere made so explicit as here. Consequently, the mix of genres would seem to be intrinsic to Treadwell's videos and imported into Herzog's film by way of the found footage.

While Treadwell uses a camcorder for various purposes, he generally employs a journal-entry approach, reflecting on his past and present experiences by looking and speaking directly into the camera. In the United States, where the genre has been especially prominent, notable exponents include Jonas Mekas, George Kuchar, Ross McElwee, Tom Joslin, Lynn Hershman, and Sadie Benning. Of course, Treadwell's videos belong not to independent cinema but rather to the camcorder phenomenon and to the even wider proliferation of autobiographical, confessional, and first-person modes of expression in American popular culture. This is also the context in which producers at the Discovery Channel first became interested in the Treadwell material. The one-hour television special *The Grizzly Diaries* (1999) combines footage shot by Treadwell and Alaskan filmmaker Joel Bennett, with narration by actor Peter Coyote. As its title suggests, the show employs a diary format, reproducing excerpts from numbered daily entries that seemingly unfold in the present. The journal-entry format also defines those portions of Treadwell's videos that appear in the "forensic investigation" of his death, a program called *Anatomy of a Bear Attack* (Discovery Channel, 2004). *Grizzly Man* draws from material shown on both programs and gives it new purpose.[67]

Rather than simply reproduce the diary format, Herzog mobilizes its emotional force and narcissistic connotations, while remaining at a certain remove from them both.[68] At one point in the narration, he acknowledges the autobiographical impulse of Treadwell's videos and their introspective function. As Herzog explains, "the camera was his only present companion. It was his instrument to explore the wilderness around him, but increasingly it became something more. He started to scrutinize his innermost being, his demons, his exhilarations. Facing the lens of a camera took on the quality of a confessional. Covering various

years, the following samples illustrate the search for himself." The selected examples show Treadwell using the camera in various ways: as a catalyst for telling his own story, as a confessional box for expiating his sins and secrets, and as a mirror for reflecting his own image.[69] In some entries, the camera is mounted on a tripod; in others, he is holding it at arm's length. Herzog assembles the images to show the private face of Treadwell's existence, while trading on the amateur or nonprofessional quality of video diaries as a genre. This move in turn has various effects, some more important than others.[70]

Above all, the autobiographical impulse of first-person video and the strong impression of sincerity and spontaneity it creates are absolutely crucial to the success of Herzog's trump move, whereby he reveals to his audience that much of the Treadwell material was fabricated, choreographed, and stylized for an effect. Another extended montage—this one including footage that Treadwell most likely never intended for others to see—depicts him in various situations: rehearsing lines, shooting multiple takes, changing costumes, even creating generic shots (stock footage that could be used in various scenarios as needed). In this context, the representation of self turns out to be literally staged and restaged, a performance of identity that takes place not just in front of the camera but also behind it.[71]

The key example is the secret role of women in Treadwell's videos, how they go unseen and—more important—how they seem to *regain* visibility in Herzog's film. It is an unexpected twist on the voyeuristic surveillance of women in some of the best-known journal-entry films such as *David Holzman's Diary* (1967; dir. Jim McBride) and *Sherman's March* (1986; dir. Ross McElwee). In contrast to those films, *Grizzly Man* shows that the women in Treadwell's life are methodically screened out of his videos, their physical presence effaced in the process of constructing the image of a solitary self living among wild bears. Here, again, it is worth recalling *Portrait Werner Herzog,* in which the filmmaker stages himself as a visionary poet walking alone in the landscape of his childhood. Unlike that film, *Grizzly Man* shows the construction of singularity as well as the effacement of other relations and reveals them both to the film audience. The ultimate example is that of Amie Huguenard. As Herzog comments, "Amie herself remains hidden in Treadwell's footage. In nearly

one hundred hours of his video, she appears exactly two times." Herzog then shows two images of her. Curiously, he observes, "We never see her face." In making this observation, Herzog invokes his now-established role as a viewer of Treadwell's footage—a viewer among others, one of "us." But the conspicuous display of women in particular is a strategic move in its own right, a visual activity of the filmmaker that is no less interested than Treadwell's own. One of the issues at stake in *Grizzly Man* is Herzog's relationship to women and their marginalization in his films. Here, as in *My Best Fiend,* revealing the secret of another person becomes a way of asserting control and setting himself apart by means of contrast, while revising his own self-image in the process. Whether he is unmasking Treadwell's self-serving performance or exposing the way in which Treadwell masks the presence of others, Herzog at once reveals and conceals his own performance as a filmmaker.

Not only staging and scripting but also spontaneity and contingency serve to delineate an image of Herzog via Treadwell. Thus Herzog claims his authority "as a filmmaker" in terms he usually employs to justify his own films and now defends Treadwell, saying, "He captured such glorious improvised moments, the likes of which the studio directors with their union crews can never dream of." In such moments, we are invited to appreciate the cinema's affinity for aleatory happenings, which the Treadwell material also puts on display, from the unexpected appearance of wild animals in frame to the rhythmic movements of wind through tall grass. The emphasis shifts from the experience of film as repetition, as epitomized by Treadwell's staged appearances, to the experience of film as evanescence—an experience that later culminates in the recording of Treadwell's death. For now, it is enough to note that when other commentators point to the "documentary" elements of Herzog's feature films, they frequently mean the inclusion and foregrounding of aleatory material. To celebrate this aspect of Treadwell's work, as Herzog does, is to create yet another correlation between the two filmmakers in terms of the images they produce.

At one point in his narration, Herzog dramatically separates himself from Treadwell, just as he had from Kinski in *My Best Fiend,* that is, in terms of nature: "Here I differ with Treadwell. He seemed to ignore the fact that in nature there are predators. I believe the common denominator

of the universe is not harmony, but chaos, hostility, and murder."[72] Contrary to Herzog's claim, Treadwell was fully aware of predators, especially among grizzlies. He called them "killer bears" and gave them ominous-sounding names like Demon and Mr. Vicious. We know this from his book and from the excerpts of his videos that have aired on the Discovery Channel and on the Internet.[73] We know it from *Grizzly Man*, too, as when Treadwell says of the bears, "They can kill, they can bite, they can decapitate." But to emphasize such contradictory evidence risks missing the larger point. To put it sharply, *Grizzly Man* isn't simply about either Treadwell or his particular view of nature (whatever it may be); rather, the first-person perspective of his videos, their emotional force and apparent immediacy, the public knowledge of Treadwell's and Huguenard's deaths—all these elements are put in the service of verifying and authenticating a central part of *Herzog's* identity as a filmmaker: his personal vision of the natural world as brutally indifferent to human existence. If self-justification underwrites all autobiographies, *Grizzly Man* is no exception.

Grizzly Man explores the relation between Herzog and Treadwell not only by means of figuration but also by means of disfiguration or defacement. It is enabled by a principle of synecdoche, which operates through the voice-over and the dialogue as well as through the cinematic procedures of staging, framing, and editing. Throughout the film we are confronted with representations of bodies in pieces: arms, legs, hands, paws, fingers, claws, heads, skulls, teeth, bones—the list goes on. In each instance, the object is a body part that once stood in a contiguous relation to an absent whole that cannot be reconstructed. One example is Treadwell's severed arm and hand, which were reportedly found lying on the ground at the scene of his death. However gruesome or excessive such details may seem, they create a physical relay connecting the videos with the film and the figures we see on-screen. In one scene, shot by Treadwell, we see his hand reaching out from behind the camera to touch a bear's nose. In another scene, which is filmed (and blatantly staged) by Herzog, the state medical examiner cuts open what he calls an "evidence bag," removes a plastic watch "still running," and declares, "This was taken off Timothy's wrist." He presents it as a bequest to Jewel Palovak, Treadwell's former girlfriend, who attaches the watch to her

wrist. In another scene, Herzog asks from behind the camera if she feels "like Treadwell's widow." And then there is Herzog's cameo, where his vocal presence momentarily transforms into a visible one, to great effect.

Throughout this scene, curiously, Herzog stages his appearance as a cinematic *Rückenfigur,* never showing his face. This move, too, creates a type of relay from Treadwell to Herzog through an elaborate choreography of hands, gestures, objects, faces, and gazes. As Herzog keeps his back to the camera, the staging here further implicates the film viewer, while setting the relay into motion. We watch Palovak's face as she watches Herzog's face, as he listens through headphones to a sound recording of the deadly attack, the audio portion of Treadwell's last videotape. Herzog's posture is significant: he is hunched forward, visibly squinting, and holding one hand to his temple, as if concentrating on the sound that we are not permitted to hear. The camera zooms in on Palovak's face, as Herzog narrates, "I hear rain, and I hear Amie. Get away, get away, go away." An abrupt cut returns us to the original two-shot and a long, dramatic pause. Herzog slowly removes the headphones, swallows, and begins to speak. "Jewel, you must never listen to this," he warns, in what is only the first in a series of injunctions. After another cut, we see him reach out and lay his hands on those of Palovak, who is dressed in black and holding Treadwell's camcorder in her lap. Finally, he puts the cassette case in her hand, and she stares at it until the scene fades to black. By choreographing his appearance as he does, Herzog literally and figuratively shows his hand in the process of filmmaking. It is a performance of collaboration that extends to the absent Treadwell by way of his "widow," who controls access to his videos.[74] Gaining access to the tape is one thing; filming it as he does is another thing, and that is what needs explanation.

In the end, Herzog's cameo serves to bolster his performing identity as a filmmaker who boldly confronts what Amos Vogel once called "ferocious reality," by which he meant death itself.[75] The obscured face, in a film otherwise packed with close-ups, visually connects a self-image of Herzog to the unheard sound of death. He appears on camera for the sole purpose of being seen in the act of listening. He does so conspicuously and exclusively, wearing headphones, so that neither Palovak nor the film audience can hear the recorded sound. By withholding it as

Herzog's cameo, *Grizzly Man* (2005).

he does, by emphatically not playing it back for others to hear, Herzog further defines himself as a filmmaker who consciously observes certain social and visual taboos surrounding death and its representation. At issue here is the representation of death as an active process of transformation (and not as a mortified thing or object). If a human corpse can be shown in a documentary film, the sight of the physical body in the process of mortification raises a set of ethical questions concerning the visual activity of the filmmaker and the viewing activity of the audience. The difference, according to Vivian Sobchack, has to do with "death as it appears on the screen and is experienced by us as indexically real, rather than iconically or symbolically fictive."[76] Although we know that documentary is constructed and subject to manipulation, our initial response to the sight of death is clearly *not* governed by the rules of fiction. When it comes to representing actual death, Herzog, too, clearly distinguishes between fiction and documentary. In *Grizzly Man*, discursively asserting that the lens cap was left on the camera becomes a meaningful sign of Treadwell's situation in the face of death and an inscription of a representational limit. Withholding the sound, moreover, calls attention to the ethical responsibilities of the filmmaker and his audience, while engaging (even fostering) a sense of morbid curiosity. The entire scene relies for its effect on the imaginative power of film viewers,

on our primal fears and fantasies of our own unavoidable mortality.

The ultimate secret to be revealed and concealed in this film is the grim matter of death. *Grizzly Man* reminds us that the taboo against representing actual death extends beyond the visual to the acoustic realm of sound recording, which is not at all surprising. What is surprising, however, is that the film also dramatizes these life-and-death issues. In his cameo, for example, Herzog invents a series of injunctions. "Jewel," he says, "you must never listen to this. And you must never look at the photos that I have seen at the coroner's office." Referring to the last videotape, he adds, "I think you should not keep it. You should destroy it."[77] The advice may sound odd, but it is consistent with the scene's internal logic. Apart from any practical reasons concerning access to material, the entire scene works to distinguish Herzog, as a filmmaker who confronts death, from others, who should avert their eyes and ostensibly need to be protected. The distinction is embodied and gendered. But that is not all. The withholding of sound is offset in the surrounding scenes by the verbal account of the coroner, who vividly narrates "the moment of death," based on his examination of the audiotape and of the human remains. Visual and narrative excess thus compensate for the absence of sight and sound, transforming an ethical moment into an opportunity for dramatic storytelling. The moment of death here is not just retold. It is reenacted, much as it is in *Anatomy of a Bear Attack,* with the coroner now playing all the parts himself. The upshot of this drama is what we might call the creaturely aspect of dying. This, after all, is precisely what the camera is able to capture and what the documentarian is prohibited from showing.

In many ways, then, *Grizzly Man* explores the ultimate autobiographical act: that of confronting death. Throughout the film, the moment of death is visually rendered as a face-to-face encounter. This is also true of the film's advertising paraphernalia. An early poster shows a horrific assemblage of truncated visual elements—eyes, faces, heads, clothes—all in extreme close-up. The human aspect has been so enlarged and distorted that the viewer must actively puzzle out the pieces of the image before it becomes clear that they refer to a face at all.[78] The bear's face, by contrast, appears quite clearly in the single lens of a sunglass. That the two faces seem to reflect one another as mirror images is obvious; so

The coroner as storyteller, *Grizzly Man* (2005).

is the visual analogy to the camera eye and lens. What is less obvious, and the point to be noted here, is how the poster graphically evokes the medium of video, its affinity for close, lived, embodied experience, and the effects of enlargement and transformation when video is put on the film screen. If the figural treatment of death in *Grizzly Man* can be traced back to Herzog's interest in the baroque—and the poster's elliptical structure and iconography recall this context, too—then the way in which this particular film confers a face on death has a more immediate visual source: it emerges from the practice of video.

The images from Treadwell's last videotape are sequenced and narrated in *Grizzly Man* as a succession of extreme close-ups. It is an interesting move on Herzog's part, not least because he usually forgoes the use of extreme close-ups, describing them as "too intrusive" for the film spectator as well as for the person being filmed.[79] The abrupt and highly fragmented pattern of editing articulates the urgency of Treadwell's and Huguenard's situation. It also creates a centrifugal movement, as if the filmmaker's life and body were coming apart before our eyes. What is most startling about this sequence, however, is Herzog's commentary to an extreme close-up of a grizzly bear. "And what haunts me," he says, "is that in all the faces of all the bears that Treadwell ever filmed I discover no kinship, no understanding, no mercy. I see only the overwhelming

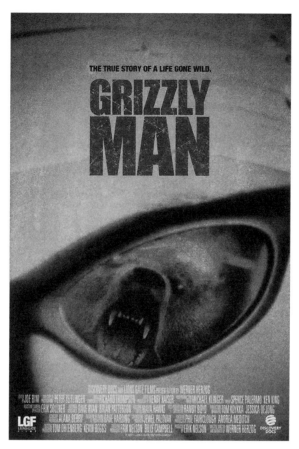

A face-to-face encounter, advertising poster for *Grizzly Man* (2005). Poster taken from *Grizzly Man* provided through the courtesy of Lionsgate.

indifference of nature." Looking at Treadwell's images, Herzog sees a ghostly face that is and isn't his own. The director might avoid his eyes in the mirror, as he has claimed, but in this extreme close-up, he encounters the very "merciless gaze" that he so often uses to characterize his own vision as filmmaker. It is a look that he multiplies and extends to "all the faces of all the bears that Treadwell ever filmed." Not only animals but also cameras represent this merciless gaze. In the prose piece noted earlier, the autobiographical subject (Jean Renoir) looks into the camera and sees "the cold, pitiless eye of death staring [him] in the face."[80] *Grizzly Man*, too, figures death as a face-to-face encounter by reframing

"I discover no kinship, no understanding, no mercy," *Grizzly Man* (2005).

the images of another filmmaker. Here is a mirror scenario that Herzog would seem to accept and even appreciate. It is not a simple reflection but a reflection of his self nonetheless.

On the face of it, *Grizzly Man* appears to be a film about Treadwell, but it doubles as a film about Herzog, about his attitude toward nature and matters of life and death, and about the camera's role in his staging of subjectivity. The voice-over concludes with a generalization:

> Treadwell is gone. The argument how wrong or right he was disappears into a distance, into a fog. What remains is his footage. And while we watch the animals in their joys of being, in their grace and ferociousness, a thought becomes more and more clear: that it is not so much a look at wild nature as it is an insight into ourselves, into our nature. And that, to me, gives meaning to his life and to his death.

For the film audience, too—and "we" are addressed here—a question arises: in assigning meaning to Treadwell's life and death, has Herzog also narrated his own cinematic epitaph?

The figures of Treadwell and Herzog converge yet again in the film's closing images, which subtly depict an alternative ending to that of Treadwell's life. Not once, but twice, we see him walk off into the horizon,

"To the end of the world and beyond," *Grizzly Man* (2005).

each time with his back to the camera and in the company of animals (first with a pair of foxes, then with a couple of bears). It is a cinematic ending par excellence, reminiscent of Chaplin's tramp.[81] In this context, however, Treadwell prefigures Herzog's stated fantasy of "disappearing into life" by simply walking away—a fantasy he's described elsewhere as a final journey on foot, "to the end of the world and beyond."[82] Ultimately, and unbeknownst to him, Treadwell enacts the very final and evanescent scenario that Herzog envisions for himself. For a director who claims to "be" his films, as Herzog does, there is no other way for *Grizzly Man* to end.

CONCLUSION: HERZOG'S VERITÉ

A few years ago, Herzog received an artist's grant from the National Science Foundation to make a film at McMurdo Station on Ross Island, the American base in Antarctica. The result is *Encounters at the End of the World,* a loose series of personal portraits and moving landscapes integrated into a larger narrative of the filmmaker's journey to the South Pole. The portraits feature an eclectic group of service, maintenance, and transportation people as well as a host of scientists. Among the many encounters in this film, one stands out in particular: that of a solitary, "disoriented or deranged" male penguin "heading toward certain death." Let me explain.

When Herzog first embarked on this project, several popular and commercially successful films about penguins had recently appeared in mainstream theaters, most notably *March of the Penguins (La marche de l'empereur,* 2005; dir. Luc Jacquet). A documentary about the heroic journey of Empire penguins in Antarctica, the French original literally gives human voices to three of the animals designated as mother, father, and child. The narrative is framed as a love story and is told, as it were, in the first person. The American version eliminated the dialogue and replaced it with commentary spoken by Morgan Freeman. It went on to win the Academy Award for Best Documentary Feature, the same year *Grizzly Man* appeared and, of course, wasn't nominated for an Oscar. Against this backdrop, it was rumored that Herzog had decided to make his own penguin film. On the contrary, he says at the beginning of *Encounters,* he "would *not* come up with another film about penguins." It comes as no surprise, however, when Herzog visits a penguin colony on Ross Island. There he meets a reputedly "taciturn" scientist and manages to draw him out by asking questions about "strange sexual behavior"

The parodic penguin, *Encounters at the End of the World* (2007).

among penguins and about the occurrence of "insanity" in the colony. The entire scene and the following encounter with a suicidal penguin can surely be understood as Herzog's answer back to *March of the Penguins*. To the human, social, and heterosexual norms that the award-winning film projects onto the species, Herzog opposes the aberrant behaviors of a single specimen; to the heroic and sentimental journey of the family, he counters with the solitude of death. *March of the Penguins* may be an easy target of parody, but the penguin in Herzog's film has another, less obvious role: to encapsulate the filmmaker's testy and contested relationship to documentary cinema itself.

This study began with the idea that documentary is, for Herzog, a repudiated mode of filmmaking in which he all the more actively intervenes and creatively participates. However dramatic his disavowal of documentary may be, it is also—more importantly—a way of engaging documentary and addressing it on his own terms. This idea remains at the core of the book. To explore its implications has involved ranging much wider: from European and North American cinemas to histories of art, music, and religion; from commissioned films and television formats to travelogues, personal portraits, and video diaries; from documentary theory and practice to literary criticism and performance studies. It has also involved separating the films from Herzog's discourse on them to a

degree, enough to open up new questions, perspectives, and interpretations. At the same time, I have tried to account for this discourse as well as for its remarkable circulation, how Herzog's preferred terms of discussion become insinuated into the films themselves, reinforced by parafilmic matter (such as DVD audio commentaries) and perpetuated by critics and scholars alike. However exemplary or idiosyncratic the Herzog material may be, my approach throughout this book has been to closely analyze both the films and the context of documentary as contingently produced and constantly reinvented in performance.

Herzog's documentaries often work to visualize aspects of human experience (emotions, desires, beliefs, and ideas) that are not in themselves visible and have therefore not traditionally fallen within the purview of documentary cinema. His approach to this project necessarily involves both collecting visible evidence and creating it so that the resulting films combine what are by custom taken to be disparate techniques of observation and stylization. When it comes to "filming spirituality," for example, Herzog mobilizes elements from well-known religious sites and ceremonies. He stages other people in acts of devotion and shows how they stage themselves. Either way, the camera calls our attention to bodies in action, the enactment of patterned behavior. In effect, this approach to filmmaking doubles as a strategy for implicating film viewers in the sensory experience of the spectacle. Much of Herzog's work in documentary can be described as a multisensory translation project, a creative endeavor to render visible what is often presumed to elude observation.

So it's interesting that Herzog has recently extended this aspect of his work from the topic of religion to that of science. One of the scientists in *Encounters* describes his search for the subatomic particles called neutrinos in this way: "We know as physicists we can measure them, they exist, but we can't get our hands on them. It's like measuring the spirit world." Clearly Herzog is leading the interviews he conducts in this film with scripted bits of speech and thereby connecting the film back to other films as well as to future projects. The result is a further extension of the allegorical dynamic in Herzog's documentaries, their movement from the natural to the supernatural, from the visible to the invisible. In *Encounters,* this movement is introduced by the dialogue,

but it is developed through various forms of scientific imaging. We see color-coded DNA sequences of newly discovered species, graphic analyses of volcanic explosions, computer animations of sea ice movements, and microscopic pictures of single-cell organisms (the latter of which, along with the undersea footage, recall the science films of Jean Painlevé). Although few, if any, of these images aim for verisimilitude or mimic our perspectival viewing habits, they're nonetheless visually potent and alluring. In a way, they are even operatic, which explains the almost constant use of music. Herzog employs scientific imaging to render what is otherwise unavailable to observation in the form of colorful, kinetic patterns on a screen, charging them with emotion, imbuing them with significance, while appealing to the viewer's imagination through the senses.

Even in its supporting role as a context for Herzog's project, the topic of science raises interesting questions and may even point to some areas of future research. Take the use of computer simulations and scientific imaging: as one scholar reminds us, "computer imaging technologies have changed the nature of 'observation' and what is considered observable." More specifically, "computer imaging and simulation represent a shift from the *perceptual* to the *conceptual,* a shift that underscores a willingness to exchange direct experience for abstractions that open up the wide vistas not directly available to the senses."[1] What implications might this shift have for the entanglement of knowledge, aesthetics, and subjectivity in Herzog's work? Does simulation create a space for allegory in documentary? How do computers and new media affect our understanding of encounter and performance as central to documentary filmmaking?

Another possible area for future research is the relationship of documentary, performance, and preservation. This is a historical relationship (not a new one), but our understanding of it has changed in recent years so that the terms are no longer simply opposed to one another.[2] If documentary film can be understood as performance, how does this affect its relation to the archive? In recent years, issues of cultural loss and preservation have moved into the foreground of Herzog's work, and yet, as we have seen, his documentaries express a baroque sensibility that imagines the world and its dissolution simultaneously. Hence the

evocative title *Encounters at the End of the World,* the ending of which may refer to either time or place and enfolds within it a dizzying array of allusions, beyond the filmmaker's journey to the South Pole: from Finisterre, the medieval end of the earth, where pilgrims visited after reaching their destination of Santiago de Compostela, to issues of global warming and the disastrous effects of climate change. In one scene, filmed inside a greenhouse, Herzog interviews a young man who trained as a linguist only to find himself "on a continent with no languages." Their discussion concerns the "extinction" of world languages, which is proceeding almost unnoticed. "In our efforts to preserve endangered species," Herzog comments, "we seem to overlook something equally important. To me, it is a sign of a deeply disturbed civilization, where tree huggers and whale huggers in their weirdness are acceptable, while no one embraces the last speakers of a language."[3] More than just a provocation directed at the film's audience, the commentary and the entire scene work to clear a space for yet another project, a long-term documentary on the last speakers of disappearing languages, which Herzog has already begun. Although he is working with experts in various fields and filming in remote parts of Ethiopia, New Guinea, and the Amazon jungle, it is obviously safe to assume that this project is not part of a scientific effort to reconstruct lost languages or to record last instances for posterity; rather, it seems to be motivated by the filmmaker's desire to confront film audiences with the transience of languages, speakers, and their surroundings and to do so in memorable ways.

Issues of performance and preservation extend throughout *Cave of Forgotten Dreams* (2010), Herzog's 3-D documentary on the prehistoric origins of art and human consciousness. A guided tour of the Chauvet Cave in southeast France, the film displays a trove of Ice Age paintings and artifacts, with explanatory commentary from well-known scientists and, of course, from the director himself. Although the film has moments of humor and absurdity, as one might expect, its prevailing attitude is one of awe and respect (even reverence), an attitude that can be traced throughout Herzog's documentaries. In this case, it can be explained by the cave's historical and cultural significance as well as by the tightly controlled conditions of filmmaking. Discovered in 1994, the site was immediately and permanently closed to the public. *Cave of*

Forgotten Dreams thus provides rare visual access to this extraordinary place and to the oldest known paintings in the world. As Herzog says on the voice-over, "We entered the Chauvet Cave aware that this may be the only and last opportunity to film inside." The resulting film, like some of the scholarship before it, interprets the cave as an Ur-site of performance, a place not just for making and viewing pictures but also for singing songs, for playing music, and for dancing with lights and shadows.[4] *Homo cinematicus*: Herzog doesn't use this phrase, but it succinctly describes his vision of the cave painters, their status as human, and our distinction from other species, living and extinct.

In its effort to visualize prehistory, in its choreography of traces (bones, paintings, hand stencils, footprints, claw marks) and spaces (aerial views, subterranean caverns, computer simulations), in its combination of the material and the imaginary, the indicative and the subjunctive, *Cave of Forgotten Dreams* raises a number of interesting questions about the terrain of documentary cinema, past, present, and future. Here I can emphasize only one of them, namely, the use of 3-D technology. Can 3-D become an accepted strategy of documentary filmmaking? Herzog makes the case. In a way, the subject itself would seem to demand as much.[5] Illustrated books about the Chauvet Cave, however loaded they may be with color photographs, discursively strain to convey a sense of how the paintings themselves make use of "the wall's volumes, its crevices, its angles, producing illusions of relief and perspective."[6] By contrast, the 3-D film renders visceral, almost palpable, these very qualities of the paintings and of their surroundings. With each foray into the cave, with each moment the camera lingers on the found images and artifacts, Herzog explores the conditions for the possibility of 3-D documentary. In some passages, the shaky, handheld camera work becomes difficult to view; immersion becomes vertiginous. And yet it is precisely in these passages that the film recalls not the thrill rides of IMAX films but rather—unexpectedly—the legacy of direct cinema. In that context, the availability of cutting-edge, portable recording equipment has been widely understood as a catalyst for expanding and transforming the paradigm of documentary. What changes may come? What other documentary situations might benefit from the creative adaptation of 3-D technology? How does 3-D affect our historical and theoretical understanding of documentary

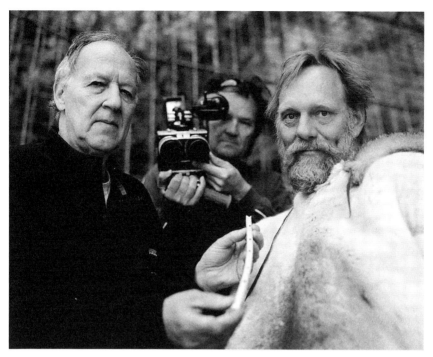

From left to right, Werner Herzog displays a replica of an ancient flute; cinematographer Peter Zeitlinger shows the tiny 3-D camera; and archaeologist Wulf Hein appears in costume, as he does in the film. Publicity still for *Cave of Forgotten Dreams* (2010).

cinema? What can we learn about spectatorship, for example? Surely the use of 3-D would also shed light on documentary's historical relationship to other forms of sensory immersion and to other sites of performance, beginning with the decorated caves.

Throughout his long career, Herzog has worked through documentary cinema to perform his own identity and difference as a filmmaker. As we have seen, he is almost constantly reworking his own cinematic past, especially the period around the making of *Fitzcarraldo,* while at the same time generating so many versions of an autobiographical self. A performance lens highlights the interrelationship of Herzog as the subject of documentaries by other filmmakers (such as Les Blank) and as a director of his own documentaries. There is a certain blurring of distinctions between the films in which Herzog performs a directorial persona in the documenting of his filmmaking and those in which he performs that role as the "real" director behind the documentary

camera. This book necessarily ranged between both the performed and the authored documentaries, and the conceptual space between these forms was also scrutinized.[7]

Because of its authority as witness, documentary film offers Herzog a means of grounding his vision of the world in the bodies of other people, who are in turn called on to testify on his behalf, whether or not they think of themselves as doing so. Take *Grizzly Man,* the film at the conceptual core of this book, if last among its key examples. The subject of this documentary is the late Timothy Treadwell. The film not only tells his story, focusing on his life and death among wild bears, but also makes extensive use of his video diaries. Depending on whom we listen to, *Grizzly Man* is a portrait film, a nature film, an expedition film, a cautionary tale, or a mash-up of all these categories. In this particular instance, however, close analysis allows us to make a rather different conclusion: it is a profoundly autobiographical act on Herzog's part, even as the various generic frameworks retain their importance. It is less obvious what larger conclusions about Herzog and documentary we should draw from this material. I want to suggest two.

This book shows, first, that Herzog and his films have in fact contributed to the ongoing process of reimagining documentary after cinema verité. A performance lens captures this dynamic, which has been effaced by the discourse on Herzog, with encouragement from the director himself, so that the received idea about his body of work has been one of singularity and isolation, not unlike some of the figures in his movies. Clearly there is some truth to that idea, as far as it goes, which is one reason why Herzog's films are usually discussed in terms of auteurism. But a wholly appropriate emphasis on auteurism cannot account for the tenacity of his engagement with documentary. His intervention is strategic in the sense that it puts documentary in the service of enacting the director's personal style, as a way of emphasizing the alterity of his work, its difference from that of other filmmakers, its resistance to classification. But his intervention is also strategic in the sense that it deliberately upsets documentary dogma. Herzog will never be a "good object" of documentary studies, at least not for scholars who are primarily concerned with politics, taxonomy, or purism. His work cannot be disciplined in this sense, and what would be the point of doing so? And yet,

to borrow Claude Lévi-Strauss's famous phrase concerning Australian totems, Herzog's documentaries are "good to think with."

The second and broader conclusion to this book is that issues of performance, actually, need even more attention than they have already received in documentary studies. The Herzog material reminds us that various forms of rehearsal, or what Schechner calls *restored behavior,* are in fact central and not peripheral to documentary cinema, even if the latter is narrowly defined as an observational project. These include not only staging, scripting, voicing, and playing to the camera (the usual suspects) but also a vast range of ordinary and special events, actions, habits, practices, and movements, constituting much of the reality that documentary film would claim to represent. However salient issues of performance have become in recent years, the discourse on documentary remains mired in a set of powerful historical assumptions about theater as illusion and make-believe, about acting as deception (even lying), and about performance as put-on and therefore invalidating or inauthentic. To make matters worse, these assumptions continue to be put in the service of identifying what is specific to documentary cinema, even though they are much older and come from other areas of Western culture. Transported as they are to documentary, they carry with them a set of "hidden moral and epistemological judgments," which have mainly had the effect of undermining analytical discussion.[8] In addition to reflecting on our use of terms, on their underlying prejudices, and on their implications for our theoretical understanding of documentary, we need to develop more positive and productive models, alternative ways of engaging issues of performance in documentary. This need will only grow as practices of documentary filmmaking and viewing spread out across an increasing number and diversity of screens, formats, and platforms. Any larger conclusions we wish to draw from the Herzog material must surely be ambiguous, like the notion of documentary cinema itself.

NOTES

INTRODUCTION

1 The dialogue with Ebert included a series of film clips, followed by questions from the audience. Unless otherwise noted, all quotations are my transcriptions of the event's audiotaped recording, "Regis Dialogue, April 30, 1999," Walker Art Center. I am grateful to Dean Otto, Daniel Smith, and Jill Vuchetich at the Walker and to Bruce Jenkins at the Art Institute of Chicago for their assistance in reconstructing Herzog's visit.

2 Werner Herzog, *Herzog on Herzog,* ed. Paul Cronin (London: Faber and Faber, 2002), 239.

3 "The Minnesota Declaration" is reproduced on the filmmaker's website, http://www.wernerherzog.com/.

4 Amos Vogel, "Grim Death," *Film Comment* 16, no. 2 (1980): 78–79.

5 This tagline admittedly came from Herzog's first cameraman, Jaime Pacheco. See Werner Herzog, interview by Daniel Sponsel and Jan Sebenig (1998), in *Revolver: Kino muss gefährlich sein,* ed. Marcus Seibert (Frankfurt am Main, Germany: Autoren, 2006), 57–58.

6 See, e.g., Werner Herzog, "On the Absolute, the Sublime, and Ecstatic Truth," trans. Moira Weigel, *Arion* 17, no. 3 (2010): 5; also available at http://www.wernerherzog.com/.

7 Maximilian le Cain, "Herzog, Werner," in *Encyclopedia of the Documentary Film,* vol. 2, ed. Ian Aitken, 556–58 (New York: Routledge, 2006). Yet another sign of change, Barry Keith Grant and Jim Hillier's *100 Documentary Films* (London: BFI, 2009) includes two films by Herzog, namely, *Lessons of Darkness* and *Grizzly Man.*

8 For a critique of this history and an alternative account focusing on documentary's beginnings, see Bill Nichols, "Documentary Film and the Modernist Avant-Garde," *Critical Inquiry* 27, no. 4 (2001): 580–610.

9 Werner Herzog, "On Walking and Dreaming," interview by Catherine Courel, in *The Great Ecstasies of the Filmmaker Werner Herzog: A*

Retrospective 1967–1995 (San Francisco: Goethe-Institut, 1995), 11. A program brochure.

10 As Herzog's presentation of the Minnesota Declaration makes clear, his work reacts in part to the historical situation of television as the main producer of documentaries and to their institutional function as a branch of journalism, even as he benefits from this situation. Many of his documentaries have been cofinanced by and first broadcast on television networks such as Süddeutscher Rundfunk (SDR), Zweites Deutsches Fernsehen (ZDF), the Discovery Channel, and the History Channel. At the same time, as we shall see, television provides a key context for Herzog's engagement with specific forms, including travelogues, wildlife films, and historical reconstructions.

11 Dieter Dengler, "Learning to Fly: Dieter Dengler Speaks about Werner Herzog's Latest Doc," interview by Doug Stone, *Indiewire,* April 14, 1998, http://indiewire.com/.

12 Thomas Elsaesser, *New German Cinema: A History* (New Brunswick, N.J.: Rutgers University Press, 1989), 164. For more on this context, see Nora M. Alter, *Projecting History: German Nonfiction Cinema, 1967–2000* (Ann Arbor: University of Michigan Press, 2002).

13 Elsaesser, *New German Cinema,* 64.

14 The film first aired on ZDF in 1970, but "AMREF used it widely as an information tool" for more than a decade. Nicky Blundell Brown, AMREF Heritage and Special Events Co-coordinator, e-mail message to the author, June 7, 2010.

15 Other commissions include *Handicapped Future* (*Behinderte Zukunft,* 1971), made for the West German state of North Rhine–Westphalia, and *No One Will Play with Me* (*Mit mir will niemand spielen,* 1976), sponsored by Munich's Institute for Film and Image in Science and Education. The movement within Herzog's body of films from commissioned to authored films, so typical of the New German Cinema, also reflects a larger historical turn, that is, the displacement of the state as the center of documentary production. As Nichols points out, documentary's shift away from state-centered propaganda and toward self-expression and personal politics was first initiated by direct cinema in the 1960s (what Herzog calls cinema verité) but only achieved later and largely in reaction to direct cinema. See Nichols, "Documentary Film," 607–10.

16 Elsaesser, *New German Cinema,* 322.

17 See esp. Alexander Kluge, *Gelegenheitsarbeit einer Sklavin: Zur realistischen Methode* (Frankfurt am Main, Germany: Suhrkamp, 1975), 201–50. See also Werner Barg, "Ein Dokumentarist des Protestes: Alexander Kluges Theorie des Dokumentarfilms: Beobachtungen zu seinen Essay-

Filmen und Fernsehmagazinen," in *Perspektiven des Dokumentarfilms,* ed. Manfred Hattendorf, 111–26 (Munich, Germany: Diskurs-Film, 1995). For a summary of Kluge's theory in English, see John Sandford, *The New German Cinema* (New York: Da Capo, 1980), 17–19.

18 Kluge, *Gelegenheitsarbeit,* 204.

19 Peter C. Lutze, *Alexander Kluge: The Last Modernist* (Detroit, Mich.: Wayne State University Press, 1998), 129.

20 Kluge, *Gelegenheitsarbeit,* 203.

21 E.g., Kluge's film *Occasional Work of a Female Slave* (*Gelegenheitsarbeit einer Sklavin,* 1973) begins by recycling the first shot of Herzog's *Land of Silence and Darkness,* a landscape view that is itself a piece of found footage.

22 For a discussion of Kluge and Herzog, among others, as part of a group, see Elsaesser, *New German Cinema,* 165–68. See also Peter W. Jansen and Wolfram Schütte, eds., *Herzog/Kluge/Straub,* Reihe Film 9 (Munich, Germany: Hanser, 1976).

23 Bill Nichols, *Blurred Boundaries: Questions of Meaning in Contemporary Culture* (Bloomington: Indiana University Press, 1994), 1; emphasis original.

24 Stella Bruzzi, *New Documentary: A Critical Introduction* (London: Routledge, 2000), 5.

25 Ibid., 6.

26 Ibid., 7.

27 See Bill Nichols, *Representing Reality: Issues and Concepts in Documentary* (Bloomington: Indiana University Press, 1991), esp. 3–6.

28 Michael Renov, "Introduction: The Truth about Non-fiction," in *Theorizing Documentary,* ed. Michael Renov (New York: Routledge, 1993), 3.

29 See, e.g., Nichols, "Documentary Modes of Representation," chapter 2 in *Representing Reality*; "Performing Documentary," chapter 5 in *Blurred Boundaries*; and "How Can We Describe the Observational, Participatory, Reflexive, and Performative Modes of Documentary Film?," chapter 7 in *Introduction to Documentary,* 2nd ed. (Bloomington: Indiana University Press, 2010).

30 Bruzzi, *New Documentary,* 7.

31 See Bruzzi, "The Performative Documentary," chapter 6 in *New Documentary.*

32 Richard Schechner, *Between Theater and Anthropology* (Philadelphia: University of Pennsylvania Press, 1985), 35.

33 See, e.g., Jonathan Cott, "Signs of Life" (includes an interview with Herzog), *Rolling Stone,* November 18, 1976, 56.

34 In *Film Follies: The Cinema Out of Order* (New York: Continuum, 2000),

Stuart Klawans suggests that the role of "physical challenge" in Herzog's films connects them to performance art, especially that of Joseph Beuys (157). He even credits Herzog for "popularizing this new strain of art, bringing it into direct contact and confrontation with the institution of the movies" (158). While I find this association to be suggestive, I should be clear: *Ferocious Reality* treats Herzog as a filmmaker (and neither as a performance artist nor as a popularizer of performance art). Performance here serves as a theoretical framework for discussing Herzog's films and their relationship to documentary cinema.

35 Volker Schlöndorff, "Imaginäre Fotogalerie," in *Werner Herzog,* ed. Beat Presser (Berlin: Jovis, 2002), 31.

1. SENSATIONAL BODIES

1 Herzog, *Herzog on Herzog,* 239.

2 Nichols, *Representing Reality,* 211. For a thorough discussion of the genre, see Linda Williams, *Hard Core: Power, Pleasure, and the "Frenzy of the Visible"* (Berkeley: University of California Press, 1989).

3 Werner Herzog, "Werner Herzog, 2004," interview by Doug Aitken, *Index Magazine,* http://www.indexmagazine.com/.

4 Tom Cheesman, "Apocalypse Nein Danke: The Fall of Werner Herzog," in *Green Thought in German Culture: Historical and Contemporary Perspectives,* ed. Colin Riordan (Cardiff: University of Wales Press, 1997), 290

5 Ibid. The taboo concerns the representation of death.

6 The scenario of *Game in the Sand* is later restaged, revised to merely suggest violence, and integrated into Herzog's debut feature, *Signs of Life (Lebenszeichen,* 1968).

7 Linda Williams, "Film Bodies: Gender, Genre, and Excess," in *Film Genre Reader II,* ed. Barry Keith Grant (Austin: University of Texas Press, 1995), 142. For a useful extension of Williams's work, see David MacDougall, "The Body in Cinema," chapter 1 in *The Corporeal Image: Film, Ethnography, and the Senses* (Princeton, N.J.: Princeton University Press, 2006). I thank David MacDougall for discussing Herzog's films with me.

8 Linda Williams, "Corporealized Observers: Visual Pornographies and the 'Carnal Density of Vision,'" in *Fugitive Images: From Photography to Video,* ed. Patrice Petro (Bloomington: Indiana University Press, 1995), 8.

9 Williams, "Film Bodies," 143.

10 Marianna Torgovnick, *Primitive Passions: Men, Women, and the Quest for Ecstasy* (New York: Knopf, 1997), 14–15.

11 Brad Prager, *The Cinema of Werner Herzog: Aesthetic Ecstasy and Truth* (London: Wallflower Press, 2007), 6.

12 See, e.g., Richard Eder, "A New Visionary in German Films" (includes an interview with Herzog), *New York Times,* July 10, 1977.

13 See, e.g., Gertrud Koch, "Blindness as Insight: Visions of the Unseen in *Land of Silence and Darkness,*" in *The Films of Werner Herzog: Between Mirage and History,* ed. Timothy Corrigan, 73–86 (New York: Methuen, 1986).

14 Quoted in Wolfgang Ruf, "Land des Schweigens und der Dunkelheit," n.p. (Deutsche Kinemathek, Sig. 55146). The film was first broadcast June 12, 1972, on ZDF. On the network's initial resistance to the film, see Herzog, *Herzog on Herzog,* 75.

15 The "decisive criterion" of this film, Herzog later commented in a journal for friends of the deaf and blind, is not understanding but rather "touching" *(anrühren).* "Dokumente über unseren inneren Zustand: Ein Gespräch mit Werner Herzog," interview by Annelie Runge, *Jahrbuch für Blindenfreunde* (1978): 28.

16 Herzog, *Herzog on Herzog,* 72.

17 Ibid., 73.

18 Carol Poore, *Disability in Twentieth-Century German Culture* (Ann Arbor: University of Michigan Press, 2007).

19 Other documentaries of the period that suggest a wider context for Herzog's film include *Blind Child* (1964) and *Herman Slobbe—Blind Child II* (1966), by Dutch filmmaker Johan van der Keuken, and *Goodbye CP* (1972), Kazuo Hara's group portrait of adults with cerebral palsy and their politicized self-display in postwar Japan. The context further widens with later films such as Fred Wiseman's Deaf and Blind series (*Deaf, Blind, Multi-handicapped, Adjustment and Work,* 1986–87) and Nicholas Philibert's *In the Land of the Deaf* (1992).

20 During World War II, Rolf Illig was an American prison of war—a point that adds further historical resonance to *Handicapped Future* and its project as a postwar film. I thank Brad Prager for this information.

21 By featuring more than one person with disability, amplifying their voices, suggesting multiple disability perspectives (not one), and placing emphasis on touch as a medium of connection, Herzog's work also differs from the prevailing "image of disability" in Hollywood, as the latter is discussed by Martin F. Norden in *The Cinema of Isolation: A History of Physical Disability in the Movies* (New Brunswick, N.J.: Rutgers University Press, 1994).

22 Ruf, "Land des Schweigens." For a sense of the critical polarity that

characterized the German reception of *Land of Silence and Darkness,* see *25 Jahre Filmwoche Mannheim: Dokumentation* (Mannheim, Germany: Internationale Filmwoche Mannheim, 1976), 79–80.

23 I borrow this phrase from Paul Rodaway, *Sensuous Geographies: Body, Sense, and Place* (London: Routledge, 1994).

24 Laura U. Marks, *The Skin of the Film: Intercultural Cinema, Embodiment, and the Senses* (Durham, N.C.: Duke University Press, 2000), 162; emphasis original.

25 Ibid., 22.

26 Ibid., 170.

27 Quoted in Ashley Montagu, *Touching: The Human Significance of the Skin* (New York: Columbia University Press, 1971), 107.

28 "Ich sehe vor mir einen Feldweg, der quer durch ein umgebrochenes Feld führt, und darüber fliegen eilige Wolken." The English subtitle contains a significant error, so this translation is my own, based on the German sound track. For the film script, see Werner Herzog, *Drehbücher II* (Munich, Germany: Skellig Edition, 1977), 195–216.

29 See Laura U. Marks, *Touch: Sensuous Theory and Multisensory Media* (Minneapolis: University of Minnesota Press, 2002), 3, 8.

30 See, e.g., William Van Wert, "Last Words: Observations on a New Language," in *The Films of Werner Herzog: Between Mirage and History,* ed. Timothy Corrigan (New York: Methuen, 1986), 57.

31 Koch, "Blindness as Insight," 79.

32 Another scene, filmed at a zoo, is worth noting. As Straubinger holds a chimpanzee, it grabs the camera and pulls out one of the lens frames just far enough to block part of our view. The blocked image is shown (not cut), as it refers to the sense of touch that the film seeks to emphasize.

33 J. Hoberman, "Alien Landscapes," *Village Voice* 26, no. 52 (1981): 66.

34 Koch interprets the unseen as the sacred and Straubinger as a "savior." Each point follows Günther Pflaum's review, "Land des Schweigens und der Dunkelheit," *Film-Dienst* 23 (November 16, 1971). Although I discuss this film in different terms, I do see a connection to this interpretation. It is based in the vestiges of religious thought, which holds that saintly bodies can be literally apprehended by means of vision—an idea that Herzog himself explores in later films such as *God and the Burdened* (see chapter 4).

35 An extreme close-up on the palm of this glove shows a diagram consisting of dots, dashes, and letters—a tactile version of the German language known as *Lormen.* Compared to other forms of sign language that are inflected and have their own grammar, the tactile system is relatively

simple, if laborious: A "speaker" taps out messages, letter by letter, onto the hand of a "reader," who responds in turn. The tactile system was invented in the late nineteenth century by the Viennese critic, journalist, and deaf–blind poet Hieronymous Lorm (born Heinrich Landesmann).

36 William F. Van Wert, "Hallowing the Ordinary, Embezzling the Everyday: Werner Herzog's Documentary Practice," *Quarterly Review of Film Studies* 5, no. 2 (1980): 185–86.

37 Herzog, *Herzog on Herzog,* 73–74.

38 Noël Carroll, "Herzog, Presence, and Paradox," *Persistence of Vision* 2 (Fall 1985): 35.

39 See, on this point, David Hevey, *The Creatures Time Forgot: Photography and Disability Imagery* (London: Routledge, 1992), 72.

40 Rosemarie Garland Thomson, "Seeing the Disabled: Visual Rhetorics of Disability in Popular Photography," in *The New Disability History: American Perspectives,* ed. Paul K. Longmore and Lauri Umansky (New York: New York University Press, 2001), 339.

41 Ruf, "Land des Schweigens." A further anecdote is worth noting: in 1972, West German film critic Hans Günther Pflaum decided to visit Straubinger in person. "Back then," he recalls, "people said that Herzog observed his characters with the soulless interest of an entomologist. This is why I asked Fini Straubinger whether Herzog had been in touch with her since the shoot. 'Oh, yes,' she said, 'he was here last Sunday.' She went on to say that he had come on his brother's motorbike and had invited her to go for a joyride. . . . The old, deaf-and-blind lady went into raptures about the whole experience, about the wind in her hair, the air and the thrill of speed." From "Instead of a Box of Chocolates, the Thrill of Speed: Hans Günther Pflaum on Werner Herzog," trans. Paul McCarthy, the website of the Goethe-Institut, June 2010, http://www.goethe.de/.

42 It helps to give some perspective here. However provocative the film may have been in postwar Germany, *Land of Silence and Darkness* seems almost benign in comparison to Hara Kazuo's *Goodbye CP* (also from 1972), whose acts of social provocation border on the physical exploitation and humiliation of people with disability.

43 See esp. Werner Herzog, interview by Kraft Wetzel, in Jansen and Schütte, *Herzog/Kluge/Straub,* 126.

44 Cf. Sharon L. Snyder and David T. Mitchell, *Cultural Locations of Disability* (Chicago: University of Chicago Press, 2006), 145.

45 Bruce Bennett, "The Nonvirtual Realist," *The New York Sun,* May 18, 2007, http://www.nysun.com/; emphasis added.

46 Roland Barthes, *The Pleasure of the Text*, trans. Richard Miller (New York: Hill and Wang, 1975), 66. The cinema analogy appears on p. 67.

47 Brian Moser, foreword to *Disappearing World: Television and Anthropology*, ed. André Singer and Leslie Woodhead (London: Boxtree, 1988), 12.

48 Quoted ibid., 8.

49 Herzog, *Herzog on Herzog*, 280.

50 Karl G. Heider, *Ethnographic Film* (Austin: University of Texas Press, 1976), 90.

51 Werner Herzog, "Was the Twentieth Century a Mistake?" interview by Paul Holdengräber, New York Public Library, February 16, 2007, http://www.nypl.org/.

52 For an "anthropological" study of Herzog's films, see Valérie Carré, *La quête anthropologique de Werner Herzog: Documentaires et fictions en regard* (Strasbourg: Presses Universitaires de Strasbourg, 2007).

53 David MacDougall, interview by Volker Kull, in *Poeten, Chronisten, Rebellen: Internationale DokumentarfilmemacherInnen im Porträt*, ed. Verena Teissl and Volker Kull (Marburg, Germany: Schüren, 2006), 74; emphasis added.

54 Marcus Banks, "Which Films Are the Ethnographic Films?" in *Film as Ethnography*, ed. Peter Ian Crawford and David Turton (Manchester: Manchester University Press, 1992), 122.

55 Rouch's *Les maîtres fous* (1954) informs the preparation for Herzog's *Heart of Glass* (*Herz aus Glas*, 1976). See, on this point, Werner Herzog, interview by Bion Steinborn and Rüdiger von Naso, *Filmfaust* no. 26 (1982): 2–15; in English, see Herzog, *Herzog on Herzog*, 126. Herzog himself selected *Les maîtres fous* to accompany a 2007 retrospective of his own documentaries at New York City's Film Forum. On "ecstatic ethnography," see chapter 8 in Catherine Russell, *Experimental Ethnography: The Work of Film in the Age of Video*, 193–237 (Durham, N.C.: Duke University Press, 1999).

56 Mary Ann Doane, "The Voice in the Cinema: The Articulation of Body and Space," in *Narrative, Apparatus, Ideology: A Film Theory Reader*, ed. Philip Rosen (New York: Columbia University Press, 1986), 340.

57 Jean Rouch, *Ciné-Ethnography*, ed. and trans. Steven Feld (Minneapolis: University of Minnesota Press, 2003), 42.

58 Herzog, *Herzog on Herzog*, 214. The recorded singer is the famous castrato Alessandro Moreschi. To those who recognize it, the castrato voice only underscores the film's concern with gender, corporeality, and vocal presence. Inasmuch as it recalls a masculine ideal of European art and society in the historical baroque, the castrato voice also suggests an

unexpected connection between seemingly disparate cultures, which, as we shall see, is in entirely in keeping with the film's project.

59 See esp. Bill Nichols, "The Voice of Documentary," *Film Quarterly* 36, no. 3 (1983): 17–30.

60 Mette Bovin, "Nomadic Performance—Peculiar Culture? 'Exotic' Ethnic Performances of WoDaaBe Nomads of Niger," in *Recasting Ritual: Performance, Media, Identity,* ed. Felicia Hughes-Freeland and Mary M. Crain (London: Routledge, 1998), 97.

61 David MacDougall, *Transcultural Cinema,* ed. Lucien Taylor (Princeton, N.J.: Princeton University Press, 1998), 165

62 Ibid. See also *Subtitles: On the Foreignness of Film,* ed. Atom Egoyan and Ian Balfour (Cambridge, Mass.: MIT Press, 2004).

63 Nichols, "Voice of Documentary," 23.

64 For a discussion of voice-over's historical uses, see Bruzzi, "Narration," chapter 2 in *New Documentary*. The quotation appears on p. 47.

65 Herzog shows his own body on-screen with remarkable restraint. Consequently, his walk-ons come to seem all the more significant, as is shown in later chapters. The quotation appears in Nichols, *Blurred Boundaries,* 68.

66 See Heider, *Ethnographic Film,* 88.

67 Quoted in Jean-André Fieschi, "Slippages of Fiction: Some Notes on the Cinema of Jean Rouch," in *Anthropology, Reality, Cinema: The Films of Jean Rouch,* ed. Mick Eaton (London: BFI, 1979), 68.

68 An extreme case, and a clear example of restored behavior, is Herzog's *Jag Mandir* or, *The Eccentric Private Theater of the Maharaja of Udaipur* (*Das exzentrische Privattheater des Maharadschah von Udaipur,* 1991), the cinematic record of a vast ethnographic exhibition featuring hundreds of Indian performers—singers, dancers, musicians, acrobats, and snake charmers—recruited from around the country and brought to Udaipur for a private show. The event was organized for the maharaja by Austrian impresario and multimedia artist André Heller, who asked his friend Herzog to record it. The resulting film, coproduced by German and Austrian television, mainly depicts the performances as they take place before an audience of the maharaja and guests. In an interesting twist, Herzog frames the entire program with a scenario taken from *The Music Room* (*Jalsaghar,* 1958; dir. Satyajit Ray), the story of a nobleman who sits in a decaying palace and spends all his money inviting India's best musicians and dancers and giving festivals.

69 Heider, *Ethnographic Film,* 125.

70 Colleen Ballerino Cohen, Richard Wilk, and Beverly Stoltje, eds., intro-

duction to *Beauty Queens on the Global Stage: Gender, Contests, and Power* (New York: Routledge, 1996), 2.

71 Cf. Doane, "Voice," 341.

72 Rosemarie Garland Thomson, "The Beauty and the Freak," in *Points of Contact: Disability, Art, and Culture,* ed. Susan Crutchfield and Marcy Epstein (Ann Arbor: University of Michigan Press, 2000), 190.

73 Herzog, "Was the Twentieth Century a Mistake?"

74 While Herzog explains *Wodaabe* in terms of universal humanism, other films imagine nonhuman perspectives of aliens and animals, which complicate the idea of Herzog as humanist. Cf. Prager, *Cinema of Werner Herzog,* 198–99.

75 Peter Loizos, *Innovation in Ethnographic Film: From Innocence to Self-Consciousness, 1955–85* (Manchester: Manchester University Press, 1993), 140.

76 Ilisa Barbash and Lucien Taylor, eds., introduction to *The Cinema of Robert Gardner* (Oxford: Berg, 2007), 1.

77 Another notable precedent, perhaps a reference point for Herzog, is Henry Brandt's 1954 *Les Nomades du soleil,* an ethnographic film now forgotten but then screened and discussed with the work of Rouch, Gardner, and others.

78 The retrospective was accompanied by a volume of essays, *Rituale von Leben und Tod: Robert Gardner und seine Filme,* ed. Reinhard Kapfer, Werner Petermann, and Ralph Thoms (Munich, Germany: Trickster, 1989).

79 Karen Rosenburg, "Moralische Erzählungen eines Reisenden," in ibid., 46.

80 Michael Lieber, review of *Deep Hearts,* in *American Anthropologist* 82, no. 1 (1980): 224; emphasis original. See also Charles Warren, "The Music of Robert Gardner," in Barbash and Taylor, *Cinema of Robert Gardner,* 17–31.

81 The film asserts this point as a matter of fact, but Gardner merely suspects as much in his journal. Cf. Robert Gardner, *The Impulse to Preserve: Reflections of a Filmmaker* (New York: Other Press, 2006), 182–215; see esp. the entry for September 11, 1978 (210).

82 Werner Herzog, "Werner Herzog on Introspection," interview by Kaja Perina, *Psychology Today* 38, no. 4 (2005): 96.

83 Bovin makes a similar move using these very terms: "There is so much involved in a Wodaabe dance that if we were to compare it with events in Western Europe, it would comprise dance, opera, beauty contest, lovemaking or flirting, and social gathering"; "Nomadic Performance," 97.

84 *Wodaabe* might not be Herzog's final statement on ethnographic film. Reportedly, he is making a film about the Mursi in Ethiopia and "their view of the world outside their own territory and cosmology." He is also "working on a series of stories about lost languages which would be his most anthropological yet." The person who first accompanied him to the Mursi (for Herzog's 2009 "opera short" titled *La Bohème*), and the producer of these new projects, André Singer, is a former anthropologist and a filmmaker in his own right, who worked on various parts of the *Disappearing World* series, including *The Mursi* (1974; dir. Leslie Woodhead). André Singer, e-mail message to the author, October 9, 2009.

2. MOVING LANDSCAPES

1 Other commentators follow suit, which is not surprising given the term's ambiguity. See, e.g., Eder, "A New Visionary," and, most recently, Brad Prager, "Landscape of the Mind: The Indifferent Earth in Werner Herzog's Films," in *Cinema and Landscape,* ed. Graeme Harper and Jonathan Rayner, 89–102 (Bristol, U.K.: Intellect, 2010).

2 On issues of power, see esp. W. J. T. Mitchell, "Imperial Landscape," in *Landscape and Power,* ed. W. J. T. Mitchell, 5–34 (Chicago: University of Chicago Press, 1994).

3 See, e.g., Herzog, *Herzog on Herzog,* 81.

4 This is obviously changing. See esp. Michael Renov, *The Subject of Documentary* (Minneapolis: University of Minnesota Press, 2004), and Elizabeth Cowie, *Recording Reality, Desiring the Real* (Minneapolis: University of Minnesota Press, 2011). For an early exception to the rule, see David Davidson, "Borne out of Darkness: The Documentaries of Werner Herzog," *Film Criticism* 5 (1980): 10–25.

5 Eric Ames, "Herzog, Landscape, and Documentary," *Cinema Journal* 48, no. 2 (2009): 49–69.

6 Herzog, *Herzog on Herzog,* 136.

7 Ibid., 83; emphasis original.

8 Anglo-American critics have been particularly receptive to Herzog's self-image as a visionary artist, especially during the 1970s, when the New German Cinema first came into view. See, e.g., Gene Walsh, ed., *"Images at the Horizon": A Workshop with Werner Herzog* (Chicago: Facets Multimedia, 1979), conducted by Roger Ebert at the Facets Multimedia Center, Chicago, April 17, 1979, esp. 21 and 25; Cott, "Signs of Life"; and Eder, "A New Visionary."

9 Werner Herzog, "Schwanger gehen mit ganzen Provinzen," *Süddeutsche*

Zeitung, June 4–5, 1983. Part of this article, where he describes Segers's landscapes as "states of mind," is translated, lightly revised, and included in Herzog, *Herzog on Herzog,* 137. For an accessible study of the artist and his work, see John Rowlands, *Hercules Segers* (London: Scolar, 1979). The German edition (Munich: Prestel, 1980) was Herzog's first encounter of this material. Most recently, he exhibited the work of Seghers in a five-channel video installation called *Hearsay of the Heart* for the 2012 Biennial at the Whitney Museum of American Art.

10 Quoted by Jeffrey Ruoff, ed., "Introduction: The Filmic Fourth Dimension: Cinema as Audiovisual Vehicle," in *Virtual Voyages: Cinema and Travel* (Durham, N.C.: Duke University Press, 2006), 17.

11 See on this point Yi-Fu Tuan, "Topophilia," *Landscape* 11, no. 1 (1961): 29–32, and Simon Schama, *Landscape and Memory* (New York: Vintage Books, 1995).

12 Werner Herzog, interview by Kraft Wetzel, in *Werner Herzog: Werkstudie, Filmographie, Gespräch,* ed. Claus Huebner and Kraft Wetzel (Stuttgart, Germany: Kommunales Kino Stuttgart, 1973), 40.

13 Herzog, *Herzog on Herzog,* 47.

14 The program consisted of more than thirty films by Kenneth Anger, Stan Brakhage, Gregory Markopoulos, Jonas Mekas, Marie Menken, Ron Rice, and Jack Smith, among others.

15 Werner Herzog, "Rebellen in Amerika: Zu Filmen des New American Cinema," *Filmstudio,* May 1964, 57. On Herzog's notion of trance and visionary images, see also "Entretien: 'Le délire d'impérialisme on peut le constater tous les jours . . . ,'" interview by Noureddine Ghali, *Cinéma* 75, no. 198 (1975): 52–61.

16 The trance film, as its name suggests, simulates a dream state and features a sleep-walking protagonist, who wanders through dramatic landscapes "toward a climactic scene of self-realization." The mythopoeic film represents either "the making of a new myth or the reinterpretation of an old one." Here "imagination triumphs over actuality, and this imagination is unqualified by the perimeters of dream or delusion, as it is qualified in the trance film." P. Adams Sitney, *Visionary Film: The American Avant-Garde, 1943–2000,* 3rd ed. (Oxford: Oxford University Press, 2002), 18, 136.

17 Elsewhere, Herzog compares this structure to that of Bosch's triptych, *Garden of Earthly Delights* (ca. 1480–1505), a reproduction of which was mounted above the editing table when Herzog worked on *Fata Morgana.* See Werner Herzog, "Playboy Interview: Werner Herzog," interview by Raimund le Viseur and Werner Schmidmaier, in *Playboy* (German edition), January 1977, 30.

18 Nichols, "Documentary Film," 596.

19 Amos Vogel, *Film as a Subversive Art* (New York: Random House, 1974), 314. In Germany, too, *Fata Morgana* was seen in relation to the American avant-garde. As one commentator wrote, referring to the film's use of mythological elements, "Herzog shapes the material into a visually potent mythopoetic epic, which is closer to the avant-garde New American Cinema than anything else in the New German Cinema." Kraft Wetzel, "Kommentierte Filmografie," in *Werner Herzog,* Reihe Film 22 (Munich, Germany: Hanser, 1979), 98.

20 Brigitte Peucker, "Werner Herzog: In Quest of the Sublime," in *New German Filmmakers,* ed. Klaus Phillips (New York: Frederick Ungar, 1984), 168. See also Alan Singer, "Comprehending Appearances: Werner Herzog's Ironic Sublime," in *The Films of Werner Herzog: Between Mirage and History,* ed. Timothy Corrigan, 183–205 (New York: Methuen, 1986); and Matthew Gandy, "Visions of Darkness: The Representation of Nature in the Films of Werner Herzog," *Ecumene* 3, no. 1 (1996): 1–21. The director himself uses the language of sublimity and is aware of its philosophical tradition. See Herzog, "On the Absolute."

21 Using portable synchronized cameras and microphones, Drew and his team produced such notable television documentaries as *Primary* (1960), *The Chair* (1962), and *Crisis: Behind a Presidential Commitment* (1963). The key study of this material is Stephen Mamber's *Cinema Verite in America: Studies in Uncontrolled Documentary* (Cambridge, Mass.: MIT Press, 1974). See also P. J. O'Connell, *Robert Drew and the Development of Cinema Verite in America* (Carbondale: Southern Illinois University Press, 1992).

22 Mamber, *Cinema Verite in America,* 115. As Mamber rightly emphasizes, the Drew films represent an early moment in the history of this development and the crisis structure only one of many forms associated with cinema verité.

23 Quoted in Dave Saunders, *Direct Cinema: Observational Documentary and the Politics of the Sixties* (London: Wallflower Press, 2007), 9.

24 Mamber, *Cinema Verite in America,* 118.

25 Although the film title comes from the mountain's name, one scholar notes that it also sounds like the French word *souffrir,* whose connotations of enduring something with a felt sense of pain or annoyance reverberate across the film's subtitle. Perhaps the catastrophe of reference is not the event of a volcanic explosion but rather the ascent of cinema verité and its impact on documentary filmmaking across the board. Is this what Herzog would "suffer" for an effect? Kent Casper, "Herzog's

Quotidian Apocalypse: *La Soufrière,"* *Film Criticism* 15, no. 2 (1991): 31.

26 The program aired June 17, 1977, on ARD, the German public broadcasting system.

27 Tom Gunning, "Landscape and the Fantasy of Moving Pictures: Early Cinema's Phantom Rides," in Harper and Rayner, *Cinema and Landscape,* 64. Within Herzog's oeuvre, the phantom ride recalls a passage from *Signs of Life,* in which another car-mounted camera roams through a Greek island town without any obvious relation to the storyline. From a broader perspective, the space and movement of early cinema is yet another interest Herzog shares with the avant-garde. Cf. Tom Gunning, "An Unseen Energy Swallows Space: The Space in Early Film and Its Relation to American Avant-Garde Film," in *Film before Griffith,* ed. John L. Fell, 355–66 (Berkeley: University of California Press, 1983).

28 Casper, "Herzog's Quotidian Apocalypse," 33.

29 Quoted in Mamber, *Cinema Verite in America,* 132.

30 Ibid., 128.

31 Richard Leacock, interview by G. Roy Levin, in *Documentary Explorations: 15 Interviews with Film-makers,* ed. G. Roy Levin (Garden City, N.Y.: Doubleday, 1971), 204.

32 Mamber, *Cinema Verite in America,* 117.

33 Ibid., 133.

34 Ibid., 137.

35 Parody figures in many of Herzog's films, and the targets vary. *Fata Morgana,* for example, has recently been discussed as a parody of the expedition film, especially Bernhard Grzimek's documentaries from the 1950s, which imagine and represent Africa as a "paradise" for animals. See Anton Kaes, "Zwischen Parodie und Phantasmagorie: Das 'Paradies' in Werner Herzogs *Fata Morgana,"* in *Paradies: Topografien der Sehnsucht,* ed. Claudia Benthien and Manuela Gerlof, 231–48 (Cologne, Germany: Böhlau, 2010).

36 See, e.g., Werner Herzog, interview by Hans Günther Pflaum, in *Werner Herzog,* Reihe Film 22 (Munich, Germany: Hanser, 1979), 71.

37 Their affinities include the complexity of authorship, the commitment to storytelling, the emphasis on physicality, the focus on ritual forms of behavior (such as contests), even the aversion to "documentary" as a label. On the aversion to documentary, e.g., see Donn Alan Pennebaker, interview by G. Roy Levin, in *Documentary Explorations,* 223–70. Shortly before my book went into production, another scholar made a similar point, identifying still other correspondences between Herzog and direct cinema: see Chris Wahl, "Das Authentische und Ekstatische versus das Stilisierte und

Essayistische—Herzogs Doku-Fiktionen," in *Lektionen in Herzog: Neues über Deutschlands verlornenen Filmautor Werner Herzog und sein Werk,* ed. Chris Wahl, 282–325 (Munich, Germany: Edition Text + Kritik, 2011).

38 Issues of media censorship have received extensive discussion. See esp. Elaine Scarry, "Watching and Authorizing the Gulf War," in *Media Spectacles,* ed. Marjorie Garber, Jann Matlock, and Rebecca L. Walkowitz, 57–73 (New York: Routledge, 1993); the essays in *Seeing through the Media: The Persian Gulf War,* ed. Susan Jeffords and Lauren Rabinovitz (New Brunswick, N.J.: Rutgers University Press, 1994); and John Taylor, "The Body Vanishes in the Gulf War," chapter 9 in *Body Horror: Photojournalism, Catastrophe and War* (Manchester, U.K.: Manchester University Press, 1998).

39 Marita Sturken, *Tangled Memories: The Vietnam War, the AIDS Epidemic, and the Politics of Remembering* (Berkeley: University of California Press, 1997), 126.

40 Herzog, *Herzog on Herzog,* 243–44; the quotation appears on p. 244.

41 Werner Herzog, interview by Alexander Schwarz, April 7, 1993, transcribed in Schwarz, "Wahre Bilder des Grauens: Ästhetik und Authentizität in Werner Herzogs *Lektionen in Finsternis* (1992)," in *Perspektiven des Dokumentarfilms,* ed. Manfred Hattendorf (Munich, Germany: Diskurs-Film-Verlag, 1995), 172. *Lessons of Darkness* was first broadcast by Premiere on February 27, 1992. Both the film and the station would win the prestigious Adolf-Grimme prizes of German television.

42 The airborne team consisted of helicopter pilot Jerry Grayson and cameraman Simon Werry. Christian Jennings, "Fields of Fire," *Sunday Times* (London), February 23, 1992. For an account of preproduction, see Herzog, "Was the Twentieth Century a Mistake?"

43 The film borrows its title from the sacred music of François Couperin, *Leçons de ténèbres* (1714), an example of which is used in *Fata Morgana.* Additionally, *Lessons of Darkness* recalls certain themes and images of Herzog's earlier film, especially its visionary aspect, only with greater urgency, focus, and coherence—a difference that might be explained by the film's occasion as well as by Herzog's development as a filmmaker.

44 Werner Herzog, "The Lion-Tamer of the Unexpected," 1996 interview by James Fry, first published in *Moon City Review* 7, no. 1 (2005): 108–9.

45 For technical discussions in English, see Martha Himmelfarb, *Tours of Hell: An Apocalyptic Form in Jewish and Christian Literature* (Philadelphia: University of Pennsylvania Press, 1983), and Richard Bauckham, *The Fate of the Dead: Studies on the Jewish and Christian Apocalypses* (Leiden, Netherlands: Brill, 1998).

46 As this section, and the well-capping scene before it, would seem to suggest, *Lessons of Darkness* may be Herzog's answer back to Robert Flaherty's *Louisiana Story* (1948), a commissioned film that employs landscape to naturalize the oil industry's infiltration of "Arcadia."

47 Susan Sontag, *Regarding the Pain of Others* (New York: Picador, 2003), 66.

48 Herzog, *Herzog on Herzog*, 248–49.

49 Roger Hillman, *Unsettling Scores: German Film, Music, and Ideology* (Bloomington: Indiana University Press, 2005), 147–48.

50 Herzog, "Lion-Tamer of the Unexpected," 105.

51 See Robert Hughes, *Heaven and Hell in Western Art* (New York: Stein and Day, 1968), and Richard Cavendish, *Visions of Heaven and Hell* (New York: Harmony, 1977). Hughes even attributes "documentary" qualities to the apocalyptic paintings of Bosch and Brueghel, emphasizing that "they painted what they saw" around them: not acts of God, but rather "acts of men" (278).

52 J. Hoberman, "Have Camera, Will Travel," *Premiere* 7 (July 1994): 39.

53 Scott MacDonald, *The Garden in the Machine: A Field Guide to Independent Films about Place* (Berkeley: University of California Press, 2001), 326.

54 In this regard, too, Herzog's landscapes interact with those of the avant-garde. See P. Adams Sitney, "Landscape in the Cinema: The Rhythms of the World and the Camera," in *Landscape, Natural Beauty, and the Arts*, ed. Salim Kemal and Ivan Gaskell, 103–26 (Cambridge: Cambridge University Press, 1993).

55 Herzog, *Herzog on Herzog*, 247.

56 For a theoretical discussion of cinematic motion that accounts for spectator participation, see Tom Gunning, "Moving Away from the Index: Cinema and the Impression of Reality," *Differences* 18, no. 1 (2007): 29–52.

57 The point can be made more vivid by contrast with *Figures in a Landscape* (1970; dir. Joseph Losey), a narrative film that makes extensive use of aerial footage shot from a helicopter moving at a frenetic pace, in effect reducing human beings to "figures in a landscape" for the purpose of targeting and killing them. Unlike that film, which reproduces the vectored landscapes of war, *Lessons of Darkness* visits historical sites of mass ruination in search of visible evidence.

58 According to Herzog, the film was "thrown off balance by the fact that I got to film only two people who had lost their speech, and they are outweighed by the flames and firefighters. . . . I had four more such people lined up," with the help of organizations documenting torture victims, but he was "expelled from Kuwait" before he could film them. Werner

Herzog, interview by Geoffrey O'Brien, *Parnassus: Poetry in Review* 22, nos. 1 and 2 (1997): 50.

59 See, e.g., Brian Winston, *Claiming the Real II: Documentary: Grierson and Beyond* (London: Palgrave Macmillan, 2008), 272, and Nadia Bozak, "Firepower: Herzog's Pure Cinema as the Internal Combustion of War," *CineAction* 68 (January 2006): 18–26.

60 Keith Beattie, *Documentary Display: Re-viewing Nonfiction Film and Video* (London: Wallflower, 2008), 25–26.

61 Winston, *Claiming the Real II*, 272.

62 Herzog, *Herzog on Herzog,* 245. For a partial account of the Berlin press conference, see Amos Vogel, "Lessons in Darkness," *Film Comment* 28, no. 3 (1992): 69–70.

63 Sontag, *Regarding the Pain of Others,* 76–77.

64 Ibid., 80.

65 Peter Bishop, *The Myth of Shangri-La: Tibet, Travel Writing, and the Western Creation of Sacred Landscape* (Berkeley: University of California Press, 1989), 10.

66 Ibid., 215–18.

67 Werner Herzog, introduction to *Pilgrims: Becoming the Path Itself,* by Lena Herzog (London: Arcperiplus, 2004), 11, 20.

68 Bishop, *Myth of Shangri-La,* 244.

69 Werner Herzog, interview by BBC Four, February 13, 2003, http://www.bbc.co.uk/; emphasis added.

70 Herzog, introduction to *Pilgrims,* 29.

71 Allegory is obviously not one thing; it changes over time. For a study of its various meanings and survivals, see Jane K. Brown, *The Persistence of Allegory: Drama and Neoclassicism from Shakespeare to Wagner* (Philadelphia: University of Pennsylvania Press, 2007). See also Angus Fletcher, *Allegory: The Theory of a Symbolic Mode* (Ithaca, N.Y.: Cornell University Press, 1964).

72 See, e.g., Nichols, *Introduction to Documentary,* 7–14. Contrary to Nichols, the problem isn't falsification. Rather, it's the specificity and control that allegory requires to maintain another meaning, the authority it imposes on interpretation, and how it makes no claim to neutrality or disinterestedness. And yet these same qualities actually make allegory relevant and even suggest its untapped possibility as a critical term for documentary studies, if only one would explore it.

3. ECSTATIC JOURNEYS

1 Carré, *La quête*, 285.

2 See, e.g., Robert Neelly Bellah, *Beyond Belief: Essays on Religion in a Post-traditional World* (New York: Harper and Row, 1970); Martin E. Marty, "Our Religio-secular World," *Daedalus*, Summer 2003, 42–48; John A. McClure, *Partial Faiths: Postsecular Fiction in the Age of Pynchon and Morrison* (Athens: University of Georgia Press, 2007); Jürgen Habermas et al., *An Awareness of What Is Missing: Faith and Reason in a Post-secular Age* (Cambridge, U.K.: Polity Press, 2010).

3 See Alan Greenberg, *Heart of Glass* (Munich, Germany: Skellig, 1976), 153–54; Herzog, *Herzog on Herzog*, 10; and Herzog, "Lion-Tamer of the Unexpected," 109–10.

4 Herzog, interview by BBC Four. See also Werner Herzog, interview by Laurens Straub, in the German-language press kit for *Wheel of Time*, available at the Deutsche Kinemathek in Berlin (Sig. 55146).

5 See esp. Herzog, *Herzog on Herzog*, 279–82.

6 Herzog, introduction to *Pilgrims*, 11–12.

7 See Rebecca Solnit, *Wanderlust: A History of Walking* (New York: Viking, 2000), and Joseph A. Amato, *On Foot: A History of Walking* (New York: New York University Press, 2004).

8 Wolfgang Brückner, "Fußwallfahrt heute: Frömmigkeitsformen im sozialen Wandel der letzten hundert Jahre," in *Wallfahrt kennt keine Grenzen: Themen zu einer Ausstellung des Bayrischen Nationalmuseums und des Adalbert Stifter Vereins, München*, ed. Lenz Kriss-Rettenbeck and Gerda Möhler, 101–13 (Munich, Germany: Schnell and Steiner, 1984).

9 Antoni Jackowski, introduction to *Peregrinus Cracoviensis* 10 (2000): 7. For a broader perspective on the contemporary situation, see Mary Lee Nolan and Sidney Nola, *Christian Pilgrimage in Modern Western Europe* (Chapel Hill: University of North Carolina Press, 1989).

10 See Greenberg, *Heart of Glass*, 153. Cf. Herzog, *Herzog on Herzog*, 10.

11 The rudiments of this story first appear in Herzog, "Playboy Interview," 37. The key source is Herzog's laudatory speech, "Die Eisnerin, wer ist das?" transcribed in *FILM-Korrespondenz* 28, no. 7 (1982): 1–2. A shorter, revised version of this speech is available as the foreword to Lotte H. Eisner's memoirs, *Ich hatte einst ein schönes Vaterland*, with Martje Grohmann (Heidelberg, Germany: Wunderhorn, 1984), 5–6.

12 Werner Herzog, *Vom Gehen im Eis: München-Paris 23.11. bis 14.12.1974* (Frankfurt am Main, Germany: Fischer, 1978); Herzog, *Of Walking in Ice: Munich—Paris, 23 November—14 December 1974*, trans. Martje

Herzog and Alan Greenberg (1980; New York: Free Association, 2008); the quotation appears in the foreword of each.

13 Herzog discusses this journey at length in his 1984 speech "Über das eigene Land," in *Nachdenken über Deutschland,* 193–215 (Munich, Germany: Bertelsmann, 1988); the quotation appears on p. 197. In English, see Peter Morgan, "'A Presence . . . Called Germany': Personal History in the Construction of National Identity by Post-war Intellectuals: Three Case-Studies," *Journal of European Studies* 26, no. 3 (1996): 239–66.

14 Herzog, *Herzog on Herzog,* 50.

15 For a compendium of these claims, see Herzog, *Herzog on Herzog,* 14–15, 279–82.

16 See, e.g., Werner Herzog, "I Feel That I'm Close to the Center of Things," interview by Lawrence O'Toole, *Film Comment* 15, no. 6 (1979): 48.

17 See Solnit, "The Path Out of the Garden," chapter 6 in *Wanderlust,* and Robin Jarvis, *Romantic Writing and Pedestrian Travel* (London: Macmillan, 1997).

18 See Amato, *On Foot,* 10–15.

19 On the pilgrim–tourist dichotomy, see Daniel H. Olsen and Dallen J. Timothy, "Tourism and Religious Journeys," in *Tourism, Religion, and Spiritual Journeys,* ed. Daniel H. Olsen and Dallen J. Timothy, 1–22 (London: Routledge, 2006), esp. 6–8. A further distinction is worth noting: in the 1970s and 1980s, Herzog compared pilgrimage to mountain climbing, as if it were only a small step from the secular practice to the sacred. Recently, he changed his mind, noting his aversion to the sport's "military" aspect, its mentality of "victory," "conquest," and "adventure." See, e.g., Herzog, *Herzog on Herzog,* 198–99, and Herzog, "Was the Twentieth Century a Mistake?"

20 For a travel perspective on his films generally, see Ewa Mazierska and Laura Rascaroli, "Out of Europe: Werner Herzog—The Cinema as Journey," chapter 4 in *Crossing New Europe: Postmodern Travel and the European Road Movie* (London: Wallflower, 2006).

21 Herzog, *Herzog on Herzog,* 169.

22 Vincent Canby, "Film: Werner Herzog Documentaries," *New York Times,* July 20, 1983.

23 On the notion of a feedback loop in performance, see Erika Fischer-Lichte, *Ästhetik des Performativen* (Frankfurt am Main, Germany: Suhrkamp, 2004), esp. chapter 3.

24 The relationship of pastor and congregants, which is here defined in terms of their physical copresence, is reconfigured in *God's Angry Man* (1980), Herzog's documentary portrait of the American televangelist Dr.

Gene Scott. For a discussion of this film, see Prager, *Cinema of Werner Herzog*, 121–24.

25 *Huie's Predigt* was coproduced by a West German television station (SDR) and first broadcast by the national public television network (ARD) on June 14, 1981.

26 Carl R. Plantinga, *Rhetoric and Representation in Nonfiction Film* (Cambridge: Cambridge University Press, 1997), 136

27 Ibid.

28 Ibid.

29 Les Blank, e.g., uses a similar technique in *The Blues Accordin' to Lightnin' Hopkins* (1970), a portrait of the African American musician in his local Texas community. The analogy of blues to preaching runs throughout this film, and one passage depicts a group of worshippers after a church service, all staring silently into the camera. Herzog began working with Blank in 1980, the year *Huie's Sermon* was made.

30 Richard Schechner, *Performance Studies: An Introduction*, 2nd ed. (New York: Routledge, 2006), 246.

31 Bruzzi, *New Documentary*, 70.

32 Herzog, interview by O'Brien, 44.

33 Victor Turner and Edith Turner, *Image and Pilgrimage in Christian Culture: Anthropological Perspectives* (New York: Columbia University Press, 1978), 138.

34 See, e.g., Herzog, interview by O'Brien, 42, and Herzog, *Herzog on Herzog*, 251–53.

35 See Schechner, *Between Theater*, 97, and Schechner, *The Future of Ritual: Writings on Culture and Performance* (London: Routledge, 1993), 27. For a longer perspective, see Jonas Barish, *The Antitheatrical Prejudice* (Berkeley: University of California Press, 1981).

36 Though he goes unnamed in the film, "The Redeemer" is none other than Vissarion, the Russian mystic who, in the early 1990s, founded the so-called Church of the Last Testament and a related settlement in a remote part of Siberia, which has attracted many Germans. In this case, if anything, Herzog shows restraint (and not cynicism). Cf. Bettina Sengling, "Die frommen Freaks," *Stern*, October 22, 2006, 86–90.

37 Diana Taylor, "Remapping Genre through Performance: From 'American' to 'Hemispheric' Studies," *PMLA* 122, no. 5 (2001): 1418.

38 On the suffering body in Catholic pilgrimage, see Andrea Dahlberg, "The Body as a Principle of Holism: Three Pilgrimages to Lourdes," in *Contesting the Sacred: The Anthropology of Christian Pilgrimage*, ed. John Eade and Michael J. Sallnow, 30–50 (London: Routledge, 1991).

39 The idea of "tactile transmission" relies on the Christian theology of incarnation, which designates selected pieces of the material world (e.g., pieces of the cross but also tombs, bodies, and relics) as sanctified through the bodily sacrifice of Jesus Christ. Turner, *Image and Pilgrimage*, 71.

40 Victor I. Stoichita, *Visionary Experience in the Golden Age of Spanish Art* (London: Reaktion, 1995), 171.

41 Withholding the venerated object is only one strategy among others. In *Wheel of Time*, Herzog displays and even lingers on such forms as the sand mandala and Mount Kailash, which are deliberately used for the religious purpose of visualization (see chapter 2). By contrast, *God and the Burdened* creates a virtual procession of competing icons and shrines so as to dramatize the historical tension among them (see chapter 4).

42 All quotations appear in Peter Brown, *The Cult of Saints: Its Rise and Function in Late Christianity* (Chicago: University of Chicago Press, 1981), 87.

43 Given Herzog's work in opera, perhaps the most tantalizing source is *The Legend of Kitezh*, a 1907 opera by Russian composer Nikolai Rimsky-Korsakov. It was a key example of religious syncretism at the fin de siècle, and its post-Soviet revival "emblematized the revival of Orthodox religion in Russia." See Simon Morrison, *Russian Opera and the Symbolist Movement*, 115–83 (Berkeley: University of California Press, 2002); the quotation appears on p. 171.

44 Herzog, *Herzog on Herzog*, 252.

45 Herzog, *Herzog on Herzog*, 295, was given to believe the series was called "music and film." The other collaborators were Hal Hartley with Louis Andriessen, Nicolas Roeg with Portishead's Adrian Utley, and the Brothers Quay with Karlheinz Stockhausen. See Eddi Fiegel, "Ears Wide Open," *The Guardian*, February 28, 2001, http://www.guardian.co.uk/.

46 See John Tavener, "The Sacred in Art," *Contemporary Music Review* 12, part 2 (1995): 49–54.

47 Herzog, *Herzog on Herzog*, 294.

48 *Pilgrimage* was first screened March 4, 2001, with live music, on London's Barbicon stage and was broadcast April 8, 2001, on BBC2. Its U.S. premiere, which also featured live music, was March 14, 2002, at Columbia University's Miller Theater in New York City.

49 Prager, *Cinema of Werner Herzog*, 127.

50 See esp. Patrik Sjöberg, *The World in Pieces: A Study of Compilation Film* (Stockholm: Aura, 2001), and Jay Leyda, *Films Beget Films: Compilation Films from Propaganda to Drama* (New York: Hill and Wang, 1964).

51 Sjöberg, *World in Pieces*, 30–31.

52 Although the *Imitation* is widely attributed to Thomas à Kempis, whether he wrote it is unknown. Attribution has a sanctioning force that Herzog employs for his own purpose. He also allegedly hesitated to use the invented epigraph but was "encouraged" to do so and thus overruled by Tavener himself. Herzog, *Herzog on Herzog,* 296.

53 Turner, *Image and Pilgrimage,* 40; emphasis original.

54 Neil Spencer, "If You Can Hum It, I'll Shoot It: The Barbicon Hosts a Unique Collaboration between Composers and Film Directors," *The Guardian,* March 4, 2001, http://www.guardian.co.uk/.

55 Schechner, *Between Theater,* 35.

56 As a counterpoint to this observation, it is interesting to note that Islam appears nowhere in *Pilgrimage* or in any of Herzog's films about spirituality.

57 Herzog, *Herzog on Herzog,* 296.

58 For more on this story, see Turner, *Image and Pilgrimage,* 77–90.

59 The idea of a moving walkway may sound ironic, at odds with the ordeal of pilgrimage, but the walkway itself is not shown, and the focus of visual interest lies elsewhere: in the faces of devotion, which are treated with utter solemnity.

60 This feature may have emerged from the collaboration with Tavener, whose music is widely associated with icons. See John Tavener and Mother Thekla, *Ikons: Meditations in Words and Music* (London: Fount, 1994).

61 Turner, *Image and Pilgrimage,* 10–11.

4. BAROQUE VISIONS

1 See, e.g., Herzog, interview by O'Brien, 45–46, 52; Herzog, *Herzog on Herzog,* 132, 136–37, 258.

2 Herzog, *Herzog on Herzog,* 23.

3 Baroque qualities of Herzog's work have been noticed but never explored. Ian Buruma, e.g., uses the evocative phrase "tropical baroque" in his review essay, "Herzog and His Heroes," *New York Review of Books* 54, no. 12 (2007): 24.

4 Brian Hanrahan, "Werner Herzog: Possibly True," *openDemocracy,* September 14, 2005, http://www.opendemocracy.net/.

5 Angela Ndalianis, *Neo-Baroque Aesthetics and Contemporary Entertainment* (Cambridge, Mass.: MIT Press, 2004), 9–10.

6 On the term's etymology, see Lois Parkinson Zamora, *The Inordinate Eye: New World Baroque and Latin American Fiction* (Chicago: University of Chicago Press, 2006), 233–35.

7 See esp. Heinrich Wölfflin, *Principles of Art History: The Problem of the Development of Style in Later Art,* trans. M. D. Hottinger (1932; Mineola, N.Y.: Dover, 1950), and Erwin Panofsky, "What Is Baroque?" in *Three Essays on Style,* ed. Irving Lavin, 19–88 (Cambridge, Mass.: MIT Press).

8 For a seminal discussion, see René Wellek, "The Concept of Baroque in Literary Scholarship" and "Postscript 1962," in *Concepts of Criticism,* ed. Stephen G. Nichols Jr., 67–114 and 115–27 (New Haven, Conn.: Yale University Press, 1963).

9 See José Antonio Maravall, "Sociopolitical Objectives of the Use of Visual Media," appendix to *Culture of the Baroque: Analysis of a Historical Structure,* trans. Terry Cochran (Minneapolis: University of Minnesota Press, 1986).

10 See esp. Zamora, *Inordinate Eye,* and Lois Parkinson Zamora and Monika Kaup, eds., *Baroque New Worlds: Representation, Transculturation, Counterconquest* (Durham, N.C.: Duke University Press, 2010).

11 As Prager, *Cinema of Werner Herzog,* 8, notes, Herzog has been described as "a revolutionary documentarian who breaks open the cinematic frame." His 2010 film on prehistoric art, *Cave of Forgotten Dreams,* and its use of 3-D technology offer only the most recent example.

12 Ibid., 153.

13 See, e.g., Daniel Zalewski, "The Ecstatic Truth: Werner Herzog's Quest," *The New Yorker,* April 24, 2006, 125–39; Roger Ebert, "A Letter to Werner Herzog: In Praise of Rapturous Truth," November 17, 2007, http://www.wernerherzog.com/.

14 On the issue of romanticism, see Prager, *Cinema of Werner Herzog,* 12–15.

15 On romanticism "in" the baroque, see Germain Bazin, *The Baroque: Principles, Styles, Modes, Themes* (Greenwich, Conn.: New York Graphic Society, 1968), 206–15.

16 Christine Buci-Glucksmann, "The Work of the Gaze," in Zamora and Kaup, *Baroque New Worlds,* 144.

17 Martin Jay, *Downcast Eyes: The Denigration of Vision in Twentieth-Century French Thought* (Berkeley: University of California Press, 1994), 47–48.

18 See Christine Buci-Glucksmann, *Baroque Reason: The Aesthetics of Modernity,* trans. Patrick Camiller (London: Sage, 1994).

19 Herzog, interview by Wetzel, in Huebner and Wetzel, *Werner Herzog,* 42.

20 See, e.g., Scott Watson, "'Harried by His Own Kind': Herzog and the Darker Dimensions of Icarus," *Arete: The Journal of Sport Literature* 3, no. 2 (1986): 71–78. In regard to sport film, Herzog owes a certain debt to *Fussball wie noch nie—George Best* (Hellmuth Costard, 1970), which also incidentally provided the model for *Zidane: A 21st Century Portrait* (Douglas Gordon and Philippe Parreno, 2006).

21 Michael Schwarze, "Der Traum von Freiheit," review of *Die grosse Ekstase des Bildschnitzers Steiner, Frankfurter Allgemeine Zeitung,* February 4, 1975.

22 The program first aired February 2, 1975, on SDR as *Border Stations: Ski Jump Planiza,* a title that was presumably imposed by the television network and has long since been forgotten; *The Great Ecstasy of Woodcarver Steiner* appeared as a subtitle. See Wolfgang Ruf, review of "Grenzstationen: Skiflugschanze Planiza," by Werner Herzog, *Kirche und Rundfunk* 8 (February 8, 1975): 15–16.

23 Werner Herzog, *Herzog,* transcript of a February 12, 1983, discussion at the Australian Film Institute (Melbourne: AFI, 1983), 9.

24 See on this point Stephen Wilson, introduction to *Saints and Their Cults: Studies in Religious Sociology, Folklore and History,* ed. Stephen Wilson (Cambridge: Cambridge University Press, 1983), 5.

25 John Rupert Martin, *Baroque* (Boulder, Colo.: Westview, 1977), 109, 108. Werner Weisbach, too, calls attention to psychology and subjectivism throughout his important study, *Der Barock als Kunst der Gegenreformation* (Berlin: Cassirer, 1921). On the "extremity" of baroque art, see Maravall, *Culture of the Baroque,* 210.

26 See, e.g., Zamora's discussion of Frieda Kahlo in *Inordinate Eye,* 182–99, and Kaup, "The Neobaroque in Djuna Barnes," *Modernism/Modernity* 12, no. 1 (2005): 85–110.

27 The carving itself recalls the Alpine tradition of wood sculpture, one of the region's contributions to baroque art and architecture. See Sacheverell Sitwell, *German Baroque Sculpture* (London: Duckworth, 1938), and Karsten Harries, *The Bavarian Rococo Church: Between Faith and Aestheticism* (New Haven, Conn.: Yale University Press, 1983).

28 One reviewer describes the image of Steiner as "a fifteenth-century-like figure straight out of a Dürer etching." Araminta Wordsworth, "When People Are Pushed to the Limits," *Times Educational Supplement* (London), December 5, 1975, 70. On the topos of melancholy, see esp. Walter Benjamin, *The Origin of German Tragic Drama,* trans. John Osborne (London: Verso, 1998), 138–58.

29 Vincent Canby, "Screen: A Surprise from Germany," *New York Times,* November 26, 1976.

30 He briefly appears as a soldier in the opening scene of his first feature, *Signs of Life.*

31 Paul Arthur, "Beyond the Limits," *Film Comment,* July–August 2005, 43.

32 See, e.g., Gregory A. Waller, "'The Great Ecstasy of the Woodcarver

Steiner': Herzog and the 'Stylized' Documentary," *Film Criticism* 5 (Fall 1980): 34.

33 Ibid., 27.

34 Davidson, "Borne Out of Darkness," 18.

35 Ibid., 19.

36 On the genre's ancient origins, see Hippolyte Delehaye, *The Legends of Saints: An Introduction to Hagiography,* trans. V. M. Crawford (London: Longmans, Green, 1907), 167, and Gordon Hall Gerould, *Saints' Legends* (Boston: Houghton Mifflin, 1916), 42.

37 Davidson, "Borne Out of Darkness," 18.

38 See, e.g., Walsh, "Images at the Horizon," 4, and Herzog, *Herzog on Herzog,* 95. The latter volume itself represents another type of hagiography: a collection—indeed, a codification—of remarkable stories that serve to promote the veneration and canonization of Herzog as a great director.

39 Waller, "The Great Ecstasy," 30.

40 Frank J. Warnke, *Versions of Baroque: European Literature in the Seventeenth Century* (New Haven, Conn.: Yale University Press, 1972), 198. For more on this genre, see Elida Maria Szarota, *Künstler, Grübler und Rebellen: Studien zum europäischen Märtyrerdrama des 17. Jahrhunderts* (Bern, Switzerland: Francke, 1967).

41 On baroque wonder, see Maravall, *Culture of the Baroque,* 75. For a longer view, see Lorraine Daston and Katherine Park, *Wonders and the Order of Nature 1150–1750* (New York: Zone, 1998).

42 Canby, "Screen."

43 Prager, *Cinema of Werner Herzog,* 24.

44 Living saints faced great dangers, including the expectations of others, who wished to see miracles performed on demand. Here it is worth noting a peasant's skeptical warning to St. Francis: "You must take great pains to be as good as all people think you are, for many have great faith in you. . . . I warn you, do not be different from what people hope you are." Quoted in Wilson, introduction, 40.

45 On the "feedback loop" of live performance, see Fischer-Lichte, *Ästhetik des Performativen,* esp. chapter 3.

46 John J. MacAloon, "Olympic Games and the Theory of Spectacle in Modern Societies," in *Rite, Drama, Festival, Spectacle: Rehearsals toward a Theory of Cultural Performance,* ed. John J. MacAloon, 241–80 (Philadelphia: Institute for the Study of Human Issues, 1984).

47 My translation. Steiner uses three different forms of the German word *quälen,* "to torture." The English subtitles use three unrelated words and thus lose the effect of intensification by repetition.

48 Prager, *Cinema of Werner Herzog,* 25; Davidson, "Borne Out of Darkness," 20.

49 The text is adapted from, though not attributed to, the Swiss poet Robert Walser.

50 Prager, *Cinema of Werner Herzog,* 25, 26.

51 Warnke, *Versions of Baroque,* 215.

52 Benjamin, *Origin of German Tragic Drama,* 160.

53 Recent performances of Gesualdo's music are notable exceptions to the rule, as baroque revivals have typically concentrated on works by later composers such as Bach and Handel. Herzog's film was produced contemporaneous to not one but two German-language operas, each titled *Gesualdo,* one composed by Alfred Schnittke (1993), the other by Franz Hummel (1996).

54 See Manfred F. Bukofzer, *Music in the Baroque Era: From Monteverdi to Bach* (New York: W. W. Norton, 1947), 33–34, and David Schulenberg, *Music of the Baroque,* 2nd ed. (New York: Oxford University Press, 2008), 34–40.

55 On the "Gesualdo controversy" in nineteenth-century music history, see Glenn Watkins, *Gesualdo: The Man and His Music* (Chapel Hill: University of North Carolina Press, 1973), 296–309.

56 Susan McClary, *Modal Subjectivities: Self-Fashioning in the Italian Madrigal* (Berkeley: University of California Press, 2004), 147.

57 Cecil Gray and Philip Heseltine, *Carlo Gesualdo, Prince of Venosa: Musician and Murderer* (New York: Dial Press, 1926), 12.

58 See Watkins, *Gesualdo,* 23–31.

59 Herzog employs this anecdote with particular relish, suggesting that Gesualdo single-handedly felled an entire forest, interpreting it as a sign of madness and comparing it to *Macbeth.* The allusion is not original (cf. Watkins, *Gesualdo,* 23; Gray and Heseltine, *Carlo Gesualdo,* 35–36). What Herzog really adds to this material is the echo of *Fitzcarraldo,* whose name remains unspoken.

60 Watkins, *Gesualdo,* 83.

61 Cf. Gray and Heseltine, *Carlo Gesualdo*; Alfred Einstein, *The Italian Madrigal,* trans. Alexander H. Krappe, Roger H. Sessions, and Oliver Strunk (Princeton, N.J.: Princeton University Press, 1971), 2:688–717; and Jonathan Cott, "On Don Carlo Gesualdo," in *Back to a Shadow in the Night: Music Writings and Interviews 1968–2001,* 307–11 (Milwaukee, Wisc.: Hal Leonard, 2001).

62 This is also true of the film's German title, *Gesualdo: Tod für fünf Stimmen.* Cf. Alberto Consiglio's historical novel *Gesualdo ovvero Assassinio*

a cinque voci [Gesualdo or Murder for Five Voices] (Naples, Italy: Berisio, 1967), and, more recently, Shlomo Giora Shoham's study, *Art, Crime, and Madness: Gesualdo, Caravaggio, Genet, Van Gogh, Artaud* (Brighton, U.K.: Sussex Academic Press, 2003).

63 Cf. Aldous Huxley, "Gesualdo: Variations on a Musical Theme," in *Tomorrow and Tomorrow and Tomorrow, and Other Essays,* 264–88 (New York: Harper, 1956); Egon Wellesz, "The Origins of Schönberg's Twelve-Tone System," lecture delivered in the Whittall Pavillion of the Library of Congress, January 10, 1957 (Washington, D.C.: U.S. Government Printing Office, 1958), 11; Igor Stravinsky, "Gesualdo di Venosa: New Perspectives," in Watkins, *Gesualdo,* v–xi. As McClary, *Modal Subjectivities,* 164, points out, writing of Gesualdo's chromatic style, "despite its superficial similarities to the harmonic experimentation three hundred years later, it pre-dates the precepts of tonal organization that served as the target motivating Stravinsky and his contemporaries."

64 See on this point Wellek, "The Concept of Baroque," 75–76.

65 Prager, *Cinema of Werner Herzog,* 197; David Church, "Werner Herzog," *Senses of Cinema* 41 (October–December 2006), filed under "Great Directors," http://www.sensesofcinema.com/.

66 Herzog, *Herzog on Herzog,* 260.

67 Ibid. See also Herzog, interview by O'Brien, 49.

68 See esp. Watkins, *Gesualdo.*

69 See Zamora and Kaup, *Baroque New Worlds,* 265–67.

70 Severo Sarduy, "The Baroque and the Neobaroque," in Zamora and Kaup, *Baroque New Worlds,* 272.

71 Ibid.

72 McClary, *Modal Subjectivities,* 146–47.

73 Since her debut in 1959, Milva (short for Maria Ilva Biocati) has enjoyed a long career on the musical stage, including opera, theater, film, and television. In the 1970s, she burst onto the German scene as a Brecht recitalist and has since recorded numerous albums of popular songs in the German language.

74 In this regard, the film relates to *The Transformation of the World into Music* (*Die Verwandlung der Welt in Musik,* 1994), a full-length documentary made for German television (without English subtitles) about Richard Wagner's opera house at Bayreuth, where Herzog himself has directed *Lohengrin.* In the film, he appears on camera both as a filmmaker and as an opera director. For a partial list of his opera productions, see the filmmaker's website, http://www.wernerherzog.com/opera.html.

75 Herzog, *Herzog on Herzog,* 261.

76 Omar Calabrese, *Neo-Baroque: A Sign of the Times,* trans. Charles Lambert (Princeton, N.J.: Princeton University Press, 1992), 139.

77 Susan Stewart, "Wunderkammer: An After as Before," in *Deep Storage: Collecting, Storing, and Archiving in Art,* ed. Ingrid Schaffner and Matthias Winzen (Munich, Germany: Prestel, 1998), 292.

78 Sarduy, "The Baroque and the Neobaroque," 284.

79 Ibid., 289.

80 See on this point Stephen Bann, "Shrines, Curiosities, and the Rhetoric of Display," in *Visual Display: Culture beyond Appearances,* ed. Lynne Cooke and Peter Wollen, 15–29 (Seattle, Wash.: Bay Press, 1995).

81 See Arthur MacGregor, *Curiosity and Enlightenment: Collectors and Collections from the Sixteenth to the Nineteenth Century* (New Haven, Conn.: Yale University Press, 2007), 39, 159.

82 Although Herzog takes credit for inventing this scene, it was taken from published sources. To them he merely adds the choirs and the ritual duration of time: the child was swung "for three days and three nights." Cf. Herzog, *Herzog on Herzog,* 262; Gray and Heseltine, *Carlo Gesualdo,* 41; and Watkins, *Gesualdo,* 34.

83 On carnival entertainments, see Frederick Hammond, *Music and Spectacle in Baroque Rome: Barberini Patronage under Urban VIII* (New Haven, Conn.: Yale University Press, 1994), 214–24.

84 There is one minor exception: Stephen Calloway mentions *Aguirre, Heart of Glass,* and *Nosferatu* in his sweeping study of twentieth-century visual culture, *Baroque Baroque: The Culture of Excess* (London: Phaidon, 1994), 174, 181.

85 Zamora, *Inordinate Eye,* xvi.

86 José Lezama Lima, "Baroque Curiosity," in Zamora and Kaup, *Baroque New Worlds,* 213.

87 See Irlemar Chiampi, "The Baroque at the Twilight of Modernity," in Zamora and Kaup, *Baroque New Worlds,* 508–28, and Monika Kaup, "'The Future Is Entirely Fabulous': The Baroque Genealogy of Latin America's Modernity," *Modern Language Quarterly* 68, no. 2 (2007): 221–41.

88 Herzog, *Herzog on Herzog,* 294, also mentions "the Basilica of the Virgin of Guadalupe in Tepeyac on the outskirts of Mexico City," but footage from this location appears only in the related film *Pilgrimage* (see my chapter 3).

89 The discursive emphasis on coercion is, of course, an interpretation and only goes so far. Cf. Octavio Paz, "Will for Form," in *Mexico: Splendors of Thirty Centuries* (New York: Metropolitan Museum of Art, 1990), 22.

90 Adding to the confusion, Herzog and Cronin refer to the German original by its subtitle, *Gott und die Beladenen,* and translate it as *The Lord and the Laden*; see Herzog, *Herzog on Herzog,* 294, 324. The alliterative title, however, is nowhere to be found either in the film or in its marketing paraphernalia.

91 The transformation from spoken commentary to intertitles is fascinating for what it says about the unifying and stabilizing effect of Herzog's vocal presence. When Herzog's words are spoken by a surrogate, they lose the biographical and intertextual associations that customarily attach to his work, as well as certain allowances that are made for Herzog's personality and certain assumptions about authorship. According to Prager, *Cinema of Werner Herzog,* 124, for example, "*God and the Burdened* is expository in a way that suggests Herzog did not write it." The series narrator's didactic tone would almost seem to override the credit sequence, where both the script and the direction are attributed to Herzog. Confidence in authorship seems to increase with *Christ and Demons in New Spain* "because this is the version released by Herzog's company." But there is another, less obvious reason that needs to be added: since Herzog began voicing his own commentary, intertitles can still be reconciled with the idea of "Herzog" and with his particular use of language, whereas another speaker's voice makes the same dialogue seem strange and un-familiar to the point of being almost unrecognizable. Both audio tracks are included and available for comparison on the *2000 Jahre Christentum* DVD (Develop Vision Design, 2007).

92 I borrow this verbal formulation from Nichols, *Introduction to Documentary,* 59–66.

93 Nichols, *Representing Reality,* 62.

94 Prager, *Cinema of Werner Herzog,* 126.

95 Christianity has long been defined and redefined in terms of images. On this point see Hans Belting, *Das echte Bild: Bildfragen als Glaubensfragen* (Munich: C. H. Beck, 2005).

96 For visual examples, see Zamora, *Inordinate Eye,* 37–38, and Pál Kelemen, *Baroque and Rococo in Latin America* (New York: Macmillan, 1951), 48–58.

97 For a useful discussion of this figure, see Sylvie Pédron-Colombani, *Maximón: Guatemalan God, Saint or Traitor* (London: Periplus, 2004).

98 Other commentators emphasize that San Andrés Itzapa is the most Westernized, grandiose, and lucrative shrine in the region, attracting a mixed crowd of urban dwellers and foreign tourists as well as locals. See Pédron-Colombani, *Maximón,* 88–90, 160, and Jim Pieper, *Guatemala's*

Folk Saints: Maximon/San Simon, Rey Pascual, Judas, Lucifer, and Others (Los Angeles, Calif.: Pieper, 2002), 115, 119–20.

99 An even more ambiguous figure, Maximón is typically described as a "sacred bundle" of corn husks, covered with multiple hats, colorful scarves, and many layers of clothing. See Michael Mendelson, "Maximón: An Iconographical Introduction," *Man* 59 (April 1959): 57–60. Maximón and San Simón have long been figures of political and religious controversy. See Pédron-Colombani, *Maximón*, 149–61, and Nathaniel Tarn, *Scandals in the House of Birds: Shamans and Priests on Lake Atitlán* (New York: Marsilio, 1997).

100 See Zamora, *Inordinate Eye*, 10–15.

101 Based on the doctrine of "real presence," the concept of transubstantiation dissolved the idea of the Eucharist as the mere symbolic presence of Christ. See Belting, *Das echte Bild*, 90–91.

102 The "idolatry" accusation refers to the growing Evangelical movement in Guatemala, which opposes the use of images by Catholics as well as by Mayans. See Pédron-Colombani, *Maximón*, 155–59.

103 Zamora, *Inordinate Eye*, 39–41.

5. CULTURAL POLITICS

1 Public charges of exploitation began with *Even Dwarfs Started Small* and continued with *Land of Silence and Darkness* and *Aguirre*, which was also filmed in Peru.

2 See esp. Les Blank and James Bogan, eds., *Burden of Dreams: Screenplay, Journals, Reviews, Photographs* (Berkeley, Calif.: North Atlantic Books, 1984). See also Nina Gladitz, "Der neue Sensibilismus oder: Wie aus der Liebe zum Film die Vergewaltigung von Menschenrechten werden kann," in *Der Fall Herzog,* a special issue of *Vierte Welt Aktuell* 12 ([1979]): 5–12, published by the German chapter of Survival International; "Werner Herzog: 'So wahr Gott, der nicht existiert, mir helfe . . . ,'" *Kirche und Film* 32, no. 10 (1979): 25; Manfred von Conta, "Die Herzog-Horror-Picture-Show," *Stern*, November 29, 1979, 100–13; the collection of materials in *Pogrom* 11, nos. 74–75 (1980): 80–88, published by the German chapter of the Society for Threatened Peoples; Elizabeth D. and Léon Mercadet, "Paranoia in Eldorado," *Time Out* (London), February 12–18, 1982, 12–13, 15, 17; "Werner Herzog und die Indianer," *Kirche und Film* 35, no. 4 (1982): A–E; *Weil wir in Wirklichkeit vergessen sind: Gespräche mit Indianern im Tiefland von Peru,* ed. Manfred Schäfer (Munich, Germany: Trickster, 1982); "Herzog's *Fitzcarraldo*," *Cultural Survival Quarterly* 7,

no. 2 (1983): 27; and *Land der Bitterkeit und des Stolzes* (Land of Bitterness and Pride, 1984; dir. Nina Gladitz). For more on the controversy, see Chris Wahl, "'Ein Erlebnis, das ich nicht missen will'—Die Rezeption von Werner Herzog in Deutschland," in *Lektionen in Herzog: Neues über Deutschlands verlornenen Filmautor Werner Herzog und sein Werk,* ed. Chris Wahl, 15–82 (Munich, Germany: Text + Kritik, 2011).

3 George Dolis and Ingrid Weigand, "The Floating Opera," *Film Comment* 18, no. 5 (1982): 58.

4 Gladitz, "Der neue Sensibilismus," 8.

5 On the stigma that attached to Herzog, see Andreas Rost, ed., *Werner Herzog in Bamberg: Protokoll einer Diskussion 14./15. Dez. 1985* (Bamberg, Germany: University of Bamberg, 1986), 24–25; Herzog's commentary on the *Fitzcarraldo* DVD, released by Anchor Bay Entertainment in 1999; and Werner Herzog, "Dreams and Burdens," an interview videotaped for the Criterion Collection's *Burden of Dreams* DVD (2005).

6 Cf. A. W. Hurley, "Dreaming? Intercultural Appropriation, Representations of Aboriginality, and the Process of Film-making in Werner Herzog's *Where the Green Ants Dream* (1983)," *Studies in Australasian Cinema* 1, no. 2 (2007): 175–90.

7 See Lutz P. Koepnick, "Colonial Forestry: Sylvan Politics in Werner Herzog's *Aguirre* and *Fitzcarraldo,*" *New German Critique* 60 (Autumn 1993): 133–59.

8 See John E. Davidson, "As Others Put Plays upon the Stage: *Aguirre,* Neocolonialism, and the New German Cinema," *New German Critique* 60 (Autumn 1993): 101–30; Davidson, *Deterritorializing the New German Cinema* (Minneapolis: University of Minnesota Press, 1999), 1–34; and Davidson, "'Das Land, das Gott unvollendet ließ': Werner Herzog und der Tropenwald seines Neuen Deutschen Kinos," in *Der deutsche Tropenwald: Bilder, Mythen, Politik,* ed. Michael Flitner, 263–78 (Frankfurt, Germany: Campus, 2000).

9 Philip Auslander, *Presence and Resistance: Postmodernism and Cultural Politics in Contemporary American Performance* (Ann Arbor: University of Michigan Press, 1992), 31.

10 On preproduction and production, see Blank and Bogan, *Burden of Dreams,* 12–13, 179; on postproduction, see Michael Goodwin, "Herzog: The God of Wrath," *American Film* (June 1982): 36–51, 72–73, esp. 46.

11 Elsewhere, instead of romanticizing the appearance of native actors, Herzog notes that many of them were assimilated and emphasizes the creative ways in which they negotiated multiple cultures. See Rost, *Werner Herzog,* 26–28, 68–70.

12 Cf. Gladitz, "Der neue Sensibilismus," 6–7.

13 For an early indication of this phenomenon, see Rost, *Werner Herzog*, 82–83.

14 Maureen Gosling, "Recuerdos Peruanos," in Blank and Bogan, *Burden of Dreams*, 131. Similarly, John Boorman's film *The Emerald Forest* (1985) enacts a violent revenge fantasy, in which a boorish German photographer named "Uwe Werner"—a crude caricature of Herzog—is ritualistically killed by a "lost tribe" of Amazonian natives.

15 On the politicization of filmmaking in West Germany, see Werner Herzog's early statement, "Mit den Wölfen heulen," *Filmkritik* 7 (July 1968): 460–61. On the reaction of Herzog's critics, see Cheesman, "Apocalypse," esp. 291 and 294–98.

16 E.g., Herzog concludes his narration in *La Soufrière* with the following line, spoken over the funeral march from Wagner's *Götterdämmerung*: "In my memory, it is not the volcano that remains, but the neglected oblivion in which those black people live." Because this concern seems peripheral to much of the film, the spectator is left with a discomfiting sense of incongruity, which punctuates the film's abrupt conclusion. This awkward gesture actually fits quite well within the parody of direct cinema, which is the film's project. And yet one could argue that Herzog sometimes foregrounds his disdain for certain aspects of documentary (especially cinema verité and social-issue filmmaking) at the expense of representing other people. Here and elsewhere, his critical detachment from the documentary tradition inadvertently clashes with his expressed attitude of empathy toward the social actors who appear in his films.

17 Schechner, *Between Theater*, 35.

18 Elin Diamond, introduction to *Performance and Cultural Politics* (London: Routledge, 1996), 1.

19 I borrow this phrase from the title of Brian Winston's *Claiming the Real: The Griersonian Documentary and Its Legitimations* (London: British Film Institute, 1995).

20 From a documentary perspective, the digital repackaging of Herzog's films holds particular significance. The *Fitzcarraldo* DVD includes extensive audio commentary by the director and the producer (Herzog's brother), Lucki Stipetić. Audio commentary, which typically overrides both music and dialogue, adds a new layer to the film's sound track and thus a new level of meaning or interpretation. This practice can also be understood in documentary terms because it emphasizes authoritative verbal testimony and makes truth claims about the film's production, while linking these claims to the final images in the moment of their appearance before an audience.

21 Diamond, introduction to *Performance and Cultural Politics*, 2.

22 Diana Taylor, *The Archive and the Repertoire: Performing Cultural Memory in the Americas* (Durham, N.C.: Duke University Press, 2003), 54.

23 Ibid., 44–50.

24 See ibid., 53–78; Coco Fusco, "The Other History of Intercultural Performance," in *English Is Broken Here: Notes on Cultural Fusion in the Americas,* 37–63 (New York: New Press, 1995); and Susan Castillo, *Colonial Encounters in New World Writing, 1500–1786: Performing America* (London: Routledge, 2006).

25 On Herzog's relation to authorship, see esp. Timothy Corrigan, "Producing Herzog: From a Body of Images," in *The Films of Werner Herzog: Between Mirage and History,* ed. Timothy Corrigan, 3–19 (New York: Methuen, 1986).

26 Michael Chanan, *The Politics of Documentary* (London: British Film Institute, 2007), 16.

27 Corrigan, "Producing Herzog," 10, 12.

28 George Paul Csicsery, "*Ballad of the Little Soldier*: Werner Herzog in a Political Hall of Mirrors," *Film Quarterly* 39, no. 2 (1985–86): 7. A similar dynamic characterized the film's German reception; see Wahl, "Ein Erlebnis," 63–64.

29 On the Miskito opposition to state socialism, see Denis Reichle's interview with Misura leader Steadman Fagoth, "Wir wollen als Menschen behandelt werden," *Der Spiegel,* January 16, 1984, 132–33. Reichle's photographs, which are interesting to compare with Herzog's film, appear on pp. 130–31. On defending native rights as "counter-revolutionary," see John C. Mohawk, "The Possibilities of Uniting Indians and the Left for Social Change in Nicaragua," *Cultural Survival Quarterly* 6, no. 1 (1982): 24–25.

30 Prager, *Cinema of Werner Herzog,* 148.

31 Herzog, *Herzog on Herzog,* 190.

32 Csicsery, "*Ballad,*" 13. Here it is worth recalling *God and the Burdened* (discussed in chapter 4), where Herzog, too, refers to Las Casas as a lone critic of Spanish conquest and a witness who "castigated this genocide."

33 Taylor, *Archive,* 63.

34 Herzog, interview by Steinborn and von Naso, 12; see also 14.

35 Thomas Waugh, "Introduction: Why Documentary Filmmakers Keep Trying to Change the World, or Why People Changing the World Keep Making Documentaries," in *"Show Us Life": Toward a History and Aesthetics of the Committed Documentary,* ed. Waugh (Metuchen, N.J.: Scarecrow Press, 1984), xix; emphasis original.

36 See Julia Lesage, "Films on Central America: For Our Urgent Use," *Jump Cut* 27 (July 1982): 15–20, and Erik Barnouw, *Documentary: A History of the Non-fiction Film,* 2nd rev. ed. (New York: Oxford University Press, 1993), 302–4.

37 Dennis West reviews these and other films, including *Ballad of the Little Soldier,* in "Revolution in Central America: A Survey of New Documentaries," *Cineaste* 14, no. 3 (1986): 14–21.

38 Herzog, *Herzog on Herzog,* 193.

39 Dan Bellm, "Ballad of the Little Soldier," *The Nation,* April 20, 1985, 475. What the journalist either doesn't know or doesn't mention is that, in 1984, shortly after the film aired on West German television, Herzog and Reichle actually returned to Managua and discussed the completed film with members of the Sandinista leadership "to have a look at the Miskito problem from their side." According to Herzog, the film provoked such "embarrassment" that the Sandinistas "focused more on the question, who might use the film for which purposes?" Quoted in Csicsery, *"Ballad,"* 14. See also Rost, *Werner Herzog,* 95–101.

40 Csicsery, *"Ballad,"* 11.

41 Ibid., 15. See also Rost, *Werner Herzog,* 95.

42 Shoshana Felman and Dori Laub, *Testimony: Crises of Witnessing in Literature, Psychoanalysis, and History* (New York: Routledge, 1992), 6.

43 As Reichle's testimony makes clear, *Ballad of the Little Soldier* tacitly affirms the postwar international project of protecting the rights of the child. This, according to Vicky Lebeau in *Childhood and Cinema* (London: Reaktion, 2008), is a key context for postwar films that depict child suffering and death and the privileged role of the child witness (135–36). For a discussion of Herzog's major contribution to the iconography of the child, *The Enigma of Kaspar Hauser,* see 56–69.

44 On this point, I disagree with the argument presented by Csicserny, *"Ballad,"* 11.

45 Michael Rothberg, "Between Auschwitz and Algeria: Multidirectional Memory and the Counterpublic Witness," *Critical Inquiry* 33 (Autumn 2006): 162. In another fine article, Rothberg explores the historical connection between the emergence of multidirectional memory and the cinema of Jean Rouch. See "The Work of Testimony in the Age of Decolonization: *Chronicle of a Summer,* Cinema Verité, and the Emergence of the Holocaust Survivor," *PMLA* 119, no. 5 (2004): 1231–46.

46 In the United States, *Ten Minutes Older: The Trumpet* (2002; part 2 is subtitled *The Cello*) first aired on the Showtime cable network and is currently available both online and as a DVD import. The other participating

directors are Victor Erice, Jim Jarmusch, Chen Kaige, Aki Kaurismäki, Spike Lee, and Wim Wenders.

47 Johannes Fabian, *Time and the Other: How Anthropology Makes Its Object* (New York: Columbia University Press, 1983), 31. The German term is more widely associated with philosopher Ernst Bloch and his 1935 book *Erbschaft dieser Zeit.*

48 Ibid., 121.

49 Cf. Taylor, *Archive,* 53–54.

50 See esp. Alison Griffiths, *Wondrous Difference: Cinema, Anthropology, and Turn-of-the-Century Visual Culture* (New York: Columbia University Press, 2002), and Assenka Oksiloff, *Picturing the Primitive: Visual Culture, Ethnography, and Early German Cinema* (New York: Palgrave, 2001).

51 Winston, *Claiming the Real II,* 234. See, e.g., Nichols, "Axiographics: Ethical Space in Documentary Film," chapter 3 in *Representing Reality,* and Renov, *Subject of Documentary,* esp. chapters 8–10. For a wider discussion, see Lisa Downing and Libby Saxton, *Film and Ethics: Foreclosed Encounters* (London: Routledge, 2010).

52 Winston, *Claiming the Real II,* 235–36.

53 Herzog, interview by Steinborn and von Naso, 6.

54 "*The White Diamond,* ein Film von Werner Herzog," German-language press kit (2004).

55 Dorrington says the argument was "completely faked—pure acting." Graham Dorrington, interview by BBC Four, September 13, 2005, http://www.bbc.co.uk/.

56 Dorrington admittedly uses the film to promote his research to a popular audience—a project he had tried to develop for more than a decade, without success, before meeting Herzog; ibid.

57 Emphasis added.

58 Apparently, Herzog asked Dorrington to rehearse part of this monologue. As Dorrington later commented, "I balked at one point when he wanted me to talk about curses"; ibid. The reference here is to Herzog's damnation of the jungle in Blank's film *Burden of Dreams,* when the production of *Fitzcarraldo* stalls, as it often does: "It's like a curse weighing on the entire landscape, and whoever goes too deep into this has his share of that curse. So we are cursed with what we are doing here." In this case, however, the superstitious pilot refused to play along.

59 In other words, they did not choose Sumatra, a location that would have put the emphasis squarely on the Dieter Plage crash and thus linked *The White Diamond* even more closely to Herzog's reenactment films *Little Dieter Needs to Fly* and *Wings of Hope* (discussed in chapter 6). Both deal

with a German trapped in a foreign jungle, and in this regard, they, too, can be seen as "*Fitzcarraldo* films."

60 The constructed nature of this scenario is further emphasized by its status as a myth that has attached to the figure of Cook's ship in popular memory; no such incident is recorded in Cook's journals, even though it is widely attributed to him. Cf. James Cook, *The Voyage of the Endeavor, 1768–1771*, vol. 1 of *The Journals of Captain James Cook on His Voyages of Discovery*, ed. J. C. Beaglehole (Cambridge: Cambridge University Press, 1955); Lynne Withey, *Voyages of Discovery: Captain Cook and the Exploration of the Pacific* (New York: William Morrow, 1987), 129. I thank Nicholas Thomas for discussing this scenario with me.

61 The unseen explorer here can be juxtaposed to the unseen natives in *Aguirre*. Because the Spaniards envision the jungle as brute nature, they fail to differentiate the Indians, "perceiving them instead as mere extensions of the prehistoric forest." Koepnick, "Colonial Forestry," 141. By contrast, *The White Diamond* offers native perspectives that are blatantly clichéd, deriving as they do from Western fantasies about non-Western peoples.

62 Prager, *Cinema of Werner Herzog*, 114.

63 The gyrating camera in Herzog's work is usually interpreted in terms of madness, solitude, and entrapment, but there are other possibilities to consider—especially those of play and games. In his excellent study *Man, Play, and Games*, trans. Meyer Barash (New York: Free Press of Glencoe, 1961), French sociologist Roger Caillois explores the action of "whirling," the resulting sensation of vertigo, and the motivating pursuit of "ecstasy" as fundamental to various forms of play. His signal examples are dancing, skiing, flying, mountain climbing, and tightrope walking as well as practicing such ceremonial practices as trance, séance, and shamanism—all of which can be traced throughout Herzog's films.

64 On epistephilia, see Nichols, *Representing Reality*, 31, 178–80.

65 Although it was exciting "to look behind the scenes of our waterfall," the climber remarks, he saw in the cave what appeared to be "endless deep black space." A vast surface suggesting a profound depth behind it, which nonetheless resists visibility—this is almost exactly how *Aguirre* and *Fitzcarraldo* each depict the rainforest. The climber's description, however, indicates that the filming conditions were completely dark, which in turn suggests that the footage was unwatchable. For his part of the interview, Herzog's use of hyperbole ("I am certain that you are the first person ever to look inside the cave") reiterates yet another scenario of discovery.

66 The conspicuous use of "appropriate," site-specific indigenous music offers a striking contrast to the sound track of *Fitzcarraldo*. Cf. Lilian Friedberg and Sara Hall, "Drums Along the Amazon: The Rhythm of the Iron System in Werner Herzog's *Fitzcarraldo*," in *The Cosmopolitan Screen: German Cinema and the Global Imaginary, 1945 to the Present,* ed. Stephan K. Schindler and Lutz Koepnick, 117–39 (Ann Arbor: University of Michigan Press, 2007).

67 At one point during the production, Dorrington suggested a scene promoting rainforest conservation, in homage to Dieter Plage, and this time it was Herzog who balked. See Dorrington interview by BBC.

68 Werner Herzog, *Eroberung des Nutzlosen* (Munich, Germany: Hanser, 2004), 82; my translation. In English, see *Conquest of the Useless: Reflections from the Making of* Fitzcarraldo, trans. Krishna Winston (New York: HarperCollins, 2009), 71. The book's title repeats a phrase spoken by Fitzcarraldo in the film and may be borrowed from the memoir of French climber Lionel Terray, *Conquistadors of the Useless: From the Alps to Annapurna* (London: Gollancz, 1963).

6. REENACTMENTS

1 See esp. Linda Williams, "Mirrors without Memories: Truth, History, and the New Documentary," *Film Quarterly* 46, no. 3 (1993): 9–21.

2 On reenactment in classical documentary, see Thomas Waugh, "'Acting to Play Oneself': Notes on Performance in Documentary," in *Making Visible the Invisible: An Anthology of Original Essays on Film Acting,* ed. Carole Zucker, 64–91 (Metuchen, N.J.: Scarecrow Press, 1990).

3 Nichols, *Representing Reality,* 21; emphasis original. Cf. Bill Nichols, "Documentary Reenactment and the Fantasmatic Subject," *Critical Inquiry* 35 (Autumn 2008): 72–89. For a wider sample of recent scholarship on this issue, see "Dossier: Reenactment in Contemporary Documentary Film, Video, and Performance—What Now?" ed. Jonathan Kahana, *Framework* 50, nos. 1–2 (2009): 46–157.

4 On ethics and issues of evidence, see Errol Morris, "Play It Again, Sam (Re-enactments, Part One)," *Opinionator* blog, *New York Times,* April 3, 2008, http://morris.blogs.nytimes.com/. Cf. Nichols, "Documentary Reenactment," 87–88.

5 Ivone Margulies, "Exemplary Bodies: Reenactment in *Love in the City, Sons,* and *Close-Up,*" in *Rites of Realism,* ed. Ivone Margulies, 220; emphasis original.

6 Schechner, *Between Theater,* 36.

7 Ibid., 38.

8 Ibid., 97. Cf. Winston, *Claiming the Real II,* 107–8.

9 For a discussion of reenactment as a cultural phenomenon, see Hillel Schwartz, "Once More, with Feeling," chapter 7 in *The Culture of the Copy: Striking Likenesses, Unreasonable Facsimiles* (New York: Zone Books, 1998). On the living history museum, see Stephen Eddy Snow, *Performing the Pilgrims: A Study of Ethnohistorical Role-Playing at Plimoth Plantation* (Jackson: University Press of Mississippi, 1993). In film history, see Alison Griffiths, "'Shivers Down Your Spine': Panoramas and the Origins of the Cinematic Reenactment," *Screen* 44, no. 1 (2003): 1–37.

10 On reenactment in contemporary art, see Anke Bangma, "Contested Terrains," in *Experience, Memory, Re-enactment,* ed. Anke Bangma, Steve Rushton, and Florian Wüst, 13–16 (Rotterdam, Germany: Piet Zwart Institute, 2005); Jennifer Allen, "'Einmal ist keinmal': Observations on Reenactment," in *Life, Once More: Forms of Reenactment in Contemporary Art,* ed. Sven Lütticken, 177–213 (Rotterdam, Germany: Witte de With, Center for Contemporary Art, 2005); Inke Arns, introduction to *History Will Repeat Itself: Strategies of Re-enactment in Contemporary Art,* 38–63 (Berlin: KW Institute for Contemporary Art, 2007); Robert Blackson, "Once More . . . with Feeling: Reenactment in Contemporary Art and Culture," *Art Journal,* Spring 2007, 28–40. The key source in performance art is Marina Abramović's *Seven Easy Pieces* (Milan, Italy: Charta, 2007).

11 See esp. Susan Murray and Laurie Ouellette, eds., *Reality TV: Remaking Television Culture,* 2nd ed. (New York: New York University Press, 2009); on the German context, see the essays in "Fernsehen: Trend zu Formatierung und Serialiserung," section 3 of Zimmermann and Hoffmann, *Dokumentarfilm im Umbruch.*

12 I borrow this example from Richard Kilborn, *Staging the Real: Factual TV Programming in the Age of Big Brother* (Manchester, U.K.: Manchester University Press, 2003), 73.

13 A third documentary from the period, *My Best Fiend,* deserves mention because it, too, involves returning to places of witnessing—in this case, film locations—and can thus be seen as yet another variation on Herzog's reenactments, with the director now playing himself as a "survivor" of the late Klaus Kinski. For a discussion of this film in terms of autobiography, see chapter 7.

14 Herzog, *Herzog on Herzog,* 267, 265.

15 For an overview of the series, see the book publication that accompanied it, *Höllenfahrten: Forscher, Abenteurer und Bessessene,* ed. Wolfgang Ebert

(Cologne, Germany: vgs, 1998). Herzog's contribution, "Flucht aus Laos," appears on pp. 8–41. I thank ZDF for making screening copies available to me.

16 Prager suggests that Herzog's approach to reenactment might refer to Lanzmann's *Shoah* (*Cinema of Werner Herzog,* 159). It is an interesting idea and worth exploring. In so doing, however, it would be important to note that Herzog first tried out his approach in *Ballad of the Little Soldier,* which appeared before *Shoah.* In this case, Herzog returns with a Miskito survivor—now a Misura soldier—to the Nicaraguan village of Sang Sang. The survivor not only gives verbal testimony of a Sandinista raid and of his escape but also dramatizes the events with his body, while touching and showing the ruins of his former village, which has since been overgrown by the jungle. After a few minutes, visibly flooded with emotion, he covers his face with his hands and turns away from the camera, unable to continue. I discuss this film in chapter 5.

17 The larger history and politics of the war are bracketed off, giving some critics reason for concern. See Prager, *Cinema of Werner Herzog,* 143, 151–52.

18 The jungle's central importance is indicated by the German titles for *Wings of Hope,* first broadcast on television as *Durch die grüne Hölle* (Through the Green Hell) and later retitled *Julianes Sturz in den Dschungel* (Juliane's Crash in the Jungle) for release on film and DVD.

19 In *Little Dieter Needs to Fly,* e.g., streamlining means eliding the fact that of the seven prisoners who escaped together, two survived, the other being Pisidhi Inradat, a Thai civilian employee of Air America, who was recaptured and later rescued by Laotian troops.

20 Herzog, *Herzog on Herzog,* 265.

21 I here take issue with the framing of this film in Prager, *Cinema of Werner Herzog,* 153.

22 Herzog, *Herzog on Herzog,* 265.

23 The opening scene tacitly refers to Herzog, who boasts on his right arm a tattoo of "Singing Death," made by Ed Hardy. More interesting, however, this scene also involves restraint on Herzog's part, an unexpected avoidance of repetition, where it might have been tempting to do otherwise. Had the film begun with images of skiers flying through the air, as Dengler describes in his memoir, such a vision would have only recalled the opening scenes from *Land of Silence and Darkness* and *The Great Ecstasy of Woodcarver Steiner,* instead of working to establish the subject of Dengler and his story. Cf. Dieter Dengler, *Escape from Laos* (San Rafael, Calif.: Presidio Press, 1979), 194, 199.

24 Herzog, *Herzog on Herzog,* 265; emphasis added.

25 On the trope of enhanced vision in reenactment, see Griffiths, "Shivers Down Your Spine," 31; Margulies, "Exemplary Bodies," 217–20.

26 Margulies, "Exemplary Bodies," 217. See also Steven N. Lipkin's discussion of "the survivor role" as a strategy of "exemplification" in *Real Emotional Logic: Film and Television Docudrama as Persuasive Practice* (Carbondale: Southern Illinois University Press, 2002), 69–70.

27 In "The Making of a True Story," a special feature of the *Rescue Dawn* DVD (MGM, 2007), Herzog makes explicit the issue of Dengler's exemplarity and does so in personal terms: "I would always have Dieter as a role model. To this day, when there is some sort of complication and some sort of decision to take, where I don't know what, what should I do now, and I ask myself what would Dieter do? What would Dieter do?"

28 Cathy Caruth, *Unclaimed Experience: Trauma, Narrative, and History* (Baltimore: The Johns Hopkins University, 1996), 4; emphasis original.

29 For a critique of this model, see Ruth Leys, *Trauma: A Genealogy,* 266–97 (Chicago: University of Chicago Press, 2000). I realize that there is no single model of trauma or approach to understanding it.

30 See "Bearing Witness," chapter 2 in Felman and Laub, *Testimony.*

31 Prager, *Cinema of Werner Herzog,* 159.

32 Herzog makes this point explicit in Herzog, *Herzog on Herzog,* 264–65. Cf. Dengler, *Escape from Laos,* 206, and esp. Alan A. Stone, "Werner Herzog's *Rescue Dawn,*" *Psychiatric Times* 25, no. 10 (2008): 10.

33 See Herzog, *Herzog on Herzog,* 266.

34 Prager, *Cinema of Werner Herzog,* 155. Cf. Herzog's account of Dengler's participation as it is represented in Tom Bissell, "The Secret Mainstream: Contemplating the Mirages of Werner Herzog," *Harper's Magazine,* December 2006, 69–78, esp. 76.

35 Emphasis original.

36 Jennifer Fay, "Werner Herzog's Perpetual War," paper presented at the annual convention of the German Studies Association, Minneapolis, Minn., October 2008.

37 Theoretically, aerial images, too, can testify. See Davide Deriu, "Picturing Ruinscapes: The Aerial Photograph as Image of Historical Trauma," in *The Image and the Witness: Trauma, Memory and Visual Culture,* ed. Frances Guerin and Roger Hallas, 189–203 (London: Wallflower Press, 2007).

38 Jean-Louis Comolli, "Historical Fiction: A Body Too Much," *Screen* 19 (Summer 1978): 41–53.

39 Geoffrey H. Hartman, "Public Memory and Its Discontents," *Raritan* 13, no. 4 (1994): 8. Although Hartman is speaking of the Holocaust, the term applies to other contexts such as Vietnam.

40 Dengler, "Learning to Fly." For Herzog's response to a similar question, see *Herzog on Herzog,* 267.

41 I here take issue with the assessment in Nichols, "Documentary Reenactment," 83.

42 A related sequence prepares the film's use of demonstration, namely, the parody of a military training film on jungle survival. Footage from this film is recycled, set to music (a frothy Italian love song), and reframed by Herzog's deadpan commentary. "Our man," as he calls the model survivor, is discursively refigured and represented as demonstrating how *not* to survive in the jungle. While I appreciate the humor of this move, I am more interested in the scenes that answer back to it. After all, this particular instance of film parody serves the reenactments and their intrinsic program of revision or improvement. It does so by offering a counterexample to that of Dengler, whose firsthand experience is coded and celebrated as superior. More, the demonstration scenes are among the "reality TV elements" that the German network highlights in its international sales catalog, http://www.zdf-enterprises.de/en/international-catalogue/zdfefactual/history-biographies/little-dieter-needs-to-fly?pager=60b45d.

43 See Herzog, *Herzog on Herzog,* 94; Bissell, "Secret Mainstream," 71.

44 For a brief description of this German-language series, see Herzog, *Herzog on Herzog,* 13–16, 227–29. Indeed, he recently created "The Rogue Film School." See http://www.roguefilmschool.com/.

45 The source becomes obvious by comparison with Dengler's memoir, *Escape from Laos,* esp. 106–7. In it, Dengler marvels at the ingenuity of his fellow prisoners, who already know how to pick handcuffs by casting lead keys and share this knowledge with him—and not the other way around, as it is represented in *Rescue Dawn.*

46 Jonathan Kahana, "Cinema and the Ethics of Listening: Isaac Julien's *Frantz Fanon,*" *Film Quarterly* 59, no. 2 (2006): 22.

47 The film's reissue on DVD (Anchor Bay Entertainment, 2004) includes a "Postscript" with video footage of Dengler's burial, in 2001, at Arlington National Cemetery.

48 Herzog quotes Dengler in "Making of a True Story." I suspect this is Herzog's phrase, which he now attributes to Dengler.

49 Herzog made this comment at a postscreening discussion with an audience in Minnesota, the evening after he delivered his Minnesota Dec-

laration. "Herzog introduces his latest film, Wings of Hope, and his work-in-progress, Kinski My Dearest," May 1, 1999, Walker Art Center Auditorium, cassette audiotape (99–5.10), Walker Art Center; my transcription.

50 Allen, "Einmal," 181.

51 For a brilliant discussion of *effigy* and its implications for our historical and theoretical understanding of visual culture, see Mark B. Sandberg, *Living Pictures, Missing Persons: Mannequins, Museums, and Modernity* (Princeton, N.J.: Princeton University Press, 2003). On the term's etymology, see p. 5.

52 Cf. Marita Sturken, *Tourists of History: Memory, Kitsch, and Consumerism from Oklahoma City to Ground Zero* (Durham, N.C.: Duke University Press, 2007).

53 Herzog is aware of certain ethical issues. To an audience at the Walker Arts Center, he said of Koepcke, "She was a little bit uneasy about sitting on seat 19F. I had imposed that on her, and I had the feeling it was right for the film, but personally I had the feeling it was not right. But as film knows no mercy, and I told her so, I placed her on seat 19F and I offered her to change the seat . . . so she could have changed it, but she said, 'No, now as we're there, as we're in this plane and doing the same route, I'm going to face it.'" "Herzog introduces his latest film."

54 A similar effect can be found in *Lessons of Darkness,* particularly the macabre display of torture instruments (discussed in chapter 2).

55 Speaking at the Walker Arts Center, Herzog accuses the television network of trading in gender stereotypes, while tacitly responding to his own critics, who emphasize the minority of women in his films: "I said, 'For god's sake, finally, here you have—everybody is asking for a real good woman on screen, for a strong, self-confident, self-reliant, good woman, and here—[*applause*]. It's the best that you can get.'" "Herzog introduces his latest film."

56 Brad Prager, "Between Sympathy and Scrutiny: Werner Herzog's Trauma Documentaries," paper presented at the First Annual Toronto German Studies Symposium, "Autobiographical Non-fiction Film: The Contemporary German Context," University of Toronto, April 2008.

57 On the search for totality in reenactments, see Allen, "Einmal," 183–85.

58 On the subjunctive mood of restored behavior, see Schechner, *Between Theater,* 92–93, 98–105, and Victor Turner, *The Anthropology of Performance* (New York: PAJ, 1988), 101–3.

59 Mark J. P. Wolf, "Subjunctive Documentary: Computer Imaging and Simulation," in *Collecting Visible Evidence,* ed. Jane M. Gaines and

Michael Renov (Minneapolis: University of Minnesota Press, 1999), 274.

60 Here, as he had with the training film in *Little Dieter Needs to Fly,* Herzog savages a preexisting film as a way of grounding and authenticating his own vision of the documentary subject.

61 The point can be made more vivid by contrast with the "monument of plaster," where the young Juliane is depicted at the foot of an angel. Here is another preexisting image and imagining that is also cast in the subjunctive, yet this one is treated with reverence (not ridicule).

62 Prager, *Cinema of Werner Herzog,* 158.

63 Cf. Margulies, "Exemplary Bodies," 220.

64 See, e.g., Bissell, "The Secret Mainstream," 76.

65 The additions created some controversy, led by the family of prisoner Gene DeBruin, concerning the portrayal of individual people as characters in a story. See http://rescuedawnthetruth.com/. For Herzog's reply, see "Making of a True Story" and the audio commentary on the *Rescue Dawn* DVD.

66 Many film reviews discuss Dengler and Bale in terms strongly reminiscent of Comolli's work on the history film. See, e.g., Richard Corliss, "Too Risky for Hollywood," *Time,* July 5, 2007, http://www.time.com/; Jessica Winter, "Re-orchestrated, Scripted, and Rehearsed," *Slate,* July 5, 2007, http://www.slate.com/; Anthony Lane, "Battle Scars," *The New Yorker,* July 9, 2007, 100–1; and Buruma, "Herzog," 26.

67 See on this point Brad Balfour, "Christian Bale Gives a Riveting Portrayal in *Rescue Dawn,*" July 7, 2007, http://www.popentertainment.com/.

68 "Making of a True Story"; second emphasis added.

7. AUTOBIOGRAPHICAL ACTS

1 For an early example, see the interview by Wetzel in Jansen and Schütte, *Herzog/Kluge/Straub,* 121. In English, see esp. Herzog, "Werner Herzog on Introspection."

2 Ian Johns, "Exit, Pursued by a Bear and an Auteur," *The Times* (London), February 2, 2006, http://www.thetimes.co.uk/.

3 Elizabeth W. Bruss, "Eye for I: Making and Unmaking Autobiography in Film," in *Autobiography: Essays Theoretical and Critical,* ed. James Olney (Princeton, N.J.: Princeton University Press, 1980), 297.

4 Ibid., 320.

5 See P. Adams Sitney, "Autobiography in Avant-Garde Film," in *The Avant-Garde Film: A Reader of Theory and Criticism,* ed. P. Adams Sitney, 199–246 (New York: New York University Press, 1978). See also John

Stuart Katz, ed., *Autobiography: Film/Video/Photography* (Ontario, Quebec: Art Gallery of Ontario, 1978), exhibition catalog.

6 See on this point Linda Haverty Rugg, "Keaton's Leap: Self-Projection and Autobiography in Film," *Biography* 29, no. 1 (2006): v–xiii.

7 See Herzog, *Herzog on Herzog,* 68. In *Portrait Werner Herzog* (which I discuss later in this chapter), Herzog describes his entire body of films as constituting a "family series" *(Familienserie),* referring to a popular genre of documentary television. The most notable example from the period is *An American Family* (PBS, 1973), a twelve-part series that aired on West German television from 1979 to 1981.

8 Herzog, *Herzog on Herzog,* 201; emphasis original.

9 Other scholars have traced this development through different materials. The key study is Renov's *Subject of Documentary.* See also Michael Renov, "First-Person Films: Some Theses on Self-Inscription," in *Rethinking Documentary: New Perspectives, New Practices,* ed. Thomas Austin and Wilma de Jong, 39–50 (Maidenhead, U.K.: Open University Press, 2009). For an overview of the Anglo-American context, see Carolyn Anderson, "Autobiography and Documentary," in *Encyclopedia of the Documentary Film,* vol. 1, ed. Ian Aitken, 67–70 (London: Routledge, 2006). For a sustained discussion, see Jim Lane, *The Autobiographical Documentary in America* (Madison: University of Wisconsin Press, 2002). On the German context, see Robin Curtis, *Conscientious Viscerality: The Autobiographical Stance in German Film and Video* (Emsdetten, Germany: Imorde, 2006).

10 Weisenborn worked as prop manager for *The Enigma of Kaspar Hauser* and as assistant director on Herzog's commissioned film, *No One Will Play with Me.*

11 Other documentaries about Herzog include *Showing the World We're Still Here,* filmed on the set of *Aguirre* and then forgotten; *Burden of Dreams,* on the making of *Fitzcarraldo* (discussed in chapter 5); another personal portrait, *Bis ans Ende . . . und dann noch weiter: Die ekstatische Welt des Filmemachers Werner Herzog* (Until the End . . . and Beyond: The Ecstatic World of the Filmmaker Werner Herzog, 1989; dir. Peter Buchka); a mockdocumentary, *Incident at Loch Ness* (2004; dir. Zak Penn); a sequel, *I Am My Films—Part 2 . . . 30 Years Later* (*Was ich bin, sind meine Filme—Teil 2—Nach 30 Jahren,* 2010; dir. Christian Weisenborn), focusing on the documentaries and commissioned by the Goethe-Institut to accompany a new edition of the *Werner Herzog: Documentaries* DVD box set; and most recently, *Ballad of a Righteous Merchant: Notes on Herzog Directing My Son, My Son, What Have Ye Done* (2012; dir. Herbert Golder).

12 Audrey Levasseur, "Film and Video Self-Biographies," *Biography* 23,

no. 1 (2000): 179. See also Gerald Honigsblum, "*Sartre by Himself:* Film as Biography and Autobiography," *The French Review* 55, no. 7 (1982): 123–30.

13 Herzog, *Herzog on Herzog,* xii.

14 Levasseur, "Film and Video Self-Biographies," 178.

15 Ibid., 179.

16 Cf. Federico Fellini's preface to *Fellini on Fellini,* ed. Anna Keel and Christian Strich, trans. Isabel Quigley (New York: Delacorte Press, 1976).

17 Corrigan, "Producing Herzog," 5. Cf. Herzog, *Herzog on Herzog,* 139–40.

18 Michel Beaujour, *Poetics of the Literary Self-Portrait,* trans. Yara Milos (New York: New York University Press, 1991), 104.

19 James Olney, *Metaphors of Self: The Meaning of Autobiography* (Princeton, N.J.: Princeton University Press, 1971), 35.

20 My section title partly derives from Carolyn Kay Steedman's autobiographical self-portrait, *Landscape for a Good Woman* (1987). There is some irony in this borrowing, as I am aware. For Herzog, the autobiographical act is taken for granted; the filmmaker assumes his central place in the landscape, as if it were a birthright. The assumed name Herzog, which in German means "duke," articulates this sense of entitlement. For Steedman, by contrast, the English tradition of landscape painting historically marginalizes both women and the working classes, and her book makes a personal claim to the landscape on behalf and in memory of her mother.

21 For a relevant discussion of walking, see Deirdre Heddon, "The Place of the Self," part 3 of *Autobiography and Performance* (Basingstoke, U.K.: Palgrave Macmillan, 2008).

22 Raymond Bellour, *Eye for I: Video Self-Portraits,* trans. Lynne Kirby, Whitney Museum of American Art, New American Film and Video Series 48, October 3–29, 1989, program brochure.

23 An indoor scene of Herzog and Lotte Eisner is the exception that proves the rule. The eminent scholar and authority of German film history, Eisner was the object of Herzog's 1974 pilgrimage from Munich to Paris, discussed in chapter 3.

24 Paul John Eakin, "Relational Selves, Relational Lives: The Story of the Story," in *True Relations: Essays on Autobiography and the Postmodern,* ed. G. Thomas Couser and Joseph Fichtelberg (Westport, Conn.: Greenwood Press, 1998), 71. The relational paradigm is not new; Eakin draws on the work of others, especially feminist scholars, who have challenged models of unified subjectivity and emphasized alternative configurations. See, e.g., Nancy K. Miller, "Representing Others: Gender and the Subjects

of Autobiography," *differences: A Journal of Feminist Cultural Studies* 6, no. 1 (1994): 1–27. The relational paradigm has also been explored in the arena of documentary studies; see Renov, "Domestic Ethnography and the Construction of the 'Other' Self," chapter 14 in *Subject of Documentary*, and Alisa S. Lebow, *First Person Jewish* (Minneapolis: University of Minnesota Press, 2008).

25 Eakin, "Relational Selves," 70; emphasis original.

26 See on this point Susanna Egan, *Mirror Talk: Genres of Crisis in Contemporary Autobiography* (Chapel Hill: University of North Carolina Press, 1999), 88.

27 For a thorough discussion of the Herzog–Kinski duo, with particular emphasis on issues of stardom, see Matthias Reitze, *Zur filmischen Zusammenarbeit von Klaus Kinski und Werner Herzog,* Aufsätze zu Film und Fernsehen 77 (Alfeld/Leine, Germany: Coppi, 2001).

28 Cf. Matthew 7:5: "Thou hypocrite, first cast out the beam out of thine own eye; and then shalt thou see clearly to cast out the mote out of thy brother's eye!"

29 For more on the Jesus Tour, see Peter Geyer, *Klaus Kinski* (Frankfurt am Main, Germany: Suhrkamp, 2006), 52–53, 75–78.

30 Cf. Klaus Kinski, *Ich brauche Liebe* (Munich, Germany: Heyne, 1991), 9–12; in English, *Kinski Uncut: The Autobiography of Klaus Kinski,* trans. Joachim Neugröschel (New York: Penguin, 1996), 1–3.

31 Dirk Kurbjuweit, "Klaus, der Feind" (includes an interview with Herzog), *Zeit Online,* [1999], http://www.zeit.de/.

32 In his autobiography, by contrast, Kinski emphasizes the interval between the Jesus Tour and his arrival and offers no evidence that might corroborate Herzog's account. Cf. Kinski, *Kinski Uncut,* 213–18. This difference further suggests that the relationship between performance and filmmaking is one of Herzog's unspoken concerns.

33 Reitze, *Zur filmischen Zusammenarbeit,* 74–75.

34 The scene with the stiff-necked aristocrats in Herzog's "old" home may be read as a play on his former poverty and his own artistic origin. Again, he took the name Herzog (Duke) on identifying himself as a filmmaker.

35 As Mauch recalls it in an early portrait of Herzog, "Once I suggested he voice all the parts himself, and then he became furious [*dann war er unter sich*]." From *Showing the World We're Still Here* (*Der Welt zeigen, dass wir noch da sind,* 1972; dir. Thomas Mauch).

36 Herzog, *Herzog on Herzog,* 69.

37 In an interesting variation on the use of recycled footage, which runs throughout this material, Kinski's image also serves to evoke Herzog's past

as a film viewer. At one point, footage from the postwar German feature *Kinder, Mütter und ein General* (Children, Mothers, and a General, 1955; dir. László Benedek) is replayed and reframed as an auspicious moment in Herzog's life, a pictured memory of the first time he saw Kinski act. A one-second clip is shown three times in rapid succession, its looping repetition serving to visualize not only what the young viewer saw on-screen and again in his mind but also a sense of the emotion he felt at the time, transfixed as he was by a single gesture. This memory of spectatorship may, of course, be invented, like the prelude to *Land of Silence and Darkness.*

38 See Geyer, *Klaus Kinski,* 7–8, 26–27, 111–14.

39 The passage does not appear in the English translation, which is abridged but unmarked as such. See Kinski, *Ich brauche Liebe,* 414; cf. Kinski, *Kinski Uncut,* 301.

40 According to Reitze, *Zur filmischen Zusammenarbeit,* 85, the entire scene works to revise Herzog's public image as the "victim" of Kinski's tirades.

41 See Geyer, *Klaus Kinski,* 128–29. The implications of Herzog's claim for the reception of *Kinski Uncut* are significant; hence the objections of his biographer, Geyer, who is also the custodian of Kinski's archive. Here it should be noted that Geyer erroneously locates the collaboration scene on the set of *Fitzcarraldo* "in Peru" and disputes Herzog's account based on this false assumption. There is, however, a more likely reason for suspicion, which has to do with the illicit status of Kinski's life narrative, for it is difficult to imagine Herzog passing up an opportunity to "reveal" a supposed secret about a fictive autobiography in the context of a documentary film.

42 Eakin, "Relational Selves," 71.

43 Ibid.

44 Sissela Bok, *Secrets: On the Ethics of Concealment and Revelation* (New York: Pantheon, 1982), 84.

45 The effect of reframing this material can be made more explicit by comparison with an interview Herzog gave to Swiss filmmaker Steff Gruber on the set of *Cobra Verde.* Because this interview is not available in English, it is worth quoting at length. Having suggested that Kinski needs "space" to create, Herzog elaborates. "We shot a scene: He tries to pull a boat into the ocean, which is of course much too difficult. Toward the end of the scene, I sensed that something was about to happen, so I leave the camera rolling. He knows that I leave the camera rolling, because he has blind faith in me, absolutely blind faith. And as it happened, he collapsed with exhaustion, began drowning, and was sucked away by the ocean. That goes on for several minutes, as it does in the film. It is a

scene that emerged in a way that no one had anticipated, neither of us, and yet we knew from one another, now we would collaborate." At the time, Herzog understood the death scene as an example of their artistic symbiosis and not as a symptom of their impending separation. Werner Herzog, "Location Africa," interview by Steff Gruber, in Herzog, *Cobra Verde Filmbuch* (Zurich, Germany: Stemmle, 1987), 133.

46 Reitze, *Zur filmischen Zusammenarbeit,* 78.

47 Cf. Prager, *Cinema of Werner Herzog,* 46–48, and Thomas Willmann, review of *Mein liebster Feind,* in *Artechock Filmmagazin,* http://www.artechock.de/.

48 Miller, "Representing Others," 2.

49 In this respect, *Grizzly Man* exemplifies an emerging issue, which is the increasing availability of personal video and its use in documentary filmmaking across the board. For a discussion of this issue with *Grizzly Man* as its prime example, see Jerry Rothwell, "Filmmakers and Their Subjects," in *Rethinking Documentary: New Perspectives, New Practices,* ed. Thomas Austin and Wilma de Jong, 152–56 (Maidenhead, U.K.: Open University Press, 2009).

50 Mark Allister, *Refiguring the Map of Sorrow: Nature Writing and Autobiography* (Charlottesville: University Press of Virginia, 2001).

51 See Timothy Treadwell and Jewel Palovak, *Among Grizzlies: Living with Wild Bears in Alaska* (New York: Ballantine, 1997), esp. chapters 1 and 4. Cf. Nick Jans, *The Grizzly Maze: Timothy Treadwell's Fatal Obsession with Alaskan Bears* (New York: Plume, 2006), esp. 10–23.

52 Paul de Man, "Autobiography as De-facement," *Modern Language Notes* 94, no. 5 (1979): 920; emphasis original.

53 Ibid., 930.

54 Ibid., 926; emphasis original.

55 Ibid., 927.

56 Ibid., 923.

57 Ibid., 921.

58 Prager, *Cinema of Werner Herzog,* 88, mentions Herzog's use of prosopopoeia in earlier films, especially in regard to landscape.

59 Werner Herzog, "Warum ist überhaupt Seiendes und nicht vielmehr Nichts?" *Kino* (West Berlin) 12 (March–April 1974): n.p. The quotation comes from the English translation, "Why Being Rather Than Nothing?" *Framework* 3 (Spring 1976): 27. Timur Lenk (aka Tamerlane) refers to the nomadic Mongol warrior who, in the late 1300s, conquered much of central Asia.

60 Werner Herzog, "Discord and Ecstasy: Werner Herzog on *Grizzly Man,*"

interview by Marrit Ingman, *The Austin Chronicle,* August 19, 2005, http://www.austinchronicle.com/.

61 For an account of the production, see the press kit for *Grizzly Man,* available at http://www.wernerherzog.com/.

62 Werner Herzog, "Werner Herzog: Onstage at BFI Southbank," interview by Mark Kermode, *The Guardian,* January 26, 2009, http://www.guardian.co.uk/.

63 Werner Herzog, "A More Athletic Approach," interview by Cynthia Fuchs, *PopMatters,* August 11, 2005, http://popmatters.com/.

64 The "BBC sniper interview" only adds to this legend. In 2006, while taping a television interview in Los Angeles, Herzog was shot in the abdomen by somebody using an air rifle. After moving to a safe location, the reporter and film critic, Mark Kermode, asks Herzog about the dangers of filming on location for *Grizzly Man,* to which he responds, "I am *really not* afraid. . . . I'm not afraid of anything." The interview also provides Herzog with an occasion to show the wound on camera, which he does, as physical proof of his mettle and manliness. See "Werner Herzog full sniper interview," http://youtube.com/. For a fuller and blatantly comic account, see Mark Kermode, "I Shot Werner Herzog," chapter 8 in *It's Only a Movie* (London: Random House, 2010).

65 See Prager, *Cinema of Werner Herzog,* 89–90.

66 Herzog is aware of this issue. In interviews, he acknowledges the need to approach the Treadwell material "with a certain respect, because he cannot defend himself"; see Herzog, "Discord and Ecstasy." He also overstates the point, turning it into a taboo that *Grizzly Man* obviously breaks: "You do not juggle around with this material, and you don't do it in your own style. You just don't do it. It's not permissible"; Herzog, "A More Athletic Approach."

67 *Grizzly Man* also shares with *Anatomy of a Bear Attack* several key personnel, including four participants (biologist Larry Van Daele, medical examiner Frank Fallico, bush pilot Willy Fulton, Treadwell's ex-partner Jewel Palovak) and two producers (Erik Nelson and Phil Fairclough). In the latest twist, Discovery produced *The Grizzly Man Diaries* (Animal Planet, 2008), an eight-episode television series that draws in turn on elements of Herzog's film. Excerpts from Treadwell's video diaries as well as written journals are readily available at http://animal.discovery.com/.

68 Herzog himself employs the diary entry as a narrative device in *Aguirre.* The opening text, which introduces the Spanish search for El Dorado, notes that "the only document to survive from this lost expedition is the diary of the monk Gaspar de Carvajal." The diary is Herzog's invention.

With a few minor changes, it could easily be adapted as the introduction to *Grizzly Man.*

69 Each example relates to the confessional mode in recent video art and television. See Michael Renov, "Video Confessions," in *Resolutions: Contemporary Video Practices,* ed. Michael Renov and Erika Suderburg, 78–101 (Minneapolis: University of Minnesota Press, 1996), and Jon Dovey, *Freakshow: First Person Media and Factual Television,* 103–32 (London: Pluto Press, 2000).

70 The rough, informal, private elements of the video diaries combine with the first-person perspective to create a powerful effect of authenticity operating throughout *Grizzly Man,* even though it is made by Herzog and an entire team of professionals. In some ways, the involvement of professionals actually enhances the authenticity effect that the video diaries create. The impression of spontaneity, for example, becomes even more convincing by juxtaposing Treadwell's verbal presentations (which are emotive, meandering, and spoken in situ) with Herzog's commentary (which is subdued, laconic, and added post hoc).

71 At this juncture, *Grizzly Man* resembles a making-of film such as *Burden of Dreams.* The resemblance is more than passing. Indeed, the terms of Les Blank's film about the making of *Fitzcarraldo*—madness, suicide, murder, nature, and civilization—are also the terms of *Grizzly Man.* Only Herzog makes the story turn out this way, by revising and reinventing it in his own image. When Treadwell is ranting and cursing on camera, e.g., Herzog comments, "I have seen this madness before on a film set. But Treadwell is not an actor in opposition to a director or a producer. He's fighting against civilization itself." To a knowing film viewer, the comparison to Kinski is obvious. What is interesting about the commentary, however, is that it also contrasts them in such a way that brings Treadwell even closer to Herzog, to the filmmaker's critique of civilization, and to his role in *Burden of Dreams.* "Has Herzog made his own *Burden of Dreams,*" asks one critic, "with . . . Treadwell playing the role of filmmaker gone mad?"; Johns, "Exit, Pursued by a Bear," n.p. Indeed, he has. For a director who claims to "be" his films, as Herzog does, the making-of film doubles as a form of autobiography.

72 In interviews, Herzog refers to his family to explain this comment: "I say in the film that I see chaos, hostility, and murder. [*Laughs*] I have an ongoing argument, but it's never a nasty argument. I argue like I argue with my brothers, and I love them"; Herzog, "A More Athletic Approach." See also Herzog, "Discord and Ecstasy," and the *Grizzly Man* press kit.

73 See Treadwell and Palovak, *Among Grizzlies,* 123–25; Jans, *The Grizzly*

Maze, 60, 81, 133; *Anatomy of a Bear Attack;* and the website for *The Grizzly Man Diaries.*

74 For the backstory to this scene, see Herzog, "A More Athletic Approach."

75 Vogel, "Grim Death," 78.

76 Vivian Sobchack, "Inscribing Ethical Space: Ten Propositions on Death, Representation, and Documentary," *Quarterly Review of Film Studies* 9, no. 4 (1984): 283.

77 In interviews, Herzog now expresses regret for dictating terms to Palovak. "What she did was more intelligent," he adds. "She separated herself from the tape; she put it in a bank vault"; Herzog, "A More Athletic Approach." See also Werner Herzog, "Filmmaker Herzog's 'Grizzly' Tale of Life and Death," interview by Dave Davies, National Public Radio, January 13, 2006, http://www.npr.org/.

78 The need for visual orientation might explain why this poster was replaced by another design, in which bear and man are immediately discernable, their bodies fully visible, and clearly situated as figures in a spectacular landscape.

79 Herzog, *Herzog on Herzog,* 109.

80 Herzog, "Why Being," 27.

81 The final sequence of *Grizzly Man* specifically recalls a scene from *The Gold Rush,* when "the lone prospector" (Chaplin) ambles down a snowy path, oblivious to the bear trailing behind him. Herzog has engaged this material before. Although it is nowhere mentioned in the scholarship, the opening sequence of *Aguirre* reworks the beginning of Chaplin's film: a mountainous landscape dotted with gold-seeking prospectors, all struggling against the elements, marching in single file toward the camera. Indeed, Herzog's parody of the expedition film derives in part from Chaplin. Finally, we should recall that *Werner Herzog Eats His Shoe,* Les Blank's personal portrait of the young German filmmaker, recycles key footage from *The Gold Rush.*

82 See, e.g., Herzog's *The Dark Glow of the Mountains* and Buchka's documentary portrait of Herzog, *Bis ans Ende.*

CONCLUSION

1 Wolf, "Subjunctive Documentary," 278, 289; emphasis original.

2 For a thorough discussion of this issue, see Taylor, *Archive.*

3 For an account of this interview written by the ex-linguist himself, see Bill Jirsa, "Being Werner Herzog," http://www.bigdeadplace.com/herzog.html.

4 The notion of the cave as a performance space was introduced in 1977 by Richard Schechner. For an archaeological discussion of this theory, see Yann-Pierre Montelle, *Palaeoperformance: The Emergence of Theatricality as Social Practice* (London: Seagull Books, 2009).

5 On documentary's relation to prehistory and on the need for new technologies, see James M. Moran, "A Bone of Contention: Documenting the Prehistoric Subject," in *Collecting Visible Evidence,* ed. Jane M. Gaines and Michael Renov, 255–73 (Minneapolis: University of Minnesota Press, 1999).

6 Jean-Marie Chauvet, Éliette Brunel Deschamps, and Christian Hillaire, *Dawn of Art: The Chauvet Cave: The Oldest Known Paintings in the World* (New York: Harry N. Abrams, 1996), 48. Cf. Jean Clottes, *Cave Art* (London: Phaidon Press, 2008).

7 Issues of parody, self-parody, and mockumentary are also in play and certainly worth exploring. See my "Werner beinhart—Herzogs Komik und Herzog-Parodien," in *Lektionen in Herzog: Neues über Deutschlands verlorenen Filmautor und sein Werk,* ed. Chris Wahl, 190–209 (Munich: Text + Kritik, 2011); in English, "Spoofing Herzog and Herzog Spoofing," *Transit* 6, no. 1 (2010), http://german.berkeley.edu/transit.

8 Edward L. Schieffelin, "Problematizing Performance," in *Ritual, Performance, Media,* ed. Felicia Hughes-Freeland (London: Routledge, 1998), 200.

INDEX

(continued from page ii)

Eric Ames is associate professor of German and a member of the Cinema Studies faculty at the University of Washington. He is coeditor of *Germany's Colonial Pasts* and author of *Carl Hagenbeck's Empire of Entertainments*.